BEIRUTER TEXTE UND STUDIEN

HERAUSGEGEBEN VOM
ORIENT-INSTITUT
BEIRUT

BAND 132

THE ART SALON
IN THE ARAB REGION

Politics of Taste Making

Edited by

Nadia von Maltzahn and Monique Bellan

BEIRUT 2018

ERGON VERLAG WÜRZBURG
IN KOMMISSION

Cover image: Visitors at the 7th Salon d'Automne, Sursock Museum, 1967–1968 (detail).
Courtesy of the Nicolas Ibrahim Sursock Museum.

Bibliografische Information der Deutschen Nationalbibliothek

Die Deutsche Nationalbibliothek verzeichnet diese Publikation in der
Deutschen Nationalbibliografie; detaillierte bibliografische Daten sind
im Internet http://dnb.dnb.de abrufbar

Ergon – ein Verlag in der Nomos Verlagsgesellschaft, Baden-Baden
ISBN 978-3-95650-527-0
ISSN 1863-9461

Die Beiruter Texte und Studien werden herausgegeben unter der Mitarbeit von Lale Behzadi,
Konrad Hirschler, Birgit Krawietz, Sonja Mejcher-Atassi und Birgit Schäbler.
Wissenschaftliche Betreuung: Torsten Wollina.

Druck: Dergham
Printed in Lebanon

CONTENTS

ACKNOWLEDGEMENTS

This volume is the result of a series of conversations and discussions that took place in various forums. It began when we, the editors, were brainstorming about a topic that we could work on together at the Orient-Institut Beirut (OIB). In her longer-term research on aesthetic reflection and the way art has been debated in the media in Lebanon and Egypt since the early twentieth century, Monique was at that time focusing on the avant-garde group Art et Liberté in Egypt, which challenged the aesthetic and political order in the late 1930s and 1940s. Nadia was becoming immersed in her case study of the Sursock Museum in Beirut, within her project on the relationship between cultural policies, cultural production and the public sphere in Lebanon. The Sursock Museum was known for its Salon d'Automne, and the salon was one of the exhibition formats rejected by the Art et Liberté Group in Cairo. We therefore started thinking about the role and impact of the art salon on the formation of public taste and debates on art in the Arab region, as well about cultural interactions between the Middle East and Europe.

Guided initially by the question of the migration of institutional patronage from Europe to the Arab region, we organised a two-part panel on "The Art Salon in the Arab Region." The first part was held at the Italian Society of Middle Eastern Studies' annual conference in Catania in March 2016, with Monique Bellan, Catherine Cornet, Morad Montazami, Nadia von Maltzahn, and Nadia Radwan, moderated by Eva Maria Troelenberg. The second part took place at the Middle East Studies Association's annual meeting in Boston in November 2016, with Monique Bellan, Nadia von Maltzahn, and Nada Shabout, moderated by Kirsten Scheid. A third panel discussion took place in January 2017 at the Sursock Museum, when Jessica Gerschultz joined us. This event was held in the frame of the Sursock Museum's 32nd Salon d'Automne, which the museum had just relaunched after many discussions as to the function of the salon format today.

Since the topic resonated both in academic and art circles, we decided to partner with the Sursock Museum to bring everyone together to discuss more comprehensively the emergence and evolution of the art salon in the

region, and to deliberate on the function of the art salon today in the context of a museum and its collection. In October 2017 we convened a two-day conference on "The Art Salon in the Arab Region."

We would like to warmly thank all the participants in these discussions, the value of which went far beyond the panels themselves: Amin Alsaden, Hala Auji, Gregory Buchakjian, Eileen Cooper, Catherine Cornet, Nancy Demerdash-Fatemi, Abed al-Kadiri, Kristine Khouri, Alain Messaoudi, Morad Montazami, Marie Muracciole, Camilla Murgia, Silvia Naef, Maria-Mirka Palioura, Dina A. Ramadan, Nora Razian, Ghalya Saadawi, Kirsten Scheid, Nada Shabout, Nayla Tamraz, Eva Maria Troelenberg, and Amar A. Zahr. Our special gratitude goes to the Sursock Museum, Zeina Arida, Rowina Bou-Harb, Yasmine Chemali, and Sasha Ussef, and we are extremely grateful to the Volkswagen Foundation for supporting the conference and contributing to publication costs.

We would also like to thank our interns Ida Forbriger, Talha Güzel, Pauline Hahn, Hans Magne Jaatun, Daniel Lloyd, Turina Schilling, Tobias Sick and Manzi Tanna-Händel, and our colleagues at the OIB for their support – in particular Torsten Wollina for his insightful comments and bringing this publication to light, as well as Virginia Myers for her expert copy-editing. The BTS Advisory Board's critical input and the peer-reviewer's constructive feedback greatly enriched the volume.

Beirut, November 2018
Nadia von Maltzahn and Monique Bellan

NOTE ON CONTRIBUTORS

Amin Alsaden is an independent scholar who focuses on the global exchanges of ideas and expertise across cultural boundaries. He is currently researching a pivotal juncture in post-World War II Baghdad, when the city became a locus of unprecedented encounters, contributing to the profound transformation of art and architecture globally while generating unique local movements. Alsaden holds a PhD and MA from Harvard University, an MArch from Princeton University, and a BArch from the American University of Sharjah.

Monique Bellan works as a Research Associate at the Orient-Institut Beirut (OIB). She holds a PhD from Freie Universität Berlin and an MA from the University of Bonn. She has worked at the collaborative research centre "Aesthetic Experience and the Dissolution of Artistic Limits" at Freie Universität Berlin and at the Academy of Arts in Berlin. Her current project examines aesthetic reflection in twentieth-century Lebanon and Egypt. She is the author of *dismember remember: The Anatomical Theatre of Lina Saneh and Rabih Mroué* (2013).

Eileen Cooper is a contemporary painter and printmaker. She studied at Goldsmiths College in London from 1971 to 1974 and was in the cohort of students selected by the artist and academic Jon Thompson. She went on to study Painting at the Royal College of Art under Professor Peter de Francia, graduating in 1977, and soon began to exhibit her work. Cooper has taught in numerous institutions including St Martins, the Royal College of Art and the Royal Academy Schools. She became a Royal Academician in 2000 and from 2010-2017 served as Keeper of the Royal Academy, the first woman elected to this role since the Academy's founding in 1768. She was the Co-ordinator of the Royal Academy Summer Exhibition in 2017, and held her first exhibition in Beirut at Letitia Gallery in 2018, entitled "Under the Same Moon".

Catherine Cornet is an Adjunct Professor at the American University of Rome and a cultural journalist for the news magazine *Internazionale*. She obtained her PhD in 2016 from EHESS Paris and University of Rome II with a thesis entitled "In Search of an Arab Renaissance: Artists, Patrons

and Power in Egypt after 2001." She studied Middle Eastern Politics and Islamic Art at the School of Oriental and African Studies (SOAS), London, and Political Sciences at the Institut d'Etudes Politiques in Aix-en-Provence.

Nancy Demerdash-Fatemi is an Assistant Professor of Art History in the Department of Art and Art History at Albion College, Michigan. An art and architectural historian, her interests centre on the modern and contemporary visual cultures of the Middle East and North Africa, as well as on post-colonial studies, diaspora and memory studies. Her current book project explores the spatial and political implications of modernist architectural schemes and urban plans in late French colonial Tunisia. Demerdash-Fatemi earned an MSc in Architecture Studies from the Aga Khan Programme of Islamic Architecture at the Massachusetts Institute of Technology, and a PhD from the Department of Art and Archaeology at Princeton University. She has published in *New Middle Eastern Studies*, the *Journal of North African Studies,* the *Journal of Arabian Studies,* and *Perspective: actualité en histoire de l'art*, among others. She is also an assistant editor with the *International Journal of Islamic Architecture.*

Jessica Gerschultz is an Assistant Professor in the Department of African and African-American Studies at the University of Kansas. She researches African and Arab articulations of modernism with an emphasis on tapestry. She was an ACLS (American Council of Learned Societies) Fellow in 2016 during the writing of her first book, *Decorative Arts of the Tunisian École* (Pennsylvania State University Press, forthcoming). She has written articles for *ARTMargins* (2016), the *International Journal of Islamic Architecture* (2015), and *Critical Interventions: Journal of African Art History and Visual Culture* (2014).

Nadia von Maltzahn is the Deputy Director of the Orient-Institut Beirut (OIB). She is the author of *The Syria-Iran Axis: Cultural Diplomacy and International Relations in the Middle East* (I. B. Tauris, 2013/2015), and other publications revolving around cultural practices in Lebanon and the Middle East. She holds a DPhil in Modern Middle Eastern Studies from St Antony's College, Oxford. Her research interests include cultural policies and urban governance, artistic practices and the circulation of knowledge. Her current research project deals with cultural policies in Lebanon, in particular cultural institutions and their role in the public sphere.

Alain Messaoudi is a Lecturer in Modern History at the Université de Nantes. He is the author of *Savants, interprètes, médiateurs. Les arabisants et la France coloniale* (1780-1930) (ENS Éditions, 2014), and currently

works on cultural transfers between North Africa and Europe, in particular the exchanges in the visual arts between Tunisia and France. He holds a PhD in History from the University of Paris 1 Panthéon-Sorbonne.

Camilla Murgia is Junior Lecturer in the History of Contemporary Art at the University of Lausanne. She studied Art History at the Universities of Neuchâtel (MA) and Oxford (PhD), with a doctoral thesis on Pierre-Marie Gault of Saint-Germain (1752-1842). She was a Junior Research Fellow in the History of Art at St John's College, Oxford, and has taught at Oxford, Neuchâtel and Geneva universities. Murgia is interested in the visual and material culture of the "long nineteenth century" and particularly its various events in France and England. She has published numerous books and articles.

Maria-Mirka Palioura studied French Letters and Art History and has a BA and PhD from Athens University and an MA from the University of Paris I Panthèon-Sorbonne. She has edited two books and presented several conference papers on nineteenth-century Greek art. She has taught at the Athens School of Fine Arts, the Hellenic Open University and has worked in the Greek Ministry of Culture. She is a Member of the Hellenic Association of Art Historians and is currently working in the Finopoulos Collection – Benaki Museum, Athens, Greece.

Nadia Radwan is an art historian specialising in modern art and architecture in the Middle East, who obtained her PhD at the University of Geneva. She was Assistant Professor of Art History at the American University in Dubai, and is currently Assistant Professor of World Art History at the University of Bern. Her research focuses on cross-cultural interactions and artistic modernities in the Middle East, as well as on curatorial dynamics and cultural practices in the United Arab Emirates. Radwan is the author of *Les modernes d'Egypte* (Peter Lang, 2017) and has published many articles about modern and contemporary Arab art.

INTRODUCTION
THE ART SALON IN THE ARAB REGION

Nadia von Maltzahn

This volume discusses the emergence and role of the art salon in the Arab region in the nineteenth and twentieth centuries, focusing on Algeria, Tunisia, Egypt, Lebanon and Iraq.[1] The institutional forms of exhibiting and teaching art migrated from Europe to the Middle East and North Africa in the late colonial and early post-colonial context and developed into stories of their own, while artists circulated between these regions. The various chapters examine how the salon had an impact on the formation of taste and on debates on art, and discuss the transfers and cultural interactions between the Middle East, North Africa and Europe. Following the institutional model of the Paris salons, art salons emerged in Algiers, Tunis and Cairo starting in the late 1880s. In Beirut and Damascus the salon tradition reached its peak only after independence in the mid-twentieth century. Baghdad never had a formal salon, but alternative spaces and exhibition formats developed in Iraq from the late 1940s onwards.

The salons in the region – like their Parisian predecessors – often defined the criteria of artistic production and public taste, while creating new societal practices. The impact of the salon also lay in its ability to convey particular values, attitudes and aspirations. At the same time, the values and attitudes promoted by the salon were subject to debate, which led to the creation of counter-salons or alternative exhibition practices. The role of the salon evolved within the context of the artistic landscape in each city, which in turn was determined by local political and economic imperatives. Thus the art salon helps us to understand changes in the art systems of these countries, including the development of art schools, exhibition spaces and artist societies, and gives insight into the power

[1] The Arab region is here taken as the region in which Arabic is one of the official languages. It is understood as a geographical term with no ethnic implications. Unless otherwise indicated, this introduction is based on the information provided in the chapters in this volume. For further reading, please refer to the selected bibliography at the end of the book.

dynamics at play.[2] It also highlights networks and circulations between the Arab region and Europe.

The art salon is understood as a group exhibition of art that takes place on a regular – generally annual or biannual – basis, in which works are chosen by a jury or selection committee. It showcases contemporary artistic production and is generally widely reviewed in the press. Participating in a salon has often constituted an important step for artists in getting their works recognised. Many salons have handed out prizes to further institutionalise taste. The Arabic term for art salon has usually been simply "exhibition" (*ma'rad*).[3] The Arab region has had a long tradition of scholarly, social or literary gatherings (*majlis*, pl. *majalis*) that have been referred to as salons.[4] Art salons showed similarities to these earlier gatherings, and constituted a (regulated) public sphere in which debates took place, styles were circulated, and a shared tradition was established. However, with few exceptions[5] the model for the art salon in the Arab

2 For an engagement with questions of modernity and exhibition practices, see Naef, Silvia. *A la recherche d'une modernité arabe: L'évolution des arts plastiques en Egypte, au Liban et en Irak.* Geneva: Éditions Slatkine 1996; Shabout, Nada. *Modern Arab Art: Formation of Arab Aesthetics.* Florida: University Press of Florida, 2007; Winegar, Jessica. *Creative Reckonings: The Politics of Art and Culture in Contemporary Egypt.* Stanford CA: Stanford University Press, 2006.

3 There are a few exceptions, including the Cairo Youth Salon (launched in the late 1980s), which directly transcribed the term "salon" in Arabic (*salon al-shabab*). The recent Salon d'Automne International de Tunisie, which held its first exhibition in May 2014, also retained the term "salon" (*salun al-kharif al-dawli bi-tunis*).

4 Older forms of scholarly and social gatherings acted as spaces of debate and encounter, enabled the circulation of ideas, contributed to establishing a shared tradition, as well as helped to spread the reputation of (literary) works. See Pfeifer, Helen. "Encounter After the Conquest: Scholarly gatherings in sixteenth-century Ottoman Damascus." *International Journal of Middle East Studies* 47 (2015): 219-239. Nelly Hanna writing about Ottoman Egypt emphasises how the literary salon (*majlis adab*) brought together literary people, poets and singers, some of whom travelled long distances in search of patrons and audiences. Hanna, Nelly. "Culture in Ottoman Egypt." In *The Cambridge History of Egypt, Volume 2: Modern Egypt, from 1517 to the end of the twentieth century.* Edited by M. W. Daly. Cambridge: Cambridge University Press 1998, 99. Hanna elaborates on the importance of the *majlis* or salon as a place of debate of literature, politics and current affairs for an emergent middle class in: Hanna, Nelly. *In Praise of Books: A cultural history of Cairo's middle class, sixteenth to eighteenth century.* Syracuse: Syracuse University Press 2003. I thank Torsten Wollina for sharing this literature with me. Social or literary salons also had a tradition in France. For a discussion of these, see Martin-Fugier, Anne. *Les salons de la IIIe République: Art, littérature, politique.* Paris: Perrin 2009.

5 Amin Alsaden in his chapter shows the explicit link between what he has termed "alternative salons" and the tradition of *diwans* in mid-twentieth century Baghdad. See also Al-Karkhi, Hussain Hatim. *Majalis al-adab fi Baghdad.* Bayrut: Al-mu'assasah al-'arabiyah lil-dirasat wa al-nashr 2003.

region was the type of art exhibition that had its origin in seventeenth-century France.

Art salons started under Louis XIV in 1667 as the official exhibition of the Academy of Fine Arts in Paris, which took its name "Salon" after the famous *Salon carré* in the Louvre, where it was held since the early eighteenth century.[6] The Royal Academy in London followed suit a century later, with its first Summer Exhibition of 1769 taking place a year after the academy was founded.[7] The art academies in Paris and London and their annual salons soon became the most powerful institutions in the European art world of the time, patronising art and directing public taste. The salon became the heart of the Parisian art system, "the instrument for review, control and reward."[8] Only in the nineteenth century did artists start to oppose the monopoly of the academy, resulting in the creation of new exhibition forums or independent salons such as the Salon des refusés, the Salon d'automne or the Salon des indépendants in France.[9] As the annual Paris Salon declined in power, art salons began to emerge in North Africa and Egypt.

Art Salons in the Arab Region

Art salons in North Africa began as part of the colonial project and stood in close relation to the metropole, the home of many of the exhibiting artists. The Mediterranean part of colonial French Algeria (1830-1961) was administered as an integral part of France and considered like any other French *département* from 1848 until 1957, while Tunisia became a French protectorate in 1881.[10] This is important to bear in mind when discussing

6 For insights into the eighteenth-century Salon that was held biannually at the Louvre, see Delon, Michel (ed.). *Diderot: Salons*. Paris: Éditions Gallimard 2008. The collection of Diderot's critiques of the Salon are also an early example of art criticism.

7 The Royal Academy's Summer Exhibition has been running annually without interruption ever since, celebrating its 250th Summer Exhibition in 2018. While not called "salon", the Summer Exhibition has the same characteristics of the art salon.

8 White, Harrison and White, Cynthia. *Canvases and Careers: Institutional Change in the French Painting World*. New York: John Wiley & Sons 1965, 156. The book gives a clear idea about the decline of the power of the art academy and the emergence of a new art system, in which the emphasis shifted from the painting to the artist, from canvas to career, with its system of dealers and critics in relation to an evolving market.

9 For a discussion of the development of the art salon in France, see Monnier, Gérard. *L'art et ses institutions en France*. Paris: Éditions Gallimard 1995.

10 For a history of French Algeria, see Martin, Claude. *Histoire de l'Algérie française: 1830-1962*. Paris: Éditions des 4 Fils Aymon 1963; McDougall, James. *A History of Algeria*. Cambridge: Cambridge University Press 2017; Peyroulou, Jean-Pierre; Bouchène, Abderrahmane; Siari Tengour, Ouanassa; Thénault, Sylvie (eds.). *Histoire*

art in a national context. In Algeria under French rule, "Algerian" artists generally denoted "French" or "European", but rarely "Muslim" or "Arab". In Tunisia, the situation was more fluid but nevertheless strongly dominated by France. Fine art exhibitions were presented as a sign of progress and modernity. They promoted European artistic norms and values, aiming to shape taste and aesthetic understanding within this context. The acquisition of "good taste" was seen as part of France's *mission civilisatrice*. The Salon tunisien – run by the newly founded Institut de Carthage, an academy of arts and sciences – was launched in 1894, following a first group exhibition in 1888. In Algiers, the Society of Algerian Artists and Orientalists established a salon in 1897, in close exchange with the Parisian Society of French Orientalist Painters (founded in 1893), which had started an annual salon in Paris in 1895.

Egypt was not under formal colonial rule in the late nineteenth century despite being occupied by Britain since 1882,[11] and was less connected to the British art scene. The first Cairo Salon took place in 1891. In Egypt, unlike in Algiers and Tunis, colonial imperatives were not behind the creation of new exhibition practices, due also to the fact that Britain did not pursue a civilising mission. Rather, the early Cairo Salon was driven by the Greek artist Theodore Ralli, together with other, mainly European, artists who were either living in or passing through Cairo. They were familiar with the Parisian salons, in which they also exhibited. The Cairo Salon was established at a time when the city boasted a vibrant cosmopolitan community, which together with Egypt's political elite made up the salon's main audience. Not being part of an overt civilising mission, the Cairo Salon was portrayed as an "artistic awakening".

From the beginning, the art salons in Tunisia, Algeria and Egypt also had a commercial aspect, both locally and trans-regionally. Tunis and Algiers provided a new market for painters from France at a moment when the traditional Paris Salon was weakening, and artists often sent works to these salons that they did not manage to sell in the metropole. In Cairo, circulation of art worked the other way round: the Salon apparently served as a testing ground for works that were exhibited in Egypt and then sent to the European salons and art market, as Maria-Mirka Palioura shows

 de l'Algérie à la période coloniale, 1830-1962. Paris: Éditions de la Découverte, 2012.
 For Tunisia, see Martin, Jean-François. *Histoire de la Tunisie contemporaine. De Ferry
 à Bourguiba*. Paris: L'Harmattan, 2003.

11 For a history of modern Egypt, see Daly, M. W. (ed.). *The Cambridge History of Egypt,
 vol. 2: Modern Egypt from 1517 to the End of the Twentieth Century*. Cambridge: Cam-
 bridge University Press 2008, and Mansfield, Peter. *The British in Egypt*. New York:
 Holt, Rinehart and Winston 1972.

in Chapter four. The delay in opening the 1894 Salon reportedly greatly affected the quality of exhibited works, as the more important ones had been sent directly to Europe without waiting for the Cairo Salon. This suggests the secondary nature of the Cairo Salon in the art market.

What can be termed the first Cairo Salon was discontinued after 1906. It was not until the early 1920s that a new art salon was founded in the capital, this time largely by Egyptian protagonists. Prince Yusuf Kamal – the founder of the School of Fine Arts in Cairo – initiated the creation of the Society of the Lovers of Fine Arts in 1923, which in turn established the annual Cairo Art Salon the same year.[12] It was preceded by group exhibitions between 1920 and 1922, and ran until 1951 under the patronage of the politician and art collector Muhammad Mahmud Khalil. Later, after Egypt had been a republic for more than three decades, the Egyptian Ministry of Culture launched a Youth Salon (Salon al-Shabab) in Cairo in 1989.

In Lebanon and Syria, it was not until post-independence that regular salons were established. Whereas group exhibitions had taken place in Lebanon since the 1930s,[13] they were organised in a systematic manner only from the late 1940s. A first Salon d'Automne (ma'rad al-kharif, Autumn Salon) was launched by the Ministry of National Education and Fine Arts in 1954, followed by a Salon du Printemps (ma'rad al-rabi', Spring Salon). Beirut's Sursock Museum held its first Autumn Salon in 1961, which is still running today in spite of some interruptions.[14] In Damascus, the first annual group exhibition took place in 1950; in the same year, the Syrian Association for Fine Arts was founded, followed by the Association of Fine Arts Lovers in 1952 and the League of Syrian Artists for Painting and Sculpture in 1956.[15] After a Ministry of Culture

12 The Cairo Art Salon organised by the Society of the Lovers of Fine Arts was formally called "Salon" or "ma'rad", but is referred to as Cairo Art Salon in this book to differentiate it from the earlier Cairo Salon. For an image of the exhibition catalogue cover of the salon of 1929, see Bardaouil, Sam. *Surrealism in Egypt: Modernism and the Art and Liberty Group*. London: I.B. Tauris, 2017, Plate 0.10.

13 In 1938, the Société des Amis des Arts organised a group exhibition of painting and sculpture referred to as "Salon" (in French), which was repeated the year after in the basement of the parliament building. Oughourian, Joseph. "Le Salon." *Phenicia* (May 1938), 1-16; el-Assi, Farid. "Le Salon." *Phenicia* (May-June 2939), 37-44. For an account of earlier group exhibitions, such as the 1931 exhibition at the Arts and Crafts school, see Lahoud, Edouard. Contemporary Art in Lebanon. Beirut: Dar al-Machreq, 1974, XL.

14 The Autumn Salon at the Sursock Museum was interrupted between 1969 and 1974 due to renovation works, between 1975 and 1982 due to the outbreak of civil war, and between 2012 and 2016 again due to renovation works. See my chapter in this volume.

15 Al-Sharif, Tarek. "Contemporary Art in Syria." In *Contemporary Art in Syria: 1898-1998*. Edited by Mouna Atassi. Damascus: Gallery Atassi 1998, 302, 304.

was established in Damascus in 1958, it started organising annual Autumn Salons.[16]

The above salons can be considered as hegemonic institutions that strove to set the taste of the time, just like the Parisian model. While Baghdad never had a formal salon, several group exhibitions started in the 1950s, such as the Baghdad Exhibition – generally referred to as the Mansur Club Exhibition – in 1956, and the exhibition of the Iraqi Artists Society (founded in 1956) in 1957. Artists excluded from exhibiting at the third Mansur Club Exhibition, which due to its popularity could only accept a small number of submitted works, protested their exclusion by holding an "Exhibition of Rejects" (ma'rad al-marfudat) in 1958.

Counter-exhibitions

Iraqi artists holding something like a Salon des refusés in 1958 was not the first time the dominant art salons in the region faced competition. Rival art salons and exhibition practices emerged in Tunis, Algiers and Cairo in the 1920s and 1930s, either because the main salons were considered too experimental or too rigid, too inclusive or too exclusive. French painter André Delacroix initiated the Salon des artistes tunisiens in 1924, in opposition to the Salon tunisien's openness to "modernist tendencies" as well as its resistance to including Tunisian Muslim and Jewish artists. This rival salon, which ran until Delacroix's death in 1934, favoured academic-style paintings by French artists. It tried to strengthen France's position in the country at a time when Tunisian nationalist tendencies were on the rise. Rival salons in Algiers and Cairo, on the other hand, were founded against exclusionary exhibition practices. The Syndicat professionnel des artistes algériens founded its own salon in the 1920s, and the Photo Club of Algiers followed with a Photography Salon in 1934, both of which served as more inclusionary places of exchange. The Union artistique de l'Afrique du Nord, founded in 1925, also established an annual salon in Algiers that ran until 1961.

In Cairo, the rejection of the dominance of the Cairo Art Salon by the Society of the Lovers of Fine Arts – caricaturised as the "dictatorship of fine arts" – soon led to the formation of groups that initiated their own salons and exhibitions. La Chimère, founded in 1924 by Egyptian artist Mahmud Mukhtar and French painter Roger Bréval, organised annual exhibitions that they decided to rebrand as "salons" in 1926 to undermine the official institution. Juryless, La Chimère's salon had no educational agenda but

16 A.G., "A Damas: Des thèmes nationaux, avant tout", *L'Orient*, 5 December 1965.

aimed at fostering a local cosmopolitan cultural scene. The group Art et Liberté was constituted in Egypt in the late 1930s. Its main concern was – as the name suggests – "free" and "independent" art that was critical of the prevailing political and social conditions. The group's members organised five exhibitions in Cairo between 1940 and 1945 that reflected their independent approach. The works exhibited were neither submitted to a jury nor received official patronage from the political establishment.[17]

Inclusion and Exclusion

Official patronage was common in salons, both in Europe and the Arab region. The initial pre-revolutionary French salon celebrated the king as patron of the arts. In the region, the endorsement of high-ranking colonial administrators or the national political elite confirmed the prestige of salons and situated them within a political project, regardless of whether or not they were initialised or organised by a public or private entity. In Tunisia, the French Résident général and a member of the Tunisian beylical family generally inaugurated the salons. The first Cairo Salon's opening ceremony was attended by members of the khedival family and the diplomatic corps. The new Cairo Art Salon took place under the patronage of the recently established royal family, generally being inaugurated by the king. King Faisal II and Prince Abd al-Ilah of Iraq opened the 1957 exhibition of the Iraqi Artists Society. Finally, the salons of the Lebanese Ministry of Education and Fine Arts took place under the patronage of the president of the republic. The mechanisms of inclusion and exclusion in a salon exhibition were determined by the selection committee, generally in the form of a jury appointed by the organising institution. Selection criteria were not clearly spelled out, but followed the overall politics of each salon. We have seen that the Salon tunisien, for instance, increasingly included Tunisian Muslim and Jewish artists, while the Salon des artistes tunisiens excluded them in favour of French artists, as did the Algerian Salon. Selection criteria during the early period thus took religion and ethnicity into account, reflecting overall colonial policies. The early Cairo Salon mostly exhibited European artists residing in or visiting Egypt, while the later Cairo Art Salon provided a forum for Egyptian artists as well as for non-Egyptian cosmopolitans. The situation in Egypt has to be considered in parallel to the development of artistic education. Whereas Egyptian non-colonial elites were active visitors and buyers of the early exhibitions, Egyptian painters and sculptors

17 On *Art et Liberté*, see Bardaouil, and Till Fellrath. *Art et Liberté, Rupture. War and Surrealism in Egypt (1938-1948)*. Paris: Skira 2016; Bardaouil, *Surrealism in Egypt*; and Monique Bellan's chapter in this volume.

began to gain track only in the early twentieth century, in particular after the foundation of the Fine Arts School in Cairo in 1908 and the increasing circulation of Egyptian artists to Europe and back.

The politics of prize-giving, developed on the basis of the Parisian system, served to validate artistic preferences – as defined by the jury – and contributed to the shaping of taste. Artist societies played an important role in this endeavour, since it was often they that initiated the salons and selected or even constituted the juries. The Society of French Orientalist Painters, for example, which was closely connected to the development of salons in Tunisia and Algeria, created an award for the Tunis Salon in 1897 for artists living in North Africa and exhibiting at the salon. Starting in 1907, the Society of Algerian Artists and Orientalists awarded the Prix Abd-el-Tif at their salons. Showing parallels to the Paris Salon's Prix de Rome, this prize sponsored the residence of metropolitan painters at the Villa Abd-el-Tif in Algiers, institutionalising the circulation of artists from France to Algeria. The contributors to this volume discuss the extent to which the reward system helped to build a notion of "national" art in Tunisia and Algeria (Chapter eight), and triggered debates about what could be considered national art, as becomes clear in the later examples of the Cairo Youth Salon (Chapter nine) and Beirut's Sursock Museum's Autumn Salon (Chapter ten).

The Debate about Categories and Disciplines

The salon was a place for debate not only as far as awards were concerned. It was often at the forefront of discussions around art. One of the earliest debates revolved around the delineation of artistic categories between fine arts and the decorative arts or crafts (artisanat). This was closely connected to debates about indigenous arts and gender. The Salon tunesien became a place where European artistic hierarchies that placed fine above decorative arts – the latter generally being associated with indigenous art often produced by women – were questioned and challenged (see Chapter two). At the Cairo Art Salon, debates arose about arts and crafts and the notions of "high" and "low" art. Huda Sharawi, who together with Princess Samiha Hussein had set up a Women's Committee of the Society of the Lovers of Fine Arts, founded an artisanal school in 1924 offering free education in pottery and ceramics. One aim of the school was to "elevate the status of the ceramics to that of artworks", as Nadia Radwan argues in Chapter five. Sharawi was successful in that works from her school were exhibited at the Cairo Art Salon from 1924 onwards, whereas the salon had shown only oil painting and sculpture up till then.

Far from being static, salons thus constantly provided a space for lively discussion and debate, either within the context of the salon itself or by stimulating alternative platforms. While the salon was a place to reconceptualise artistic categories, the domestic gatherings in Baghdad in the 1950s and 1960s served to bridge the gap between art and architecture as two distinct and separate disciplines, as Amin Alsaden argues in Chapter seven. Being grounded in one discipline did not prevent exchanging ideas and inspiring each other, quite the contrary. The Beirut salons of the second half of the twentieth century also attest to this interdisciplinary interaction, as architects often served on the juries.

The art salons in the Arab region were a place where questions of authenticity and "Arab" or "national" art were discussed. The Cairo Youth Salon launched in the late 1980s was an occasion for discussing "Egyptian art", modernity and artistic trends; references to Ancient Egypt were encouraged as part of a quest for authenticity and as a political tool for constructing a national narrative. A review of the 1965 Salon d'Automne in Damascus notes that "the ministry suggested to painters and artists to treat nationalist subjects, and the priority should be for works of a style if not Arab then at least Oriental," in line with the Arab nationalist politics of the day.[18] The debates around abstract versus figurative art that dominated the Beirut salons of the 1960s can also be placed within the discussions around authenticity, and who determined what constituted "good" and prize-worthy art.

The salon was an important stage in the transition of an artist from a beginner or even amateur practitioner to a professional, as it constituted a validation and presented the artist's work to the public and hence to the market. Even artists who rejected the official salons had previously exhibited there, and turned against them once they were more or less established artists.

Outline of the Book

This volume is divided into four thematic parts. The first two focus on early salons and the institutional construction of taste, with case studies from North Africa (Part I) and Egypt (Part II). Alain Messaoudi analyses the emergence and evolution of the Tunisian annual art salons, classifying the Salon tunisien as a provincial salon in a colonial location. In particular, he reflects on the salon as a public space in which taste was formed, and on the values that were promoted. Jessica Gerschultz examines the foundational role played by the

18 A.G., "A Damas".

Salon tunisien in the development of artistic categories and networks among Tunis-based artists, the Salon serving as the earliest institutional framework for delineating the concepts of "fine" and "decorative" art under the French Protectorate. In a similar vein, Nancy Demerdash-Fatemi enquires into the nature of the salon in French colonial Algeria, reconsidering the power dynamics at play and underlining the processes of taste-making in Algerian salons of the late nineteenth and early twentieth century.

In Cairo, Maria-Mirka Palioura sheds light on the archive of the Greek Orientalist painter Theodore Ralli, one of the co-founders of the first Cairo Salon, examining the production of art and its reception by the communities of the European bourgeoisie in colonial Cairo. Focusing on the annual Cairo Art Salon of the Society of the Lovers of Fine Arts and the rival La Chimère Salon, Nadia Radwan discusses the Egyptian art salon as a space of cultural transfer in which taste and canon were established, but were also challenged in the early twentieth century. She analyses the initiatives that aimed to introduce new objects in the exhibitions of the Cairo Art Salon, looking in particular at the debates around arts and crafts.

Challenging the official salon and creating alternative exhibition practices, which Nadia Radwan starts to discuss, is the subject of the third part of this volume. Monique Bellan considers the resistance to the art salon, in particular from the historical avant-garde in Egypt. She discusses the exhibition catalogues and invitation cards of Art et Liberté as media of defying established taste and modes of perception. Amin Alsaden argues that domestic spaces in mid-twentieth century Baghdad represented alternative salons, a hybrid model that acted as what Rancière termed a "community of sense", and fostered exchanges, circulated ideas and formulated aesthetic taste among middle- and upper-class Baghdadis.

The fourth part focuses on circulations between Europe and the region and on institutional guidance. While the migration of institutional patronage is an aspect present in all chapters, this section highlights the movements of systems and artists. Camilla Murgia concentrates on the artistic exchanges between North Africa and France that were determined by the systems of rewards, scholarships and subsidies of North African salons, revealing how the system affected the rise of a national art and how this art became progressively different from the French model. Catherine Cornet scrutinizes the nexus between the Cairo Youth Salon and the international arena. She shows how participation at the Cairo Youth Salon was instrumental in being admitted to the Egyptian Academy in Rome and also in selection for the Venice Biennale as part of the state-sponsored art circuit. My own chapter revolves around the Salon d'Automne at Beirut's Sursock Museum in its cultural context. It examines the influence of the museum's Salon in

patronising art, and contextualises the role of the museum as an institution in shaping the artistic landscape in Lebanon.

The final contribution is the edited transcript of a conversation with British artist and Royal Academician Eileen Cooper. It took place in Beirut in October 2017 in the frame of the conference "Contextualising the Art Salon in the Arab Region". Eileen Cooper was in charge of coordinating the 249th Summer Exhibition at the Royal Academy in London, the longest continuously running salon-style exhibition. The conversation illuminates the selection process and organisation of the Summer Exhibition, drawing parallels to the Sursock Museum's Salons d'Automne. It shows to what extent the selection process is based on personal preferences. We decided to include the conversation in this volume because it shows how the exhibition is a collaborative effort that needs to be dynamic in order to remain relevant today. The link to the art market is also underlined, because the main *raison d'être* of the Summer Exhibition is and has been to provide a platform for selling the artworks.

The volume is by no means exhaustive, but offers insights into the evolution of the art salon in selected countries in the Arab region. One observation made by several of the contributors concerns the limitations of available sources. Information on the non-official salons, such as the rival salon of the Algerian Professional Artists Syndicate, can be scarce because the media of that time largely covered only the salons connected to the dominant political agendas. Further research is needed, for instance into the impact of the European art salons on Arab artists' careers, and on other salons in the region such as the Salon d'Automne in Damascus or salons in Morocco. Each of the salons and group exhibitions discussed here can of course be approached from different angles, and we hope that this book will stimulate further research.

PART I

EARLY SALONS AND THE POLITICS OF TASTE MAKING: NORTH AFRICA

CHAPTER 1
THE ANNUAL ART SALONS IN TUNISIA UNDER THE FRENCH PROTECTORATE*

ALAIN MESSAOUDI

It is generally considered that the art salon, as it developed in Europe in the eighteenth and nineteenth centuries, contributed to an affirmation of the importance of public space. The works exhibited generated critiques that were widely circulated and debated.[1] But can this interpretation be extended to a colonial context such as Tunis? The practice of regular collective exhibitions of works of art was instituted in the aftermath of the occupation by the French army and the signing of a Protectorate Treaty (1881-1883). During the following century, between 1888, the year of the first documented collective exhibition, and 1984, the year of the last annual exhibition of fine arts titled Salon tunisien, there were almost a hundred exhibitions based on the salon model.[2] This excludes those organised by the Italian Dante Alighieri Society (which amounted to around ten events between 1932 and 1942); the exhibited works of students and alumni of the School of Fine Arts (which amounted to around thirty between 1931 and

* Translated from French by Karen Gray Harvey and Aline Quinard.

[1] This hypothesis, developed by Jürgen Habermas, is the basis of the work of Crow, Thomas. *Painters and Public Life in Eighteenth Century Paris*. New Haven/London: Yale University Press 1985, translated into French by André Jacquesson, *La Peinture et son public à Paris au XVIIIᵉ siècle*, Paris: Macula, 2000. I thank Nadine Atallah and Nadia Jelassi for their proofreading and judicious remarks.

[2] I counted 76 exhibitions organised by the art section of the Institut de Carthage, soon to be known as Salon tunisien (13 exhibitions between 1894 and 1914, 22 between 1920 and 1941, 25 between 1945 and 1968, 16 between 1968, year of the foundation of the Union nationale des artistes plasticiens graphistes, and 1984) and 11 exhibitions of the Salon des artistes tunisiens (1924-1934). We can add the six editions of the Exposition artistique de l'Afrique française presented in Tunis between 1928 and 1950, and a number of intermittent exhibitions (the exhibition of 1888, the salons organised by the Syndicat des artistes professionnels in the Spring and Autumn of 1944, and in the Autumn of 1945).

1968); and the exhibitions of amateur artists' works.[3] The total number of exhibited works within the format of the annual art salon steadily increased until 1897.[4] At the beginning of the 1920s, their number began to fluctuate as a result of competing exhibitions such as the Salon des artistes tunisiens created in 1924.[5]

These art exhibitions were designed in the context of a monarchical and aristocratic political regime, as the French authorities had maintained the Beylicate of the Ottoman tradition throughout the protectorate period. The French administration, which sought the collaboration of Tunisian public servants and the local elite, was not based on democracy. The opposition, in the form of elected assemblies, remained weak until the end of the protectorate in 1956. However, the majority of the French public servants stationed in Tunis shared republican and progressive ideals and were in favour of fine art exhibitions. The exhibitions were presented as contributing to the country's prosperity and economic progress, encouraging trade and 'civilising' the population – France's *mission civilisatrice*.

The Salon tunisien had a twofold impact, commercial and political. It allowed artists to show their works to the public and enabled them to reach a number of potential buyers outside of their personal circle. There were no art galleries in Tunis before the end of the 1920s, even though during the 1890s certain shops allowed the display of artworks for sale. For instance, in 1911, the photographer and bookseller Emilio d'Amico organised group exhibitions of paintings in his shop.[6] However, these shop windows did not have the same appeal to art lovers as they were not dedicated solely to art.[7] Alongside its commercial dimension, the Salon was supposed to showcase the country's prosperity and good governance through the quality of the artistic production that was displayed. Therefore the discourses and aims of the art salons in Tunis were not exactly the same as in Paris and the metropole.

[3] For instance, the Salon des artistes cheminots de Tunisie, organised by the Union intellectuelle et artistique des cheminots in 1948, and the salons organised annually by the Union féminine artistique et culturelle (UFAC) from 1949.

[4] Whereas the exhibition of 1888 recorded 144 works and the one in 1894 200 works, 448 pieces were exhibited in 1895 and 550 in 1897.

[5] In 1907, 80 works were exhibited in the Salon tunisien, 130 in 1920, more than 400 in 1921 and close to 450 in 1922.

[6] Henri Leca Beuque, "Visite à la galerie artistique", *La Tunisie illustrée* 20, 20 March 1911.

[7] For example, the *Galeries Parisiennes*, Avenue de France, exhibited in the spring of 1896 a canvas of a certain Francesco Aducci representing an *Arabe en prière* (*La Dépêche tunisienne* [*DT*], 21 March 1896). Two years later, one could see the watercolours of a certain Spaddy in the display of the bookstore Saliba (*Id.*, 7 April 1898). These presentations took place just before the inauguration of the Salon tunisien, perhaps to benefit from the interest generated by the event.

In Tunis, the Salon tunisien attested to the development of artistic production corresponding to the norms developed in Western Europe. We can see the influence of a foreign culture within a colonial framework, with the Salon contributing to a public education that promoted the French language and the values associated with it.

However, the first exhibitions not only presented the works of artists trained in France (paintings, sculptures and other artworks) that one could find at the salons of the metropole. Up until the 1920s, the Salon also showed how artisanal products inscribed in a local tradition could adapt to the social changes that accompanied the process of modernisation implemented during the protectorate, by giving them a display space and attesting to their quality. It often showed, generally in the form of a separate annex, objects produced by Tunisian artists: carpets, lace, pottery, sculpted plaster, chiselled brass, and furniture. The Salon was a framework that allowed the affirmation of a local specialty in art and craft, and would contribute to the birth in the 1950s of an "École de Tunis." The Salon tunisien survived the country's independence in 1956 and became a tool for promoting 'national' artistic production. This artistic production found a place in the Burguibian project of social modernisation and continued to receive state subsidies. One can even consider that, in certain aspects, the Salon prolonged itself after 1984 through the annual exhibitions of contemporary art organised by the Union des artistes plasticiens tunisiens, up until the Printemps des arts plastiques de La Marsa created in 2003.

Research on the Tunisian salons has most often been addressed as part of a general history of fine arts during the protectorate and the first decades of independence.[8] The available archives being rare,[9] these works rely on two

8 Ben Romdhane, Narriman. "Naissance de la peinture de chevalet en Tunisie au XXᵉ siècle." PhD thesis, Paris: École du Louvre 1985; Ben Romdhane, Narriman. "La peinture de chevalet en Tunisie de 1894 à 1950." In *Lumières tunisiennes*, catalogue of the exhibition presented at the Pavillon des arts in Paris, Paris: Paris musées/Association française d'action artistique/Ministère tunisien de la culture 1995, 11-35; Ben Romdhane, Narriman. "Naissance de la peinture de chevalet." In *Anthologie de la peinture en Tunisie 1894-1970*. Edited by Narriman El Kateb-Ben Romdhane, Ali Louati and Habib Bida. Tunis: Simpact 1998, 14-80. See also Louati, Ali. *L'aventure de l'art moderne en Tunisie*. Tunis: Simpact 1997; al-Aṣram, Khâlid [Khaled Lasram]. "As-Ṣālūn at-tūnisī fī 'ahd al-ḥimāya [Le Salon tunisien in the time of the Protectorat]." *Dā'iraï al-ma'ārif al-tūnisiyya [Encyclopédie de la Tunisie]*, 2ⁿᵈ volume. Tunis/Carthage: Al-mu'assasaï al-waṭaniyyaï Bayt al-ḥikmaï [Fondation nationale Beit al Hikma] 1991, 108-112.

9 Some files concerning the exhibitions are conserved in the National Archives of Tunisia (ANT). The archives in the artistic section of the Institut de Carthage seem to be lost. The *fonds Abéasis* deposited in the Archives nationales d'Outre-Mer (ANOM) in Aix-en-Provence preserve a photocopy of the minutes of the meetings of the section for a period between 13 December 1924 and 17 January 1931.

principal sources that this chapter is also based on: the exhibition catalogues of the salons and their reviews in the press. I base my work here on those catalogues that I was able to consult in the National Library of Tunisia.[10] This library also keeps collections of periodicals published in Tunisia. Several of them that regularly reported on exhibitions provide us with an overview of the main works of art exhibited and give some indication of their reception.[11] Our current state of knowledge leads us to question the exact conditions of the functioning of the Tunisian salons. In the following discussion, I intend to analyse the genesis of the salon as an institution and regular event. How did what started as private initiatives find support from public authorities? What are the specific features of the Tunisian salons as compared with multiple provincial salons that emerged in France during the nineteenth century? Finally, what was the function of the Salon tunisien in the context of a partnership policy?

Private Initiatives Supported by Public Authorities

The first exhibition of 1888, like those organised annually from 1984 onwards by the art section of the Institut de Carthage,[12] was the result of private initiatives. However, a large number of the exhibition's creators were civil servants, French citizens working for the Tunisian administration under the protectorate or for the Résidence générale.[13] The organising committee of the 1888 exhibition was composed of the Director of the Antiquities and Arts Department, René du Coudray de la Blanchère (1853-1896), the Tunisian government architect Adolphe Dupertuys (circa 1837-1898), as well as a former student of the School of Fine Arts of Lyon, Charles Beau, who

[10] The reconstruction of the complete collection of catalogues is in process under the supervision of a research group of the Centre national de la recherche scientifique (CNRS), InVisu, located in Paris. They aim to digitalise them.

[11] My principal sources are the *Revue tunisienne*, voice of the Institut de Carthage, and two daily papers closely aligned to the government or politically neutral (*La Dépêche tunisienne*, which was regarded as the daily reference from its creation in 1889, and *Le Petit Matin*, founded in 1923), as well as two periodicals (*La Tunisie française*, the voice of the colonialists published since 1892, and *Tunis-Socialiste*, founded in 1921).

[12] The Institut de Carthage was founded in November 1893. For its main publication, the *Revue tunisienne*, see Gutron, Clémentine. *Les débuts de la Revue tunisienne (1894-1914) en Tunisie. Une histoire originale entre savoir colonial, 'découvertes scientifiques' et échanges culturels*. MA thesis supervised by Colette Zytnicki, University of Toulouse Le Mirail, June 2002.

[13] Messaoudi, Alain. "Un musée impossible. Exposer l'art moderne à Tunis (1885-2015)." In *L'orientalisme après la Querelle. Dans les pas de François Pouillon*, under the supervision of Guy Barthèlemy, Dominique Casajus, Sylvette Larzul, Mercedes Volait, Paris: Karthala, 2016, 66-67.

was working both as a teacher of drawing at Sadiqi College, the modern secondary school that trained the Tunisian Muslim elite, and as a draftsman for the municipality of Tunis.[14] In 1894, 10 of the 17 members of the organising committee were serving the French and Tunisian governments.[15] With one exception (Jules Henry, arbitrator-expert from the commercial tribunal), the other seven were linked to the world of the press (the editor of *La Tunisie française*, a voice defending the colonists, and the director of *Havas* in Tunis), or of art (an architect and three artists). The French public authorities – in the form of the Ministry of Public Education and Fine Arts in Paris and the Résidence générale in Tunis – provided material support for the organisation of these first exhibitions. This support took many forms: the ministry regularly sent art objects produced by the Sèvres manufactory and a number of prints to be used as raffle prizes to cover part of the organisational costs.[16] Additionally, the Tunisian state made available public buildings for the preparation and presentation of the exhibition itself. Between 1894 and 1896, the art section of the Institut de Carthage met in the buildings of the Lycée français de jeunes filles in Rue de Russie, before being accommodated in the former Palais Cohen, in Avenue de Paris. The latter building was acquired by the Tunisian government and refurbished under the name of Palais des sociétés françaises, to host the offices of the various associations and the annual exhibition of fine arts. The presence of senior French and Tunisian officials at the exhibition opening confirmed the salon's official character:[17] The Résident général usually delivered an inaugural speech.[18] The Bey was either present or represented by other members of the Hussaynite

14 *Catalogue des animaux, instruments et produits agricoles, produits et objets divers, etc., de l'Exposition scolaire et de l'Exposition de beaux-arts.* Tunis: French edition B. Borrel 1888, 83-95.

15 Among the public servants, four were from the Ministère de l'Instruction publique et des beaux-arts. We find as well in the committee two from the military, the president of the civil tribunal, an auxiliary landed property registrar, and a head of department in the Tunisian government. See "Chronique de l'Institut de Carthage." *Revue tunisienne* [hereafter *RT*] 2, April 1894, 305-310, 307.

16 In 1894, the Director of Fine Arts, Henri Roujon, sent a decorated porcelain vase, produced by the Sèvres manufactory. "Une exposition artistique à Tunis." *RT* 3, July 1894, 319-339, 339). They continued to organise a raffle with biscuits from Sèvres among the prizes in 1912. *RT*, 1912, 316.

17 French ministers would visit the salon, as did in 1895 the radical Antoine Gadaud, short-lived Minister of Agriculture in the cabinet of Alexandre Ribot.

18 Between 1894 and 1940, no Résident général seemed to deviate from the rule, except through *force majeure*. The absence of Marcel Peyrouton in 1934 was exceptional. It resulted without doubt from the tension between him and the president of the art section of the Institut de Carthage Alexandre Fichet, also an activist in the SFIO.

family.[19] Between the World Wars, the art section of the Institute de Carthage continued to request from the Résidence générale and the Secrétariat générale of the Tunisian government the names of senior officials of the French and Tunisian administration who should be invited to the opening of the salon.[20] The involvement of the French and Tunisian public authorities was also symbolically marked by decorations that were officially awarded to the organisers and to certain exhibitors during the awards ceremony at the closing of the exhibitions.[21] These were either the Nichan Order,[22] issued by the Bey on the initiative of the Director of Public Education from 1894 onwards,[23] or the Ordre des Palmes Académiques, which was awarded by the Minister of Education from 1896. Decorations were systematically awarded on the occasion of the Salon tunisien until at least 1914.

The inclusion of the Salon in the school policy of the French authorities was explicit: it becomes evident in the choice of the Director of Education, Louis Machuel, as honorary president of its organising committee between 1894 and 1898. It was not only a question of encouraging the teaching of drawing in schools, but the affirming of a cultural policy that aimed to promote the defence of beauty and to safeguard local heritage through works that signified its value – be these ancient objects, traditional crafts, or representations of monuments or sites. In 1888, the exhibition was scheduled for the eve of the official inauguration of the Alaoui Museum, now known as the Bardo Museum.[24] The first exhibitions often combined antiques and modern objects, sometimes to highlight the work of French archaeologists who ran the Beylical service of antiquities and arts: In 1895, a space was reserved for antiquities, which assistant inspector and painter Eugène Sadoux was put in charge of; the same happened in 1897, when the organising committee of the exhibition was headed by the Director of Antiquities, Paul Gauckler.

19 The report of the inauguration of the Salon in 1901 indicates the presence of Prince Muhammad. "Ouverture du sixième Salon tunisien." *RT* 31, July 1901, 368-374, 368.

20 I found a list of agents of the Direction générale de l'Intérieur to be invited in 1926, and different lists of agents from the Secrétariat général of the Tunisian government, sent in 1923, 1930 and 1937. See ANT, FPC, series SG2, box 24, file 68; and ANT, FPC, serie SG6, box 163, file 6.

21 On the concept of these rewards, see Camilla Murgia's chapter in this volume.

22 The honourable order of *nīchān iftikhār*, instituted by the reformers of the Beys in the first half of the 19th century, was preserved within the structure of the French protectorate. It permitted the allies of the regime to be rewarded in gratitude.

23 Suggestions for decorations came from Louis Machuel and were passed through and intermediated by the Résidence générale, who submitted them to the Bey for final signature. See "Une exposition artistique à Tunis," 324. In 1894, the star of the exhibition, Louis Chalon, was nominated for the title of Commandeur du Nichan, and the organisers of the exhibition for the title of officer.

24 The exhibition ran from Friday 27 April to Sunday 6 May 1888.

The Salon also allowed the French state to propagate its cultural vision by setting up a collection of paintings, sculptures and *objets d'art*, after the project to establish a "French museum" in Tunis failed.[25] In 1895, the Ministry of Public Education and Fine Arts opened a credit of 1,000 francs for the acquisition of works in order to create a museum.[26] This initiative had the support of local notables including Jules Pillet (1842-1912), professor at the École nationale des beaux-arts, who was sent on a mission to study indigenous art industries in Tunis.[27] The choice of works to be acquired was left to the exhibition committee, which was usually in charge of the selection of works to be exhibited.[28] The state grants for acquisitions were regularly renewed.[29]

Despite the involvement of the state and the interest expressed by public authorities, the exhibition remained an independent event, with private individuals acting as its promoters and organisers. One could use the example of Ali Bey, who in 1894 made a financial contribution in his personal capacity,[30] or that of Shaykh al-madina Muhammad al-Asfuri. The organisation of the first salons was only possible through the investment of individuals, including public servants, publicists and artists, and the material support of patrons. In 1894, the financial commitment of the members of the then very young Institut de Carthage helped to organise the exhibition in a sufficiently central place to attract a large audience. Although the Director of Education had suggested using the large hall of the drawing class at the Collège Alaoui, the organisers preferred a place they thought was less eccentric and easier to access. They chose the halls of the Maltese Labour Association Valletta, which were "large, well-lit and located in the centre of the city"[31] – they were actually in the middle of the new European neighbourhoods.[32] The operation was also made possible because of the modest fee requested of the Association by the owner of the hall, which the *La Revue Tunisienne* describes as "great disinterestedness."[33] In the following two years, the Salon again found

25 This project was led in Paris by the amateur painter Georges de Dramard (1838-1900) between 1892 and 1894. See Messaoudi, "Un musée impossible."

26 "Deuxième exposition artistique à Tunis." *RT* 7, July 1895, 281-294, 286.

27 Pillet wished for the creation of a museum of industrial art hosting in the same space art and craft, both retrospective and contemporary. His speech was published in "Deuxième exposition artistique à Tunis." *RT* 7, July 1895, 290-292.

28 "Deuxième exposition artistique à Tunis." *RT* 7, July 1895, 286.

29 "Assemblée générale du 8 novembre 1901." *RT* 33, January 1902, 108-111, 109.

30 Ali Bey donated 300 francs to the Institut de Carthage. "Une exposition artistique," 324.

31 "Chronique de l'Institut de Carthage (1er trimestre 1894)," 308.

32 The building situated in Rue de Grèce is still in place today.

33 "Une exposition artistique," 323.

rent-free lodging in the centre of the European part of the city. In 1895 it took place in the Palais Cohen, Avenue de Paris, thanks to the kindness of its owners, and then in 1896 in the Passage de Bénévent.[34] This private sponsoring made the Salon somewhat fragile because the intellectual elite, upon which it relied, was relatively small in number and fluctuating in composition (with civil servants, employees and artists often staying only a few years in Tunis). At the turn of the century (1899 and 1900), the disruption of the exhibitions testified to this instability; "our social budget is so light that a wisp of straw destroys its balance," said Eusèbe Vassel, president of the organising committee, in his inaugural speech at the 1901 exhibition.[35] Accidental causes may have contributed to this crisis[36] as well as the competition from Algiers, where a salon was regularly organised from 1898 onwards.[37]

In 1901, it was decided that the shipping costs would be borne by the exhibitors, with the result that the number of shipments from France was reduced.[38] Despite the lower expenses, the Salon experienced a new period of instability. The art section of the Institut de Carthage cancelled the salons between 1902 and 1907 and it is not known whether the "artistic exhibition" planned in 1903 under the auspices of the Société de géographie commerciale and the Société d'horticulture de Tunis actually took place. There is evidence of internal dissension in the art world, with the formation of two competing societies: the Société des amis des arts, which would have the support of the Résidence générale, and the Société tunisienne des beaux-arts, which was founded and presided over by Paul Proust (1861-ca.1925). A draftsman at the firm Bône-Guelma, Proust sought subsidies

34 It was in this space graciously given by the Comte Landon de Longeville that the photographer Albert organised, in the autumn of 1896, the first cinematic screenings in Tunis. "Chronique de l'Institut de Carthage (2ᵉ trimestre 1896)." *RT* 11, July 1896, 461-483, 470; Corriou, Morgan. "Tunis et les 'temps modernes': les débuts du cinématographe dans la Régence (1896-1908)." In *Publics et spectacle cinématographique en situation coloniale*, 95-133, 94. Tunis: IRMC/CERES 2012.

35 "Notre budget social [est] si léger qu'un fétu en détruit l'équilibre". "Ouverture du sixième Salon tunisien," 369.

36 Such as the abrupt departure of two active members of the organising committee of 1895 and 1896, the first, Jean Servonnet was killed in December 1896 in a duel with the second, Charles Maillé, who then left Tunis (account of the court case against Maillé, *DT*, 10 February 1897).

37 That competition is mentioned in the *Revue tunisienne*, which indicates that Algeria built on the Tunisian experience for their own first salon in 1898. It took place one year after the foundation of the new Société des peintres algériens et orientalistes. "Ouverture du sixième Salon tunisien," 369. On the Société des peintres algériens et orientalistes and the salon in Algeria, see Nancy Demerdash-Fatemi's chapter in this volume.

38 "Ouverture du sixième Salon tunisien," 369.

from the Ministry of Public Education and Fine Arts in Paris to organise an exhibition in April 1904.[39]

From 1907, the Salon tunisien regularly opened every spring under the auspices of the Institut de Carthage for a period of about a month. This rhythm was interrupted only during the two World Wars.[40] The Salon was soon associated with Alexandre Fichet, a professor of drawing at the Collège Alaoui, who ran l'Essor, an association promoting the theatre, and who campaigned for the Socialist International. He organised the Salon between 1913 and 1960 and ensured a certain continuity. Fichet's desire not to impose a normative aesthetic line, and thus to open the Salon to "modern trends,"[41] led to a split in the organisation in 1924. A painter named André Delacroix decided to organise a competing salon, the Salon des artistes tunisiens, which excluded "modernisation and all other extravagances that young artists had discovered during the last years."[42] He made sure that this new salon was also hosted at the Palais des sociétés françaises, a sign that the authorities were careful to maintain a position of neutrality between the opposing currents.

This competition lasted until Delacroix's death in 1934. The financial situation of the Salon Tunisien seems to have remained fragile. In 1930, Alexandre Fichet appealed to the generosity of individuals, highlighting the "modest" resources compared to the "heavy burdens" that the organisers took on.[43] The situation probably worsened in the following years as a result of the economic depression. In 1935, Fichet abstained from any speech at the inauguration of the salon, marking his dissent with the authoritarian policy (probably unfavourable to the arts) of the new Résident général Marcel Peyrouton.

A Provincial Salon in a Colonial Situation

The Salon tunisien can be compared to the French provincial salon in that it was based on the Paris model, while seeking to assert its specificity and stand

39 ANT, series E, box 299, file 3 (1904).

40 It appears that there was no Salon between 1915 and 1920, nor between 1940 and 1943, with the exception of the Exhibition artistique de l'Afrique française, presented in Tunis in 1941.

41 This expression was used in the anonymous minutes of the two salons that followed each other in 1924 ("Les salons de peinture." *RT*, 161, August 1924, 182-185, 182).

42 Lafitte, Georges. "Le Salon des artistes tunisiens," *Le Petit Matin*, 8 March 1927, cited by Ben Romdhane, "La peinture de chevalet," 25.

43 ANT, FPC, series SG2, box 24, file 68 (1923-1930), Invitations and funding requests of the Salon tunisien, art section of the Institut de Carthage.

apart from Algiers.[44] According to a speech by Lucien Bertholon, president of the Institut de Carthage, given at the inauguration of the 1894 exhibition, "the Salon tunisien would be of bigger importance than most similar provincial exhibitions."[45] In 1895, Commandant Servonnet, president of the organising committee, identified the exhibition as an "attempt of artistic decentralization."[46] This expression was characteristic of the time and was regularly used until the 1920s.[47]

The Parisian Salon des artistes français remained the reference model. Although not strictly speaking an official salon, as the state declined to organise it after 1881, it preserved this official image and asserted itself as the pinnacle of the art world.[48] This also goes for the period following the creation of the salon of the Société nationale des beaux-arts in 1890. The prestige of the Paris Salon was manifested by the status given to artists who received prizes or medals from the members of the jury. They could exhibit concurrently in Tunis but not as part of the competition, to ensure they did not monopolise the awards. Many artists thus took part in both salons, as it gave them two platforms from which they could appeal to buyers, and the double participation served equally as a seal of quality. As early as 1888, the Salon tunisien followed the Paris Salon in holding the exhibition in the spring, and the name "salon" was gradually adopted, in parallel to the exhibition becoming a regular annual event.[49] Tunis also adopted the jury model from Paris; it was initially constituted by the members of the organising committee nominated each year from among the members of the Institut de Carthage. Between 1894 and

44 Houssais, Laurent and Lagrange, Marion. "Le 'sol ingrat de la province'." In *Marché(s) de l'art en province 1870-1914*. Edited by Laurent Houssais and Marion Lagrange, 9-15, 10. Bordeaux: Presses universitaires de Bordeaux 2010.

45 Speech on 11 May 1894 by Doctor Bertholon, president of the Institut de Carthage, in the presence of Résident général Charles Rouvier ("Une exposition artistique…", 322).

46 Speech of Lieutenant de vaisseau Servonnet, reproduced in "Deuxième exposition artistique…,"287.

47 We find it for example in a text by Jules Anselme de Puisaye, and in a speech by Alexandre Fichet at the inauguration of the Salon tunisien in 1924. *Choses d'art. Le VIᵉ Salon tunisien à l'hôtel des sociétés françaises*. Tunis, Imprimerie rapide 1901, 5; and *DT*, 7 March 1924.

48 Vaisse, Pierre. *La Troisième République et les peintres*. Paris: Flammarion, 1995, 100-101.

49 In 1888, as well as in the documents produced by the Institut de Carthage in 1894 and 1895, the term "exposition artistique" is used. In contrast, the critical review by lawyer Henri Goin from 1894 already spoke of the "Salon tunisien." The term "salon" was first used in the press and eventually adopted by the organisers in 1896, who instituted a "prix du salon." It appears in the exhibitors' notebook from 1897. "Une exposition artistique," 327-339.

1898, they were responsible for the selection and setting up of works and awarding prizes.[50] It could also be noted that the Salon tunisien, like the Paris Salon, was intended to be representative of all artistic activity. According to the rules of the 1894 exhibition, one could find there art that "related to all times, all schools, all countries."[51] It was by opposing this lack of aesthetic boundaries that the Salon des artistes tunisiens was constituted in 1924. Its initial profile was reminiscent of that of the Salon de la Société nationale des beaux-arts and it was thus "described as an elite institution."[52]

Tunisian salons can also be compared to those organised in France by taking into account their accessibility and target audience. We know that the exhibition in 1894 had no entrance fee. Its regulations showed the intention to ensure access to the largest possible audience. Only on Thursdays would a fee of one franc per person be taken "for the benefit of charitable works."[53] We can assume, however, that visitors were invited, also on the other days, to buy a ticket for 50 cents that allowed them to participate in the organised raffle, to cover part of the costs.[54] In the following years an entrance fee was introduced, based on the model of the Parisian salons. This fee became effective from 1895, which probably explains the doubling of sales, with the raffle now being organised "for the benefit of artists."[55] The following year the ordinary entrance fee was lowered, with 25-cent tickets being issued

[50] In 1901, this jury was constituted independently from the Salon's organising commit-
 tee. Speech of Benjamin Buisson on the occasion of the awards, "Ouverture du sixième
 Salon tunisien," 371.

[51] Article 3, "Chronique de l'Institut de Carthage (1er trimestre 1894)," 308.

[52] Vaisse, Pierre. "Réflexions sur la fin du Salon officiel," *"Ce Salon à quoi tout se
 ramène". Le salon de peinture et de sculpture, 1791-1890.* Edited by James Kearns
 and Pierre Vaisse. Oxford: Peter Lang, 2010, 117-138, 133. But contrary to the Société
 nationale des beaux-arts, the Tunisian artists did not appear to constitute a society to
 which they needed to be admitted by co-optation.

[53] Article 16, "Chronique de l'Institut de Carthage (1st trimester 1894)," 308. It was the
 same price as an entry ticket to the Paris Universal Exhibition on an ordinary day of
 the week, in 1889 or 1900 (but you had to add one to five francs extra for the attrac-
 tions inside the exhibition space in Paris). In either case, the price was not symbolic:
 in France, in 1890, workers were paid on average 2.50 francs per day for women and
 5 francs for men (Chanut, Jean-Marie, Heffer, Jean, Mairesse, Jacques and Postel-
 Vinay Gilles. "Les disparités de salaires en France au XIXe siècle." *Histoire &
 Mesure*, volume 10 - n°3-4, 1995 Consommation, 381-409).

[54] A review made at the end of 1895 by the general secretary of the Institute announced
 1,071 entries and 63 permanent entry cards for 1894. "Assemblée générale du 6 décem-
 bre 1895." *RT* 9, January 1896, 3-16, 8.

[55] In 1895, 2,235 entry tickets at 50 cents each (or 1 franc on Fridays) and 100 permanent
 entry cards were sold. "Assemblée générale du 6 décembre 1895," 8.

at the headquarters of the art committee of the Institut de Carthage and at the offices of *La Dépêche Tunisienne*.[56] Personal permanent entry cards continued to be issued,[57] giving access to the exhibition not only on ordinary days, but also on reserved days[58] and allowing for admission to the opening as well as to the award ceremony.

The introduction of an admission fee was explained by the need for a revenue stream to offset the costs incurred by the Salon such as supervision and fire insurance contracts, even though the sites were granted free to exhibitors.[59] It also helped to enhance the Salon's prestige – the press regularly emphasised its fashionable character – which was confirmed by the celebrations that accompanied it.[60] The fee excluded beggars and people of little means, but was set at a sufficiently modest level to allow access to the Salon by a large audience on ordinary days,[61] with the exhibition being accessible every day of the week, morning and evening.[62]

It is difficult to get a precise idea of the size and social backgrounds of the Salon's audience. In 1896, while the *Revue Tunisienne* was delighted with the Salon's success,[63] an article published in *La Dépêche Tunisienne* deplored the fact that the number of visitors decreased in the latter half of the exhibition period. On the other hand, it celebrated the interest expressed by the "Muslim element" which "seemed to understand and appreciate the various modes and processes of painting."[64] What is meant here by the phrase "Muslim element"? Without being able to rely on exact information, we can assume it referred to Tunisian men from

56 The daily paper *La Dépêche tunisienne* shared with the Salon the status of a private company close to the French local authorities, and served as a voice for the Résidence générale. In 1896, the daily claimed that more than 250 tickets of 25 cents each to take part in the lucky draw were delivered each day to its newsroom. (*DT*, 25 April 1896).

57 Cards sold for five francs in 1897, and 3 francs to members of the Institut de Carthage (*DT*, 21 March 1897).

58 That is, on Thurdays when the price of entry was higher than on ordinary days.

59 Article 14 of the regulations for the year 1895 (*RT*, 6, April 1895, 271).

60 A few "*fêtes de nuits*" were organised in 1896 in the building of the "*exposition in-digène*," that is, in the industrial section. "Exposition artistique et industrielle," 473.

61 We do not know precisely when the entrance became free of charge. It was likely in 1913 or after World War One.

62 In 1896, the Salon had to be open every day, in the morning from 9:00 to 11:00 and in the afternoon depending on the art. Number 14 of the general regulations (*RT*, 10, April 1896, 356).

63 "Pendant tout le mois d'avril, de nombreux visiteurs se sont succédé devant les œuvres exposées." See "Exposition artistique et industrielle," 473.

64 "Le Salon tunisien." *DT* 27, April 1896.

the urban elite who had begun to take an interest in painting since the 1840s, commissioning their portraits from foreign artists.[65] However, the expression of this interest might also have been sheer politeness on behalf of the elite, forced to deal with the French occupiers in order to preserve or to establish their position.[66] In 1909, the painter and critic Henri Leca deplored the "faded role of the Salon tunisien, the small number of shipments, the scarcity of visitors and the mediocre influence it has in Tunis."[67] The question is then whether we should believe the official speech of the Résident général Alapetite, claiming in 1914 that "the clientele of salons represents all classes of the population,"[68] and what exactly he meant by that?[69] We have an estimate for 1921, when the number of visitors "of all classes" was said to have risen during the five weeks of opening to more than six thousand.[70] We also know that part of this audience was female, which was sufficiently rare to be recorded in 1895 and again in 1913 in the minutes of the inauguration of the exhibition.[71]

65 On that topic, see Moumni, Ridha (ed.). *L'Éveil d'une nation*, catalogue of the exhibition presented at Bardo by la Fondation Rambourg (palace of Qsar es-Saïd, 27 November 2016-27 February 2017), Verona, Officina Libraria, 2016.

66 It is the elite that one sees again at the opening of the salon, without being able to determine if they were attending by obligation, with respect to French social convention or out of interest in the exhibited art.

67 Leca, Henri. "Le Salon tunisien." *RT*, 1909, 244-247, 244-245.

68 "Le XVIe Salon tunisien." *RT*, 105, May 1914, 280-285, 285.

69 One can suppose that the Résident général meant all the social classes within the French community (where the elite and top management were prominent), including the European population but excluding the Tunisians.

70 *Tunis-Socialiste*, 27 April 1921 (rubric "*les 7 jours*" signed "*le journalier*"). The population census of 1921 counted more than 170,000 inhabitants in Tunis, of whom close to 100,000 were "*indigènes*" (approximately 80,000 Muslims and 20,000 Jews). Among the Europeans, the Italians numbered more than 42,000, the French more than 22,000, the Maltese more than 7,000. Bernard, Augustin. "Le recensement de 1921 dans l'Afrique du Nord." *Annales de Géographie*, 169, 1922, 52-58, 55.

71 "Deuxième exposition artistique," 281; "Le 15e Salon tunisien." *RT*, 99, May 1913, 261-271, 261. At the end of the nineteenth century, it was relatively rare to have mixed public spaces and this speaks to the exceptional and remarkable presence of women amongst the visitors of the salon. The women attending the Salon before World War I were probably exclusively Europeans or women from the Livorno Jewish community. The first secondary public school for young Muslim girls, Rue du Pacha in Tunis, opened only in 1900 (and brought about a new generation of elite Muslim women who appeared in the public sphere). The first commissions of portraits of middle-class Tunisian women, Jews and Muslims, seem to be dated between 1920 and 1930 (for instance, the portraits of Maria Pia Bessis, daughter of Clemente Uzan and wife of the lawyer Albert Bessis (1920), and of Mme Cohen Tanugi (1929?) from Breïtou Sala, or the one of Mme Kortbi from Jilani Abdulwahab (1931).

The expectations of the organisers of the Tunis exhibition seem comparable to those of their counterparts in Paris and in the provinces. The Salon appeared to encourage, on the one hand, the promotion and awakening of a sensitivity to art among the wider population, and on the other hand, to reinforce the appeal of Tunis for artists, art lovers, and tourists. Numerous speeches presented the Salon as a means of developing the taste for art and creating a fertile context among the artists in Tunisia. The works exhibited had to contribute to the emergence of an audience whose culture was to be refined, as well as serve as a model for local artists, professionals or amateurs, who were invited to compete with Parisians.[72] Its organisers took care to bring to Tunis works of recognised quality, which had been exhibited in selected shows in Paris. As in the provincial salons, Tunis presented works that had already circulated in the metropole. An example of this was the 1888 *exposition-tombola*, which exhibited *Le Rêve du croyant* by Achille Zo (1826-1901). This painting had been exhibited at the Paris Salon almost twenty years earlier.[73] The Salon tunisien also included the works of other artists who regularly exhibited in Paris such as the successful Maurice Boutet de Monvel (1850-1913)[74] and the Orientalist landscape painter Eugène Girardet (1853-1907).[75] Charles Landelle, Albert Maignan, Léon du Paty, Eugène Dauphin, and Mario Carl-Rosa were other regulars of the Paris Salon represented in Tunis in 1894.[76] In 1895, the trend continued with the participation of Félix Régamey,

[72] The demarcation was not explicit, because nothing differentiated one from the other, except perhaps the more or less advantageous wall on which they were displayed.

[73] The painting was exhibited in the 1870 Salon, then in Lyon in 1872. Dumas, Dominique. *Salons et expositions à Lyon (1786-1918). Catalogue des exposants et liste de leurs œuvres.* Dijon: L'échelle de Jacob 2007, vol. 3, 1336. One can note that the French authorities did not seem to be concerned about how Muslim spectators would receive the painting, although one could assume it would offend their sensibilities. It is probable that those Muslims who were predisposed to come and see the work belonged to the city elite and were not necessarily prudish, and it was improbable that the religious dignitaries would venture to visit the exhibition.

[74] For his first Salon exhibition in 1873, Boutet de Monvel was rewarded with a bronze medal and afterwards a silver. In 1888 he presented in Tunis, *Enfants jouant dans une rue, Constantine*.

[75] Girardet exhibited in 1888 a view of *Hauteurs de Beni Fera*, a site of Aurès close to al-Kantara. One can also cite, among the artists who exhibited regularly at the Paris Salon, the Marseillais Alexandre Moutte (1840-1913) and Alexandre Defaux (1826-1900), known for his farmyards and landscapes. Only Defaux and Girardet were again exhibited in Tunis (in 1896 and 1897).

[76] Charles Landelle (1821-1908) exhibited at the Paris Salon from 1841, Albert Maignan (1845-1908) from 1867, Léon du Paty (1849-v.1920) from 1869, Eugène Dauphin (1857-1930) from 1880, and Mario Carl-Rosa (1853-1913) from 1884.

Adrien Demont and his wife Virginie Demont-Breton,[77] Blanche Moria[78] and Charles Lallemand.[79] In 1896, *La Dépêche tunisienne* reported that Paris announced with pride that more than one hundred pieces had been sent, most of them works of renowned and decorated painters.[80] In 1897, in Tunis, along with many of the ordinary exhibitors,[81] all 28 representatives of the Society of French Orientalist painters who exhibited had already exhibited at the salon in Paris.[82]

In the twentieth century, the educational function of the Salon continued to be championed by Alexandre Fichet. The speech he made on the occasion of the inauguration of the Salon tunisien in 1924, stated that the exhibition contributed to the awakening of artistic consciousness and thus facilitated the creation of a favourable environment for the development of the arts. By allowing "the public to come into direct contact with artistic expression," the Salon would make the public "aware of their own taste and of the gap that there is between this taste and the design and the emotion of the artists," and would eradicate "from that, the visual and mental apathy, which is to artistic life what stagnant water is to the river."[83]

The Salon was also a way to gain the support of public authorities[84] for the development of fine arts by promoting Tunisia to European artists.[85]

77 The press highlighted that she had recently been nominated Chevalier de Légion d'honneur and that one of her works, *Stella maris*, was known to have been a great success at the Parisian Salon des artistes français.

78 Blanche Moria exhibited at the Paris Salon between 1883 and 1890.

79 Known for his illustrated work, *La Tunisie, pays de protectorat français* (1892), Charles Lallemand (1826-1904) exhibited *Fruits* at the Parisian Salon des artistes français of 1881.

80 *DT*, 24 March 1896. The article cited the exhibitors decorated with the Légion d'honneur or the Palmes académiques.

81 An evaluation of the number of ordinary exhibitors who had already exhibited in one of the Parisian salons was around twenty-five.

82 Either before 1881 at the salon, or after 1881 at the Salon des artistes français, or after 1890 at the Salon de la Société nationale des beaux-arts.

83 *DT*, 7 March 1924. The majority of Fichet's audience at the inauguration was overwhelmingly European. We can imagine that the president of the art section of the Institut de Carthage had at the fore of his mind the artistic culture and the taste of the Tunisian Europeans and that he wished it to grow, as he perceived in the development of culture a way of transcending community boundaries. This was also evident in his theatrical activities in the association *l'Essor*.

84 It was on the occasion of the Salon that the inspector of Drawing Education and of Museums Jules Pillet travelled to Tunis in 1895, the Director of Fine Arts Henry Roujon in 1896, and the Director of the Musée du Luxembourg Léonce Bénédite in 1897.

85 See the speech given by Lucien Bertholon, president of the art section in 1895. "Deuxième exposition artistique," 289.

Hence, the organising committee covered the cost of transporting the works from Europe and Algiers and offered free hanging space to artists up until 1898. In 1894, the Salon was organised around the works of a promising young painter, Louis Chalon,[86] thanks to the intermediation of the deputy secretary of the art section of the Institut de Carthage, the designer and engraver P. Bridet. But Chalon did not settle in Tunis, nor did the sculptor Théodore Rivière, who was given special attention in the Salon tunisien of 1895,[87] nor the other members of the Society of French Oriental painters who sent their works in 1897 without themselves making the journey.[88] Some young painters trained in Paris exhibited in Tunis, such as the Frenchmen Avy and Richebé,[89] as well the Swede Anders Zorn[90] and the German Hermann Linde, who was the only one to have resided in Tunis, but without settling permanently.[91] It is possible, however, that this policy had a certain effectiveness. The choice of Tunis rather than Algiers as a destination and place of residence by some major figures of the avant-garde – Vassily Kandinsky and Gabriele Munter in 1904-1905, then Paul Klee, August Macke and Louis Moilliet in 1914 – was linked to their awareness that the country seemed to have remained authentic by comparison with Algiers, which was much more Europeanised. One can imagine that they were also attracted by the prospect of finding a safe city in which they could exhibit and access a clientele, with the possibility of buying material from specialised dealers and which offered a favourable working environment.[92]

[86] Louis Chalon (1866-1916), former student of Jules Lefebvre and Gustave Boulanger at the Académie Julian, regularly exhibited from 1880 at the Parisian Salon des artistes français.

[87] Théodore Rivière (1857-1912) regularly exhibited from 1875 at the Paris Salon. He stayed in Tunis from 1890. In 1891 he created *Buste du Bey de Tunis*, and at the Salon tunisien of 1894 he exhibited *Zouave allumant sa pipe*.

[88] The expectations expressed at the end of 1896 seemed not to have been met: "Les peintres viendront avec leurs œuvres et ce sera en quelque sorte un congrès artistique." See "Assemblée générale du vendredi 4 décembre 1896." *RT*, 13, January 1897, 7-15, 12.

[89] Joseph Marius Avy exhibited at the Salons Tunisiens of 1895 and 1896 and Horace Richebé only at the Salon of 1896. The two painters were born in 1871.

[90] Anders Zorn (1860-1920), whose reputation was already established, was then residing in Paris. It is possible that his proximity with Antonin Proust, who was "ministre des Arts" in the government of Léon Gambetta, played a part in the shipment of his artworks. For an account of his work, see the exhibition catalogue *Anders Zorn, le maître de la peinture suédoise*, Paris: Paris-Musées, 2017.

[91] Hermann Linde (1863-1923) made his first journey to Tunisia and Egypt in 1890, before his sojourn in India between 1892 and 1895.

[92] No Salon was organised in 1905, so not surprisingly there is no trace of writings left by Kandinsky and Münter. In 1914, Klee, Macke and Moillet, who arrived in Tunis the day before the opening of the Salon on April 8th, seemed not to be interested. On the topic of the stay in Tunis of these artists, see Benjamin, Roger. "L'œuvre de Wassily

An element that distinguished the Salon tunisien from the Parisian Salon des artistes francais was undoubtedly the different relationship it had with the affirmation of a French national identity. The adjective "Tunisian" is indeed likely to be understood in different ways. The word could be used as a provincial connotation – there would be a Salon tunisien, as there could be a Salon breton or a Salon provençal – or it could be seen as a national identity. Whereas the members of the Salon des artistes français all had to be French, this was not the case for the members of the Institut de Carthage or for the exhibitors at the salon.[93] The Salon tunisien promoted French artists and French art, but it also made room for local productions and welcomed some foreign European artists. In 1897, for example, the *Dépêche tunisienne* was delighted by the presence of the Italian painter Gaetano Musso of Palermo, hoping that "many Italian artists would follow his example."[94] While being selective, because of the existence of an admission jury, the exhibit could also be seen as a relatively open space.

The Salon, Symbol of Association or Inclusion

The Salon tunisien is generally presented as an expression of harmony between communities, in accordance with the discourse that art and the meaning of beauty are universals likely to win the support of all.[95] The organisers of the first Salon wanted to make it a unifying event, with participation of all the communities living in Tunisia. The composition of the various organising committees of the Salon testified to this. As early as 1894, the 17 members included a Lebanese Christian, Chekri Ganem, a head

Kandinsky au musée national d'art moderne." *La Revue des Musées de France. Revue du Louvre*, 64-5 (2014): 33-42 and *Id.*, *Kandinsky and Klee in Tunisia* (with the collaboration of Cristina Ashjian), Oakland (CA): University of California Press, 2015.

93 The statutes of the association were published in the first number of the *RT*, dated January 1894, 4-9.

94 *DT*, 2 April 1897. The general political context is that the French protectorate over Tunisia was recognised by Italy after the defeat of Adoua and the failure of the colonial politics of Crispi. A Franco-Italian consular convention was established and declared by the Bey in 1897.

95 This was the discourse constantly proclaimed by the socialist Alexandre Fichet. In 1923, he said, following the ideal, "de persuader notre population cosmopolite, divisée par ses origines, ses goûts, ses mœurs, ses occupations, que l'Art est une patrie accueillante. Les différences de races, d'émotions, d'expressions constituent de nouvelles sources de richesse pour cette patrie et concourent à la rapprocher de la vérité générale et humaine, seule harmonieuse." See "Le Salon tunisien. Discours de M. Fichet." *RT* 155-156, January-April 1923, 97-100, 97.

of section in the Tunisian government.[96] In 1895, three of its 16 members were Tunisian Jews (painter Emma Darmon, and two photographers, Isaac Sadoun and Albert Samama).[97] In 1896, three out of 12 members were Tunisians: two Jewish traders, Cohen Tanugi and Sebag, and a Muslim public servant, Muhammad Belkhodja, who was head of the accounting office at the Tunisian government's secretariat general.[98] The commission responsible for organising the "artistic, industrial and ethnographic" exhibition was also formed to represent the European, Jewish and Muslim populations.[99] The minutes highlight the support jointly offered by representatives of the city's Muslim and Jewish elites to the efficient organisation of the salon, with the "benevolent assistance" of two of the founding members of the Institut de Carthage, Shaykh al-madina (president of the municipality of Tunis) Muhammad al-Asfuri, and Gabriel Medina (the former being among the members of honour, the latter from among its *comité d'initiative*).[100] This mix was again found 60 years later, after independence, in the composition of a jury which from then on was made up of artists.[101]

The Salon tunisien showcased a high standard of French hospitality, making room for other Europeans as well as for Tunisians, Jews and Muslims. The Salon was thus endowed with a unifying function, which in

[96] Originally from Beirut, Chekri Ganem (1861-1929) settled in France after marrying a Frenchwoman in Tunis, Anaïs Couturier. He pursued his literary work, and managed to have a play in verse performed in the Odéon Theatre, *Antar*. *RT* 5, January 1895, 95; Larcher, Pierre. *Orientalisme savant. Orientalisme littéraire. Sept essais sur leur connexion*. Arles: Sindbad/Actes Sud 2017, 115-132.

[97] We suggest identifying Isaac Sadoun with Jacques Sadoun, born in 1872, who established himself from 1903 as a photographer in Rue des Maltais, according to the entry about him in the *Dictionnaire illustré de la Tunisie* published in 1912 in Tunis by Paul Lambert. On Albert Samama called Samama-Chikli (1872-1934), who was known for his cinematic productions, see Corriou, "Tunis et les 'temps modernes'," 106-113.

[98] "Exposition artistique et industrielle de 1896." *RT* 10, April 1896, 354-356, 354; "Liste des membres arrêtée au 1er avril 1898." *RT*, 18, April 1898, 258-274, 262.

[99] This commission headed by the Durkheimian sociologist Paul Lapie, was composed of Ernest Dollin du Fresnel, Muhammad Lasram, in charge of the administration of olive tree forests (*ghâba*) at the Directorate of Agriculture, and Gabriel Medina (1842-1910), commercial representative, originally from Smyrna, who was secretary of the regional committee of the Alliance Israélite. "Compte rendu de la séance du comité directeur du 9 janvier 1896." *RT* 10, April 1896, 157.

[100] "Chronique de l'Institut de Carthage (2e trimestre 1896)." 471. It is the re-publication of a review of the Salon tunisien previously published by the lawyer Goin in *La Dépêche tunisienne*.

[101] In 1959, for the first time an artist from a Muslim family, Yahya Turki, sat on the jury of the Salon, alongside two painters originally from the Tunisian Jewish community, Henri Saada and Edgard Naccache, and French artists.

some respects was similar to that of its Parisian counterpart.[102] Despite a will to highlight the artistic quality of indigenous productions, the distinction between works of art signed by an author's name and numbered in the catalogue – which could be artworks other than painting and sculpture (*objets d'art*) – and this "industrial art" produced by anonymous hands in private workshops (whose owners are named), in the workrooms organised by the Sœurs blanches or under the authority of the Directorate of Indigenous Economic Services, remained clearly established.[103] The separation was also spatial, the exhibition rooms being generally specialised according to the types of object.[104] The "Section artistique" and "Section industrielle" were clearly separated in 1896 when the exhibition was presented in the Passage de Bénévent.[105] The distribution of jobs was also significant: if we find "natives" employed among the staff of the salon, it was in the form of "faithful Moroccans" who ensured security.[106] Nevertheless, the idea of an opposition between Aryans and Semites, and the capacity for artistic creation being reserved for the former, of which the French, inventors of the salon, would be the representatives, is expressed by only one author.[107]

[102] Pierre Vaisse reminded readers that the Paris Salon was there to perpetuate the imaginary unity of *l'école française*. Vaisse, "Réflexions sur la fin du Salon officiel," 133.

[103] I take here the example of the Salon tunisien of 1922. But this distinction can be found since the 1888 exhibition. A few salons did not give space to contemporary artisanal work, except as decorative elements used in the frame of the exhibition (this seemed to be the case in 1894), but presented some ancient "Arab" objects, collected by the Directorate of Antiquities (this was the case in 1897, and, it seems, in 1895). Others include a "section industrielle indigène", as in 1896. On the question of the boundaries between European applied arts and "l'artisanat d'art indigène", see the contribution of Jessica Gerschultz in this volume.

[104] In 1895, we can find "salles de peinture, de sculpture, de photographie et la salle du service des beaux-arts". "Deuxième exposition artistique," 286.

[105] In 1896, the artistic section and the "industrial" section were presented in two different locations. The space showing the latter, called "exposition indigène," served as the setting for "quelques fêtes de nuits … fort suivies du public." "Chronique de l'Institut de Carthage (2e trimestre 1896)," 473.

[106] As the evening ended, they "announced the closure of the salon." Maillé, Charles. "Notes sur le Salon tunisien." *RT* 7, July 1895, 295-303, 298. The employment of Moroccans to guarantee security was a common practice in Tunis in the first half of the twentieth century.

[107] According to the lawyer Hippolyte Goin, who reported on the Salon of 1894, Tunisia "stérilisée depuis des siècles … dont l'horizon semblait borné par d'étroites conceptions de l'esprit sémite (la spéculation et l'agio), s'est subitement réveillée, sous l'influence fécondante du pur génie aryen, venu de France" and the salon "nouveau-né" testified of "un éveil" and the future victory of Apollo over Mercure. "Une exposition artistique," 328.

We can consider that the Salon tunisien was an instrument for the definition of an open and modern Tunisian national identity, characterised by the recognition of a diversity of contributions (including those from abroad), a discourse formulated during the period of the protectorate and continued by the governments of independent Tunisia after 1956.[108] In the 1890s, the Salon had been the only annual collective event where artists could present their works. Its exhibitions separated European paintings, sculptures and other works of art from Tunisian handicrafts, but associated them with each other. During the 1930s, the central significance of the Salon was no longer as transparent. It was now in competition with other exhibition spaces – department stores, large hotels, halls of buildings housing press editorial offices,[109] and the first private art galleries.[110] Products of local craftsmanship were no longer displayed at the Salon. Other spaces had taken over to present to the public selections of these objects. However, the Salon's political function as a place of affirmation of plurality and national cohesion remained important enough to allow its continuation and support by state authorities until the early 1980s. With the development of cinema and especially of television, the symbolic power of affirming a common representation of the world through the official and social recognition of a selection of shared images, diminished. However, the art salon played a significant role in the history of the development of a public space and of the imagined national Tunisian identity.

[108] This discourse was still in practice at the beginning of the twenty-first century. We can cite, for example, in historiography, the work directed by Jacques Alexandropolos and Patrick Cabanel, *La Tunisie mosaïque. Diasporas, cosmopolitisme, archéologies de l'identité*. Toulouse: Presses universitaires du Mirail 2000. In his contribution, Lucette Valensi, to illustrate "l'émergence et la pratique d'un langage commun," cited the Art déco style in architecture and the Ecole de Tunis in painting. "La mosaïque tunisienne: fragments retrouvés," 23-29, 28-29.

[109] We can cite the *salon de thé* and the *salon de correspondance du Magasin général*, Avenue de France, the salons of Tunisia Palace, Avenue de Carthage, or, from 1923, the hall of the daily paper *Le Petit Matin*, Rue Saint-Charles.

[110] The first of them, Art Nouveau, opened its doors in 1927 Rue Saint-Charles (the current Bach Hamba street).

CHAPTER 2
THE CONCEPT OF "DECORATIVE" ART IN TUNISIAN SALONS: ROOTS OF THE TUNISIAN ÉCOLE

JESSICA GERSCHULTZ

The Salon tunisien played a seminal role in the development and negotiation of artistic concepts and networks among Tunis-based artists in the twentieth century.[1] Established in 1894 under the French Protectorate, this annual salon was the earliest institution in colonial Tunisia to demarcate between "fine" and "decorative" art forms and to differentiate these from "indigenous industry." Yet, the unsettled status of the "indigenous" arts reflected looming and uneasy questions about hierarchical relations of power, anticipating a prominent and lengthy aesthetic inquiry into the "decorative" that linked artists across colonial-era art institutions. This chapter explores how, at the turn of the century, the Salon tunisien's earliest presidents grappled with the low status of "indigenous" and "decorative" arts in artistic hierarchies, including the relationship between Tunisian and "Islamic" art forms and European decorative arts. The salon's two longest-serving presidents, Alexandre Fichet (serving from 1913 until 1967) and Ali Bellagha (serving from 1968 until 1984), both addressed the troubled relation of these transnational concepts to the country's rich heritage of Arab, Islamic, and Jewish art, amid shifting political discourses. Over time, officials and artists increasingly imbued the term "decorative" with gendered, racialized connotations stemming from wider colonial hierarchies of art and culture, as well as contesting the conceptual underpinning of artistic production and classification. The Salon tunisien thus established the foundations for critical engagement with what Fichet in 1913 called the "indigenous decorative arts," a nebulous category continually negotiated by a group of Tunis-based artists in the course of the twentieth century.

[1] I would like to express my gratitude to Patrick Abéasis for generously sharing with me his private archives that stimulated my interest in the Salon tunisien. I also thank Monique Bellan and Nadia von Maltzahn for their invitation to present this research at the Sursock Museum in January 2017. Finally, I am grateful to Edmée Ravelonanosy and Féla Kéfi Leroux for providing me with precious materials about the artist Victoire Ravelonanosy and women's salons and exhibitions in Tunis in the 1950s and 1960s.

The Salon tunisien facilitated the early formation of artistic networks that were crucial for these debates and for the associated inclusive or exclusionary definitions of art. The salon's recognition of and deliberation over a range of Tunisian art forms, although these were initially segregated from those produced by Europeans, began from its inception. In the 1920s, Fichet granted visibility and exhibition space to Tunisian Muslim and Jewish painters as well as to those classified by authorities as "artisans," while two European painters and a Tunisian Jewish architect of Italian origin, all members of the salon, established a "fine" arts school. The salon subsequently assembled a group of artists, professors, students, and "artisans" who disputed the dominant Eurocentric hierarchies that elevated "fine" art above "decorative," "indigenous" craft during a period of post-World War II reconstruction and architectural commissions.

Through concerted collaborations led by Tunisian artists such as Ali Bellagha, Fichet's successor as president of the Salon tunisien, and Safia Farhat, professor of decorative arts at the École des beaux-arts, this group of artists utilised the concept of the artist-as-craftsperson and attempted to restore the "indigenous" decorative arts to a privileged position in modern art during the late nationalist and early postcolonial period. Another artist in this circle, Victoire Ravelonanosy, founding president of the Association des artistes peintres et amateurs d'art de Tunisie, which held annual salons from 1948, similarly sought to elevate the status of the decorative arts from her native country of Madagascar in Tunis salons. These artists' mid-century endeavours, which connected institutional settings in the re-envisioning of artistic concepts, stemmed from categories established and later revised in the Salon tunisien in the preceding decades.

Archival records demonstrate that the enduring question of how to approach "indigenous" art forms was present in the Salon tunisien at the turn of the twentieth century. Moreover, the issue of categorizing "minor arts" such as textiles, lace, ceramics, jewellery, and weaponry may also be traced to the earliest salons, whose organizers struggled to define various modes of artistic production and to assess their aesthetic merit in a value system rooted in imperialist, gendered hierarchies. Frictions over what constituted art and the relations of power within this sphere resurfaced in a number of ways over time, from the creation of a counter-salon for French academic painters in 1924 to the increased feminization of the artisanat and "decorative arts" in the 1950s. Notably, the salon became an acceptable, lauded site for the public recognition of women artists, who, in addition to contributing to the Salon tunisien, participated in and also directed women's art and literary salons and other organizations with salon-type venues, such as the Union féminine artistique et culturelle de Tunisie (UFAC) and the

Association des artistes peintres et amateurs d'art de Tunisie, which were directed by women, notably Ravelonanosy and Farhat.

At the same time, the increased prominence of women in Tunisian art institutions deepened associations between the decorative arts and femininity, as many talented young women concentrated on the decorative arts, ceramics, and other "artisanal" genres. The issues of artistic and social hierarchies, and particularly the gendered connotation of "craft," were never fully resolved in art historiography. Many written and photographic accounts of the *Salon tunisien* narrowly focus on its role in advancing Tunisian painting (and the careers of male painters); this is evident, for example, in press coverage for its 50th anniversary in 1950 and in subsequent government publications.[2] Yet, as this chapter shows, the Salon tunisien established categories that became a basis for mid-century challenges to the dominance of painting in Tunisian modernism. The salon model also permitted the elaboration of gendered concepts and ideals that fostered associations between women, indigeneity, and the decorative arts.

The Salon Tunisien: Roots of the Tunisian École

The institutional foundation for the concepts of *beaux-arts*, *arts décoratifs*, and *arts indigènes* in Tunisia date back to 1894, when the Salon tunisien was established under the French Protectorate. The Salon tunisien was the artistic branch of the Institut de Carthage, the Tunisian Academy of Letters, Sciences, and the Arts.[3] It held an annual spring exhibition loosely modelled on salons in the metropole, and its membership was drawn from various communities in Tunisia: French, Italian, Arab, Jewish, and Maltese. At the turn of the century, the salons were intended to cultivate artistic ties with French artists and institutions and to promote French cultural values. They also served to assert colonial dominion over "indigenous" art industries, as Alia Nakhli has argued.[4] Because the newly installed Protectorate government viewed Tunisia as bereft of fine art, the Salon tunisien represented the first official effort to create an artistic movement within a

2 For an example of press coverage, see articles appearing in *La Dépêche Tunisienne*, 20 April 1950, 23 April 1950, and 28 April 1950. Such publications include Narriman El Kateb Ben Rhomdane et al. *Anthologie de la Peinture en Tunisie, 1894-1970*. Tunis: Partenariat Euro-Tunisien 1998.

3 For an overview of the Salon tunisien, see Abéasis, Patrick. "Le Salon Tunisien (1894 – 1984): espace d'interaction entre des générations de peintres tunisiens et français." In *Les relations tuniso-françaises au miroir des élites (XIX^e, XX^e siècles)*. Tunis: Faculté des Lettres, Manouba 1997.

4 Nakhli, Alia. *La vie artistique en Tunisie sous le protectorat français de 1894-1914*. Mémoire de D.E.A., Université Marc Bloch de Strasbourg 2005.

a perceived void. While its funding was frequently tenuous, it nevertheless granted some financial support and visibility to Tunis-based artists through the display and sale of their work, as well as attracting visiting artists from neighbouring Algeria and France. Casting a wide net, the salon was open to professional artists as well as to "amateurs" and students.

The establishment of the School of Fine Arts, initially called the Centre d'enseignement d'art, in Tunis in 1923 assured the growing participation of local artists in the salons and provided an additional space for engagement with the French system of classification.[5] Demonstrating early, enduring institutional linkages, the art school's staff was drawn from contributors to the Salon tunisien. French painter Pierre Boyer directed the school, which was originally located in the Tunis medina. Another French painter, Armand Vergeaud, and the Tunisian-Italian Jewish architect Victor Valensi instructed students.[6] Of the three men, Valensi was most interested in local art forms. He studied Tunisia's architectural patrimony, publishing a book entitled *l'Habitation Tunisienne* in 1928 that featured documentation of architectural ornamentation and spaces found in the medina, Sidi Bou Saïd, and La Marsa; he later collaborated with ceramic artists of the Chemla family in the design and building of homes reflecting a stylized colonial arabisance.[7] In addition, the salon's first long-standing president, Alexandre Fichet, taught drawing, painting, and sculpture in the early years. A small group of beaux-arts students constituted an initial target audience for the Salon tunisien, as well as its future participants. A photograph of a young woman posing for a male student as he sculpted her portrait in the school's

5 Though referred to as a École des beaux-arts in archival records from its inception, the school in Tunis did not adopt this official appellation until 1930. The formal name change came at the request of the Association des élèves, anciens élèves, et amis du centre d'enseignement d'art de Tunis in order to combat the negative perception that the centre was an "amateur" art school, a view that tarnished graduates' reputation as serious artists. Archives diplomatiques de Nantes: 1TU/1/V/2080. See also Lasram, Khaled. "Création de l'École des Beaux-Arts de Tunis, 1923-1966." *Mujtam'a wa 'umran 12/11(1988)*; Rolin, Béatrice. *Armand Vergeaud (1876-1949)*. Angoulême: Musée des Beaux-Arts: 1997.

6 Pierre Boyer, born in Paris in 1865, seems to have come to Tunisia on an artistic voyage around 1890, and remained there until he died in 1933. For biographical information on Armand Vergeaud, see Rolin, *Armand Vergeaud (1876-1949)*. Victor Valensi (1884-1977) was a Paris-trained architect from a prominent *tunisois* family who valued historical preservation.

7 See Chemla, Jacques, Monique Gaffard, and Lucette Valensi. *Un Siècle de Céramique d'Art en Tunisie*. Tunis and Paris: Éditions Démeter, Éditions de l'Éclat 2015; Kechari, Bechir. "The Architects of the 'Perchoir' and the Modernism of Postwar Reconstruction in Tunisia." *Journal of Architectural Education* 59, 3 (Feb. 2006): 80-81; Valensi, Victor. *l'Habitation Tunisienne: Réimpression conforme à l'édition publiée en 1928*. Tunis: Alif Éditions 2008.

courtyard provides a glimpse into such activities (Figure 1). Colonial officials also intended to create an art museum for pedagogical purposes, which would exhibit state acquisitions from the salons alongside loans from French museums.[8] Conceived of during the first Salon tunisien of 1894 and later tasked to Boyer, this museum never materialized.

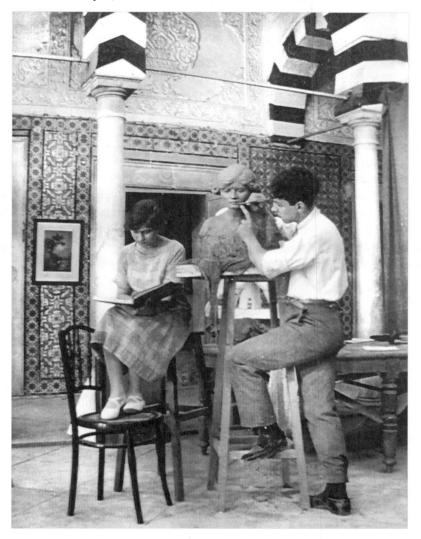

Figure 1: Centre d'enseignement d'art, c/1927. From the private archives of Patrick Abéasis, transferred to the Archives nationales d'outre-mer.

8 See "Chapître du Budget concernant la création d'une École des Beaux-Arts et d'un musée d'art moderne à Tunis." 1922. Archives diplomatiques de Nantes: 1TU/1/V/2080.

Race, Gender, and the "Decorative" in Colonial Art-Historical Discourse

Even though the Salon tunisien served as the pre-eminent gathering place for male painters in Tunisia in the early twentieth century, it also afforded considerable space and resources for the display of "decorative arts" and "indigenous arts," two sweeping categories whose associated art forms and materials overlapped considerably due to their materials, techniques, and functional characteristics. In Europe and its colonial institutions, both categories existed in opposition to the high status of painting and "fine" art, and were perceived to reflect feminized qualities. In the categorical and spatial separation of painting from the utilitarian arts, comprising the decorative arts and "artisanal industry," the Salon tunisien introduced and perpetuated an art/craft binary that arose alongside colonial theories of the evolution of culture. The meta-narrative of evolutionism, which positioned peoples and cultures on an evolutionary scale based on race, presumed that Arab and African subjects belonged to less advanced, "degenerate" civilizations and primitive, uncivilized cultures that lacked sophisticated and refined aesthetics. Colonized artists were, according to these theories, weak, imitative, feminine, and intrinsically incapable of intellectual engagement with abstraction or the intentional production of fine art and modern design. The study of art and artistic practices therefore became a tangible measure for the application of racist hypotheses, the assertion of European cultural and artistic superiority, and the maintenance of patriarchal institutions.[9] Gendered and racial hierarchies of the early to mid-twentieth century distinguished the "fine artist" from the "artisan," creating a mutable boundary that was contingent upon the perceived identity of the artist. The indeterminate status of the decorative arts and so-called *artiste-décorateurs* hovered around this boundary in Tunisia and elsewhere in Africa and the Arab world, particularly as the term 'decorative' often assumed racialized, feminized connotations in colonial localities.

According to evolutionist positions, filtered into the art world through the writings of such prominent figures as Adolf Loos and Le Corbusier, the "indigenous" artist, bereft of purposeful abstraction and autonomous thought, produced repetitious "arabesques," utilitarian craft, and primitive

9 See Preston Blier, Suzanne. *"Enduring Myths of African Art" Africa, the Art of a Continent.* New York: Guggenheim Museum 1996; Coombes, Annie E. *Reinventing Africa: Museums, Material Culture and Popular Imagination in Late Victorian and Edwardian England.* New Haven: Yale University Press 1997; Irbouh, Hamid. *Art in the Service of Colonialism: French Art Education in Morocco 1912-1956.* London: Tauris Academic Studies 2005.

body art.[10] Speaking of the aesthetic locus of men's decorated bodies in Papua New Guinea, Loos (in)famously argued in *Ornament and Crime* that "the more cultivated a people becomes, the more decoration disappears," a view repeated by Le Corbusier in 1925 in his essay "The Decorative Art of Today."[11] Le Corbusier reflected on the concept of "decorative art," specifically using an ubiquitous term in the emerging field of "Islamic art" in an unfavourable manner as he pondered over what he saw as a paradox in taxonomy:

> To include under this rubric everything that is free from decoration, whilst making due apology for what is simply banal, indifferent, or void of artistic intention, to invite the eye and the spirit to take pleasure in the company of such things and perhaps to rebel against the arabesque, the stain, the distracting din of colours and ornaments...[12]

Later in the essay, in colonial and racist language, he called decoration "charming entertainment for a savage."

To contextualize these statements with regard to salons in the Maghreb, Le Corbusier made these remarks as artists from francophone Africa participated in a grand-scale exhibition in Paris, the 1925 "Exposition internationale des arts décoratifs et industriels modernes." Valensi, a prominent member of the Salon tunisien and a professor at Tunis's fledgling art school, was one of two architects who designed Tunisia's pavilion.[13] Moreover, Tunisian ceramic artists associated with the studios of the Fils de Chemla and Hassan al-Kharraz, whose works were classified in the Salon tunisien as "indigenous arts," designed the faïence tilework, decorative pavements, basins, and vases for the pavilion, earning gold and bronze medals for their contributions. Thus, as this example suggests, the conceptual history of "decorative," including the "indigenous" art industries frequently subsumed under this descriptor, is inextricable from the violent rhetoric of colonialism, including the application of evolutionist hypotheses to the arts. In addition to Le Corbusier, numerous other figures deployed an enduring evolutionist paradigm in art-historical writing and museum collecting. Some posited that "indigenous" artists either emulated European

10 Loos, Adolf. "Ornament and Crime." In *Adolf Loos: Ornament and Crime: Selected Essays*, Selected and with an Introduction by Adolf Opel, translated by Michael Mitchell. Riverside, CA: Ariadne Press 1998; Le Corbusier, *L'Art décoratif d'aujourd'hui*. Paris: Éditions Arthaud 1980.

11 Le Corbusier, *L'Art décoratif d'aujourd'hui*.

12 Le Corbusier, *L'Art décoratif d'aujourd'hui*, 88-84.

13 Chemla, Gaffard, and Valensi, *Un Siècle de Céramique d'Art en Tunisie*.

models or were rapidly disappearing, as new forms of production did not meet European standards of "authenticity".[14] These discourses shaped institutional developments throughout Africa and the Arab world.

During this period, hierarchies in the art world likened women to the weaker "races," refuted their ability and intellect, and denounced their work as ornamental, intuitive, and superfluous. Le Corbusier's 1925 essay also shows the convergence of demeaning ideas about gender and race, as he imagined an ignorant, lower class woman existing in spaces associated with the arts of indigenous peoples. He wrote, "The pretty little shepherdess shop-girl in her flowery cretonne dress, as fresh as spring, seems, in a bazaar such as this, like a sickening apparition from the show-cases of the costume department in the ethnographic museum."[15] Hierarchies of medium that delineated "fine" and "decorative/indigenous" arts, also labelled as "major" and "minor" arts, were thus mapped onto colonial territories and gendered bodies.

Because concepts of "fine", "decorative" and "indigenous" arts circulated in transnational spaces such as salons, colonial expositions, and Écoles des beaux-arts, they became ubiquitous in institutions throughout Africa, the Arab world, and beyond. However, by resisting any singular or fixed meaning, these malleable terms connoted various strategies and stances over time and place. Taxonomic systems served as frameworks for articulating aesthetic and political visions and reworking relationships of power. Both Fichet and Bellagha sought to reconcile the relation of the concepts of fine art, decorative art, and handicraft to discourses about Tunisia's heritage of Arab and Islamic art at different points during the colonial period. In addition, Fichet concerned himself with Jewish artists such as Maurice Bismouth, Jules Lellouche, and Jacob Chemla, whose identities at that time fell under the rubric of "indigenous" artists.

By the 1920s, the corpus of work produced by Tunisian Muslim and Jewish artists spanned painting and "indigenous" arts, and both categories were exhibited in the Salon tunisien. Yet, French colonial authorities classified the latter as belonging to the domain of the artisanat. In 1933, the Tunisian artisanat was formally institutionalized with the creation of the Office des arts indigènes, even though European members of the Salon tunisien had been involved with "indigenous" design and workshop production for decades. Nonetheless, as will be discussed, the Office des arts indigènes marked anew an official separation of the *beaux-arts* and *arts*

14 Littlefield Kasfir, Sidney. "African Art and Authenticity: A Text with a Shadow." *African Arts* 25, 2 (April 1992): 40-53 and 96-97; Meier, Prita. "Authenticity and Its Modernist Discontents: The Colonial Encounter and African and Middle Eastern Art History." *The Arab Studies Journal* 18/1 (Spring 2010).

15 Le Corbusier, *L'Art décoratif d'aujourd'hui*, 89-90.

indigènes at a point when Fichet was attempting to dissolve these categories in the salons. Moreover, this office's early emphasis on the arts of Muslim women intensified the already feminized status of the artisanat. Thus, the artists, officials, and others involved in Tunisian art institutions in the early to mid-twentieth century found in the Salon tunisien a site for a continual engagement with these boundaries. While never eluding or transcending French colonial hierarchies, the salon's organizers maintained subtle differentiations from other colonial institutions until 1950, with the arrival of director Pierre Berjole at the École des beaux-arts in Tunis.

Negotiating Artistic Categories in the Salon Tunisien

The General Regulations of the Salon tunisien for 1901 indicated its early emphasis on displaying artworks that exhibited an "Oriental character," although attitudes toward these works and their definitions constantly shifted. The salon included retrospectives for painters like Fichet and Vergeaud, as well as a section reserved for what was generally referred to as "indigenous industry." From its inception in 1894, the salon exhibited arts defined variably as Arab, Islamic, traditional, and indigenous in the latter section. The revue of the Institut de Carthage described the indigenous space of the first salon as "an Arab exhibition of the Collège Alaoui: decorative arts, calligraphy, plasterwork, and arabesques." Subsequent salons reveal that members and associates of the Institut de Carthage sought to protect, defend, and support local art industries, and some organizers argued for both their economic and artistic value even as they grouped these artworks separately from those of Europeans – including the "decorative arts," initially presumed to be European in conception and design, even if appropriated from North Africa and elsewhere in the French colonial empire and despite multi-directional influence and collaborations.

The president of the salons in 1908 and 1909, the architect and ceramicist Elie Blondel, exhibited paintings, drawings, sculptures, and what he called "Islamic art objects" in two salons.[16] In his 1908 inaugural speech he also described the latter as "Arab art," indicative of what would become a paradigmatic interchangeability of terms in academic Art History. Blondel praised Arab designers, illuminators, sculptors, and embroiderers, as "veritable artists and very capable people who largely merit encouragement." As Clara Ilham Álvarez Dopico has shown, Blondel was among the first European artists associated with the Salon tunisien to bring "indigenous" art into the domain of decorative art through the assertion

16 *Revue Tunisienne XV* (1908): 286-288; *Revue Tunisienne XVI* (1909): 211.

of a noble Islamic heritage.[17] This approbation appealed to the colonial nostalgia for "disappearing" artisans as well as to attempts to control their production and sales. She writes of Blondel's strategy, "by linking the ancient Tunisian heritage with Islamic decorative arts, he advocates the interest and importance of indigenous industries."[18] Blondel experimented with these classifications and associated arts in his studio "La Poterie Artistique" in the neighbourhood of Bab Saadoun, collaborating with Jacob Chemla, the future founder of the Fils de Chemla enterprise, who conducted ethnographic research on ceramic traditions with the intention of revitalizing the industry and attracting decorative and architectural commissions. While constituting a significant precedent for the modernist exploration of material and collaboration at the interface of art and artisanal practice, Blondel's studio in Bab Saadoun diverged from his management of the Salon tunisien, where he left intact the French classifications of his predecessors.

Shortly after, in 1911, an explicit invitation for the submission of indigenous arts first appeared in salon regulations. The 1911 Salon tunisien included a section of "Traditional Arts" devoted to "indigenous pottery, carpets and weapons having an artistic character." Its president, Alphonse Clémont, stated that he included what he called "Arab art" in order to awaken the aesthetic sense among Tunisian artisans.[19] However, despite sustained interest, the early salons continued to be segregated. The division between an artistic section for European artists (indicated by "universal" labels denoting the medium) and an industrial section for Tunisian artisans (marked by the term "indigenous") may be seen in the 1912 catalogue of the Salon tunisien (Figure 2). Classifications for artworks exhibited included "Sculpture" and "Art Décoratif," which stood apart from the "Section Indigène." Jewish artists, notably ceramicists from the Chemla family, exhibited in this latter section. For example, in 1912, Jacob Chemla and the ceramicist Belaisch exhibited *poteries indigènes*, and in 1914 they presented audiences with copies of historic ceramic panels located in the city of Kairouan and the collection of the Bardo Museum. In addition, on a par with practices in colonial expositions and world fairs, "native" artisans exhibiting in the Salon tunisien gave live demonstrations of artistic techniques to a predominantly European audience. For example, in 1922 the "Indigenous Arts" section featured a Tunisian woman weaver whose Black "African" descent was publicly noted.

17 Álvarez Dopico, Clara Ilham. "Tradition et rénovation dans la céramique tunisienne d'époque coloniale: Le cas d'Elie Blondel, le Bernard Palissy africain (1897-1910)." Accessed proof from academia.edu, 2014.

18 Álvarez Dopico, "Tradition et rénovation," 230.

19 "Salon Annuel Tunisien 1911 Règlement." Archives nationales de France: F/21/4745. *Revue Tunisienne XVII* (1911): 379.

Figure 2: Catalogue of the Salon tunisien of 1912.

SCULPTURE
Salle B

VERMARE (H. C.),
Paris

190 Le Rhône, bronze (fragment).
191 Printemps, bronze.
192 Berger romain, bronze.
193 Terraccinella, bronze.

VIEL NOË (Mme),
Le Kef.

194 Torse de nègre.
195 Buste vieille femme.
196 Tête de vieillard.

FULCONIS.

196 bis Statuettes.
196 ter Bas relief du monument Gallini.
196 quater Buste.

ART DÉCORATIF
Salle C

CHOCHOD N. (Mme).

197 Rochers sur la côte d'azur, couleurs de grand feu sous émail
198 Oratoire dans les Maures, ———

EXPOSITION INDIGÈNE
Salle F et A

AZIZ DARYGOUT.
Ecole Professionelle, Emile Loubet.

218 Modèle de métier à tisser.

NIZARD.
01, rue de l'Eglise, Tunis.

219 Lampe, plateau, cache pôt, brûle parfums, aiguière, cuivre ciselé.

HADI BEN MALEK.
20, Souk-el-Belat, Tunis.

220 Meubles arabes

HASSEN EL BRADAHY,
Amine des Menuisiers
45 bis Souk-el-Belat, Tunis.

221 Meubles arabes.

AHMED BEN ABD-EL-KADER,
1, rue du Témoin, Tunis.

222 Etoffes arabes.

MOHAMED BEN-OKAZE,
17, Souk-Esserairia, Tunis.

223 Incrustations et Marquetterie.

Alexandre Fichet and the "Indigenous Decorative Arts"

Initially dominated by French Orientalist paintings on the one hand and exhibitions of Tunisian industry on the other, the Salon tunisien grew to encompass various international styles under the leadership of Alexandre Fichet, a French *artiste-décorateur*, who endeavoured to modify the salon's relationship to Tunisian artists and art forms over the decades. Fichet served as president of the Salon tunisien from 1913 until his death in 1967, when Ali Bellagha, an École de Tunis artist and owner of the gallery Les Métiers (al-Ḥiraf), succeeded him. Born in 1881, Fichet graduated from the École des métiers d'arts in Paris. He travelled to Tunis in 1903 to fulfil a decorative commission for the Art Nouveau-style Palmarium complex in Tunis's *ville nouvelle*. Aside from deportation for his socialist views during World War II, he remained in Tunisia all his life. He presided over the Salon tunisien and taught art at two eminent institutions, the Collège Sadiqi and Collège Alaoui, as well as at the newly inaugurated Centre d'enseignement d'art, which changed its name to the École des beaux-arts in 1930. He directed a theatrical society, l'Essor, which hosted political debates that included the topic of Muslim women's status in society. An ardent socialist, Fichet published articles on politics and art. Significantly, throughout his career he served on the juries for numerous exhibitions, cultural initiatives, and salons, including the women's salons sponsored by the Union féminine artistique et culturelle de Tunisie (UFAC) in the early 1950s.

Fichet's various roles within Tunis's cultural sphere illuminate the networks linking European and Tunisian artists with transnational art concepts and their uneven power differentials. Patrick Abéasis argues that Fichet's training in the decorative arts in France sharpened his appreciation of the materials and processes of the Tunisian artisanat, while his socialist, anti-colonial views aroused his sympathy for Tunisian nationalists, many of whom sought to uplift "popular" arts and folklore.[20] Among his students at the Collège Sadiqi was Habib Bourguiba, the founder of the Neo-Destour political party and future first president of Tunisia. The Collège Sadiqi, in which Fichet's successor Ali Bellagha taught art years later, was the secondary school founded in 1875 by reformist Khair al-Din al-Tunsi to prepare Tunisian men for modern political office.

[20] Abéasis, Patrick. "Alexandre Fichet à Tunis: une vie, une œuvre (1881-1967)." In *Les Communautés Méditerranéennes de Tunisie.* Tunis: Faculté des Lettres, des Arts et des Humanités de Manouba, Centre de Publication Universitaire 2006.

Alia Nakhli, however, dissents from views positing that Fichet was sympathetic to an emergent nationalism.[21] Rather, she contends that colonial politics engendered the sense of nostalgia articulated by members of the salon, and argues that economic considerations were the principle motivation behind their interest in Tunisian artisanal production. Additionally, the subordination of Tunisian art forms as appropriable source material for French decorative arts stimulated ideas about the value and constitution of "indigenous arts." Situating himself in the midst of these conflicting currents that pervaded the art world under the French Protectorate, Fichet nonetheless supported a rising group of Tunisian artists exhibiting in the Salon tunisien. This recognition spanned an emergent generation of painters trained in the École des beaux-arts in Tunis, many of whom would form the prominent group the École de Tunis decades later, as well as those working in the "traditional," "indigenous" arts previously introduced to the salon through figures such as Elie Blondel and Alphonse Clémont.

Indicating his intent to confront local artistic hierarchies, Fichet began to accept Tunisian Jewish and Muslim painters and slowly introduced new terminologies into the salon. He granted Jewish painter Maurice Bismouth space within the salon for a solo exhibition in 1922. In 1923, Yahia Turki became the first Tunisian Muslim artist to exhibit in the salon, showing two easel paintings entitled Voûte d'Hadjamine and Place Bab Souika. Furthermore, in the early 1920s, the Salon tunisien established a scholarship for painters to travel to France and awarded these to three Muslim and Jewish artists: Yahia Turki, Ali Ben Salem, and Jules Lellouche. While Fichet admitted a wider range of styles than his predecessors, including Orientalist, academic, and Cubist paintings from 1913, he took longer to reframe artworks labelled as "decorative" and "indigenous." Under his initial direction, the salon maintained its practice of dividing "Tunisian" art forms from "European" ones. This segregation extended to the decorative arts, which were separated into a "universal" designation for European arts and a qualified one for Tunisian arts. In the 1923 Salon tunisien, for example, copperware, theatrical designs, and watercolour maquettes created by Europeans were identified simply as arts décoratifs.[22] The salon added the qualifying term indigènes to denote works executed by Tunisians, labelling textiles, lace, ceramics, furniture, jewellery, and weapons as arts décoratifs indigènes (Figure 3). Yet, while this new term differentiated the latter from European decorative arts, it also seemingly recognized their intrinsic artistic value by grouping them within the same overarching concept.

21 Nakhli. La vie artistique en Tunisie.
22 Catalogue of the Salon Tunisien 1923. Collection of Beït el-Bennani.

— 24 —

LIVRES D'ART

TOURNIER, Avenue de France, Tunis.
 303 Quelques « Beaux livres ».

ART DÉCORATIF

BRUNEL André, Avenue de Madrid, 20, Tunis.
 304 Horloge (Cuivre repoussé « Les Hiboux »).

ELLUL Joss, Rue Barca, 2, Tunis.
 305 Projet de char (*Aquarelle*).

LE MONNIER Louis, Sidi-Bou-Saïd, Tunisie.
 306 Parsifal, 1er Acte, Maquette de Théâtre (*appartenant à M.*)

PELOSSIEUX Paul, Villa Henriette, Montfleury, Tunis.
 307 Plateau « Marguerites » (*Cuivre repoussé*)
 308 Plat à gâteau « Bleuets » —
 309 Cadre « Clématites ». —
 310 Cadre « Fleurettes ». —
 311 Cadre « Les marguerites » —

— 25 —

ARTS DÉCORATIFS INDIGÈNES

BOCCARA E. et J., Souk des Femmes, 35, Tunis.
Tapis anciens et modernes.
 — de Tunisie.
 — de Turquie.
 — d'Algérie.
 — de tous les pays d'Orient.
Broderies, Soieries, Faïences, Bronzes, Meubles, Bijoux, Armes,
 Objets d'Art.

Les Fils de J. CHEMLA, Route du Barb, Tunis.
 2 Poteries (genre ancien).

KALLAL-EL-KEDINE, P. de Verclos et Faure Miller, Nabeul (Tunisie).
 Poteries artistiques reproduisant l'art ancien (13 pièces).

SEYRIG (Mme), Rue des Andaloux, 35, Tunis.
 Adaptation de la dentelle arabe à l'ameublement moderne
 (*d'après de vieux dessins*).

TISSIER Louis, Nabeul (Tunisie).
 Poteries artistiques (6 pièces).

Figure 3: Catalogue of the Salon tunisien of 1923.

As evident in his creation of the category *arts décoratifs indigènes*, Fichet appears to have used the salon forum to pose questions about the imposition of European hierarchies onto Tunisian artistic production, an institutional reality experienced and negotiated by an expanding number of Tunisian artists such as Turki, Ben Salem, Chemla, and Bellagha. Excerpts from his speeches and designs point to his level of engagement with the subject. For instance, Fichet's design for the cover of the 1920 Salon tunisien catalogue not only demonstrates his long-standing interest in *décoration*, but also locates it in the Tunisian environment (Figure 4). In this design, Fichet assembled an array of *objets d'art* to create an image of an interior scene in the coastal village of Sidi Bou Saïd to the north of Tunis. In the foreground of the composition, two objects balance on the top of a stool: a ceramic vessel filled with plants and a female bust, reminiscent of the portrait bust to be photographed in the courtyard of the Centre d'enseignement d'art (Figure 1). On the wall hang three framed paintings that appear to be landscapes and an unidentifiable oval object. To the left of these hangings is a circular stained-glass window looking out onto the rooftops of Sidi Bou Saïd, replete with mosque, domed structures, and the iconic mountain known as Bou Kornine. Floral sconces, striped walls, and rectangular objects placed on the floor, themselves decorated with curvilinear compositions, add movement and vitality to the cover's design.

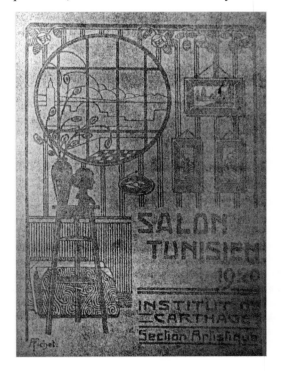

Figure 4: Cover design by Alexandre Fichet for the catalogue of the Salon tunisien of 1920.

Given his training in Paris and his decorative commissions and designs
in Tunis, Fichet's emphasis on the decorative domain, at least from a
hegemonic French position, is quite clear. But from the onset, Fichet appears
to have grappled with the segregation of the decorative arts according to
race, religion, and nationality, which he may have found troubling given
the extent of known European-Tunisian collaborations during this period
(such as that between Blondel and Chemla), as well as long-standing cross-
influences in the production of both categories of decorative arts. He began
to dissolve the distinction, first combining the terms in a single phrase,
"indigenous decorative arts," in a speech for the fifteenth Salon tunisien
in 1913.[23] He repeated it in written correspondence. In his request for
reinstating the salon's precarious funding after World War I, Fichet wrote
sympathetically that the Salon tunisien in 1919 was to be "a supportive
environment for local decorative arts, whose special character offers so
much originality."[24] In 1927, he finally ended the division and applied the
term "decorative arts" to all works in this genre, a labelling practice that
continued throughout his tenure as president. For example, in the Salon
tunisien of 1953, artists of various cultural and artistic backgrounds,
André Chemla, Jellal Ben Abdallah, Ray Langelot Elot, and Antoine
Galia, exhibited ceramics, screens, tables, and mosaics together as *les arts
décoratifs*.[25]

With the birth of the Tunisian nationalist movement in the 1920s, the
Salon tunisien's inclusion of Tunisian Muslim and Jewish artists, whether
they exhibited easel paintings or "indigenous decorative arts," constituted
a political act countered by the Résidence (the seat of French government
in Tunisia) through the creation of a well-funded rival salon, the Salon des
artistes tunisiens, in 1924. Presided over by artist André Delacroix, this
salon rejected "all forms of artistic extravagance." It was more closely
aligned with exclusionary exhibition practices found in Algiers, more or
less refusing entry to artists of Muslim and Jewish origin, and exhibiting
academic-style paintings of French artists residing in Tunisia or from the
métropole, "*les Français de France*".[26] The Salon des artistes tunisiens
also denied entry to any artist who chose to exhibit in the Salon tunisien,

23 World War I halted the Salon tunisien. See Fichet's handwritten correspondances. Ar-
 chives nationales de France: F/21/4745. Revue Tunisienne XX (1913): 266.
24 Archives nationales de France: F/21/4745.
25 *Catalogue of the Salon Tunisien 1953*. Beït el Bennani; Interview with André Chemla,
 Paris 2015.
26 Interview with Patrick Abéasis, Paris, 2016. Records mentioning the Salon des artistes
 tunisiens may be found in the Archives nationales de Tunisie and the Archives nation-
 ales de France.

whose funding was withdrawn for two years. This rival salon sought to reinforce France's superiority in the realm of fine art and culture, as an emergent nationalism threatened its political and cultural hegemony. The termination of the Salon des artistes tunisiens occurred in 1934 following Delacroix's death.

Furthermore, in 1933, the colonial government established the Office des arts indigènes in order to study, document, collect, and control Tunisian artistic production across the country. Directed by Jacques Revault, a French ethnographer-administrator and the former *sous-inspecteur des arts indigènes* in Morocco, the office opened regional branches and forged connections with "artisans" working in a variety of media. Revault, highly impressed with the range and quality of women's historical textile production, centred on women's fibre arts in his initiatives to revive industries increasingly framed by authorities as "ossified" and "dying." The figure of the Muslim woman weaver soon became synonymous with the artisanat, contributing to its feminized status and deepening the gendered association over time as large numbers of women joined these initiatives. Although Revault contracted beaux-arts students and graduates to conduct ethnographic research for the office, and artists such as Ali Ben Salem contributed drawings of "traditional arts" to its documentation programme, the delineation between "fine" art and "indigenous" art hardened on an institutional level that extended far beyond the reaches of the Salon tunisien and created anew the necessity to rework artistic concepts and categories. While art institutions officially adopted different terminology because of the negative, colonial connotation of the word *indigène* (in the later 1930s the Office des arts indigènes changed its name to the Office des arts tunisiens), the concept *indigènes* did not drop out of colloquial usage but was increasingly replaced by "artisanal."

As this section has illustrated, Fichet, as the salon's first long-term president, engaged with the problem posed by the decorative arts in a predominantly Arab Muslim country from 1913, as well as expanding the salon's denotation of "artist" to include Tunisian Muslim and Jewish painters. He thereby helped to create a venue for the emergence of Tunisian modernism in the salons, firstly through his inclusion of Tunisian painters, and secondly by slowly dissolving the separation of European decorative arts from "indigenous" industry even as other institutions arose that were dependent on their separation. He, along with figures such as Blondel, thus anticipated the burgeoning practices of modernists like Bellagha, who devoted himself to reviving Tunisian artisanal traditions through fastidious research on "traditional" objects, collecting Tunisian and "Islamic" art

forms for study, and collaborating with artisans to create modern designs using historically rooted materials and genres. Fichet first sought to overcome persistent divisions between fine and decorative art and artisanal production three decades before Bellagha and the "Tunisian École", a loose grouping of artists, artisans, and art students, probed this interface.[27] However, despite Fichet's contentions with the institutionalization of such differentiations and his attempts to transcend them, aesthetic deliberation about the overarching concept of the "indigenous decorative arts," and its powerful charge, only heightened during the late nationalist and early postcolonial period.

Critical Forays at Mid-century: Gender and the decorative

World War II brought artistic production, salons, and exhibitions to a standstill, but intensive bombing created the need for reconstruction and architectural decoration. In the wake of a massive reconstruction and development programme in the late 1940s and early 1950s, leading artists of the Salon tunisien received decorative commissions for new buildings as mandated by the "One Per Cent Law" of 1950.[28] While teams such as Elie Blondel and Jacob Chemla had attempted to forge such patronage networks in the early twentieth century, the One Per Cent Law assured an unprecedented number of artistic commissions. Fichet oversaw the selection of artists, along with two artists who exhibited regularly in the Salon tunisien, Pierre Boucherle and Jellal Ben Abdallah. Boucherle, a Tunis-born French artist and the inaugural winner of the salon's travel scholarship, had organized various artists' groups and initiatives in the 1930s and 1940s, culminating in his founding of the group the École de Tunis in 1948. Ben Abdallah, a prominent Tunisian member of the École de Tunis, was among its artists who increasingly engaged with "artisanal" and "Islamic" art forms such as miniature painting and weaving. A third member of this committee, Pierre Berjole, was the new director of the École des beaux-arts with expertise in theatrical design and an interest in expanding the art school curriculum to emphasize *arts appliqués*. A fourth

27 Gerschultz, Jessica. *Decorative Arts of the Tunisian École: Fabrications of Modernism, Gender, and Power*. Refiguring Modernism. University Park, PA: Pennsylvania State University Press, forthcoming 2019.

28 Initiated under the French Protectorate in 1950 and reinstated by decree in 1962, the "One Per Cent Law" allocated one per cent of a civic building's construction budget to its decoration with artwork. As a result, artists created and installed monumental works throughout Tunisia between 1950 and 1978. See Boucherle, Pierre. "Le cinquantenaire du Salon Tunisien." *ARS* 265 (June 1950): 3.

de facto member, Jacques Revault, had established the institutional backing for "artisanal" production that Blondel and Chemla had lacked, as well as serving as the interim director of Tunis's École de beaux-arts between 1949 and 1950 before the arrival of Berjole. Building on concepts and networks rooted in the salons of the early twentieth century, teams of artists and artisans produced more than one hundred decorative programmes for government offices, schools, hotels, banks, and factories from 1950 under the One Per Cent Law, which granted new visibility and legitimacy to the "decorative" in public space.

At the same time, the wartime environment gave way to the struggle for independence, when aesthetic deliberations over the materials, processes, and content of Tunisian modernism gained momentum. Artistic networks emergent in the Salon tunisien decades earlier had flourished with the development of Tunis's art infrastructure as well as amid the shifting, heightened discourses about the role of the artist in society. The convergence of art with *tunisianité*, a concept of cultural specificity that anchored nationalist and development discourses, constituted a vital avenue of aesthetic inquiry, particularly for members of the École de Tunis as they designed and fabricated monumental works for architectural commissions following independence in 1956. Like Fichet, Ali Bellagha, a member of the École de Tunis trained in the École des beaux-arts in Paris, desired to unify "modern" art and the *artisanat d'art*, but within the broader nationalist-inflected discursive framework that linked art with social uplift. Before assuming the direction of the Salon tunisien in 1967, Bellagha grappled publicly with modernist issues of classification and relations of power, which he brought to the fore in his art gallery on the rue de Yougoslavie in Tunis. In 1960, Ali and artist Jacqueline Guilbert Bellagha, newly wed, opened a gallery called Les Métiers, also known as al-Ḥiraf, to showcase modern objects designed from historical models, many of which were executed by artisan-collaborators whom the Bellaghas commissioned to create pieces in materials such as wrought iron, silver, wood, stone, and embroidery. Ali Bellagha also experimented with ceramic production and sculptural objects, specifically rejecting painterly discourses and asserting the value of Tunisian craftsmanship (Figure 5). He, too, participated in the design of decorative programmes under the One Per Cent Law, furnishing Tunisian hotels with locally-inspired objects from Les Métiers. As exemplified by such endeavours, Bellagha joined many artists in collaborations with the burgeoning artisanal and tourism sectors, and even assumed entrepreneurial roles therein, which reinforced their ties to the ideological forces of postcolonial Tunisia.

Figure 5: Ali Bellagha, Les Métiers/al-Ḥiraf, c. 1960. Private archives of Jacqueline Guilbert Bellagha.

This era also saw the influx of Tunisian women artists into the Salon tunisien and other institutions such as the École des beaux-arts and the Office national de l'artisanat (formerly the Office des arts indigènes and the Office des arts tunisiens). The socio-psychological and creative transformation of the Tunisian woman formed the basis of societal progress for the country's new president, Habib Bourguiba. He positioned women's enfranchisement and autonomy as central to the struggle against underdevelopment, and he selectively adapted colonial terminology to describe his vision for societal evolution. The Bourguibists strove to cultivate Muslim women through legislation and a broad and rigorous programme of state feminism that drew heavily on the arts. Visual arts practices provided a metaphor for the wider world in which the young woman should not passively inhabit, but rather shape and define. As I have argued, artist Safia Farhat stood at the nexus of these transformations.[29] The sole woman to join the École de Tunis in 1960, Farhat was a professor at the École des beaux-arts before becoming the school's first Tunisian director in 1966. She addressed

[29] Gerschultz, Jessica. "The Interwoven Ideologies of Art and Artisanal Education in Post-colonial Tunis." *Critical Interventions: Journal of African Art History and Visual Culture* 8:1 (2014): 31-51. Gerschultz, *Decorative Arts of the Tunisian École*.

Bourguibist concerns by training art students for careers in the artisanal, tourism, and textile industries. This partnership substantiated the view held by the administrative elite and their visiting European consultants that the artisanat was a "civilizing discipline" that could mould the traditional labourer, symbolized by the woman artisan, into the "modern" citizen. The operative concept here was that "fine artists" were more highly evolved than artisans socially, intellectually, and spiritually, but that artists and artisans should collaborate for the social advancement of the latter. While Tunis's art scene and its institutions displayed continuities after independence rather than experiencing a clear rupture, the implementation of Bourguibist state feminism from 1959 placed new emphasis on the question of women's creativity, autonomy, and societal elevation, articulated through the practice of the "decorative" arts, specifically weaving, in a transformed social and political context.

Women in Tunisian Salons

The salon venue facilitated young women's public recognition in this charged and dynamic environment. Elite women students of the École des beaux-arts, many of whom had studied decorative arts and design under Safia Farhat, increasingly contributed to the Salon tunisien. They included Fela Kéfi, Halouma Karaoui, Saïda Besrour, and Nebiha Bahri. Kéfi, among the most prolific students from this period, won first prize in the 1964 Salon tunisien for her painted portrayal of female labourers harvesting olives. Moreover, she was the first artist featured in a series of articles appearing in the journal *Femme*, published by the National Union of Tunisian Women, which highlighted the perceived beneficial professional and socializing elements gained from participation in the Salon tunisien and other public events.[30] Notably, the author of these articles, Abdelmajid Tlatli, was also the director of the Galerie Municipale, where the Salon tunisien was held in the early 1950s. During this period, the École des beaux-arts held its own salon-style exhibitions in the Galerie Municipale, in which women played a visible, active role and received official approbation (Figure 6). Despite an official atmosphere that promoted women's liberty and creativity as fundamental to Tunisian modernity, pre-existing gender biases paradoxically steered women art students toward the decorative arts, especially weaving and ceramics.

30 Tlatli, Abdelmejid. "Femme et culture: Fella Kéfi, ou la passion de peindre." *Femme* 1 (1964): 36. I thank Féla Kéfi Leroux for sharing her photographs, press clippings, and memories of this period. Interviews with Féla Kéfi Leroux, Paris and Tunis 2016.

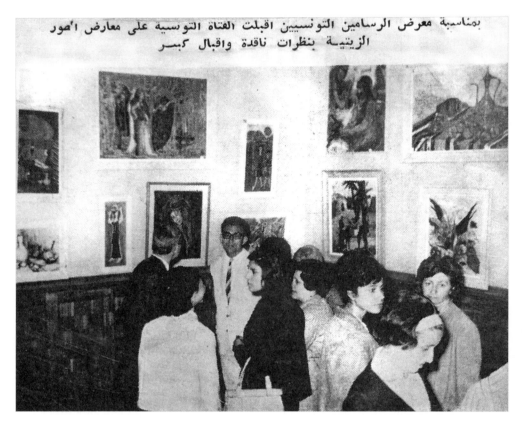

Figure 6: Exhibition of Tunisian women painters, early 1960s, Tunis. Private archives of
 Féla Kéfi Leroux.

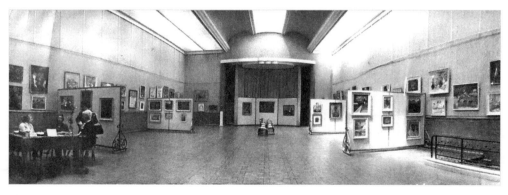

Figure 7: Galerie Municipale, Tunis, early 1960s. Private archives of Féla Kéfi Leroux.

A photograph from the early 1960s depicts the wide, well-lit space of
the Galerie Municipale, filled with paintings, while a group of unidentified
women clusters around a table (Figure 7). Painting, however, while largely
retaining its traditional dominance, was only one of several mediums on
display in such exhibitions. For example, in a student-led show in the
early 1960s, Féla Kéfi exhibited a full-size bar fabricated in wrought iron
and wood (Figure 8). On its bright white surface, she painted designs
playfully evoking women's jewellery and textile motifs, including a
stylized camel found on woollen tapestries from the southern city of
Gafsa. Behind the group of students admiring her work hung a group of
ceramic tile panels produced in the majority-female class of Professor
Abdelaziz Gorgi. In addition, numerous women-only exhibitions,
such as those sponsored by the Club national féminin, illuminated the
new administrative emphasis on female creativity and highlighted the
work of women students. Here, too, Kéfi earned first prize; upon her
graduation from Tunis's art school, she won an artist's residency at the
Cité internationale des arts, studied at the École des métiers d'art in Paris,
and pursued a career as a designer, representing a model path for other
women students.

Figure 8: Bar designed by Féla Kéfi, c. 1954. Wood, wrought iron and paint.
 Private archives of Féla Kéfi Leroux.

Salons dedicated to or directed by women similarly provided women artists with a space to explore various media and new artistic identities.[31] However, they faced mounting tensions over the direction of art among artists of various nationalities, particularly as some artists and critics rejected state patronage, the concept of a national Tunisian art, and "folkloric," feminized iconography in favour of art's perceived autonomy, a modernist myth that was rooted in constructions of masculinity. Léa Chapon, a Tunis-based artist, founded the Union féminine artistique et culturelle de Tunisie (UFAC) in 1948 with the dual goals of offering young women artists professional experience through salon participation, and generating support for women artists suffering from age or illness. Marie Goyer-Autray and Victoire Ravelonanosy, a Malagasy artist based in Tunis and member of the Salon tunisien, later co-organized this salon (Figure 9). While it relied heavily upon the artistic and literary production of European women in Tunis, by 1961, Jelila Mohsen, a graduate of the École des beaux-arts, served as Vice President. Significantly, Alexandre Fichet was a member of its jury, revealing his continual dominant presence in Tunisian artistic and cultural life and reflective of broader continuities in artistic personnel before and after independence. However, Fichet's eminence did not spare critics from writing such commentary as what an unidentified journalist penned for the Carnet des Arts in 1959,

> In this elegant assembly, we don't know exactly whether it is better to admire the coquetry and charm of the exhibiting artists or the works they have hung on the rails of the Galerie Municipale, with great taste, where we find the hand of a master.[32]

While the location of UFAC salons alternated between Tunis, Algiers, Vichy, Clermont Ferrand, Liège, and Brussels, in the postcolonial period the majority took place in France or Belgium.

[31] I consulted catalogues, press clippings, and photographs pertaining to UFAC and the Association des Artistes Peintres et Amateurs d'Art de Tunisie in the collection of Beït el Bennani in Tunis, the private archives of Ali Bellagha in Tunis, the private archives of Patrick Abéasis in Chabris, and the private archives of Jacqueline Guilbert in Paris.

[32] "Le Salon de L'U.F.A.C.: À la Galerie Municipale des Arts de Tunis du 3 au 18 avril 1959." *Carnet des Arts.* Press clipping in private archives of Patrick Abéasis.

Figure 9: Ali Bellagha, Victoire Ravelonanosy and Marie Goyer-Autray (Vice President of UFAC), at Bellagha's solo exhibition at the Dar al-Maaref in Tunis. Private archives of Jacqueline Guilbert Bellagha.

An active member of the Salon tunisien from the late 1940s, Victoire Ravelonanosy was instrumental in organizing new venues based on the salon model throughout the 1950s.[33] Like Bellagha, Ravelonanosy's long-standing engagement with the conceptualization of "indigenous decorative arts" spanned institutional settings, including Tunis salons, as well as motivating personal undertakings. Born in Madagascar and residing in Tunisia and France, Ravelonanosy was an artist, writer, organizer, and, toward the end of her life, a philanthropist who founded a museum of modern art in Antananarivo. In insisting on the visibility and validity of Malagasy art and the reframing of *arts indigènes*, she connected the decolonizing aspirations of Tunisian artists to those of artists located across the French empire through experimentations with the salon format. Shortly after her arrival in Tunis as the spouse of a military doctor, Ravelonanosy arranged an exhibition of Malagasy art forms: rosewood sculptures, basketry, embroidered textiles, and *lambas* (a genre of textile and garment ubiquitous in East Africa and the Indian Ocean world) for a promotional fair of the French empire in 1947 in

33 Unpublished memoire of Edmée Ravelonanosy with press clippings from the artist's private collection. Interview with Edmée Ravelonanosy, Paris, 2016.

Tunis. In this exhibition, she also displayed her own sculptural figures made from vanilla pods, embossed paper, and raffia fibre. Just as Ali Bellagha turned increasingly from painting to "artisanal" forms and materials in his practice in the early 1960s, Ravelonanosy undertook studies of *aloalos*, a form of Malagasy funerary art, to design murals and tapestries, as well as establishing an artistic practice in ceramics. Moreover, she sought to recuperate the historical arts of Madagascar and wrote extensively about Malagasy art, which she positively referred to as "decorative" in her writings and interviews.

In addition to playing a leadership role in UFAC, Ravelonanosy was the founding president of the Association des artistes peintres et amateurs d'art de Tunisie, which held its first salon-style exhibition in 1954 at the Tunis Automobile Club and staged itinerant exhibitions throughout Tunisia, including at Sfax, Sousse, Menzel Bourguiba (Ferryville), and El Kef, as well as travelling to Paris and Marseille.[34] Safia Farhat, too, assumed leadership positions in this organization, albeit for a short period. Like UFAC, this salon drew local and international participation. For example, the fourth annual exhibition in Tunis in 1957 featured male and female artists from Tunisia, Madagascar, and France. Moreover, the salons of the late 1950s reveal the consolidation of central figures in Tunis's salons and institutional life as well as their transnational networks. Ali Bellagha won the Grand Prix of 1958, while Ravelonanosy and Jacqueline Guilbert Bellagha received the 1958 Prix de Décoration. Invited artists in 1959 included pre-eminent South African artist Gérard Sekoto shortly before his permanent exile to France as the result of apartheid, while an essay on "Painting in Yugoslavia" served as the catalogue's main feature. However, while artists such as Ravelonanosy exhibited tapestry maquettes in its salons, artistic hierarchies remained in a state of constant renewal, with pressing questions over who held sway over power, patronage, and the ultimate purpose of art.

By the 1960s, the art world in Tunis had assumed new, gendered dimensions. Its discourses were shaped by the paradox of an official state feminism on the one hand, and on the other, the continuation of established biases in which hegemonic constructs of gender and race converged. At the École des beaux-arts in Tunis, attempts to "emancipate" Muslim women intersected with transnational art-historical paradigms designating suitable mediums for women. Furthermore, the feminization of the Office national de l'artisanat intensified as women joined its training programmes (80 per cent of its employees were women during this period), and existing

34 See "Rappel de Quelques Activités" in the Association des Artistes Peintres et Amateurs d'Art de Tunisie catalogue of its Exposition Internationale in 1959.

linkages between "decorative" arts, handicraft, and Muslim women crystallized. Meanwhile, critics of excessive state patronage and the tourism industry underlying the growth of what was called the *artisanat d'art* increasingly focused on the "universal" qualities of painting. Some artists, notably Bellagha, voluntarily assumed the title "artist-artisan" during this fraught period. While men had the resources and mobility to equate themselves with artisans at their discretion without forfeiting their privileged status, women artists, including Ravelonanosy and other participants in the various salons, were marginalized as female producers, rendered doubly suspect if working in a feminized, "artisanal," or "local" genre. The concept *décoratif* resurfaced as a denigrating term that could be used to qualify women's work, especially if the work involved "artisanal" materials or the motifs of "traditional" Muslim women. Women's salons and public engagement with the "decorative" faced additional scrutiny in this turbulent context.

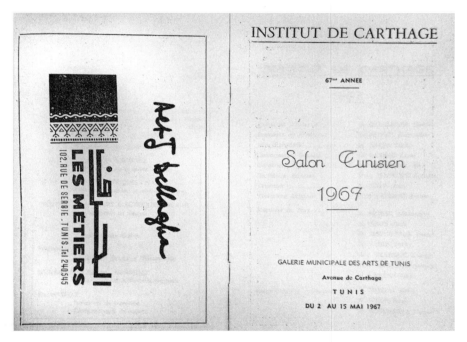

Figure 10: Catalogue of the Salon tunisien of 1967 with advertisements for Les Métiers/ al-Ḥiraf

By the time Bellagha became the first Tunisian president of the Salon tunisien in 1967, the salon exhibited an assortment of paintings, tapestries, and decorative objects. Women art students and graduates of the École des

beaux-arts created many of these works. Noticeably, Bellagha promoted his gallery Les Métiers at the Salon tunisien, publishing advertisements in the catalogues' front pages (Figure 10). Yet, despite his endorsement, stark divisions emerged anew over art's constitution and role. An emergent group of painters equated artistic renditions of *tunisianité*, such as the portrayal of artisans at work, with a feminized, folkloric art subservient to the state and the tourism industry it supported. In 1973, artist Néjib Belkhodja took the Salon tunisien by storm after he had already staged alternative exhibitions committed to the exploration of painting's universal language, including those of the Groupe des Six in 1964 and Groupe des Cinq in 1967.[35] While facilitating important debates concerning artistic categories, the Salon tunisien never fully eschewed wider art world discourses that rejected the decorative, with its connotations of femininity, superficiality, and racialized Otherness, as a mode of serious artistic inquiry.

[35] El Goulli, Sophie. "Du Nouveau Au Salon Tunisien: Néjib Belkhodja et Ridha Bet-taieb." *La Presse* 1967.

CHAPTER 3
THE AESTHETICS OF TASTE MAKING IN
(AND OUT OF) THE COLONIAL ALGERIAN SALON

NANCY DEMERDASH-FATEMI

On 9 March 1910, an anonymous review of the 12th Salon of the Société des artistes algériens et orientalistes (Society of Algerian and Orientalist Artists), published in the newspaper *Le Sémaphore algérien*, intoned outrage at foreign incursions of French works into the salon held in Algiers:

> The access to our exhibitions is made easy to foreign painters, displeasing many. It should not be forgotten that the artistic manifestations of the Society of Algerian and Orientalist Artists were originally created in favour of our artists alone in order to show their efforts and to obtain for them financial support for their work. For it was not until 1906 that the Committee of the Society had the evil idea of appealing to the painters of the Metropole. But in order to conceal the personal profit they hoped to withdraw, and that they had in fact obtained, from the invasion of our Salons, foreign works, those promoters of the project declared loudly that these consignments would be a lesson for our Algerian artists, that they would serve as models and stimulants, and finally that they would form the taste of the public![1]

These infiltrations undermined Algerian artists, the author exclaims. Paintings submitted by mostly Parisian artists – sub-par pieces deemed to be their "unsellable breadcrumbs" (*croûtes invendables*) – not only dominated the exhibition space, but in doing so, drastically drove down the sales and prices of Algerian artists' works to "dirt cheap" values (*à vil prix*).[2] With

[1] P. P. "Le XIIᵉ Salon de la Société des Artistes Algériens et Orientalistes," *Le Sémaphore algérien*, 9 March 1910, 1.

[2] P.P. "Le XIIᵉ Salon de la Société des Artistes Algériens et Orientalistes": "C'était plutôt malheureux et blessant, tant pour les Artistes de la Colonie que pour les Algériens. N'ayant à supporter aucune des charges pécuniaires imposées aux sociétaires algériens, en dehors de la retenue de dix pour cent faite sur le montant de toutes les

vociferous disdain, the author calls attention to Algeria's transformation into a "Promised Land" for artists of the metropole to showcase their work. It was this diminution of Algerian artists' originality and abilities by the Comité de la société des artistes algériens that impelled some artists' to defect from the larger society, forming their own Salon d'automne and Syndicat des peintres professionnels.[3]

On a superficial level, this may come across as no more than an intra-societal squabble. As a newspaper representing the maritime, commercial, industrial and agricultural interests of colonial Algeria, it is unsurprising, from an economic standpoint, that *Le Sémaphore algérien* would voice resistance to outside competition, especially from the aesthetic heavyweights of the French. But this newspaper clipping is revealing for a number of reasons, not least because it highlights settler colonists' awareness of their own cultural indoctrination and their admission that their tastes were, in fact, being actively shaped by metropolitan standards. Although the salon in Algeria was an institution of colonisation, it came to be colonised and overrun by French artists. At the time of this piece's publication in 1910, Algeria had been a colony for 80 years (since 1830) and its affairs had been subsumed under the French Ministry of Interior for 62 years (c. 1848). Algeria represents an anomaly in French colonial history, in that despite its contentious status as an occupied colony, the country was often conceived of in militaristic and governmental propaganda as an extension of metropolitan France. It was, like all French provinces, designated as a *département*.

ventes; assurés qu'une réclame inconsciente serait faite autour de leurs envois, au détri-
ment de leurs confrères de la Colonie, les peintres de la Métropole se hâtèrent de nous
envoyer tous leurs fonds d'atelier, leurs croûtes invendables en France. Et quelques gras
mécènes, ignorants, alléchés par les coups de tam-tam faits à l'arrivée de ces toiles, se
hâtèrent de se les disputer aux prix fort poussant leur inconscience jusqu'à se débar-
rasser à vil prix de tout ce qu'ils possédaient de nos peintres algériens."

3 P.P. "Le XIIᵉ Salon de la Société des Artistes Algériens et Orientalistes": "Du coup,
l'Algérie devint la 'Terre promise' tant recherchée où il suffisait aux artistes de se
présenter pour liquider avantageusement tout ce qu'ils avaient. Et c'est ainsi que l'on
vit à Alger, pour ne citer qu'un seul cas, en décembre dernier, durant la même quinzaine
onze expositions de tableaux, pour la majeure partie, composées d'œuvres d'artistes
parisiens! Il y eut certes des désillusions cruelles et elles serviront peut-être de leçons.
Les mécontentements n'avaient pas tardé à se manifester contre les projets imprévoy-
ants du Comité. De nombreux artistes algériens, et non des moindres, puisque membres
exposants de la 'Société Nationale des Beaux-Arts de Paris', froissés de l'outrecuidance
du Comité de la Société des Artistes Algériens qui prétendaient leur faire donner
des leçons par les peintres métropolitains, protestèrent hautement contre cette intru-
sion et, devant l'indifférence voulue du Comité, se retirèrent et organisèrent le 'Salon
d'Automne' et le 'Syndicat des Peintres Professionnels'. Chacun sait que nos artistes
les plus en vue et les plus aimés du public font partie de ce syndicat."

Apart from the economic consequences of colonisation for practising artists in Algeria, these micro-aggressions[4] were not only a political defiance against transparent forms of manipulation, but a bold illustration of the diversity and the ideological, even anti-colonial, factionalism inherent in the notion of the salon in Algeria. Although a fundamentally French institution, it would seem that some critics of the colonial Algerian salon sought to define Algerian artists' deviations as regionally divergent from a metropolitan norm, hence challenging the very standard against which tastes were constructed, cultivated and measured. In the framework of this paper, the broad term "Algerian artists" refers both to ethnically indigenous Algerian painters who rose to prominence, of which there were few (for reasons resulting from colonial power relations), and to pied-noir artists who either claimed Algeria as their *pays natal*, or were born in Europe but settled in Algeria. In such circumstances, one should be cognisant of the realities that segregated and elevated the work of some artists at the expense of others.

This chapter inquires into the historical transplantation and nature of the salon in French colonial Algeria. It reconsiders the power dynamics inherent in the development of the salon in a North African context, in particular as expressed in popular journals and newspapers such as *L'Afrique du Nord illustrée*, *L'Illustration algérienne, tunisienne et marocaine*, and *Les Annales Coloniales*, but also in the way that popular colonialist discourses on taste mediated between production and consumption, reception and collection. Of course, such a methodology has its shortcomings. Reconstructing a history of the Algerian salon from sources of obvious colonial extraction alone threatens to flatten the dynamics between actors, amid these institutions' emergence across the Maghreb, and inhibits our understanding of the broader picture. For a more nuanced and balanced approach, one would ideally consult sources in French or Arabic by contemporary artists and critics of an Algerian intelligentsia. However, the merits of French colonial archives and inventories do not lie just in their documentary functions that record how these art institutions formed, but in the self-evident manner that settler colonial publics and colonial subjects are imagined in it, and ultimately fashioned as well. Jill Beaulieu and Mary Roberts have sought to unpack such assumptions and unsettle canonical thinking that regards Orientalist visual culture as monolithic. Instead, they raise questions of counter-narratives, heterogeneity, and intersectionality

4 I am referring here to the double-edged micro-aggressions of the Society of Algerian and Orientalist Artists exhibiting and imposing metropolitan artists on Algerians, and the countering micro-aggression of critics openly denouncing the "invasion" of foreign artists.

that open up new modes for "interlocution [operating] through its varied semantic resonances of dialogue, response, and interruption."[5] The following discussion underscores these dialogical processes by which artistic taste is socially constructed through mechanisms of inclusion and exclusion in Algerian salons of the late nineteenth and early twentieth century, and their polemical – but also artificial – aspects.

"Le goût du vrai et du beau": Algerian taste formation

To visualise the artistic milieu in early twentieth-century Algeria, it is pertinent to first trace the Algerian salon's antecedents in France. In *fin-de-siècle* France, artists' societies represented the special interests and aesthetic agendas of movements. The institution that had most influence on the transplanting of the salon to Algiers was the Société des peintres orientalistes français, founded in Paris in 1893 by Léonce Bénédite (1859-1925), an art critic and curator for the Luxembourg Museum, and the French artist and Muslim convert Étienne Dinet (a.k.a. Nasreddine Dinet, 1861-1929). The Society's honorary presidents included the eminent Orientalists Jean-Léon Gérôme (1824-1904) and Jean-Joseph Benjamin-Constant (1845-1902).[6] It was modelled after the International Congress of Orientalists of 1873 – a body of philologists, archaeologists and early ethnographers – and founded on similar aims of discursive formation.[7] Roger Benjamin claims that the society functioned "like a visual propaganda-development wing of the Ministry of the Colonies, which helped fund its annual Salons," in light of its prodigious contributions to universal and colonial expositions in France.[8] The Society possessed formidable institutional heft within this network of colonial power relations.

While the bifurcation of *objets d'art* (fine art objects such as paintings and sculptures) and visual and material cultures of the *artisanat* (crafts or handicrafts) has a deep-rooted, but complex intellectual history in French art education, the establishment of sharp hierarchical differences between art and craft seems to have been a much murkier endeavour with regard to

5 Bealieau, Jill and Mary Roberts. "Orientalism's Interlocutors." In *Orientalism's Inter-locutors: Painting, Architecture and Photography.* Edited by Jill Bealieau and Mary Roberts. Durham, NC; London: Duke University Press 2002, 3.

6 Cazenave, Élisabeth. *Les artistes de l'Algérie: dictionnaire des peintres, sculpteurs, graveurs, 1830-1962.* Algiers: Éditions de l'Onde, Association Abd-el-Tif 2010, 31.

7 Benjamin, Roger. *Orientalist Aesthetics: Art, Colonialism, and French North Africa, 1880-1930.* Berkeley, CA; London: University of California Press 2003, 66. For dis-cussions on the political implications of discourse and knowledge production in British and French colonies of the Middle East, see Said, Edward. *Orientalism.* New York: Pantheon Books, 1978.

8 Benjamin. *Orientalist Aesthetics*, 7.

the artistic traditions of the Middle East and North Africa. Notably, 1893 witnessed a critical corollary in the "Exhibition of Muslim Art," the first general exhibition of Islamic arts in the Palais de l'Industrie on the Champs-Elysées, organised by amateurs and prominent curators and sponsored by the Société de topographie. According to one contemporary reviewer, curators had a double aim: to reunite and methodically present to the public "specimens of bygone industries", and to examine the possibility of rejuvenating the domestic artistic production vis-à-vis exposure to specifically Maghrebi art objects.[9] Out of approximately 2,500 objects, the exhibition placed emphasis on those from Algeria and Tunisia, such as Kabyle jewellery and ceramics or Tunisian embroideries, but it received criticism for its lack of a classificatory or organisational structure, as well as for its haphazard juxtaposition of noteworthy pieces amid less refined bric-a-brac.[10] Photographs of some of the exhibition galleries reveal a sumptuous ethnographic staging of mannequins dressed in an arresting array of contrasting patterns and materials, and a hodgepodge of disparate ethnic and cultural referents, including mannequins dressed as shahs, sheikhs, and sultans.

Nevertheless, as David Roxburgh reminds us, the collecting practices of private individuals and amateurs greatly fuelled France's imperial consciousness.[11] Collections of Islamic art objects put together by amateurs were viewed in a homosocial, male-dominated setting, and exclusivity was reinforced through the restriction of top-tier objects in circulation. It is harder to discern whether this inclusion of sub-par *objets* was a deliberate curatorial strategy, to tacitly inculcate connoisseurial judgments that would have the double effect of further deepening divisions and distinctions among these circles, as well as underlining a narrative of artisanal decline against works

9 Gaudefroy-Demombynes. "L'Exposition d'Art Musulman au Palais de l'Industrie." M. Ludovic Drapeyron (ed.), *Revue de Géographie*, vol. 33 (Juillet-Décembre 1893), 473-474: "Les organisateurs de cette dernière exposition, d'après la notice que M. Georges Marye a mise en tête du catalogue, avaient un double but: d'une part, réunir et présenter méthodiquement au public pour son instruction des 'spécimens des industries disparues', et secondement, permettre 'l'examen de la possibilité d'amener une renaissance des arts, dont les deux grandes provinces musulmanes soumises à la domination de la France doivent bénéficier.'"

10 Gaudefroy-Demombynes, "L'Exposition d'Art Musulman au Palais de l'Industrie," 474: "Des raisons d'ordre pécuniaire empêchent sans doute de faire aux organisateurs de l'exposition un grief d'y avoir introduit la réclame envahissante d'un magasin de nouveautés, qui a exhibé, avec le prix, quelques belles pièces parmi beaucoup d'insignifiantes. Mais était-il nécessaire de n'apporter aucune méthode au classement des objets exposés? Voici une inscription maghrébine perdue parmi des tapis persans dans une salle où, d'ailleurs, des arrangements savants interceptent la moitié jour."

11 Roxburgh, David J. "Au Bonheur des Amateurs: Collecting and Exhibiting Islamic Art, ca. 1880-1910." *Ars Orientalis*, 30 (2000): 9-38; 16-17.

representing the former halcyon days of Islamic artisanship.[12] Along with increasing demand for Middle Eastern and North African visual and material culture, the parallel renewal of Orientalist art heightened the lust for colonial expansionism,[13] which for Bénédite and others, strengthened their aspirations to embed the Orientalist genre and its subject matter into the canon of French painting. Beginning in February 1895, an annual salon of the Société des peintres orientalistes français elevated the society's public profile in Paris.

In Algeria, since the beginning of the French occupation in 1830 and subsequent settler colonisation, several arts organisations and societies grew out of the colonial administration's need for cultural reconnaissance and hegemony *in situ*. From 1854, a group of art lovers founded the Société des beaux-arts d'Alger (Society of Fine Arts in Algiers), holding artworks that would promote Algerians' acquisition of "true and beautiful taste" (*le goût du vrai et du beau*).[14] By 1908, the first, small Musée municipal des beaux-arts d'Alger (put together by Mayor Frédéric Altairac and Léonce Bénédite) opened its doors, displaying works by local artists and by their French counterparts (shipments were sent on loan from the Musée du Louvre);[15] this museum would later become the Musée national des beaux-arts in 1930, directed by Jean Alazard. This national museum's catalogue, and presumably the walls of its galleries, featured artworks by notable French Orientalists like Eugène Delacroix (1798-1863), Jean-Étienne Liotard (1702-1789), and Alfred Dehodencq (1822-1882), pastoral pieces by artists of the Barbizon school such as Jean-François Millet (1814-1875), or realists like Gustave Courbet (1819-1877), Impressionist works by Pierre-Auguste Renoir (1841-1919), and modern sculpture by Auguste Rodin (1840-1917). The Algerian cities of Oran, Philippeville, and Constantine all came to possess their own departments for cultural and indigenous affairs, and art museums as well, although the bulk of displays were dominated by Roman archaeological artifacts, no doubt a pronouncement of France's inheritance of ancient Rome's legacy in Algeria. It is notable that within these museums and institutions across Algeria no prominence was given to objects categorised as *art musulman* that had been so lauded at the 1893 "Exposition d'art musulman." In the realm of arts instruction, and initiated by the Society of Fine Arts in Algiers, the first institution established was the École de dessin

12 Roxburgh. "Au Bonheur des Amateurs," 14.

13 Benjamin, *Orientalist Aesthetics*, 61. Benjamin notes Bénédite thought that the craving for or lure of the exotic motivated artists to travel.

14 Cazenave, *Les artistes de l'Algérie*, 41 : "La Société devient elle-même propriétaire de nombreuses œuvres d'art qui viennent compléter cette première collection, destinée à éveiller et à développer chez les Algériens 'le goût du vrai et du beau.'"

15 Cazenave, *Les artistes de l'Algérie*, 44. Even a Société des amis du musée was created in January 1923 modelled on the Louvre's.

(School of Drawing) in 1843 (later known as the École municipale de dessin in 1848). It was led initially by Jean-Baptiste Bransoulié (1817-1890), and then taken over by the Barbizon painter, Émile Labbé (1820-1885).[16] However, the institution with by far the most lasting impact upon artistic production in Algeria was the Société des artistes algériens et orientalistes, whose artistic stance precluded exhibiting those works representative of indigenous material cultures because of their subsequent categorisation as *artisanat* (craft) and not art.

The annual salon of the Société des artistes algériens et orientalistes, founded in 1897, just two years after its French parent, served as the primary platform through which Orientalist themes in painting were exhibited, judged, prized, and promulgated. It was the largest in terms of the number of works represented, and the most widely attended and publicised by amateurs and collectors alike. In their quest for an Orientalist revival, Bénédite and Charles Jonnart, the Governor General of Algeria, founded the Prix Abd-el-Tif, which, being based on the famed Prix de Rome, organised the *concours* (competition), structured the jury and supported the residence of metropolitan painters in Algiers.[17] The Prix Abd-el-Tif, named for the Villa Abd-el-Tif – a restored eighteenth-century Ottoman courtyard house, sometimes referred to as the "Villa Medici of Algiers" – sponsored the recipients of these travelling scholarships. As part of the Society's propagandistic mission, the salon facilitated the buying and selling of pieces that would be "dispersed in many African homes" and would "maintain a robust confidence in the artistic future" of Algeria.[18]

But other salons existed that were motivated by different artistic agendas, such as the Salon de la photographie (established 1934, initiated by the Photo-Club d'Alger) and the Salon d'hiver, organised by the Syndicat professionnel des artistes algériens. These salons had a dual function as places to feature up-and-coming artists and as spaces for the mingling of elite

16 Cazenave, *Les artistes de l'Algérie*, 289. Labbé was the student of Rousseau and Diaz and worked in the atelier of Cabot in Paris. "L'institution compte d'excellents professeurs: le sculpteur Fulconis (anatomie); Marquette (architecture et perspective); Brunet (mathématiques); Armand (dessin, ronde-bosse et ornement); Rousselet (dessin élémentaire); de la Blanchère (histoire de l'art, archéologie); Godard (travaux pratiques) et Hippolytes Dubois (peinture)."

17 Juilliard Beaucan, Colette. "Abd el Tif, la villa Médicis d'Alger," *Les Cahiers de l'Orient* vol. 1, no. 89 (2008): 141-148; 142.

18 "Le vernissage du Salon de 1930," *L'Afrique du Nord Illustrée: journal hebdomadaire d'actualités nord africaines: Algérie, Tunisie, Maroc* (1 March 1930), 5. "Puissent toutes les œuvres qu'il renferme se disperser dans de nombreux foyers africains pour les embellir de leur lumière, de leur beauté et y entretenir une robuste confiance dans l'avenir artistique de notre pays."

Algerians (e.g. ethnically and religiously diverse mercantilist communities, landowners, etc.), pieds-noirs, and non-Algerians (e.g. Italians, Armenians, etc.). However, because these alternative salons did not represent the hegemonic cultural platform of the colonial establishment, contemporary media coverage of their activities is barely discussed in archival sources.

Taste Making in the Algerian Salon: Exceptionalism, exclusionism, and the évolué

The salon of the Société des artistes algériens et orientalistes played a significant role as a discursive, albeit homosocial, space where the artistic trends and vogues of the metropole could steer and define aesthetic shifts in the colony. A photograph featured on the front page of an issue of *L'Afrique du Nord Illustrée* (from 9 February 1908) shows the judges – French artists who had lived in Algiers for some time (Herzig, Brunot, Mulot, Quirot, Noailly, Fourquet, Rochegrosse, Fritz Muller, Rouanet, and Reynaud) – huddled together assessing the various submissions to the 10th Salon of the Society of Algerian and Orientalist Artists (Figure 1).

Figure 1: "Le Jury du X^e Salon examine les toiles soumise à son verdict; De gauche à droite: MM. Herzig, Brunot, Mulot, Quirot, Noailly, Fourquet, Rochegrosse, Fritz Muller, Rouanet, Reynaud," *L'Afrique du Nord Illustrée* (8 February 1908), BnF.

One conspicuous art critic, Raoul d'Artenac, consistently praised the judgements of the society's salons for their contribution to public art education. In one editorial review of the Society's 10th Salon, he asked some fundamental questions around which the entries in this volume revolve:

> What, in short, is a 'salon' with all of the various sanctions it entails? Is it an open exhibition for all or is it a selection of beautiful and strong, meaningful and meritorious works? Can any canvas with paint be admitted on any condition? Or should this admission constitute an approval given by recognized authorities and grant a value to the work received?[19]

Within the context of the salon, d'Artenac affirms that "the Society promotes the artist's prospective purchaser" and that, based on the sales prompted by the discriminatory judgements of the juries, "the successful painting immediately receives a stamp of value."[20] He continues,

> a 'salon' must therefore propose to work carefully to form the taste of the public, to show what is necessary to love, what is preferable, to submit to them the chosen documents so that their judgement is informed and that an enlightened affection for the work of art will flourish within themselves. Any 'salon' which would not be inspired by this double aim would become useless; I would even say a dangerous thing, because it would serve the artists, deceive the public and compromise the urgent and passionate cause of the artistic education of the Algerian people.[21]

19 D'Artenac, Raoul. "Le X^e Salon des Artistes Algériens et Orientalistes," *L'Afrique du Nord Illustrée : journal hebdomadaire d'actualités nord africaines : Algérie, Tunisie, Maroc* (8 février 1908), 2-3: "Qu'est-ce, en somme, qu'un 'Salon' avec toutes les sanctions diverses qu'il comporte ? Est-ce une exposition ouverte à tout venant ou bien est-ce une sélection d'œuvres belles et fortes, significatives et méritoires ? L'admission est-elle due sans conditions à toute toile couverte de couleurs ? Ou cette admission doit-elle constituer une approbation donnée par des autorités reconnues et octroyer une valeur à l'œuvre reçue ?."

20 D'Artenac, "Le X^e Salon des Artistes Algériens et Orientalistes": "En fournissant aux artistes l'occasion, conforme à leur juste désir de notoriété, de produire leurs œuvres dans un cadre élégant et approprié où le public viendra les apprécier, où les amateurs pourront les acquérir, la Société favorise la rencontre du peintre et de l'acheteur éventuel. Mais le tableau admis reçoit tout de suite une estampille de valeur. L'idée de jury implique un choix : l'idée de choix donne un prix à l'œuvre choisie."

21 D'Artenac, "Le X^e Salon des Artistes Algériens et Orientalistes": "Un 'Salon' doit donc se proposer de travailler avec soin à former le goût du public, à lui montrer ce qu'il faut aimer, ce qu'il faut préférer, à lui soumettre des documents choisis pour que son jugement se renseigne et que fleurisse en lui une affection éclairée pour l'œuvre d'art. Tout 'Salon' qui ne s'inspirerait pas de ce double but, deviendrait une chose inutile ; je dirais

Juries of the salon wielded considerable power in setting the value of an artwork,[22] and its conformity (or lack thereof) with an appropriate concept of 'taste.'

Embedded in terms like *goût* and *bon goût* – which appear throughout periodicals, newspapers, and journals – lies an assertion of the self-evidentiary properties of this knowledge. In other words, good taste seems to be a natural proclivity. In spite of the ubiquity of these terms, the tempting assumption that taste was accepted in generalised or universalised ways must be resisted. Yet, what was the meaning and value of these criteria for 'taste' and how did their usage inform the selection of artists, the formation of exhibitions, and the institution of the salon in Algeria? From Pierre Bourdieu's pioneering studies into status, symbolic capital and the political construction of taste, we understand that taste is in fact very much socially determined by dominant, hierarchical groupings.[23] The value of art is situated and framed by who judges it. Aesthetic consensus is grounded in social and institutional conditions, and cultural taste is entangled in networks of social, cultural and political power, in colonial settings and elsewhere. Its construction occurs and is validated communally.[24] Bourdieu demonstrates how the new bourgeoisie exercised its conspicuous consumption.[25] He reminds us of the performative dimensions of taste-making,

même une chose dangereuse, parce qu'elle desservirait les artistes, tromperait le public et compromettrait la cause si urgente et si passionnante de l'instruction artistique du peuple algérien."

22 Appadurai, Arjun. "Introduction: Commodities and the Politics of Value." In *The Social Life of Things: Commodities in Cultural Perspective*. Edited by Arjun Appadurai. Cambridge: Cambridge University Press 1986, 3-63; 30. Appadurai demonstrates how issues of taste are ensnared in the politics of value.

23 Bourdieu, Pierre. *Distinction: A Social Critique of the Judgement of Taste*. Translated by Richard Nice. Cambridge, MA: Harvard University Press 1996 [1984], 41. This runs counter to the Kantian notion in which such judgements are disinterested, or based purely on the provocation of delight or displeasure in the viewer. Bourdieu says, "In order to apprehend what makes the specificity of aesthetic judgement, Kant ingeniously distinguished 'that which pleases' from 'that which gratifies,' and, more generally, strove to separate 'disinterestedness,' the sole guarantee of the specifically aesthetic quality of contemplation, from 'the interest of the senses,' which defines 'the agreeable,' and from 'the interest of Reason,' which defines 'the Good.'"

24 Woodward, Ian and Michael Emmison. "From Aesthetic Principles to Collective Sentiments: the Logics of Everyday Judgements of Taste." *Poetics* 29 (2001): 295-316; 297.

25 Bourdieu, *Distinction*, 310-311: "The new bourgeoisie is the initiator of the ethical retooling required by the new economy from which it draws its power and profits, whose functioning depends as much on the production of needs and consumers as on the production of goods. The new logic of the economy rejects the ascetic ethic of production and accumulation, based on abstinence, sobriety, saving and calculation, in favor of hedonistic morality of consumption, based on credit, spending and enjoyment. This economy demands a social world which judges people by their capacity for consumption, their 'standard of living,' their life-style, as much as by their capacity for production. It finds ardent spokesmen

its staged enactment, its simultaneous assertion and persuasion. He explains that the legitimacy of the 'taste-maker' rests in their performance of choice, and the presupposed value of that choice imposes itself onto the audience:

> The manner which designates the infallible taste of the 'taste-maker' and exposes the uncertain tastes of the possessors of an 'ill-gotten' culture is so important, in all markets and especially in the market which decides the value of literary and artistic works, only because choices always owe part of their value to the value of the chooser, and because, to a large extent, this value makes itself known and recognized through the manner of choosing. What is learnt through immersion in a world in which legitimate culture is as natural as the air one breathes is a sense of the legitimate choice so sure of itself that it convinces by the sheer manner of the performance, like a successful bluff. It is not only a sense of the right area to invest in, directors rather than actors, the avant-garde more than the classical or, which amounts to the same thing, a sense of the right moment to invest or disinvest, to move into other fields, when the gains of distinction become too uncertain. It is, ultimately, the self-assurance, confidence, arrogance, which, normally being the monopoly of the individuals most assured of profit from their investments, has every likelihood – in a world in which everything is matter of belief – of imposing the absolute legitimacy, and therefore the maximum profitability, of their investments.[26]

In a settler colony like Algeria, the colonisation of taste necessitated its standardisation,[27] which was far from stable in the early twentieth century, but that task was precisely the purview of the salon. In the salon, taste was enacted and publicly performed. The salon served as the intermediary space where aesthetics met business. The reception and consumption of objects and art works was dialectically shaped in relation to patterns of production, but continually re-moulded according to social tensions, refusals, and

in the new bourgeoisie of the vendors of symbolic goods and services, the directors and executives of firms in tourism and journalism, publishing and the cinema, fashion and advertising, decoration and property development. Through their slyly imperative advice and the example of their consciously 'model' lifestyle, the new taste-makers propose a morality which boils down to an art of consuming, spending and enjoying."

[26] Bourdieu, *Distinction*, 91-92.

[27] Brower Stahl, Ann. "Colonial Entanglements and the Practices of Taste: An Alternative to Logocentric Approaches." *American Anthropologist* 104/3 (2002): 827-845; 830. Stahl cites research from the consumer cultures of the American Revolution and the shifting semiotic meanings of certain commodities and objects. "... mundane items of household economies took on a new symbolic function as they became politicized; tea became a 'badge of slavery' and homespun cloth a symbol of resistance."

constraints. It was the socially reproduced 'distinction' of the salon that reinscribed patterns of aesthetic and racial prejudice across colonial Algeria.

The most mainstream and widely publicised Algerian salons were governed and predicated on these exclusionary, discriminatory premises. The didactic ramifications of the salon, in educating a class of settler colonists and expecting Algerian fine artists to conform to French metropolitan concepts of taste, was tied to the French *mission civilisatrice* and the Social Darwinian rhetoric of evolution and the *évolué*,[28] the exemplary native who has evolved from his or her depraved state. The Algerian painter Mammeri Azouaou (1892-1954) represents the "successful" development of the *indigène*. In response to a salon in Oran, in 1921, one reviewer wrote that "M. Mammeri is indigenous, and he demonstrates how, against all appearances to the contrary, it is that the Arab people can evolve."[29] Despite Mammeri's supposedly "evolved" state, his visibility at salons remained rather limited. Muhammad Racim, the Algerian miniaturist known for his paintings that build on Persian traditions of manuscript illumination, received far more coverage in the press, but was nevertheless considered a "copyist" by French critics and deprived of the title of "artist" in his own right. Racim's placement with the Cabinet de dessin (Division of Drawing) and continual exhibiting within the category of drawing further delegitimised his credibility as a "creator," Indeed, within the hierarchies of the Society of Algerian and Orientalist Artists, drawing occupied the lowest rung.[30] Pied-noir artists like Eugène Deshayes (1862-1939) and Emile Aubry (1880-1964), born in Algiers and Sétif respectively, had access to a host of privileges and cultural capital (e.g. both had comparable pedigrees, having studied in the École nationale des beaux-arts in the atelier of Gérôme) that was withheld from Muslim artists like Racim and Mammeri. It would appear that ethnic and religious discriminatory mechanisms filtered out aspiring indigenous artists who sought access and acclaim beyond their designated station in colonial society.

In as much as salons functioned didactically to "teach" preferred aesthetic dispositions, no matter how complex or sophisticated the worldviews of figures like Racim and Mammeri were, their exclusion from these major salons persisted. But it is important to recognise that these omissions resulted

28 Ross, Kristin. "Starting Afresh: Hygiene and Modernization in Postwar France." October 67 (1994): 22-57; 27-28.

29 R. M. "À Oran, Le Salon des Orientalistes," *La Méditerranée Illustrée (Anciennement L'Afrique du Nord Illustrée: journal hebdomadaire d'actualités nord africaines: Algérie, Tunisie, Maroc),* 28 May 1921, 12.

30 Orif, Mustapha. "De l''art indigène' à l'art algérien." *Actes de la recherche en science sociales* 75 (1988): 35-49; 36-37.

from a combination of political acts ranging from systemic rejections to self-removal/defections by the artists themselves. D'Artenac, in his critique of the 11th Salon of 1909, complains not simply of an absence of Algerian artists on view, but a lack of cohesion and unity among the artistic, stylistic, and political factions:

> We do not yet have Algerian art, local art which has its sources here ... its own genius. Painters stand far from each other, in hostile and selfish attitude of relentless commercial competitors ... They seem to agree with the friend who defined the work of art: a commodity. But they do themselves wrong and harm themselves by not seeking to unite a little more and prefer small rivalries of people to the bases that would give us an Algerian school of original orientalists. We have an official School of Fine Arts, noisy Academies of Painting, Courses, Artistic Societies. Where in the XIth Salon are the works that have emerged from these laborious hives and nurseries of young talent? Where is the new work of Cauvy, a former resident of the Villa Medici of Algiers?[31]

In a seeming response to d'Artenac's plea for a consolidated aesthetic philosophy in the colony, by 1923, an "École d'Algérie" was declared by Robert Migot, who was yet another critic writing for *L'Afrique du Nord Illustrée*. Migot pooled together the profiles of an arbitrary conglomeration of artists who share an "air de famille" on the basis of their similar treatment of atmosphere, light, and sky, all "under the influence of the African soil."[32] Yet, the novelty and coherence of this École was nonetheless predicated on contrivance. Racim stands out as the sole autochthonous Algerian amongst seven French artists, two pied-noir artists, and one Italian as constituting this so-called "École d'Algérie," [including Georges Rochegrosse (1859-1938), Alphonse-Étienne Dinet (1861-1929), Maxime Noiré (1861-1927), Eugène Deshayes (1862-1939), Marius Reynaud (1860-1935), Emile Aubry (1880-1964), Alexandre Rigotard (1871-1944), Alphonse Birck (1859-1942), Paul Simoni (?-?), and Emile Deckers (1885-?)]. With the exception of Racim, these artists had previously been grouped together in a telling set of caricatures published in *Illustration Algérienne, Tunisienne et Marocaine* (from 7 February 1907) (Figure 2). The art criticism of d'Artenac and Migot artificially gave rise to a colonial style

31 R. D'Artenac, "Le XIe Salon de la Société des Orientalistes." *L'Afrique du Nord Illustrée: journal hebdomadaire d'actualités nord africaines: Algérie, Tunisie, Maroc,* 6 February 1909, 8-11.

32 Migot, Robert. "Les Grands Peintres de l'Algérie," *L'Afrique du Nord Illustrée: journal hebdomadaire d'actualités nord africaines: Algérie, Tunisie, Maroc,* 24 March 1923.

by virtue of these otherwise arbitrary categorizations; the members of this fabricated "École" did not work collectively, nor did they share ideological or aesthetic preferences as such. Although these artists definitely moved in the same artistic circles, their unification as a cooperative "École d'Algérie" seems contrived. These political issues of representation, publicity, and aesthetic legitimacy continued well into the 1930s, with the formation of the Syndicat professionnel des artistes, peintres et sculpteurs algériens, who collectively sought to protect their interests on the market.[33] Taken together, these commentaries reflected a desire by local critics to formulate an aesthetic identity of the French Algerian colony rooted in its sense of place, which made it distinct from metropolitan standards.

Figure 2: "Au Salon Algérien, Silhouettes d'Exposants, par J. Guérin," *Illustration Algérienne, Tunisienne et Marocaine* (7 February 1907).

33 "Le Syndicat Professionnel des Artistes Peintres et Sculpteurs Algériens," *Alger Étudiant,* 27 avril 1935: "Nous saluons la naissance de ce nouveau syndicat, caractérisé par sa tendance professionnelle et corporative. Nous lui souhaitons longue vie et nous profitons de l'occasion pour féliciter MM. Bascoules, Bouviolle, Brouty, de Buzon, Carré, Casabonne, Halbout, Nicolaï, Racim, Segond-Weber, auxquels est plus particulièrement due une aussi heureuse initiative. Les artistes algériens avaient besoin, pour défendre ou protéger leurs intérêts, d'un semblable groupement, on pourrait même s'étonner de la tardiveté de sa création. Les étudiants ont eu le plaisir de prêter leur maison aux fondateurs, réunis en assemblée constitutive le 18 avril 1935, dans notre salle d'honneur. En nous priant de leur accorder l'hospitalité pendant quelques jours, nos peintres et sculpteurs savaient combien nous serions heureux de les abriter. Les artistes ont toujours été les amis des étudiants. Nous renouvelons donc nos vœux de prospérité au nouveau syndicat."

Conclusion

As in France, Algerian salons witnessed fierce competition and divisive schisms along political, ideological, and aesthetic fault lines. Art criticism published in early twentieth-century newspapers and illustrated journals pronounced that taste had to be cultivated in France's Algerian subjects, and that it had yet to evolve. Far from being natural, taste in colonial Algeria was to be socialised through the machinery of artistic societies, museums, and salons. Vasari's idea of the artistic genius was reserved for artists from the metropole, and certainly not attributed to pied-noir or indigenous fine artists, or to the indigenous artists of Kabyle or Islamic visual and material culture. Critics' persistent positioning of Algerian artists within developmentalist discourses served to bolster French claims of aesthetic superiority. The evolutionary framework in which this diverse range of artists of the colony was embedded only served to strengthen the notion that the aesthetics of the colony had not yet "arrived," that its growth was somehow stunted in its embryonic form. Moreover, the taxonomic epistemologies and nationalist, ethnic, and religious hierarchies of late nineteenth-century art criticism and the history of art not only precluded indigenous artistic practices, demoted to the status of artisanat, but could not wrestle with the complex creative junctures spawned by the colonial condition. As Bourdieu notes, taste-making stands as a performative act of artifice, and within Algerian salons this public staging of taste was intended to sway and shift popular opinion. Yet, regardless of salon or syndicate affiliation, all artists served a clientele constitutive of pied-noir households[34] or "Arabised French" and "Francophile Algerians."[35] But the promotion of Parisian artists and the racial, ethnic exclusionism endemic to these cultural spheres, nurtured in turn resistances that sought to challenge and, over time, overturn this constructed metropolitan hegemony.

34 Benjamin. *Orientalist Aesthetics*, 4.
35 Orif, Mustapha. "De l''art indigène' à l'art algérien." *Actes de la recherche en science sociales* 75 (1988): 35-49, 35.

PART II

EARLY SALONS AND THE POLITICS OF TASTE MAKING: EGYPT

CHAPTER 4
ARCHIVAL TESTIMONIES OF THE CAIRO SALON'S EARLY YEARS (1891-1904)

MARIA-MIRKA PALIOURA

The establishment of the Cairo Salon, an annual art exhibition, early in 1891 shaped the course of artistic production in Egypt. After 1805, when Egypt was first opened to the West by the Khedive Muhammad Ali (1769-1849), the increasing number of European artists – especially French and British who sojourned or resided in Egypt – had led to an extensive Orientalist pictorial production destined for the art shows of Europe. The Cairo Salon, however, could be considered an institution in its own right, as it was characterised by all those features that accompany an art salon: a selection committee, a permanent exhibition space, an annual function, appeal to a specific public, sales of works, articles of art criticism in the press. It became the template for organised exhibitions in Egypt, and also inaugurated systematic training in fine arts. This training was related to a series of drawing classes by European artists living in the country.

The documentation of the Cairo Salon, which came under khedival auspices shortly after its inception, is an interesting record of the presence and activity of European artists and the pervasive atmosphere of the colonial milieu. It also provides insight into Europe's cultural influence[1] and relations with its south-eastern neighbours. On a cultural level, the Salon was a unique event in that it was organised in a systematic fashion unprecedented in Egyptian society. Furthermore, it constituted a novel means of socialisation that favoured the integration of members of foreign communities residing in the Egyptian capital and, at the same time, allowed individuals from the Egyptian elite classes to participate.

The years of the Salon examined here (1891-1904) coincided with a transitional phase in the development of modern Egypt as a British

[1] Volait, Mercedes. *Fous du Caire, excentriques, architectes et amateurs d'art en Égypte (1867-1914)*. Apt: L'Archange minotaure, coll. L'âme du monde, 2009.

Protectorate (1882-1914).[2] Major Evelyn Baring (Lord Cromer), the first British Consul General and the highest-ranking British administrator in Egypt, poured scorn on the Egyptian people, stating in no uncertain terms that they could never "fully adopt British ways or achieve the levels of civilization that the British and other Europeans enjoyed."[3] In such a context, the new institution might have become a tool in Egyptian politics, given the anti-British attitude of the newly enthroned Khedive Abbas II of Egypt (1892-1914). Because the British achievements in assisting education were negligible,[4] Abbas II may have expected that art could emerge as a way of introducing Westernization.[5] The creation of such a tradition could be incorporated into a new narrative that would favour the forging of a national identity and add a new component in the struggle for Egyptian independence.

An Archive to Explore

In this environment, the Greek Orientalist painter Théodore Ralli (1852-1909) (Figure 1),[6] following the example of his teacher Jean-Léon Gérôme (1824-1904), made his first trip to Egypt in about 1880,[7] after completing his studies at the École supérieure des beaux-arts in France (registration date: 15 January 1873). Until the end of his life, although settled in Paris, he made numerous trips to the Greek lands,[8] the Middle East, the Maghreb, and

2 Daly, M. W. (ed.). *The Cambridge History of Egypt, vol. 2: Modern Egypt from 1517 to the End of the Twentieth Century*. Cambridge, UK: Cambridge University Press 2008, 153.

3 Tignor, Robert, L. *Egypt: A Short History*. Princeton & Oxford: Princeton University Press 2010, 230.

4 Daly, *Cambridge History of Egypt*, 153.

5 The opinion that there was no art in the country before Western art is a different issue, and is not discussed in the present paper. See Naef, Silvia. Á *la recherché d'une modernité arabe. L'évolution des arts plastiques en Égypte, au Liban et en Irak*, Genève: Slatkine, 1996, 57. Shabout, Nada. *Modern Arab Art: Formation of Arab Aesthetics*. Gainesville: University Press of Florida, 2015.

6 Palioura, Mirka, text editor, *Theodoros Ralli Looking East,* Athens: Benaki Museum 2014 (Exhibition Catalogue). See also (in Greek), Παλιούρα, Μαρία. *Το ζωγραφικό έργο του Θεόδωρου Ράλλη (1852-1909): πηγές έμπνευσης – οριενταλιστικά θέματα*, διδακτορική διατριβή, ΕΚΠΑ 2008. [Palioura, Maria. *The work of the painter Theodore Ralli (1852-1909): sources of inspiration – orientalistic subjects*, Ph.D. thesis, National and Kapodistrian University of Athens, Faculty of History and Archaeology, Department of Archaeology and History of Art 2008], accessed 7 January 2018, https://goo.gl/YeESDQ.

7 El Nouty, Hassan. *Les peintres français en Egypte au XIX^e siècle*. PhD thesis, Université de Paris, 1953, 217-218.

8 Among his journeys, Ralli's trip to Mount Athos in 1885 holds a special position. In 1899 in Cairo, Ralli published in French some excerpts from his Athos diary. *Ralli, Théo, Au Mont Athos, Feuillets détachés de l'Album d'un peintre par Théo Ralli.*

Egypt, residing in Cairo for the winters between 1891 and 1904.[9] During these years, Ralli's work was inspired by Egypt. His stay there might also have been related to the decline of the Paris Salon,[10] which in the 1890s owed its survival mainly to the influential Prix de Rome and the medals it awarded. With the decline of the official Salon, the large and lucrative art market it represented was replaced by smaller specialised businesses. Egypt, therefore, offered a new market with the foreigners living in the country and with Egyptian officials as potential customers.

Figure 1: Theodore Ralli (1852-1909), albumen print. Private Collection.

Caire: Imprimerie central, 1899. Translation and comments in Greek: Υπό Θεοδώρου Ράλλη, *Στο όρος Άθως, Αποσπάσματα από το ημερολόγιο ενός ζωγράφου* (Εισαγωγή – μετάφραση – σχόλια, Μ. Παλιούρα). Αθήνα: εκδ. Κασταντιώτης 2004. Palioura, Maria-Mirka. "Theodore Ralli's diary on his travel to Athos (1885)." In *Knowledge is Light, Travellers in the Near East*. Edited by Katherine Salahi, 78-87. Great Britain: Astene and Oxbow Books 2011.

9 Ralli's Archive, vol. 1, 1. The first reference to Ralli's stay in Cairo is found in a quote from the newspaper *Egyptian Gazette* on 18 March 1890.

10 After the Exposition Universelle de Paris in 1889, it was divided into two, because the Salon de la Société nationale des beaux-arts was inaugurated in 1890.

Ralli's contribution to the Cairo Salon was evident from its outset. The excerpts he kept mainly from the local French- and English-speaking press form a valuable personal archive (Figure 2), and although it relates primarily to his personal *oeuvre*, the wealth of information it provides forms a separate corpus in its own right. [11] The archive does not, however, include any article in Arabic. Even if this caveat adds to the fragmentary character of the material and consequently of the event's representation, it does not detract from the importance of the information provided.

Figure 2: Ralli's Archive. Cover of the second volume.

[11] The archival substrate consists of four volumes bound with Moroccan skin with gold monograms on the cover. It is in the hands of the artist's descendants until today. It will henceforth be referred to as Ralli's Archive.

In its four volumes, the archive offers a detailed picture of the Cairo Salon during its early years. It also attests to Ralli's significant contribution as one of the Salon's co-founders.[12] The archive, arranged chronologically, covers his career and attests to his uninterrupted participation in the Paris Salon (1875-1909) and Cairo Salon (1891-1904), allowing us to understand the alternating criteria by which he chose his artistic subjects. It includes 250 photographic reproductions of the artist's works, handwritten notes, and art-criticism articles that appeared mainly in the Greek-, French- and English-language press of that era in Egypt. Amongst these articles, 14 were written by Ralli himself under the pseudonyms *Le Rapin* (the apprentice painter)[13] and ILLAR (a backwards writing of his last name). In addition, the archive contains information about the preparations leading to the Salon.

The contemporary nature of the archive's contents lends it an aura of directness.[14] The accuracy of the information has been corroborated selectively by verifying the notes independently and also the dates of the articles, which, despite some gloating on the part of the author, demonstrated his concern to set up and preserve the archive. Further corroboration or not of the evidence could fill the gaps and correct possible mistakes and inaccuracies. The bulk of the material consists of excerpts from newspapers and reviews, printed documents that were "intentionally produced for public viewing and meant to be understood by a wide audience."[15] They all relate to Ralli's work as an artist and art critic, and to a lesser degree to his everyday life. The handwritten notes, referring to exhibitions in which he participated, to several versions of a painting, or to the city where one of his works was purchased – usually Paris or Cairo – are proofs "of what the past was like."[16] The interpretation of both the given and the missing information hints of a series of artists who were connected to Ralli. If he was keen to provide us with traces of his work in order to claim a piece of immortality, he appears as a figure surrounded by traces of artists whom he met, collaborated with or disliked. As the archive "always preserves an infinite number of relations to reality"[17] in a given historical period, we try today to give voice to an absent witness of the past.

12 "Ralli, le vraie père, l'ancêtre, celui qui, il y a déjà dix ans, fut le promoteur premier du Salon." *Chronique,* 20 February 1900, Ralli's Archive, vol. 3, 11.

13 *Ul moyad,* 8 March 1900, Ralli's Archive, vol. 3, 16. It is reported that the *Rapin* of the newspaper *Réforme* is Ralli.

14 Cooke, Jacqueline. "Heterotopia: Art Ephemera, Libraries and Alternative Space." *Art Documentation* 25:2 (2006): 35-40.

15 Farge, Arlette. *The Allure of the Archives* (The Lewis Walpole Series in Eighteenth-Century Culture and History), translated by Thomas Scott-Railton. New Haven & London: Yale University Press 2013, 5.

16 Farge, *The Allure of the Archives* 11.

17 Farge, *The Allure of the Archives,* 30.

The Cairo Salon: The beginning

We delve into this rich material in pursuit of the history of the Cairo Salon. The chronicle-like listing of the data, year-by-year, is by no means simplistic or linear. It serves a methodological purpose of highlighting aspects of the social and political context of the time.

The circumstances under which the institution was eventually established are aptly recorded in the press of the era. Ralli's major contribution as chairman of the Organising Committee presiding over the first painting exhibition in Egypt is described as follows:

> Ralli, having finished some paintings of his, was planning to show them in his workshop for the sake of friends when Bogdanoff[18] asked him to include some of his works as well, a request which was echoed by Moscheles.[19] Ralli's beautiful studio[20] was not large enough for such an undertaking, in which Philippoteaux[21] was the last to join. It was then that the decision was taken to organize a real art exhibition for which a committee was elected with Ralli presiding over it. All itinerant painters passing through Egypt were invited to exhibit their works, and the opening of the exhibition in February 1891 in the Foyer of the Khedival Theatre was celebrated in a festive atmosphere. Indeed, the Khedive's mother, as a way of rewarding Ralli's initiative, bought the *Palm Sunday*, one of his most beautiful paintings.[22]

The inaugural event seems to have subsequently given place to a fully developed and systematic organization. From the very beginning of

18 Unidentified painter. Bénézit, E. *Dictionnaire des peintres, sculpteurs, dessinateurs et graveurs*. Nouvelle édition, vol. 2. Librairie Gründ 1976, 115.

19 Felix Moscheles (1833-1917). English genre painter. Bénézit, vol. 7, 561.

20 His studio's address was: "Sharia el Saha No 2, en face du Dr Green pacha et derrière l'école des frères de la Doctrine chrétienne, district Ismailieh." *Bosphore* 9 February 1891. *Sphinx* 9 February 1891, Ralli's Archive, vol. 1, 49. Τ—ς, "Καλλιτεχνικά. Ο ζωγράφος Ράλλης", *Αλεξάνδρεια*, 16 March 1893, Ralli's Archive, vol. 1, 11. [Translated from Greek: "Brilliantly illuminated, in the middle of a cool garden, Mr Ralli's studio, is the most European of all the other studios in Cairo. Illuminated by electric light and also ventilated by an electric motor, it includes all the necessary innovations and all the comforts, proving how much the distinguished artist has the sense of the good"].

21 Paul Dominique Philippoteaux (1846-1923). French Orientalist painter. Bénézit, vol. 8, 1976, 285.

22 Translated excerpt from the Greek newspaper *Άστυ*, 31 March 1898, Ralli's Archive, vol. 1, 91. See also, Μποέμ (Δημήτριος Χατζόπουλος), "Συνομιλία με καλλιτέχνην," *Ακρόπολις*, 6 April 1899, Ralli's Archive, vol. 3, 2. In the interview Ralli reports that works worth 100,000 francs are sold to the exhibition every year.

February[23] 1891, the self-appointed Organizing Committee publicized the purpose, the venue and the duration of the exhibition. Ralli, Bogdanoff, Moscheles and Philippoteaux, after inviting artists[24] to submit their works within a certain deadline (16 February 1891), selected 122 of them[25] to be exhibited (oils, watercolours and drawings). According to the press, all itinerant painters, including those living in Egypt, sent works. The exhibition's opening took place in the presence of the Khedive and the diplomatic corps[26] on the afternoon of 20 February 1891 at 3pm in the foyer of the Khedival Opera House,[27] and the Organizing Committee sent personal invitations to important members of Cairo's society.[28] The exhibition lasted for a week and remained open during mornings and afternoons. The entire fee earnings were donated to the European hospital of Abassieh.[29]

The event, characterized as a "*nouveauté*" in the press,[30] was received with great interest and positive reactions. It was hailed as Egypt's first "artistic awakening"[31] and as an example of the tendency towards "artistic decentralization,"[32] while the city of Cairo, where art issues had until then no place in the public discourse and sphere,[33] saw for the first time such a "kind of celebration."[34] (Figure 3).

23 The Salon was held every February, before the one in Paris.

24 "Première exposition annuelle de peinture," *Bosphore,* 9 February 1891. *Sphinx,* 9 February 1891. Ralli's Archive, vol. 1, 49.

25 *Sphinx,* 9 February 1891, Ralli's Archive, vol. 1, 49. *Moniteur des arts,* 20 March 1891, Ralli's Archive, vol. 1, 51. It was mentioned that half of these works were sold at very reasonable prices.

26 "Une exposition de peinture au Caire", *Moniteur des arts,* 20 March 1891, Ralli's Archive, vol. 1, 51.

27 See photo in *Album photographique comprenant soixante et une vue exécutés d'après les constructions élevées au nouveau Caire sous le règne de S.A. le Khédive Ismail-Pacha* / by E. Béchard, Le Caire, A. Lenègre, Paris 1874: https://goo.gl/5ZN5DR, accessed 7 January 2018.

28 *Scarabée,* 14 February 1891. *Sphinx,* 9 February 1891, Ralli's Archive, vol. 1, 49.

29 The ticket was set at 5 P.T. [piastres]. *Egyptien Gazette,* 21 February 1891. *Sphinx,* 22 February 1891. *Journal Officiel,* 23 February 1891. *Sphinx,* n.d., Ralli's Archive, vol. 1, 49.

30 *Sphinx,* 9 February 1891, Ralli's Archive, vol. 1, 49.

31 Translation from French. "Le Salon de 1891", *Scarabée,* n.d., Ralli's Archive, vol. 1, 51.

32 Translation from French. "Le Salon du Caire", *Sphinx,* 2 June 1891. Republication by the newspaper *L'Autorité,* 22 May 1891, Ralli's Archive, vol. 1, 47.

33 *Journal Officiel,* 23 February 1891, Ralli's Archive, vol. 1, 49.

34 Translation from French. The account was taken by Count Zaluski in *Bosphore égyptien,* 22 February 1891. Ralli participated with 15 works, a pastel and drawings. "Le Salon de 1891," *Scarabée,* n.d. Ralli's Archive, vol. 1, 50.

Figure 3: Ralli's Archive, vol. 1, 55-56.

These comments reveal the lens through which the press, reflecting prevailing perceptions, welcomed the exhibition. The texts highlighted the country's position on the cultural and political map of the Mediterranean. Of the two main points of interest, the first was associated with the concept of artistic awakening, which took the glorious pharaonic past as a point of reference. This use of this term insinuated that the period before the exhibition was one of inactivity and stagnation. Such a sweeping generalization ignored the long tradition of traditional art production in the region and excluded a priori and uncritically the previous period as some kind of cultural void. The second point of interest was that of artistic decentralization, automatically including Egypt into a larger geographical region but as part of its periphery, with the metropolitan centre remaining firmly in Europe. In this context, the exhibition seemed to have drawn its legitimacy, on the one hand, from a glorious past and on the other, from the presence of a contemporary political power. The purchase of a painting by a member of the royal family – *Palm Sunday* purchased by the Khedive – declared the belief of the Egyptian regime in the new institution. The presence at the inauguration of members of the royal family, as well as of Lord Cromer and his wife, testified to the organizers' desire not to exclude the representatives of English domination in the country.[35]

35 The following persons of Cairo's society are mentioned: H. E. Abderrahman Pasha Rouchdi, H. E. Mustapha Pasha Fehmy, H. E. Ali Pasha Moubarek, H. E. Zeky Pasha,

The general picture given by the press of the day bears evidence of the enthusiastic support given to the new institution by Cairo's cosmopolitan and multicultural foreign community along with the Egyptian political elite. They bought artworks and established an art market, and the Cairo Salon took on an annual and regular character. The common practice of artists – Ralli included – of exhibiting their works at the newly established Cairo Salon and subsequently at the Paris Salon[36] demonstrated the presence of the Egyptian capital on the cultural map of European cities[37] hosting similar artistic events. The works were thus first "tested", so to speak, by an audience that "came in touch" with Art for the first time.

Following the success of the first Salon, Ralli received from the Khedive the Order of the Medjidie Grade 3rd class for his artistic contribution to Egypt.[38] The recognition by the Egyptian authorities showcased the importance they attached to the project. The following year, with the ascent of Abbas II to the khedivate in 1892, the Salon continued to attract more and more artists. In the years to come, the Cairo Salon, at whose openings the new Khedive would unfailingly be present, continued to be one of the most celebrated events in the Egyptian capital, both for its artistic value and its secular character.

An Unexpected Continuity

In 1892, following the Salon's success, Ralli received a commission from the new Khedive[39] to paint a portrait of his deceased father, Tawfiq Pasha

Sir Evelyn and Lady Baring, Mr and Mme Maccio and their daughters, Mme d'Aubigny, Mme Maskens, Count and Countess Della Sala and Mlle d'Ortega, Baron and Baroness de Malortie, Lady Galloway, Lady Bulkeley and her daughter, Lady Grenfell, Mrs Rodgers, Lady Charles Beresford, Baron Richthofen, Mr Oppenheim, Mr and Mrs Royle, Mr and Mrs Fabricius. *Egyptian Gazette,* 23 February 1891. *Sphinx,* 22 February 1891, Ralli's Archive, vol. 1, 50.

36　Mécène. "Beaux-Arts," *Autorité,* 22 May 1891, Ralli's Archive, vol. 1, 47: "Le succès que ces deux toiles ont eu au Caire vient d'être confirmé par celui obtenu à Paris. C'est tout à l'honneur du goût de la ville égyptienne."

37　The establishment of the Salon in the Egyptian capital is mentioned in Thalasso, Adolphe. "Orient." *L'Art et les Artistes* 10 (1910), 140 and on various occasions in the Greek press, as attested in other references in the present paper.

38　*Diplomatic Historical Archives* (Y.D.I.A.) *of the Hellenic Ministry of Foreign Affairs,* Department B, Box 26, Envelope 1. Ralli's letter to the Greek Ministry of Foreign Affairs requesting permission, in accordance with the law, to wear the medal (17 October 1891).

39　"Το Σαλόν του Καΐρου. Αι εικόνες του κ. Ράλλη. Κρίσεις περί αυτού. Ο Κεδίβης και ο Έλλην ζωγράφος. Οι κ.κ. Ρίζος και Καμπόσος." *Άστυ,* 1-2 March 1892, Ralli's Archive, vol. 1, 57.

(1852-1892).[40] The press commented on the Salon's impact,[41] noting that the ever-growing number of tourists in the country during the winters went a long way to contribute financially to the *"colonies européennes"* and the *"société indigene"*, so that artists living in Egypt felt that they could show their works to a more populous and better informed public.[42]

From 1893 the Salon was housed in the building of the Cercle Artistique,[43] an association "led by the doctor and scientist Onofrio Abbate Pacha", an Italian archaeologist and art lover, who was extremely active during his stay in Egypt (1845-1915) in the service of the khedival authorities. [44] The building that lodged the Cercle Artistique belonged to Baron Alphonse Delort de Gleon (1843-1899), a French engineer and collector who displayed works by artist friends in his house.[45] It is probably due to this habit that the name of the association emerged. In the first year 150 works were exhibited, of which more than 60 were sold.[46] In the same

40 Πολίτης, Αθανάσιος. *Ο Ελληνισμός και η νεωτέρα Αίγυπτος*, Β΄, Αθήνα 1930, 480-81: ["He has made a lot of portraits, especially of Khedive Tawfiq and princes Saït Halim and Hussein. Khedive Tawfiq, a great admirer of Ralli's work, bought eleven of his paintings."]

41 The Salon opened its doors on Saturday, 6 February 1892. The inauguration was postponed upon the request of the new Khedive. *Paris-Londres,* 21 February 1892, Ralli's Archive, vol. 1, 57. The Salon's Organizing Committee consisted of Philippoteaux, Ferraris, Ralli and the Russian Prince Diplomat Dabija under the honorary presidency of Marquis de Reverseaux. In 1892 the Salon included engravings and drawings, apart from the section with oil paintings and part of watercolours. *Débats,* 16 February 1892, Ralli's Archive, vol. 1, 57.

42 *Débats*, 18 February 1892, Ralli's Archive, vol. 1, 4΄.

43 The house, one of the last surviving buildings of the era (today at 27 Sherif Street, Cairo), was built in Mameluke style by the French engineer and art collector Alphonse Delort de Gléon in 1884. See, Volait, Mercedes. "The birth of Khedivial Cairo." *Rawi Egypt's Heritage Review* (September 2017), accessed 7 January 2018, http://rawi-magazine. com/articles/khedivial_cairo_birth/. See photo of the house in: *Album photographique comprenant soixante et une vue éxécutés d'après les constructions élevées au nouveau Caire sous le règne de S.A. le Khédive Ismail-Pacha* / par E. Béchard, Le Caire, A. Lenègre, Paris 1874, accessed 7 January 2018, https://goo.gl/btDWuW. Volait, Mercedes. "The Rue du Caire at the Exposition Universelle in Paris (1889)." BNF, Bibliothèques d'Orient, accessed 10 January 2018, http://heritage.bnf.fr/bibliothequesorient/ en/street-of-cairo-art.

44 See Nadia Radwan's chapter in this volume. For Onofrio Abbate (1824-1915) see Brancato, Francesco. "Abbate, Onofrio", *Treccani, Dizionario Biografico degli Italiani* 1 (1960), accessed 7 January 2018, http://www.treccani.it/enciclopedia/onofrio-abbate_ (Dizionario-Biografico)/.

45 Shawkat, Nabil. "Street Smart: The hidden jewel on Shawarbi Street", *ahramonline* (May 2011), accessed 7 January 2018, http://english.ahram.org.eg/NewsContent/32/97/12638/ Folk/Street-Smart/Street-Smart-The-hidden-jewel-on-Shawarbi-Street.aspx.

46 Τ-ς, "Ο ζωγράφος Ράλλης," *Αλεξάνδρεια*, 16 March 1893, Ralli's Archive, vol. 1, 11. Ράλλη Θ. (Le Rapin), "Επιστολαί εξ Αιγύπτου. Η έκθεσις του Καΐρου.", *Παναθήναια*, Δ', 29 February 1904, 316.

year, the first of a series of art-criticism articles about the Salon, penned by
Ralli, appeared in the French-speaking press.[47] These articles, in which he
formulated a more comprehensive and structured kind of art criticism, were
characterized by humour and lack of animosity.[48] The year 1893 honorary
and financial prizes were established, which were awarded to artists whose
works were considered distinguished.[49] The Salon of 1894, opening on 15
March in the large room of the Cercle Artistique, did not include major
works.[50] According to a long article by Ralli, the lack of important paintings
in this exhibition was to be explained by the delay in the opening of the
event and the dispatch of the works to other European exhibitions.[51]

Formal invitations to the opening were cancelled for the Salon of 1895, in
response to strong protests from those who did not previously receive them.
A system of lottery tickets was introduced, the possession of which secured

[47] Ralli exhibited twelve works in the Salon, all of which were sold. Τ-ς, *Αλεξάνδρεια*,
16.3.1893, Ralli's Archive, vol. 2, p. 39. Dabija, Ferraris, Philippoteaux, le Comte de
Noüy, Ralli and Thaddeus are mentioned as members of the Organizing Committee.
A reference to a newly established Egyptian School of Fine Arts remains to be further
investigated. Rapin, "Exposition de peinture," 1893, Ralli's Archive, vol. 1, 105.

[48] Rapin, "Le Salon de 1895," *Progrès*, n.d., Ralli's Archive, vol. 1, 95: "Je n'attaquerai
que les forts, et ne persécuterai pas les gens sans valeur. Et comme il n'y a pas de chef-
d'œuvre parfait, je ne parlerai que des bons tableaux, mais en cherchant leurs points
faibles, que j'indiquerai de mon mieux, laissant à mes confrères, critiques d'art, plus
timides, le soin de brûler de l'encens et d'épuiser leur vocabulaire élogieux." [I will
attack only the strong and will only persecute those who have value. And as there is no
perfect masterpiece, I will speak only of good works, but looking for their weak points
that I will point out as best as I can, letting my shy colleagues, the art critics, to burn
incense and exhaust their fanciful vocabulary.] Articles can be found in press excerpts
from the years 1893-1896, 1899, 1900, 1902, 1903 (in two parts) and 1904. They were
mainly published in the newspaper *Réforme*.

[49] Rapin, "Exposition de peinture," 1893, Ralli's Archive, vol. 1, 105. It is reported that
the Commission awarded an honorary award to the English Donne for the painting
Lever de soleil aux Pyramides. The same prize was given to the amateur Scribe for
his paintings *Nil à Ghézireh* and *Environs du Caire*. The same information is found in
Rapin, "Exposition de peinture," 1893, Ralli's Archive, vol. 2, 83, where it is reported
that the Commission has awarded honorary and financial prizes to Rossi, Donne and
Seribe."

[50] Rapin, "Le Salon," *Etoile*, 17, 20, 22 March 1894, Ralli's Archive, vol. 1, 72: "Les
tableaux sont admirablement et également éclairés par de grandes baies ouvertes au
plafond. Des tapis ornent le plancher, et quelques bustes disséminés parmi les plantes et
les fleurs, contribuent à donner à cette exposition l'air d'un véritable Salon." *Egyptian
Gazette,* 17 March 1894. *Etoile,* 22 January 1894, Ralli's Archive, vol. 1, 84.

[51] Rapin, "Le Salon. Quatrième exposition annuelle du Caire." *Etoile*, 17, 20, 22 March
1894, Ralli's Archive, vol. 1, 99-102. It is reported that Philippoteaux called some peo-
ple to visit his studio in order to exhibit the painting that he was going to send to Europe.
The rest of the artists packed and sent their works without the Cairo audience admiring
them. Ralli's Archive, vol. 1, 72.

entry on the appointed day.[52] The Salon's pronounced secular character was clearly conveyed in a press release,[53] and references in the press to dignitaries and distinguished persons of Cairo society were frequent. For members of the foreign communities in the Egyptian capital, the Salon satisfied their personal vanity, emphasised their social status and stimulated the cohesive bonds between them.[54] The participating artists[55] were mentioned in the press along with the purchase of works by members of the Khedive's family.[56] The appearance of Impressionist paintings was emphasised and the belief that Cairo was on the way to progress was expressed.[57] Western art was identified with the positivist concepts of culture and progress.[58]

In 1896, Cairo's Salon received a wealth of entries, with 250 paintings.[59] Ralli published a review in the newspaper *Le progrès* about those that were exhibited. His sharp remarks on the favour shown by the Khedive to the painter Birck testified to a thinly veiled rivalry between artists.[60]

The Salon must have contributed to the large demand for painting and drawing lessons, especially from the ladies of Cairo's high society. Ralli's need to improve his livelihood may have led him to found a School of Painting

52 Rapin, *Le Progrès,* February 1895, Ralli's Archive, vol. 1, 95.

53 Rapin, "Le Salon de 1895," *Progrès*, n.d. Ralli's Archive, vol. 1, 94-98.

54 An article by Ralli, concerning the Salon of 1902, reveals in satirical manner the preparations of women for the day of inauguration and stigmatizes the secular aspect of the exhibition. Le Rapin, "Le Salon du Caire. Impressions d'une dame au lendemain du vernissage", *Réforme*, 17 February 1902, Ralli's Archive, vol. 3, 54: "Vous donc, qui aimez vraiment l'art, et les sensations qu'il donne, et l'infini qu'il ouvre aux yeux de votre âme, pourquoi obéir à la mode et aller dans cette cohue parfumée, babillarde, sautillante, frivole, quintessenciée de luxe léger et que rien ne saurait toucher qu' à fleur d'épiderme?."

55 Rapin, "Le Salon de 1895," *Progrès*, n.d., Ralli's Archive, vol. 1, 94-98: Mme Capamagian, Rossi, Mme Nubar Pacha, Kosler, Zullo, Forcella, Saccaggi, Wagner, Dastugue (portrait de Peltier Bey), Lessieur, Nichanian. Watercolour artists: Talbot-Kelly, Birck, Wilda (professionals), Rogers Pacha, La Baronne de Heyking, Maskens, La Comtesse Lavison, Roullier Bey (amateurs), Saltelli, Wynne, Le Baron Below, Allongé.

56 W. Abbate, "Le Salon," *Bosphore,* 25 February 1895, Ralli's Archive, vol. 1, 24. Ralli exhibited eleven oil paintings and a watercolour, a number of which were bought by the Khedive's brother, Prince Mohamed Ali.

57 Rapin, "Le Salon de 1895," *Progrès*, n.d., Ralli's Archive, vol. 1, 94-98.

58 Naef, Silvia. "Re-exploring Islamic Art: Modern and Contemporary Creation in the Arab World and its Relation to the Artistic Pasvol." *Anthropology and Aesthetics* 43, Islamic Arts (Spring 2003): 166, 164-174.

59 Le Rapin, " Le Salon de peinture," *Le Progrès,* 12, 14, 18, 20 February 1896, Ralli's Archive, vol. 1, 92-94. The participating artists: Birck, Rossi, Philippoteaux, brothers Forcella, Uhl, Kosler, Bonnard, Cirigotis, Schiffi, Talbot-Kelly, Maskens, Rouiller, I. G. Rogers, W. Abbate, Mme Baravelli, Beurmann, Rizo, Vernier, Mme la Comtesse Lavison, Mme Bongleux, Libert. Τηλέγραφος, 27 March 1896, Ralli's Archive, vol. 1, 105.

60 *Le progrès* 12, 14, 18, 20 February 1896, Ralli's Archive, vol. 1, 92-94.

and Design together with Philippoteaux in December 1896.[61] The lessons were held in the artist's small studio at his home, while the main studio was in the Ismailieh district.[62] In the description of Ralli's atelier by the non-Arabic press of the era, it was believed to exude a sophisticated artistic European ambience that was in contrast to the city's general atmosphere. Cairo was considered as a sterile place lacking in artistic sensibility, in which Ralli's studio created a kind of heterotopia, where the visitor could get the exactly opposite impression as if he or she were somehow transported to a European capital where an artistic spirit triumphed.[63] This antithetical juxtaposition pointed to the prevailing colonial perceptions of Western primacy over the underdeveloped East.

For the 1897 Salon, the press applauded an improved quality of the works compared to past years, and their well-prepared presentation. It also referred to the stricter selection policy by the Organizing Committee and to the presence of worthy painters who tried to raise the level of art in Egypt and were accordingly appreciated by the more discerning of the Cairo public.[64] At the Salon of 1898, Ralli was once again a member of the artistic committee[65] that selected 230 paintings for exhibition, and one of his drawings was included in the elegant catalogue.[66] Among the artists who took part, the "*indigène*" Haddad is mentioned as the only non-European. The article refers to Haddad's success over the years and to the painting that he exhibited, a portrait of I. R. Bey.[67] The Salon attracted "all the

61 *Progrès,* 8 December 1896. *Sphinx,* 16 January 1897, Ralli's Archive, vol. 1, 102. The inauguration of the school took place on 13 December 1896. The morning classes were for women (9.30-12.30am) and afternoon classes for men (2-5pm). "Cours de peinture," *Journal Egyptien,* 4 December 1896, Ralli's Archive, vol. 1, 102.

62 Description of Ralli's studio. *Sphinx,* 16 January 1897, Ralli's Archive, vol. 1, 102. The courses continued under the same programme in 1897 starting on 15 November, the price being two pounds per month. *The Sphinx*, 11 December 1897, Ralli's Archive, vol. 1, 55. *Réforme,* 9 November 1897, Ralli's Archive, vol. 1, 102. *Progrès,* 8 November 1897, Ralli's Archive, vol. 1, 104.

63 *L'Arte,* 11 December 1897. Ralli's Archive, vol. 1, 18.

64 Illar, "Le Salon du Caire," *Réforme*, 25 February 1897, Ralli's Archive, vol. 1, 91-92. *Phare d'Alexandrie,* 16 March 897, Ralli's Archive, vol. 1, 84.

65 The artistic committee included Forcella, Girardet, Philippoteaux, Ralli, Rossi and Talbot-Kelly. Le Grinceux, *Réforme,* 12, 16, 18, 21 February 1898, Ralli's Archive, vol. 1, 89-91.

66 *Réforme,* 5 March 1898, Ralli's Archive, vol. 1, 55.

67 Le Grinceux, *Réforme,* 12, 16, 18, 21 February 1898, Ralli's Archive, vol. 1, 89-91. He can be identified with the inventor and self-taught portraitist Selim Shibli Haddad (1864-after 1915) of Lebanese origin (Abbaeih/ Abadiyeh), who lived in Cairo and developed the first successful Arabic typewriter keyboard. Messenger, Robert. "The Arabic Typewriter Keyboard and the Syrian Artist," accessed 7 January 2018, https://oztypewriter.blogspot.com/2014/10/the-arabic-typewriter-keyboard-and.html.

foreigners passing through the city,"[68] and Henry Bacon, Tyndall, Girardet and Ter-Linden participated for the first time. It is interesting to note that the American Henry Bacon invited several people to the Shepheard Hotel to present his watercolours before the Salon's opening. This gave art lovers an opportunity to see the paintings admitted to the Salon, as well as their preparatory designs and studies.[69]

The Salon and the Dreyfus Affair

The interconnection of art with contemporary political events sometimes asserted itself unexpectedly. Apart from the portraits of foreign and Egyptian officials that were common in the Salon,[70] such as that of Prince Said Halim Pasha, which caused a delay in the opening of the 1899 Salon,[71] a particular painting is of special interest. After a trip to Palestine probably in 1896, Ralli produced a series of works inspired by the region.[72] In 1899, he completed a painting whose subject was the well-known Jewish habit of worship at the Wailing Wall (Figure 4). The painting was exhibited at the Cairo Salon under the title *Que son innocence soit reconnue*.[73] It depicted Jews praying at the Wailing Wall, while one of the onlookers is trying to write something on one of the stones. Next to them is part of a wooden stool, where books and a scroll (Torah) had been deposited, while a staff (indicating Aaron's Rod) is resting against the wall. All of these refer to the symbols of Israel. The difficulty of linking the seemingly unrelated title

For further biographical information on Haddad, see *Lebanon – The Artist's View: 200 Years of Lebanese Art*. Exhibition catalogue. London: British Lebanese Association 1989.

68 Translation from Greek. The Salon was inaugurated on 12 February. Άστυ, 31 March 1898, Ralli's Archive, vol. 1, 91.

69 *Egypt Gazette,* 18 January 1898, Ralli's Archive, vol. 1, 55.

70 Le Grinceux, *Réforme,* 12, 16, 18, 21 February 1898, Ralli's Archive, vol. 1, 89-91. Ralli exhibited 16 works, including Consul's Ivanoff portrait.

71 *Journal du Caire,* 23 February 1899, Ralli's Archive, vol. 3, 7. *Bulletin de l'art,* 9 April 1899, Ralli's Archive, vol. 3, 13. *Chronique,* 21 February 1899, Ralli's Archive, vol. 3, 2.

72 Such as the painting *In front of Solomon's wall in Jerusalem*, which he exhibited at the Paris Salon in 1897. See Palioura M., *The work of the painter Theodore Ralli (1852-1909),* see fig. 153, accessed 10 August 2018, https://goo.gl/qk81VC.

73 *L'Arte,* 4 March 1899, Ralli's Archive, vol. 3, 12. Another title given to the painting was *Les juifs priant pour Dreyfus devant les pierres du temple*. Le Rapin, "Le Salon," *Réforme,* 3, 6, 7 March 1899, Ralli's Archive, vol. 3, 64. A different version of the title is also mentioned: *Faites mon Dieu que son innocence soit reconnue*. See Fig. 174, accessed 10 August 2018, https://goo.gl/MVmoTk. The painting's title was drawn from the proceedings of the trial. Reinach, Joseph. *Histoire de l'affaire Dreyfus*. Paris: Librairie Charpentier et Fasquelle 1905, 293.

to the illustrated subject would remain a mystery were it not for an article excerpt that solved it.[74]

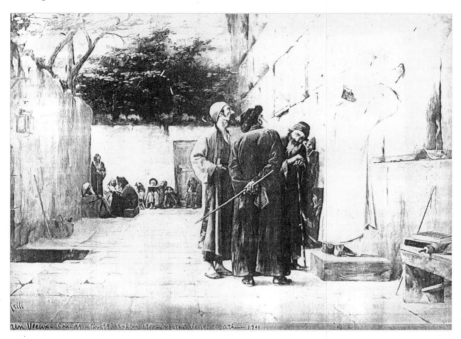

Figure 4: *Un vœux*, 1899, oil on canvas, signed l. l., present location unknown. Reproduction in Ralli's Archive, Vol. 3, 14.

The title and theme of the painting referred to the infamous case of Alfred Dreyfus (1859-1935), who was accused of treason and was a victim of judicial and political blunder in France (1894-1906). In January 1898, the real culprit Major Esterhazy was acquitted (November 1897-January 1898). This prompted Emile Zola to write his famous open letter to the President of the French Republic, Félix Far, under the title "*J'accuse!*".[75] Zola's text and the proceedings of the trial, released in the press, would have been read by Ralli, who chose the following month to hang his work in a

74 "… he will exhibit a big painting inspired by Dreyfus's affair." Μποέμ (Δημήτριος Χατζόπουλος), "Συνομιλία με καλλιτέχνην", *Ακρόπολις,* 6 April 1899, Ralli's Archive, vol. 3, 1. *Journal du Caire,* 23 February 1899, Ralli's Archive, vol. 3, 7.

75 The Dreyfus affair caused a shock in the Third French Republic and pushed Emil Zola to write the famous "J'accuse…! Lettre au Président de la République". It was first published on 13 January 1898 in Ernest Vaughan's newspaper *L'Aurore*, before being released in a brochure. https://goo.gl/z1qnV1, accessed 10 August 2018. See also, Zola, Émile. *Combat pour Dreyfus* (Préface de Martine Le Blond-Zola. Postface de Jean-Louis Lévy), Présentation et notes d'Alain Pagès 2006.

particularly elevated position in the Cercle Artistique. He even copied the painting's theme in separate works[76] and exhibited them in different parts of the hall, fearing – because of the anti-Semitic fury that was on the rise – a possible invasion of the Salon by members of the far right nationalist Ligue des patriotes.[77] At the end of the exhibition, Ralli transported the painting to France and exhibited it at the Paris Salon in May 1899. However, in the Salon's catalogue a different title summarizes the meaning: "A Wish, 1898". This change was made because the artist probably took into consideration a likely public anti-Semitic reaction against the painting. The criticism of the work focused on the characteristic postures of the figures that were in contrast to reality. There was no comment on the Dreyfus Affair. The painting kept its secret and was subsequently lost. Ralli, in favour of Dreyfus's rehabilitation, took a clear political position, as did his teacher Gérôme following Dreyfus's condemnation in 1894. He linked the painting with Dreyfus by giving prominence to its ethnicity and religious elements. The scene's inspiration did not derive from the events, because the subject was common among Orientalist painters, as shown in similar works.

The Salon at the Turn of the Century

In the process of accepting paintings for the Cairo Salon, the Organizing Committee's leniency was tested many times. Ralli, as a member, defined the parameters within which the choices should be made: "Le Salon est un lieu où l'originalité, l'acquis, la science devraient avoir un libre accès, mais où par contre, ne pourraient être admises les productions qui ne posséderaient aucune des qualités énoncées précédemment."[78] There was a need for greater rigour in the selection as the participation of amateurs presented problems related to the artistic level. The general atmosphere of the event was revealed by Ralli himself in an interview during his visit to the Athens Art Exhibition that same year. Comparing the two exhibitions, he described the climate of unity that prevailed among painters in Cairo.[79]

76 Palioura, M. *The work of the painter Theodore Ralli (1852-1909),* 2008. See fig. 176, accessed 7 January 2018, https://goo.gl/MVmoTk .

77 A nationalist movement of the far right, founded in May 1882 by the poet Paul Déroulède. Accessed 7 January 2018, https://goo.gl/WxEBHW. Roux, Jean-Pierre. *Nationalisme et conservatisme: la Ligue de la patrie française (1899-1904).* Paris: Beauchesne 1977. Sternhell, Zeev, *La droite révolutionnaire (1885-1914), Les origines du fascisme français.* Paris: Gallimard 1997.

78 It is also reported that about 100 paintings were rejected. Le Rapin, "Le Salon", *Réforme* 3, 6, 7 March 1899, Ralli's Archive, vol. 3, 60-63.

79 Μποέμ, "Συνομιλία με καλλιτέχνην", *Ακρόπολις,* 6 April 1899, Ralli's Archive, vol. 3, 1. [Translation from Greek: In Cairo although we are strangers to each other and have different ideas, yet we love and support our exhibition.]

Although Ralli's contribution to the Salon's establishment is unquestionable, the sporadic negative reviews of his work in the early period multiplied over the years, although they did not seem to have greatly influenced the sales of his paintings.[80] At the Salon of 1900 he showed twelve works, among them the portrait of Prince Hussein Pasha Kamel.[81] In this Salon, several women were among the exhibiting artists.[82] In addition to the Salon's sales, it appears that auctions were held in which paintings were sold at relatively high prices.[83]

After the Exposition Universelle in Paris in 1900 – where the new century was greeted with optimism – and following the recognition of Ralli as a member of the International Hellanodikai Commission and *hors concours*, his return to Cairo, where he prepared the catalogue for the Salon of 1901, was triumphant.[84] The following year, the 250 works at the Salon included some by amateur painters, a fact that led to the withdrawal of certain professional artists who feared a lowering of the overall standard.[85] The uncertain fate of the Salon was emphasized in the press.[86] In 1903, the Salon's catalogue, illustrated by Ralli, was printed by Moures at the Organising Committee's bequest.[87] The press urged visitors to buy it, maintaining that no one could lose by buying a "real work of

[80] He is criticized for the "purity" of the figures and the flawless detail. Geo, *Journal du Caire,* 27 February 1899, Ralli's Archive, vol. 3, 7.

[81] *Chronique,* 20 February 1900, Ralli's Archive, vol. 3, 11. "Théo Ralli," *Phare d'Alexandrie,* 20 February 1900, Ralli's Archive, vol. 3, 15.

[82] Le Rapin, "Le Salon de 1900," *Réforme,* 19, 21, 23 February 1900, Ralli's Archive, vol. 3, 58-60. The participants were as follows: Mme Du Brucq, Mme Eithel Sidley, Mlle Wood, Mlle Rawlinson, Is Monte (pseudonym of a lady from Mansourah), Mme Parker, Mme Grosvenor, Mlle Joachim, Mlle Punchetta, Philipoteaux, Talbot-kelly, Toscani, Rossi, Anderson, Kosler, Mathiopoulos, Forcella, Lavergne, Simpson, West, Cirigotis, Monteforte, Othoneos, Gasté, Gialinas, Ferrant, Jaronek, Schiffi, Mme Schutz, Nistri, Washington, Girardet, Prince Mohamed Ali, Fleurent, Maskens, Michelet, Caprili, Mme Longworth, Piattoli, Coppens.

[83] In March 1900, Ralli held an auction sale in Cairo and sold Charles Louis Muller's painting *1814* to Bogos Pacha Nubar (it was said, on behalf of an association) for 800 pounds and Gérôme's *The Duel After the Masquerade* at the highest auction price. *Réforme,* 19 March 1900, Ralli's Archive, vol. 3, 2.

[84] The Salon opened its doors on 15 February. Ralli participated with eleven paintings. "Le Salon du Caire", *Egyptian Gazette,* 15 February 1901, Ralli's Archive, vol. 3, 19. Michelet, *Correspondance egyptienne,* March 1901, Ralli's Archive, vol. 3, 16.

[85] *Petit Egypt* 16 February 1902, Ralli's Archive, vol. 3, 22.

[86] Πινακοθήκη, "Η έκθεσις Καΐρου", Β', 1902-1903, σ. 46. Ralli participated with 14 paintings. G.V., "Le nouveau Chevalier. Théodore Ralli", n.d., Ralli's Archive, vol. 3, 21.

[87] Le Rapin, "Le Salon du Caire. Impressions d'une dame au lendemain du vernissage," *Réforme,* 17 February 1902, Ralli's Archive, vol. 3, 54. The arrangement of the exhibition spaces is described with the observation that at the centre of the hall divans were placed for visitors to sit on. It is also noted that the catalogue had many mistakes.

art."[88] That year, the Committee had allowed representatives of the press
to enter the exhibition hall on the eve of the opening, so the columnist,
observing that bad painters were absent that year, mentioned the names of
the participating artists.[89] The criticisms of Ralli's work must have created
an unfavourable climate,[90] and he decided to leave Cairo for good in the
following year. At an artists' meeting held in March 1903 at the Metropole
Hotel, he presented an overview of the exhibition's contribution thus far,
thanking the artists, the press and the Cercle Artistique.[91] According to
Ralli, the quality of the 1904 Salon was far superior compared to previous
years because the Committee had courageously excluded mediocrity,
whose pale and murky attempts had blurred the aesthetic impression.[92] Out

[88] The inauguration took place on Friday 6 February 1903 at 2.30 pm. The programme
 was for sale in the room at a fixed price that was affordable to everyone. *Réforme,* 16
 February 1903, Ralli's Archive, vol. 3, 4.

[89] Le Rapin, "Le Salon de 1903, Le Caire, 3 février", *Réforme,* 5 February 1903, Ralli's
 Archive, vol. 3, 52. Le Rapin, *Réforme,* 10 February 1903, Part II. Ralli's Archive, vol. 3,
 52-53.

[90] Michelet, *Phare d'Alexandrie,* 10 February 1903, Ralli's Archive, vol. 3, 31. He partici-
 pated with twelve paintings.

[91] "Messieurs et chers confrères, C'est avec un sentiment particulier de fierté que je vous
 vois réunis pour la première fois au Caire dans ce petit dîner confraternel. C'est grâce
 aux Expositions annuelles de peinture que nous sommes aujourd'hui en mesure de nous
 connaître, de nous aimer, de nous apprécier. Je suis persuadé que ce banquet consolidera
 les bons rapports qui n'ont jamais cessé d'exister entre nous, car il est indispensable,
 pour l'avenir de notre Exposition, pour que notre salon continue sa marche ascendante
 que tous les artistes se tendent la main sincèrement.
 Je tiens à remercier au nom de tous mes confrères, la direction du Cercle Artistique qui
 depuis dix ans apporte un appui précieux à nos Expositions. C'est grâce au Cercle que
 nous avons une salle spacieuse, bien éclairée pour montrer nos tableaux. Nous avions
 vraiment l'air, lorsque nous faisions nos Expositions au foyer du théâtre, d'une tribu
 nomade qui plante sa tente où le hasard la conduit. Le Cercle nous a donné un campe-
 ment confortable.
 Je tiens aussi à présenter nos remerciements chaleureux à la presse égyptienne,
 laquelle avec un désintéressement qui lui fait honneur n'a jamais cessé depuis 13 ans
 d'encourager avec bienveillance nos modesties tendances artistiques.
 Un mot encore de remerciements pour les artistes étrangers qui ont pris part à notre
 Exposition ; ils ont apporté un écho lointain de leur pays ; ils donnent une note nouvelle
 à notre salon, note pittoresque, savoureuse, que nous admirons et que nous voudrions
 entendre souvent.
 Je bois donc à la direction du Cercle Artistique et particulièrement à S.E. Abbate pacha,
 son président. Je bois aux peintres et à l'avenir de l'Exposition annuelle de peinture."
 Phare d'Alexandrie, 18 March 1903, Ralli's Archive, vol. 3, 50. "Le Banquet des Pein-
 tres", *Bourse Egyptienne,* 17 March 1903. "Premier Banquet des Peintres", *Réforme,* 18
 March 1903, Ralli's Archive, vol. 3, 50.

[92] Ralli participated with about ten paintings, of which he sold seven, at prices higher
 than those listed in the catalogue. "Sale of Pictures at the Cercle Artistique", *Egyptian
 Gazette,* 21 March 1904, Ralli's Archive, vol. 3, 46.

of the 440 paintings offered, 150 were excluded.[93] But the works did not attract as many sales as expected. However, around 30 paintings were sold.

The increasingly negative comments in the press about Ralli's work, inversely proportional to the amount of praise showered on him in the early years of the Cairo Salon,[94] coupled with the new artistic art forms and styles in Europe – a reaction to academic traditionalism – that took the lead, contributed to an environment that was no longer so welcoming for him. The Cairo press announced Ralli's departure in early April 1904 with regret. He announced his decision to sell the whole contents of his studio.[95] Although he left Cairo, he continued to participate in its Salon for two more years, sending one and three works respectively.[96]

Conclusion

The continuation of the event, at least in 1905 and 1906, showed that the Salon still existed into the first decade of the twentieth century. An overview by the press in 1904 pointed out that although the founders of the Salon – including Ralli – as well as the 60 other artists living in Cairo, both professionals and amateurs, had shown zeal, the institution did not manage to establish itself permanently. The reviewer believed that this was because, despite all efforts, the official support that never came would have been the only way of transforming it to a real success.[97] He presented the Salon in an overall negative light. This pessimistic approach is not justified by the strong resonance that the Cairo Salon appears to have created in circles of the European and Egyptian elites of the time. Given the prevailing conditions in the country, the very survival of the institution for at least 15 years was a success in its own right.

The evidence in Ralli's archive offers a chronology of the first Egyptian Salon and creates a remarkable, if limited, picture of its early years. The

[93] Le Rapin, "Ἐπιστολαί ἐξ Αἰγύπτου. Ἡ ἔκθεσις τοῦ Καΐρου." *Παναθήναια*, Δ΄, 29 February 1904, 316-317. Ralli's Archive, vol. 3, 46-47.

[94] Mlle X***, "Le Salon de peinture du Caire", *Nouvelle Revue d'Egypte*, Mars 1904, 109-114. Ralli's Archive, vol. 3, 66-71: "Le cycle de la sottise et de l'arbitraire est révolu, Mr. Ralli a fait son temps."

[95] "Départ" n.d. *Pyramides,* 23 March 1904. *Egyptian Gazette.* The sale of the works took place on Friday, 25 March 1904 in Ralli's studio. Della Torre was responsible for the auctione. "Vente pour cause de départ", *Journal du Caire,* 21 March 1904. "On va fermer!" *Journal du Caire,* 24 March 1904. "Chez Th. Ralli," *Journal du Caire,* 26 March 1904, Ralli's Archive, vol. 3, 43.

[96] *Bulletin de l'art,* 18 March 1905, Ralli's Archive, vol. 4, 8.

[97] *Phare d'Alexandrie,* 2 March 1904, Ralli's Archive, vol. 3, 43.

Salon acted as a form of cultural expression and reached a very limited and specific audience. The multiple connotations of the textual material point to a complex reality in constant flux that was juxtaposed against the timeless, exotic, idyllic, and fragmentary world depicted in the paintings themselves. The relations between the political echelons of the country, both the Egyptian and British residents of Cairo,[98] and the artistic circles involved prove the existence of a particular urban population that consumed this art and apparently determined, to a certain extent, the commissions and sales of works. If we consider that the years of the Salon assisted to the formation of a collective identity based on a new and invented artistic heritage, we may conclude that this, as Silvia Naef notes, "came from above,"[99] in that it imposed on Cairo cultural life an event led by European artists and involving Europeans who lived in the country. Nevertheless, for the Egyptian elite, the Salon familiarized them with artistic events and contributed to the development of artistic production in the country by Egyptian artists in subsequent years. This first period of the Salon adds its own weight to the process of western modernity's adoption.[100]

In this context, we propose that the interpretation of what we call "modern" in Egypt in the years preceding 1908, when the School of Fine Arts was founded in Cairo, should be amended.[101] The School and the training of artists in corresponding European schools would promote the participation of Egyptian artists in the Salon in the first decades of the twentieth century, both in its organisational and exhibition aspects. This indicates a gradual "Egyptianization" of the institution and defines its contribution to the changing Egyptian experience.[102]

[98] In 1893 Ralli illustrated a programme for an event at the house of S. E. Tigrane Pasha, a candidate for prime minister in 1892 and a man who shared an anti-British sentiment with Khedive Abbas II. W. Abbate, *Le Caire Salon 1894*, Ralli's Archive, vol. 1, 63. Ralli organized tableaux-vivants attended by a select audience in the "salons du Lord High Commissioner." *Egyptian Gazette,* 18 February 1902, Ralli's Archive, vol. 3, 5.

[99] Naef, "Re-exploring Islamic Art", 165.

[100] Naef, Silvia. "Peindre pour être moderne? Remarques sur l'adoption de l'art occidental dans l'Orient arabe." In *La multiplication des images en pays d'Islam*. Edited by Bernard Heyberger and Silvia Naef, Band 2, 140-153. Würzburg: Ergon Verlag 2016, 141.

[101] Ramadan, Dina. *The Aesthetics of the Modern: Art, Education, and Taste in Egypt 1903-1952*. PhD thesis, Columbia University 2013.

[102] Scheid, Kirsten. "The agency of art and the study of Arab modernity." *MIT-Electronic Journal of Middle East Studies* (MIT-IJMES) 7 (Spring 2007): 6-23.

CHAPTER 5
HOW A CERAMIC VASE IN THE ART SALON CHANGED ARTISTIC DISCOURSE IN EGYPT

NADIA RADWAN

Salons, as mundane social practices, were held in the houses of the Egyptian elite from the end of the nineteenth century. These gatherings, dedicated to readings, discussion and debate about political, philosophical, scientific, artistic or literary subjects represented a space of social encounter and cultural exchange. The salon was also a space where official discourses were established and political agendas discussed. Exploring the Egyptian art salon in particular brings to the fore the significance of this space as a site where the politics of patronage materialised and taste and canon were established. In fact, it would be the particular setting of the salon that eventually enabled the emergence of counter-discourses which arose in reaction to the hegemony of certain canons. Also, the circulation of people and artworks between Egypt, the Middle East and Europe, was crystalised through the connective and creative aspects of the salon, and contributed to the emergence of new cultural practices. From this perspective, I shall argue that the politics of culture and their related art discourses emerged hand in hand with various forms of soft resistance in the framework of the early twentieth-century Egyptian art salon.

This chapter thus explores, on the one hand, the role played by key intermediaries through whom the migration of institutional models, such as the salon, was made possible. On the other hand, it underlines the contribution made by artists, intellectuals and patrons, in particular women, to subverting the space of the art salon. Indeed, the official Cairo Art Salon led to the formation of independent societies, such as the artistic group La Chimère. Other counter-voices within the space of the salon arose in parallel to the debate around arts and crafts, which was linked to the growing interest in decorative and applied arts that was promoted by industrial exhibitions and the establishment of new schools. These subtle signs of resistance were significant because they embodied a major questioning of the hierarchical

notion of "high" and "low" arts as defined by the politics of culture in Egypt and, accordingly, by the official Salon. The negotiation between these official and marginal spaces, and the transition from the institutional model of the French art salon to the creation of autonomous spaces, provided the conditions for the formation of Egyptian avant-garde movements that would develop at the end of the 1930s, such as the Egyptian surrealist group Art et Liberté.[1]

The Salon between Egypt and Europe

Like the contemporary salons in Europe, the Egyptian Salon was a mundane site for sociabilities,[2] often presided over by women from privileged backgrounds and held in their private homes. Some of these salons were renowned, such as that of Princess Samiha Hussein (1889-1984), patron, artist, and granddaughter of Khedive Ismail, or that of the intellectual Huda Sharawi (1879-1947), founder of the Egyptian Feminist Union. By the beginning of the twentieth century a multitude of literary salons, characterised by their cosmopolitanism, flourished in Cairo and Alexandria, among them the literary salon of the writer Amy Kheir, which included such personalities as Georges Duhamel, Jean Cocteau, Jean Moscatelli and Ahmed Rassim.[3]

The first salons in Egypt specifically dedicated to art were organized by patrons and art lovers, who mainly promoted French, British and Italian Orientalist artists.[4] Exhibitions were organised in the early 1890s by the Cercle Artistique, a society that published a review called L 'Arte.[5] The society

[1] Recently, Egyptian surrealism was the subject of important exhibitions, one entitled "When Arts Meet Liberty: The Egyptian Surrealists (1938-1965)," organized by the Sharjah Art Foundation and held at the Cairo Palace of Arts (28 September-28 October 2016), and the other "Art et Liberté: Rupture, guerre et surréalisme en Egypte (1938-1948)," an itinerant show inaugurated at the Centre Georges Pompidou in Paris (19 October 2016-16 January 2017). See the catalogue of the Paris exhibition: Bardaouil, Sam and Till Fellrath (eds.). *Art et Liberté: Rupture, Guerre, et Surréalisme en Égypte (1938-1948)*. Paris: Skira/Centre Georges Pompidou 2016. For a detailed study on Egyptian surrealism, refer to Bardaouil, Sam. *Surrealism in Egypt: Modernism and the Art and Liberty Group*. London: I.B. Tauris 2017.

[2] For a study about the French art salon and the concept of sociability, see: Lilti, Antoine. *Le monde des salons. Sociabilité et mondanité à Paris au XVIIIème siècle*. Paris: Fayard 2005.

[3] Other examples are the salon of the writer Henri Thuile held in Agami until 1922, and literary societies such as Les Amis de l'Art, founded in Alexandria in 1921, or Les Essayistes created in 1924. Luthi, Jean-Jacques. *La littérature d'expression française en Egypte (1789-1998)*. Paris: L'Harmattan 2000, 32-42.

[4] About the first Cairene art exhibitions, see Radwan, Nadia. *Les modernes d'Egypte: une renaissance transnationale des beaux-arts et des arts appliqués*. Bern: Peter Lang 2017, 61-63. Also see Mirka Palioura's chapter in this volume.

[5] For more details about the Cercle Artistique, see Volait, Mercedes. "Fragments d'une histoire artistique," *Qantara* 87 (2013): 24-27.

was headed by Onofrio Abbate Pacha (1824-1915), a prominent doctor from Palermo, who came to Egypt to serve as chief doctor to the khedivial army and became president of the Royal Khedivial Society of Geography in 1894. These first exhibitions were held in the Opera House in Cairo and featured mainly European artists, including several pupils of the famous French painter Jean-Léon Gérôme.

Another key figure was Prince Yusuf Kamal (1882-1967), an art lover and founder of the School of Fine Arts in Cairo in 1908.[6] He regularly held a salon in his private palace in Matariyya, north of Cairo, where he also exhibited his collection of antique objects and European artworks. These salons played a major role in defining the future of Egypt's cultural politics. For instance, it was most probably during one of his salons that Prince Yusuf Kamal became acquainted with the French sculptor Guillaume Laplagne (1870-1927), and started to conceive the idea of the first school dedicated to the fine arts in Cairo.

Whereas these first Egyptian salons were mainly animated by European artists, who travelled to Egypt at the end of the nineteenth century to establish their studios in Cairo or Alexandria or who came to work as drawing professors in technical schools, from the 1920s a flow of young Egyptian artists was moving in the opposite direction to complete their studies in Florence, Rome or Paris. Because they came to Europe on governmental grants, these artists experienced the tough selection process of the European art salon. It became an almost implicit requirement of their curricula to send their works to a European art salon, such as the Salon des artistes français or the Salon d'Automne. Thus, in addition to the diploma obtained at the end of the governmental grant, the salon functioned as a supplementary validation of artistic value, or, in other words, as a second institutional distinction. For instance, before the sculptor Mahmud Mukhtar (1891-1934)[7] passed the exam to enter the École des beaux-arts in Paris, his talent was asserted by the admission of his work *Aïda* to the Salon des artistes français in April 1914.[8] Moreover, Mukhtar's model

6 About the foundation of the School of Fine Arts in Cairo, see Radwan, *Les modernes d'Egypte*, 69-81.

7 The names of the artists and cultural actors have been transcribed according to their usual form in Latin script.

8 The sculpture was admitted under the title of *Aïda, amour d'esclave par M. Mouktar, artiste égyptien, élève de M. Laplagne et de M. Coutan.* Press cuttings from *Le Progrès Egyptien,* unsigned, 29 April 1914, Governmental Grant Documents, Egyptian National Archives. About Mahmud Mukhtar's Parisian experience and the impact of French modernism on his work, see Correa Calleja, Elka. *Nationalisme et Modernisme à travers l'œuvre de Mahmud Mukhtar (1891-1934).* PhD thesis, Aix-Marseille University 2014; Correa Calleja, Elka. "Modernism in Arab Sculpture. The Works of Mahmud Mukhtar," *Asiatishe Studien/Etudes Asiatiques* 70/4 (2016): 1115-1139.

for his famous sculpture, *Egypt's Awakening* (*Nahdat Misr*), which was to become the epitome of Egypt's cultural renaissance (*nahda*), was considered a national monument in Cairo only after the admission of its model to the Salon des artistes français in Paris. It was indeed this endorsement of the sculptor's talent and his success in Paris that led the Egyptian Wafd delegation to visit Mukhtar's studio and, consequently, to the decision to erect the monument in a public square in Cairo. Thus, admission to the Parisian salon constituted a major criterion for the value of artistic Egyptian production (Figure 1).

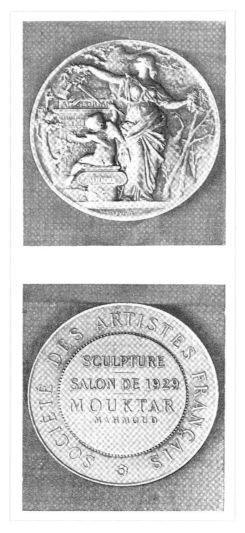

Figure 1: Medal received by Mahmud Mukhtar at the 1929 Sculpture Salon of the Société des artistes français, Paris, 1929, Courtesy of Imad Abu Ghazi.

Besides fixing artistic value, the European salon promoted genres –
and subsequently the taste for certain genres – that would dominate artistic
practice in Egypt. The painter Ahmed Sabry (1889-1955), for example,
participated for the first time in the Paris Salon d'Automne in 1929, with
a large portrait entitled *The Nun* that was exhibited at the Grand Palais and
received the Honorary Prize from the Société des artistes français.[9] On his
return to Cairo, Sabry specialised in portraiture, a genre that he had explored
at the École supérieure des beaux-arts in Nantes during his training with the
Breton painter Emmanuel Fougerat (1869-1958). Sabry became one of the
favoured portraitists of the Cairene bourgeoisie, whose growing taste for
this genre attested to a change in societal habits derived, to a large extent,
from frequenting an art salon. The acquisition of a portrait to decorate
one's household functioned as a distinctive sign of belonging to the more
discerning of the bourgeoisie and to a cultured society.

Some European salons also contributed both to creating and maintaining
political networks between Egypt and Europe. This was the case, for
instance, of the salon of the French writer and feminist Juliette Adam (1836-
1936), founder of the influential literary magazine, *La Nouvelle Revue*.
Adam had been a close friend of the nationalist leader Mustafa Kamel and a
fervent advocate of Egypt's independence. After the publication of her book
L'Angleterre et l'Egypte in 1922, in which she expressed her support for
the struggle against British occupation, many Egyptian writers and painters
visited her salons in her property in the Chevreuse Valley in France. The
Alexandrian painter and diplomat Muhammad Nagy (1888-1956), as well
as his sister, the artist Effat Nagy (1905-1994), regularly attended Adam's
salons. Nagy took this opportunity to paint her portrait (1922-23), which
would be presented for the first time in Cairo at the salon of the artistic
group La Chimère in 1924.

Thus, while the Egyptian salon brought together various patrons and
artists and began to define the official trends of modern Egyptian art, the
European salon acted as an arbiter of canon and value. They shared, however,
common points in that they both represented major relays for the circulation
of cultural actors – whether patrons or artists – and both functioned as spaces
where the politics of taste were delineated and new artistic practices defined.

Institutional Patronage and Taste-making

The movement of artists and the migration of institutional models from
Europe to Egypt had a major impact on the creation of artistic societies.

9 Ahmed Sabry's work *The Nun* is today in the residence of the representative of the
 Egyptian mission to the United Nations in New York.

Among the most important of these associations in Egypt was the Society of the Lovers of Fine Arts (Jam'iyyat muhibbi al-funun al-jamila), founded in 1923 on the initiative of Prince Yusuf Kamal.[10] The members of its first Committee not only reflected its political power, but also attested to the growing network of Egyptian cultural actors and patrons who would dominate the national cultural landscape over the coming decades. The administration was led by Prince Yusuf Kamal as president; the businessmen Muhammad Muhib and Emile Miriel as vice-presidents; the collector and politician Muhammad Mahmud Khalil was secretary general; the politician Yusuf Qatawi was treasurer; and the critic and curator Fuad Abdel Malik and the French painter Charles Boeglin were elected secretaries.

It is interesting to note that in the official documents written in French, the Society is designated by the name of Society of the Friends of Art (Société des amis de l'art), whereas the documents in Arabic mention it as the "Society of the Lovers of Fine Arts" (Jam'iyyat muhibbi al-funun al-jamila). This distinction shows to what extent, in Arabic, it was important to emphasise the notion of the "fine arts" (*al-funun al-jamila*) – which in the French version is implicitly understood in the term "art" – to differentiate it from the generic word *fann* that would comprise all the arts including decorative and applied arts. Thus, the use and understanding of the term "fine arts" was not only echoed in new artistic practices, but also became the means to express a certain level of education and the understanding of a "high" culture, as defined by the European canon.

The Society established the annual Cairo Art Salon in 1920, which would rapidly determine the official criteria of art production as well as lead public taste for almost half a century. Indeed, from then on, visiting an exhibition, understanding and collecting art became a distinctive expression of progress and modernity. According to certain critics, the idea of establishing a salon in Cairo was first formulated by the curator and secretary of the Society, Fuad Abdel Malik, who organized several "Spring exhibitions" between 1920 and 1922 before suggesting to the members of the Society that they should hold an annual event called the Cairo Art Salon in reference to the Salon des artistes français.[11] Thus the institutional model for the new Cairene event was the French salon. However, contrary to

10 The Society of the Lovers of Fine Arts distinguished itself from other Egyptian societies of that time by its longevity, as it still exists today. Its headquarters are located in Ahmed Pasha Street in the Garden City neighbourhood of Cairo.

11 Salim, Ahmad Fuad. *Shahid 'iyyan 'ala harakat al-fann al-misri al-mu'asir* [*Witness of the Contemporary Egyptian Art Movement*]. Cairo: al-Hay'a al-misriyya al-'amma li al-kitab 2008, 164. Fuad Abdel Malik was also the founder of the wax museum in 1934, located since 1955 in the Helwan district of Cairo.

the latter, which usually presented the works of laureates of the École des beaux-arts, participation at the Cairo Art Salon was open to professionals as well as to the many amateurs working in Egypt at that time. The artworks were nevertheless submitted for selection by a jury composed of members of the Society. From 1923 to 1928 the event was held in a villa located in the neighbourhood of Bulaq, before it was transferred to the Tigrane Palace.[12]

A number of the early amateur participants in the Cairo Art Salon were members of the court or the royal family, who practiced painting or sculpture as dilettantes. For instance, the 1923 Salon, inaugurated by King Fuad I, exhibited Prince Muhammad Ali's paintings, a series of portraits of royal family members by Mahmud Sabit, the King's Second Chamberlain, and the sculptures of Princess Samiha Hussein, one of the first women to exhibit in the Salon.[13] Besides the royal family, there were young Egyptian artists newly graduated from the School of Fine Arts in Cairo, such as Ahmed Sabry and Ragheb Ayad, as well as their professors, the decorator James Alfred Coulon and the painter, critic and caricaturist Juan Sintès.

The Cairo Art Salon opened the way to art criticism, and influenced the evolution of the artistic scene to the point where certain critics based their opinion essentially on the works presented at the Salon when they discussed the Egyptian contemporary art scene. The critic Morik Brin, for instance, talking about the 1935 Salon, affirmed that

> the success of the Cairo Art Salon, not only with regards to the artists but also to its public, attests to the fact that there is currently in Egypt an artistic movement that is of much greater importance than one may generally think in Europe and even in Egypt.[14]

Thus, the Cairo Art Salon had a significant impact on a burgeoning artistic milieu. It not only contributed to the development of art criticism, but also to the formation of a growing audience and, consequently, of an art market. A close study of the press from the beginning of the 1920s until the end of the 1930s shows that the number of participants increased significantly year by year. Moreover, their lists reflected the cosmopolitanism of the event. The enumeration of the artists exhibiting in the 1928 Salon was emblematic of its cultural variety, as it counted 50 Egyptians, 12 Greeks, 10 French,

[12] Sintès, Juan. "Le Salon du Caire 1923", *L'Egypte Nouvelle*, March 1923, 7.

[13] According to the painter and critic Juan Sintès, Princess Samiha Hussein presented some "patriotic works" including a sculpture entitled *Awakening* in the 1923 Salon. Sintès, "Le Salon du Caire 1923," 7.

[14] Brin, Morik. *Peintres et sculpteurs de l'Egypte contemporaine*. Cairo: Les Amis de la Culture française en Egypte 1935, 55.

10 British, six Turks, five Austrians and dozens of Armenians,[15] as well as a few Swiss, Belgians, Hungarians, and Czechoslovakians.[16] The Cairo Art Salon would also include a number of women, who were denied access to art education at the School of Fine Arts in Cairo at that time.[17] For them, the salon represented an alternative space through which they could integrate in the contemporary art scene.

The Cairo Art Salon was linked to cultural politics and remained a space that conveyed a dominant official discourse. This discourse was consolidated by an influential figure, the politician and art collector Muhammad Mahmud Khalil (1877-1953), who replaced Prince Yusuf Kamal as president in 1932 and headed the Society of the Lovers of Fine Arts as well as the jury of the Cairo Art Salon until 1951.[18] Thus, for more than twenty years under his patronage, the major international art events in Egypt would be affected by his taste and personality to the point that his name would become inseparable from that of the Society of the Lovers of Fine Arts. Khalil, who was named several times senator and became minister of agriculture in 1937, spent his life between Cairo and Paris where he had studied Law at the Sorbonne. Through his multiple activities as a politician, businessman and patron, and especially, through his dual identity in Egypt and France, he played a significant role as a cultural intermediary between both countries. It was indeed thanks to his network with curators from the Louvre and the Musée du Luxembourg that he managed to import artworks from French Museums for display in Egypt. It was also his ties with the French political elite that would lead him to be named curator of the Egyptian Pavilion at the international exhibition in Paris in 1937.

It was in the French capital that he met his wife, the French comedian Emilienne Hector Luce. The Khalils acquired an important collection

[15] Generally, the Armenian presence in the Salon was significant from one year to another and reflected the important contribution of this community to the development of the Cairene artistic scene. This is underlined in Aimé Azar's book on Armenian painters in Egypt. Azar, Aimé. *Peintres arméniens d'Egypte*. Cairo: Imprimerie française 1953.

[16] Hostelet, Christiane. "La Peinture au Salon 1928 des Amis de l'Art", *La Semaine Egyptienne*, special Christmas edition, December 1928, 9.

[17] The subject of Egyptian women artists and art education has been discussed elsewhere: Radwan, Nadia. "Ideal Nudes and Iconic Bodies in the Works of the Egyptian Pioneers." In *Art, Awakening and Modernity in the Middle East: The Arab Nude*. Edited by Octavian Esanu, London: Routledge 2017.

[18] Muhammad Mahmud Khalil was chosen to head the Society of the Lovers of Fine Arts in February 1932, at the time when Yusuf Kamal renounced his title of prince following a conflict with the government of Prime Minister Muhammad Mahmud. "Tanazil al-amir Yusuf Kamal 'an laqabihi" ["Prince Yusuf Kamal renounces his title"], unsigned, *al-Musawwar*, 22 April 1932, 2-3.

of French Impressionist and Post-Impressionist art including works by
Monet, Manet, Rodin, Gauguin and Van Gogh, to name but a few, which
were displayed in their mansion in Giza.[19] Khalil's taste for French art
was reflected in the events organized by the Society of the Lovers of Fine
Arts, such as the "Exposition d'art français au Caire: 1827-1927" held in
the Tigrane Palace in 1928. Beyond the themes of the exhibitions, Khalil's
patronage and taste clearly guided the selection criteria for admissions to the
Art Salon and, to a certain extent, public taste. The Society's acculturating
endeavour was underlined by Khalil himself, who affirmed that

> the goal of the Society of the Lovers of Fine Arts was, in the minds
> of those who created it in 1923, on the one hand, to raise awareness
> about foreign art and artists amongst the young Egyptian artists, who
> didn't have at their disposal the numerous museums of the European
> capitals.[20]

As the Cairo Art Salon became the artistic establishment and set the trends
of the contemporary art scene, dissident voices started to criticise the
overshadowing personality of Muhammad Mahmud Khalil and his control
over artistic production. This is reflected in a satirical image by the painter
and sculptor Muhammad Hassan (1892-1961) entitled *La Dictature des
Beaux-Arts* (1939) (The Dictatorship of Fine Arts), which shows Khalil on
a pedestal being saluted as the "*Führer*" of the Fine Arts by the journalist
Georges Rémond, who was named controller of the Fine Arts in Egypt, and
the painter Pierre-Beppi Martin, who was professor at the School of Fine
Arts in Cairo at the time (Figure 2). The caricature reflects the authority
of the collector over the art world, as well as French domination of the
Egyptian institutional structure. Furthermore, Hassan was a fervent advocate
of training in the domain of applied arts, as he had studied decorative arts
in Britain and in 1933 would become director of the School of Applied Arts
in Cairo. From that perspective, his caricature could also be understood as
an implied criticism of the French institutional and educational model of the
École des beaux-arts in Egypt.

19 The Khalil mansion was constructed at the beginning of the twentieth century in an
 eclectic classicising style on the shores of the Nile in Giza (1, Kafur Street). It was in-
 augurated as the Muhammad Mahmud Khalil Museum in 1962. International attention
 was brought to the Khalil collection by an exhibition held in 1994 at the Musée d'Orsay.
 See the catalogue: Lacambre, Geneviève, "Les oubliés du Caire : Chefs d'œuvres des
 musées du Caire" (Paris, Musée d'Orsay, 5 October 1994- 8 January 1995), Paris:
 AFAA; MO 1994.
20 Khalil, Muhammad Mahmud. "La Société des Amis de l'Art", *La Revue du Caire*, spe-
 cial issue, May 1952, 106.

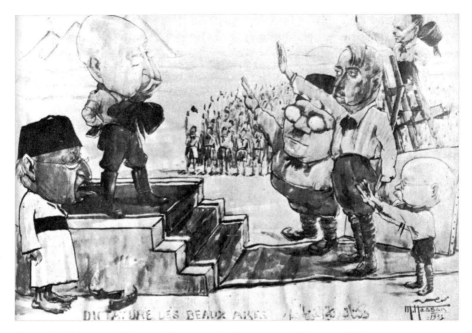

Figure 2: Muhammad Hassan, *Dictature des Beaux-Arts*, Al-Imara, 1939.

Hassan's caricature echoes certain counter-voices that started to arise in the 1920s among the artistic community against the official discourse and the domination of the Society of the Lovers of Fine Arts and its salon. This challenge opened the way for other societies to spring up proclaiming their freedom and independence, such as La Chimère (the Chimera). This group was founded in 1924 by Mahmud Mukhtar and the French painter Roger Bréval, who was a graduate of the École des arts décoratifs in Paris and taught at the School of Fine Arts in Cairo.[21] Unlike the Society of the Lovers of Fine Arts, La Chimère's objective was neither to organize major international exhibitions of French art, nor to educate the Egyptian audience in the canons of the European Schools, but to promote an "independent renaissance"[22] through a local and cosmopolitan cultural scene formed by artists working in Egypt. The name of the group evoked the fantasy, the mystery, the dream and the eroticism embodied by this fabulous monster,

[21] The Committee of La Chimère was constituted as follows: Mahmud Moukhar, President, Albert Mizrahi, Vice-President, Roger Bréval, Treasurer, Charles Boeglin, Secretary, Mahmud Said and Jacques Hardy, Advisers. Letter of the Committee of La Chimère addressed to Mahmud Mukhtar, Cairo, 17 October 1927, Imad Abu Ghazi Archives.

[22] Caneri, José, De Laumois, André et al. *Un pionnier de l'art français en Egypte: Roger Bréval*. Cairo: Les Amis de la Culture française en Egypte 1938, 24.

which was dear to symbolists such as Gustave Moreau. Its emblem, a winged female sphinx in Art Déco style, was designed by Roger Bréval and echoed his work between 1912 and 1913, under the supervision of the Nabi painter Maurice Denis, on the decoration of the cupola of the Theatre of the Champs-Elysées. The allusion to the chimera and its symbolism broke with the rigid universe of the official Society and the Cairo Salon and prefigured, in a sense, the emergence of avant-garde groups. The surrealist group Art et Liberté and the Egyptian Group of Contemporary Art would later break away more radically from the established art world and express clear political opinions.

The first exhibition of La Chimère was held in December 1924 in the workshop of Roger Bréval in Antikhana Street in downtown Cairo. Many artists had established their studios around this street, and the neighbourhood was a sort of Cairene Montmartre, where a bohemian atmosphere prevailed and creative freedom could be expressed without constraint. Among the participants in this first exhibition were the painters Muhammad Nagy, Mahmud Said, Roger Bréval and Charles Boeglin. It has to be emphasised that despite La Chimère's intention to distance itself from the Society of the Lovers of Fine Arts, it was essentially composed of powerful personalities from the political and financial worlds. It thus appears that the audience who attended the first exhibitions of La Chimère was similar to that at the Cairo Art Salon.[23] This signifies that in the 1920s, despite the goal of art societies to democratise these events, they remained limited to a privileged social class that also had the financial means to acquire artworks.

Nevertheless, following the success of its first exhibition, which presented more than a hundred works to the public, La Chimère regularly organized shows in Roger Bréval's workshop. Until December 1926 the shows were announced as "Exhibitions", until the group decided to give them the name of "Salon". Although the artists of La Chimère regularly presented their works at the Cairo Art Salon, they undoubtedly adopted the new name in order to subvert the official institution. In this sense, the Salon of La Chimère can be considered as an Egyptian version of the Salon des indépendants in Paris, characterised by the absence of a jury. In 1929, on a postcard showing the Salon of La Chimère sent by Mahmud Mukhtar to his Parisian companion Marcelle Dubreil, who was his model for a number of sculptures, he proudly announced that "La Chimère was not any more a Chimera" (Figure 3).

23 The visitors of the exhibition included Henri Gaillard, Minister of France in Egypt, Mazloum Pasha, President of the Chamber of Deputies, Emile Miriel, President of Egyptian Land Credit, as well as Muhammad Mahmud Khalil. Gaudet, J. B., "Une exposition au studio Roger Bréval", *L'Egypte Nouvelle*, 27 December 1924, 9.

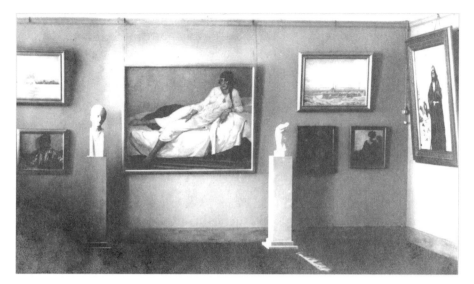

Figure 3: The Salon of La Chimère held in 1929 in the workshop of Roger Bréval in Antikhana
 Street. Postcard sent by Mahmud Mukhtar to his Parisian companion Marcelle Dubreil
 and co-signed by Roger Bréval and Louis Marcerou, Cairo, 7 December 1929. Courtesy
 of Imad Abu Ghazi.

Challenging the Canon: Women and the Validating of Arts and Crafts

As mentioned, women belonging to the elites had been the first to establish
art salons in their private homes as spaces for social encounter, an activity
that could function as a palliative for their lack of access to the public
sphere. The feminist Huda Sharawi (1879-1947) recalls in her memoirs
how stimulating and liberating it was for her in her youth to frequent the
weekly Salon of Eugénie Le Brun, a Frenchwoman married to the politician
Hussein Rushdi Pacha, who became prime minister in 1914.[24] Sharawi
would later organise her own salon and become an important patron of the
arts. She supported many artists financially, including Mahmud Mukhtar,
after whose death in 1934 she founded the Society of Mukhtar's Friends
which organized an annual prize to encourage young sculptors. She was also
the first to call for the restitution to Egypt of Mukhtar's sculptures that had
stayed in Paris after his death.[25]

[24] Sharawi, Huda. *Harem Years: The Memoirs of an Egyptian Feminist*. Translated from
 Arabic by Margot Badran, Cairo: The American University in Cairo Press 1998, 19.

[25] Nabaraoui, Céza. "Pour que l'œuvre de Mukhtar revienne à l'Egypte", *L'Egyptienne*,
 June 1934, 2-7.

Together with Princess Samiha Hussein, Sharawi decided to found the Women's Committee of the Society as a feminine counterpart to the Society of the Lovers of Fine Arts. Many of its members were the wives or daughters of Society members and their activities were recounted in the monthly *L'Egyptienne*. This magazine, founded in 1925 by Huda Sharawi and directed by Sayza Nabarawi, regularly published articles on women's rights, focusing in particular on access to public education, minimum marital age, divorce and polygamy. Thus, Egyptian female art patronage was strongly linked to the domains of education and charity. The women engaged in activities that had long been dominated by female colonial charitable organizations.

Huda Sharawi also founded an artisanal school in 1924 in the poor neighbourhood of Rod al-Farag in north Cairo to offer free training in pottery and ceramics to young Egyptian girls and boys. The school's educational endeavour included the aim to present a discourse of authenticity based on the revival of traditional arts and crafts. Its training would ensure an income to the craftsmen by selling the ceramic objects that were produced, according to the official advertisement, "by the children of the country in the purest Egyptian tradition." This was, of course, pure invention because the Rod al-Farag School was directed by the French artist James Alfred Coulon, who was also a professor at the School of Fine Arts in Cairo, and Sharawi had financed the young craftsmen's trip to France to be trained in the best workshops of the Sèvres manufactory.[26]

A photograph published in *L'Egyptienne* shows a collection of large enamelled vases and plates finely decorated with interlacing floral and geometrical elements, as well as with Arabic calligraphy, elegantly arranged on a tablecloth-covered piece of furniture decorated with flowers (Figure 4). Thus, the pieces supposedly produced by the "children of the country" testified to the technical mastery of highly qualified craftsmen. Beyond the school's social endeavour, Sharawi's ambition was equally to elevate the status of ceramics to that of artworks. To this end, she encouraged elite patrons to acquire the pieces produced in the school's workshops. These were sold at relatively high prices and displayed in the luxurious windows of the Parisian department stores of Le Bon Marché in Cairo.

[26] Marcerou, Louis. "Une Renaissance de la céramique arabe en Egypte," *L'Egyptienne*, special issue, 49.

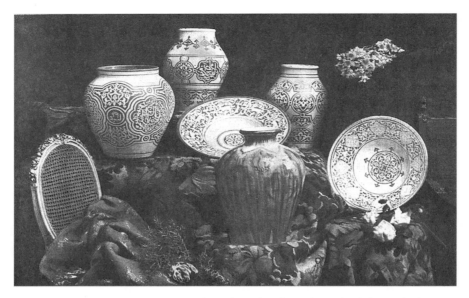

Figure 4: Photograph of the ceramics of Huda Sharawi's school in Rod al-Farag. *L'Egyptienne*, October 1926.

The second step, and probably the most significant, was that Sharawi tried to get the ceramics admitted to the Cairo Art Salon. She succeeded in 1924, when a ceramic piece of Rod al-Farag was selected to be exhibited among the paintings and sculptures chosen by the jury. From then on, the works of Sharawi's school would be exhibited annually at the Salon. The acquisition of a large vase by Queen Nazli at the 1929 Salon, intended to adorn one of the royal palaces, marked the project's crowning achievement. The introduction of ceramics in the Salon was a major step in the elevation of ceramic handicrafts to the status of art, which had previously been reserved for the so-called "high" arts, such as easel oil painting and sculpture. The admission of ceramics may have also benefited from the favourable conditions linked to a growing interest in the revival of decorative arts exhibited at the Agricultural and Industrial Exhibition held in Cairo in 1926, followed by the announcement by the Ministry of Public Instruction in January 1928 of the creation of the School of Decorative Arts (Figure 5).

Figure 5: Publicity for the ceramics of the Rod al-Farag School. *L'Egyptienne*, April 1927.

Besides the Rod al-Farag School, which Huda Sharawi financed entirely privately, other handicraft training projects were implemented through the Egyptian Feminist Union. For instance, towards the end of the 1920s, a weaving workshop was established in the premises of the Egyptian Feminist Union located at the foot of the Citadel. Sharawi's pilot projects in the traditional crafts of ceramic and tapestry were unprecedented in Egypt, in that they contributed to elevating the status of so-called "low" arts to that of "high" arts, a concept that had been at the heart of intellectual debates since the creation of the School of Fine Arts in Cairo. Indeed, the common idea that the fine arts – imported from the West – would replace decorative and applied arts – rooted in local tradition – had been an important subject of public debate,[27] but women intellectuals remained pioneers in that they were the first to establish actual projects. Indeed, they proposed a soft resistance to the high/low distinction that had been imposed by the migration of European institutional models and strengthened by Khalil's Society of the Lovers of Fine Arts. Their success was due, on the one hand, to the admission of ceramic pieces to the Salon and, on the other hand, to the political discourse that accompanied the fabrication of these objects and stimulated both the social vocation and nationalist sentiments of the feminine elites.

Huda Sharawi's schools opened up ways to reflect on the resurgence of traditional know-how, and contributed to the promotion of craftsmanship and the elevation of the status of the craftsmen. They can be considered as the first attempts to create a renaissance (*nahda*) of traditional arts, whose main objective was to redefine Egyptian identities through the upgrading of local know-how. This idea would have a preponderant influence in the 1940s on many artists, who began to look for ways to create this artisanal *nahda*. Indeed, they laid the foundations for the later projects of craft schools founded by the pedagogue Habib Gorgui (1892-1965) and by his son-in-law, the architect Ramses Wissa Wassef (1911-1974).[28]

Decorative Arts and the Egyptian Pavilion in Paris: A Heated Debate

Women intellectuals' subversion of the official discourses conveyed by the Society of the Lovers of Fine Arts did not happen without tension. Indeed, a serious clash between Huda Sharawi and Muhammad Mahmud

27 On the debate about fine arts and applied arts in Egypt's artistic renaissance, see: Radwan, *Les modernes d'Egypte*, 81-88.

28 Radwan, Nadia. "Les arts et l'artisanat." In *Hassan Fathy dans son temps*. Edited by Leïla El-Wakil, 104-123. Gollion/Paris: Infolio 2013.

Khalil would lead to the secession of the Women's Committee from the Society. This conflict would be publicly revealed when Muhammad Mahmud Khalil was named artistic director and curator of the Egyptian Pavilion in the 1937 Paris international exhibition. The Egyptian women, together with several personalities from the cultural sphere, started to question his curatorial choices. First of all, Sayza Nabaraoui criticized him for exhibiting only the most notorious Egyptian artists, such as Mahmud Mukhtar, Muhammad Nagy and Mahmud Said, thus excluding younger artists. Moreover, she regretted that one of the famous works by Mahmud Said, a large panel entitled *The City*, had been exhibited in the curator's private office reserved for high-ranking guests, therefore depriving the audience of what she considered "the most representative painting of modern Egyptian trends and techniques". She also underlined the absence of "national character" in the design and scenography of the Pavilion, even going so far as to describe Khalil as "the most foreign man of all to real Egyptian life".[29]

Nabaraoui pointed out the hierarchy in Khalil's scenography between traditional crafts, such as ironwork, stained glass and furniture, produced by the students of the Giza School of Applied Arts, and the works by already famous artists such as Nagy and Said. The reason behind this criticism was that despite the fact that Khalil had admitted the Rod al-Farag ceramics to the Salon, the overall curatorial orientation of the Egyptian Pavilion maintained the distinction between the fine arts and decorative arts. In other words, the Egyptian women would have envisaged a scenography in which the craftsmen would come out of anonymity to be valorised as individuals. In order to support this argument, they had even conducted a survey among craftsmen in the Khan al-Khalili market to find out whether they had been involved in the Pavilion's scenography. It proved that no Cairene craftsmen had been involved in this.[30] The report of the Exhibition, however, mentions a large decorated bay with a stained-glass window executed by Cairene craftsmen, presumably according to the traditional method of *qamariyya*.[31] One may deduce that this type of work was carried out by the students of the School of Applied Arts, or that some ancient objects were taken directly from old Cairene mansions and brought to Paris to be redeployed in the Pavilion, as was often the case

29 Nabaraoui, Céza. "Comment l'art et la technique moderne sont représentés à l'Exposition de Paris," *L'Egyptienne*, June 1937, 14.

30 Nabaraoui, "Comment l'art et la technique moderne sont représentés", 15.

31 Labbé, Edmond (ed.). *Exposition internationale des Arts et Techniques dans la Vie moderne: Paris 1937. Rapport général présenté par Edmond Labbé: les sections étrangères*, vol. 9, Paris: Imprimerie nationale 1940, 162.

in international exhibitions since the nineteenth century. Khalil himself would later defend himself against these criticisms, affirming that even the smallest details of the Pavilion, its stained glass windows, sculptures, paintings, ironworks, decorative objects and reliefs, all came from Egypt.[32]

One important issue that may explain the virulence of the Egyptian women's criticism of Khalil was that he unexpectedly decided to exclude the Rod al-Farag ceramics from the Egyptian Pavilion. Indeed, in October 1936, the Organizing Committee of the Paris Exhibition had asked Huda Sharawi to select the pieces that would be exhibited in the Pavilion. However, while the ceramics were packaged and prepared for export, the Committee reversed its decision on the grounds of lack of space. James Alfred Coulon, then director of the workshops of Rod al-Farag and of the decorative section of the School of Fine Arts in Cairo, suggested that Sharawi could instead exhibit her ceramics in the French section of "Oriental Ceramics." However, Muhammad Mahmud Khalil strongly opposed this decision and the ceramics of Rod al-Farag never travelled to Paris.

While this episode seems to reveal conflicting political and cultural agendas, it also highlighted the debate about the distinction between "high" and "low" arts initiated by the exclusive institutional model of the official art salon. Indeed, Egypt's presence, for the first time, as an independent nation at an international exhibition marked a rupture with the past and opened a new space for a debate on the notion of art and the role of patronage in the Egyptian context. From the moment a ceramic vase entered the Cairo Art Salon, applied arts were acknowledged as a major traditional and living practice, as shown by the debate between the Egyptian women and Muhammad Mahmud Khalil.

Conclusion

The Cairo Art Salon led to the creation of new spaces of debate as well as new artistic practices. Such events defined the criteria of art production and public taste, while they inspired new societal practices. Khalil's Salon was rapidly associated with the establishment and the official canon, whereas "counter-salons" that were independent from the authority of the collector's Society emerged soon after on the Cairene artistic scene. Newly founded artistic groups, such as La Chimère, claimed the salon as a space that was free from the jury's edicts and was instead a space of artistic self-determination. For Egyptian women intellectuals, the salon represented a space to invest in the public sphere and express political claims. The salon

32 Khalil, "La Société des Amis de l'Art," 108.

was not only a space of social encounter, but also an alternative to colonial cultural and charitable organizations. Linked to social endeavours, it enabled the elevation of the status of traditional arts and opened up a crucial debate underlying the discourse of identity politics. Overall the Egyptian Salon – or, rather, salons – attested to a constant cross-cultural exchange by bringing to the fore the connective and creative aspects, as well as the impact of the migration of institutional models and cultural transfer on the formation of Egyptian artistic modernism.

PART III
DEFIANCE AND ALTERNATIVES

CHAPTER 6
DEFYING THE ORDER FROM WITHIN: ART ET LIBERTÉ AND ITS REORDERING OF VISUAL CODES*

MONIQUE BELLAN

Le moyen le meilleur d'asphyxier un grand talent, c'est de l'acadé-
miser. Et après tout, c'est bien sa faute s'il se laisse faire.[1]

Georges Henein, 1936

This chapter addresses the subversive potential of the exhibition practices of the Surrealist Art et Liberté group (1938-1948) in Egypt – especially their exhibition catalogues and invitation cards. In what ways did the members of Art et Liberté attempt to challenge the established order and break with its visual codes? Against what did they level their criticism and what were their objectives? The following discussion attempts to show how the Surrealists tried to reorder existing conditions while aiming to preserve, and not to demolish, the basic structures. Of particular interest is the Surrealists' attitude towards academic art and conventional exhibition formats such as the salon. The Surrealist practices in general are contextualised, and some of the particular approaches and objectives of Art et Liberté are examined.

Throughout the twentieth century, numerous avant-garde movements attempted to break with the bourgeois order and undermine its moral,

* Translated from German by Christine O'Neill.
 I am grateful to Sam Bardaouil who generously provided me with images of the catalogues and invitation cards.
[1] "The best way to stifle a great talent is to academise it. Though it is its own fault if it allows this to happen."
 Thus wrote the Egyptian poet Georges Henein (1914-1973) during his stay in Paris from May to September 1936, in his contribution "Hommage aux inflexibles" which appeared in the journal *Les Humbles* in Paris. Alexandrian, Sarane. *Georges Henein*. Paris: Seghers 1981, 19-20.

aesthetic, and political claims to hegemony. Their respective goals and methods were as diverse as the movements themselves, but always moved within the structure of the existing order. As sociologist Pierre Bourdieu pointed out, these struggles for power and ultimately for social recognition were an outcome of the structure of the field itself, namely, its "antagonistic positions (dominant/dominated, generally accepted/newcomer, orthodox/heretical, old/young etc.)."[2] The bourgeois order, whose social, political and aesthetic conventions did not leave any space for the irrational or for political participation in the sense of a role for the community, also provided a framework for the Surrealist movement in Egypt.[3]

Art et Liberté (al-Fann wa-l-hurriyya) was closely connected with French Surrealist thinking and its protagonists André Breton (1896-1966), Philippe Soupault (1897-1990), Louis Aragon (1897-1982), and Paul Éluard (1895-1952). Georges Henein (1914-1973), poet and spokesman of the group, was in personal communication with André Breton, whom he had met in Paris in 1936. As early as 1935, in the journals *Un Effort* and *Les Humbles*,[4] Henein had professed Surrealism, which he considered "the most ambitious attempt of our epoch against obscurantism."[5] He joined the Surrealists and, in late December that year, wrote a letter to André Breton with numerous suggestions regarding the movement's role. Breton did not reply until 8 April 1936.[6] Recognising Surrealism in Egypt, he wrote: "The

2 "Die aus der Struktur des Feldes selbst, das heißt aus den synchronen Gegensätzen zwischen antagonistischen Positionen (dominant/dominiert, allgemein anerkannt/Neuling, orthodox/häretisch, alt/jung usw.) hervorgehen...". Bourdieu, Pierre. *Die Regeln der Kunst. Genese und Struktur des literarischen Feldes*. 7th edition. Frankfurt/Main: Suhrkamp 2016, 379.

3 In connection with Art et Liberté, Abdel Kader el-Janabi talks of a Surrealist intention rather than a movement: "For the main characteristic of a movement is to be a natural outcome of the theoretical turmoil situated in time, thereby accomplishing a necessary change of outlook. An intention, on the other hand, is always a proposition which certain individuals introduce into public debates thinking that they effect a movement of ideas that can bring about a sought-for change." Kader el-Janabi, Abdel. *The Nile of Surrealism. Surrealist Activities in Egypt*. (1987), accessed 17 January 2018, http://www.egyptianSurrealism.com/index.php?/contents/the-nile-of-Surrealism/.

4 The former was a publication by *Les Essayistes*, a francophone literary group in Cairo to which Henein belonged; the latter a Marxist-Leninist journal published in Paris. Bardaouil, Sam. *Surrealism in Egypt. Modernism and the Art and Liberty Group*. London and New York: I. B. Tauris 2017, 5.

5 "Si nous y regardons d'assez près le surréalisme représente la plus ambitieuse tentative de notre époque dirigée contre l'obscurantisme." Alexandrian, *Georges Henein*, 16.

6 Extract from a letter by Breton to Henein: "...Je sais que les propositions que vous faisiez, quant au rôle que nous pouvons avoir, ont été prises en grande considération, je veux dire très particulièrement retenues mais certes vous vous faites des illusions à distance: le fait est que qu'il nous a été, malgré nos efforts, tout à fait impossible de con-

imp of the perverse, as he deigns to appear to me, seems to have one wing here, the other in Egypt."[7]

The language of Art et Liberté when referring to its own practices was of "free" or "independent" art and not of "Surrealist" art. Its members described the exhibitions they organised as "Expositions de l'art indépendant" and not as "Expositions surréalistes." This was partly because the group was very heterogeneous and not all its members were associated with specifically Surrealist techniques. Moreover, "freedom" and "independence" were widely known terms and more tangible than "Surrealism." They shared less of a strictly applied uniform artistic vision and technique than was the case with Breton and his group. Their objective was rather for change in the status quo through the replacement of existing material and the dissolving of ideational boundaries. Based on the manifesto of the FIARI (International Federation of Independent Revolutionary Art) that André Breton and Léon Trotsky had drawn up in the house of Frida Kahlo and Diego Rivera in Mexico in 1938, the members of the Egyptian group were similarly influenced by Freud's theories and vehemently opposed fascism, imperialism, and the Egyptian feudal system. The label Art et Liberté was also a reference to the group's programme, which elevated "art" and "freedom."

Surrealism had aimed to overcome all antagonisms and thus all boundaries. This included the contrasts between dream and reality, the conscious and the unconscious, or states of sleep and wakefulness. The Surrealists criticised the prevailing political and social conditions and academic art as well as the traditional concepts of art that, above all, were associated with the ideas of the beautiful and the good. Finally, they rejected any moral concepts relating to these. They were convinced that all academic art moulded any talent according to its standards, thus robbing the artist of his imagination and sensuous perceptiveness. However, this remained the responsibility of the artist who was by no means considered a victim, as the opening quotation from Henein showed: "Though it is its [referring to talent] own fault if it allows this to happen." ("Et après tout, c'est bien sa faute s'il se laisse faire"). When André Breton drew up the first Surrealist manifesto in Paris in 1924, he built on the existing protest culture of Dada, a movement from which he himself had emerged. For Dada and later for Surrealism, the terrifying experience of World War I was crucial, as was the stiflingly

certer une action un peu suivie avec ceux que vous dites et à qui nous pensions, en effet, principalement. Voici trop d'années que les forces oppositionnelles se sont constituées en groupes autonomes et rivaux pour qu'ils nous appartienne à les unifier, de les aider à se constituer en un tout menaçant...." Alexandrian, *Georges Henein*, 17.

7 Bardaouil, *Surrealism in Egypt*, 6. French original: "Le démon de la perversité, tel qu'il daigne m'apparaître, m'a bien l'air d'avoir une aile ici, l'autre en Egypte." Alexandrian, *Georges Henein*, 17.

oppressive spread of fascism that followed. The concept of an *amour fou* (Breton)[8] was consequently elevated as an ideal that was meant to challenge the bourgeois values manifested in the rigid and constrictive structures of family, religion, and nation. This concept represented an irrationality and intensity that exploded all limitations and stood for the uncontrollable and eruptive, but also for impermanence and the rejection of any form of institutionalisation and definition. The ideal of freedom that the Egyptian group Art et Liberté announced in its name, found its equivalent here.

The Founding of Art et Liberté

Art et Liberté was founded in Cairo on 22 December 1938 by a group of young writers and artists who dedicated themselves to intervening in social and political questions by means of art. Leading among them were poet Georges Henein, painter, critic and later film-maker Kamel al-Telmissany (1915-1972), author Anwar Kamel (1913-1991) and his brother, the painter Fuad Kamel (1919-1973), as well as theoretician and painter Ramses Yunan (1913-1966).[9] They took a stand not only in relation to internal Egyptian affairs, as their founding manifesto *Vive l'art dégénéré* (Long live Degenerate Art) attested, but also declared their solidarity with those European artists whose art was deemed degenerate by fascist regimes.[10] The statutes of Art et Liberté of 9 January 1939 declared that the group had been founded "for the defence of the freedom of art and culture, and to circulate up-to-date books, to offer lectures, and to apprise Egyptian youth of literary, artistic and social movements in the world."[11] Art et Liberté published a periodical – *al-Tatawwur*[12] – and had an office at 28 Madabegh Street in Cairo, an address that was printed in each

8　Breton, André. *L'Amour fou*. Paris: Éditions Gallimard 1937.

9　Bardaouil, *Surrealism in Egypt*, 3.

10　"…We believe that it is mere idiocy and folly to reduce modern art, as some desire, to a fanaticism for any particular religion, race or nation … O men of art, men of letters! Let us take up the challenge together! We stand absolutely as one with this degenerate art. In it reside all the hopes of the future. Let us work for its victory over the new Middle Ages that are rising in the heart of Europe," accessed 14 January 2018, http://www.egyptianSurrealism.com/index.php?/contents/manifesto/. For the heated debate that ensued in *al-Risala* newspaper, see LaCoss, Don. "Egyptian Surrealism and 'Degenerate Art' in 1939." *The Arab Studies Journal*, vol. 18, no. 1, "Visual Arts and Art Practices in the Middle East" (Spring 2010), 78-117.

11　Gharib, Samir. *Surrealism in Egypt and Plastic Arts*, Prism Art Series 3, Cairo, Foreign Cultural Information Department 1986 (http://egyptianSurrealism.com/files/Samir-GhariebBook.pdf). Arabic original: *Al-Tatawwur*, no. 1 (January 1940). Published by Art et Liberté, re-edited by Hisham Qishta. 2nd edition. Cairo: Elias Publishing 2016, 89.

12　*Majalla shahriyya tasduruha jamaat al-fann wa-l-hurriyya/Evolution: Revue mensuelle publiée par le groupe Art et Liberté*. All in all, seven issues appeared between January and September 1940.

issue (see Fig. 1). The office of the Cairo Surrealists was open daily from 7.30 to 9.30 pm.[13] This information can be found in the final issue of *al-Tatawwur* of September 1940. Interestingly, Art et Liberté's office was in the immediate vicinity of the former Cercle artistique, the first artistic association in Egypt, which at the end of the nineteenth century was based at 27 Madabegh Street (now Sherif Street) in the downtown district.[14]

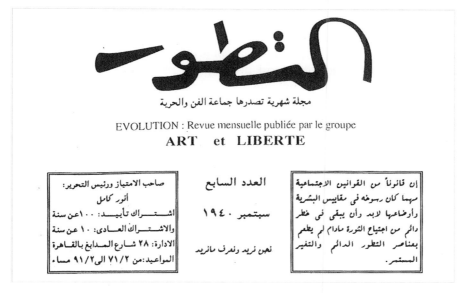

Figure 1: Upper part of cover page of *al-Tatawwur*, no. 7 (September 1940). Re-edited by Hisham Qishta. 2nd edition. Cairo: Elias Publishing 2016, 89.

Like other Surrealist groups, Art et Liberté operated at several levels: a manifesto explained its position, goals and intentions, and was the initial point of contact with the public; exhibitions, catalogues and invitation cards disseminated its message on an aesthetic level; and a periodical expressed its concepts and opinions. From the start, the group aspired to be effective among the general public. The central address at 28 Madabegh Street and regular office hours gave them a certain respectability and created a sense of a party headquarters.

13 The Paris Surrealists also had an office at the Rue de Grenelle 15 which opened on 11 October 1924. Its daily hours were between 4.30 and 6.30 pm. Two Surrealists manned the office, receiving visitors, suggestions and ideas, and answering questions. Thévenin, Paule (ed.). *Bureau de recherches surréalistes, Cahier de permanence, Octobre 1924-avril 1925*. Paris: Gallimard 1988.

14 Volait, Mercedes, "27 Madabegh Street. Prelude to an art movement." *Rawi Egypt's Heritage Review,* no. 8 (Fall 2016): 17-19.

Between 1940 and 1945 Art et Liberté organised five exhibitions in Cairo. Henein, who largely financed these, intended

> to integrate the activity of the young artists in Egypt into the grand circuits of modern, passionate and tumultuous art that rebels against any police, religious or commercial rules, an art whose pulse we can feel in New York, London, and Mexico, everywhere where the Diego Riviveras, the Paalens, the Tanguys and the Henri Moores are combatting.[15]

The aim was to enable Egypt's artists to connect internationally and to integrate them into a globally active network of revolutionary art. In the absence of their own spacious premises, all exhibitions took place at non-artistic venues such as hotels, schools, and half-finished buildings. The first so-called "Exposition de l'art indépendant" (Ma'rad li-l-fann al-hurr) was held at the Nile Club from 8-24 February 1940, the second at the Immobilia building at 26 Madabegh Street from 10-25 March 1941, and the third at the Hotel Continental from 21-30 May 1943. The final two took place at the Lycée français in Youssef el Guindy Street (12-22 May 1944 and 30 May-9 June 1945).

Anti-art, Anti-Salon and the Desacralisation of Academic Art

How did the Egyptian Surrealists attempt to challenge academic art as the aesthetic authority, and the salon as the standard exhibition format? Was it merely a case of a counter position, a kind of "anti-salon,", or is such a designation reductive? Even if the members of Art et Liberté wanted to distance themselves from established aesthetic ideals and exhibition concepts – and addressed this explicitly in their programmatic negation – their approach was more wide-ranging. It encompassed exhibition concept and organisation, for example, and the role of the artists themselves. The group's members were simultaneously artists, writers, curators, and designers of their own media. The idea of an independent group of artists and writers was also mirrored in their exhibitions, which tended towards a *Gesamtkunstwerk* or total work of art. The idea of independence expressed in the French title "Exposition de l'art indépendant" is central and, at the same time, refers to an emancipation from the dominant official discourse. The latter was to a great extent defined by politician, businessman, and art collector Muhammad Mahmud Khalil (1877-1953) and his Association des amis des beaux-arts (The Society of the Lovers of Fine Arts/ Jam'iyyat muhibbi al-funun al-jamila), which was also responsible for the focus of the official Cairo Salon. The quest for independence

15 Alexandrian. "L'art indépendant en Egypte." *Catalogue de la II⁰ Exposition de l'Art Indépendant*, Cairo 1941, 34.

further implied emancipation from selection committees, museums, patrons, press bodies, popular exhibition venues, etc. and thus a change of allocated positions within the existing order of the art world.[16] The individual "dares to individuate himself."[17] In so doing, emancipation became an individual political act by which the subject manifested himself as a political being.[18]

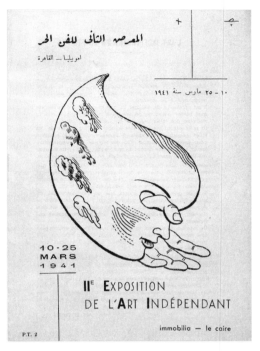

Figure 2: From the catalogue of the second Exhibition of Independent Art, 10-25 March 1941, Immobilia, Cairo, Sam Bardaouil and Till Fellrath. *Art et Liberté, Rupture. War and Surrealism in Egypt (1938-1948)*. Paris: Skira 2016, 61. Courtesy Sam Bardaouil.

16 Rancière, Jacques. *Das Unbehagen in der Ästhetik*. Wien: Passagen 2007, 34.

17 Sherman, Marshall. *All that is Solid Melts into Air. The Experience of Modernity*. London/New York: Verso 2010, 22.

18 There had been initiatives before Art et Liberté to undermine Khalil's control over the production of art and exhibition formats such as the Cairo Salon, as Nadia Radwan has pointed out. One such attempt was the foundation of the La Chimère group that had been set up in 1924 by the Egyptian sculptor Mahmud Mukhtar (1891-1934) and the French painter Roger Bréval. They demanded freedom and independence and progressively turned away from the establishment by organising, for example, exhibitions entirely without juries. They were forerunners of avant-garde groups such as Art et Liberté that later broke away even more radically from the art establishment and expressed themselves politically. Radwan, Nadia. *Les modernes d'Egypte. Une renaissance transnationale des Beaux-Arts et des Arts appliqués*. Bern: Peter Lang 2017, 164. See also Radwan's chapter in this volume and Bardaouil, *Surrealism in Egypt,* 28-31.

With the appearance of Art et Liberté on the artistic and literary scene in Egypt at the end of the 1930s, the artistic space as something quasi-sacred, connected with certain rituals and ceremonial practices – such as the inauguration of exhibitions by representatives of the political class – was broken up.[19] The exhibitions of Art et Liberté no longer needed to be legitimised by the political establishment, but were intended to legitimise themselves. The group's attitude to academic art became clear in the cover illustration of the catalogue of the second exhibition they organised, from 10-25 March 1941 in the unfinished Immobilia building in Cairo (Figure 2). At the centre of the cover page, a colour palette can be seen that simultaneously represents a human profile. It is held by a hand, and in the place of the eye, there is a hole through which a thumb projects. A few spots of colour are dabbed on the palette, which tilts downwards as if in a nosedive. Through the double meaning of head and palette, this image symbolises academic art and the academic artist. Instead of the eye, which is of great importance to Surrealism and a symbol of a different perception of the world (with the inner eye that expands into the hidden realm), there is a gaping hole through which a finger is thrust. As suggested here, the craft and its technical execution have greater significance in academic art than the 'seeing' in the sense of an in-depth process of perception and reflection. On the other hand, the illustration also contains a symbol of death, suggested by the lifeless eye and the grub-like thumb that projects as if through the eye of a corpse. The two right angles, top right and bottom left, frame the image; their horizontal lines indicate the duration of the exhibition and, in the opposite corner, the name and place of the venue. The desacralisation of academic art is as evident here as it is in the group picture with the empty chair and easel taken at the time (Figure 3).

The photo shows the members of Art et Liberté arranging themselves around an empty chair and a blank easel. This is no 'innocent' group photo, but carries a loaded message. The artist as genius is desecrated and pushed off his/her pedestal. The empty space at the centre points to the absence/presence of academic painting which is displayed with a certain irony. This photo makes clear the relationship between academic painting, now present only in spirit, and that which is to come – a new vision encompassing both life and art. Nevertheless, the chair and the easel occupy a central place, indicating that their own definition of their position as avant-garde (even if they don't explicitly refer to themselves as such) with respect to painting is a major concern. It also portrays the contrast between the individual artist –

[19] On the connection between art and state power in Egypt in the 1920s and 1930s, see Bardaouil, *Surrealism in Egypt*, 41.

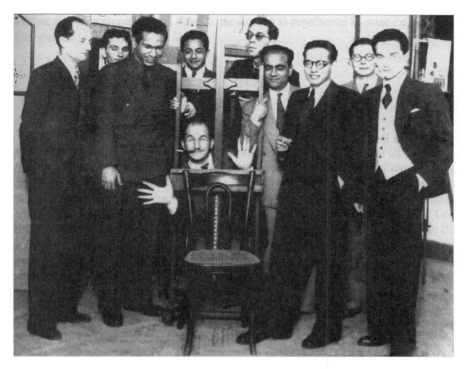

Figure 3: Group photo with members of Art et Liberté during the second exhibition in 1941, accessed 26 July 2018, http://www.egyptiansurrealism.com/index.php?/images/.

here represented by the chair – and a group of artists. It is a conceptual break that includes both the working method and the artistic artefact. At the same time, Art et Liberté's sense of superiority manifests itself in the image's composition. A new generation of artists and writers makes fun of the old. They burst the aura by invading the picture frame and by turning the empty chair from the easel towards the audience. In so doing, both become desacralised and reduced to mere objects.

The Dialectic of Art and Rubbish, of New and Old

As we have seen, Art et Liberté took a radical stance against "the aesthetic orthodoxy's norms of production and evaluation and made the products that reflect these norms appear old-fashioned and outdated."[20] Like any artistic avant-garde, the Surrealists considered themselves as "the last possible

20 "… die Produktions- und Bewertungsnormen der ästhetischen Orthodoxie und lässt die diesen Normen entsprechenden Produkte als überholt und altmodisch erscheinen." Bourdieu, *Die Regeln der Kunst*, 401.

approach"[21] in their search for the true and authentic. Reality and the reference to reality – in Surrealism via the unreal, meaning the subconscious, dream worlds, etc. – plays a central role in all artistic and literary expression. However, the "new" is not new in the sense of introducing a reality wholly detached from the old, but is novel inasmuch as it represents the result of a "new interpretation, a new contextualization or decontextualization of a cultural attitude or act."[22] Hence, it builds on the old, which it ridicules. Part of this reconsideration is the visual opposition of the artistic ideal of perfect proportions to the ugliness of reality. The principle of *l'art pour l'art*, of an art liberated from all moral and political demands and simply existing for its own sake, was vehemently rejected by Art et Liberté. It was seen as the result of cultural degeneration, while at the same time it was partly responsible for it:

> A tragedy lies behind this cultural degeneration, and that is the tragedy of 'art for art's sake', an old principle that our artists had learned from their European schools where they spent their years of primary education amidst the mortification of copying and reproducing from the heaps of inherited 'artistic garbage and groceries' [original: *az-zubala wa-l-biqala al-fanniyya*] that governments store on the walls of their classical schools and in the hallways of their museums....[23]

A founding member of Art et Liberté, Kamel al-Telmissany, criticised the principle of *l'art pour l'art* and the production of artworks completely detached from the personality of the artist and his or her life, artworks that were primarily meant to be "beautiful" and convincing by their craftsmanship alone. This principle contrasted with the avant-garde's aspiration for a dissolution of the boundaries between art and life so that they – and thus art and politics – merged to become indistinguishable. This reconceptualisation of art went hand in hand with an equally different understanding of life (and its political organisation). Al-Telmissany contrasted this with his understanding of "free art" (*fann hurr*):

> By 'free art' I mean the way we express our desires and rights through dreams and unrestrained, uncontrolled imagination, unfettered by time and place ... I mean that art which expresses the shades of misery and pain we see and the suffering that mankind endures and from which we all, in turn, suffer in this sick existence, a sick

21 Groys, Boris. *On the New*. London and New York: Verso 2014, 3.

22 Groys, *On the New*, 57.

23 Al-Telmessany, Kamel. "Egyptian Art and Present Society." *Al-Tatawwur,* no. 5 (May 1940), 28. English translation: Bardaouil, *Surrealism in Egypt*, 127.

existence that continues despite the many medicines that exist which have in all senses become poison.[24]

An art that is free is one that exposes the innermost reality and is not content with the superficial, which aims only to represent the beautiful and to aestheticise reality. At the same time, a pessimism is expressed here – or rather a revulsion at the "sickness of our time and most of the commonly envisaged remedies."[25]

The provocative comparison of art with rubbish is well-liked, and appears, for example, in Henein's *Suite et Fin* and in the pamphlet *Le Rappel à l'ordre*[26] that he co-authored with Jo Farna (alias Joseph Habashi) in 1934.[27] This can be seen as an allusion to the "Return to order" (Retour à l'ordre) movement that was formed immediately after World War I to campaign for a return to academic art in reaction to the avant-garde. By the simple insertion of the letter 'u' into the French word 'ordre' (order) its visual order is destroyed and its meaning with it. The "order" is turned into rubbish ("ordure"). Not only does this represent an attack on bourgeois values and national pride, but it also pokes fun at the academy, the government, and the museum and undermines their (aesthetic) authority. In Henein's and Farna's *Dictionnaire à l'usage du monde bourgeois* of 1935, the museum is referred to as "a large aggrandized official garbage heap."[28] It is possible to interpret this as an institutional critique. However, the Surrealists – unlike, for example, the Futurists – did not call for the destruction of the museum as an institution, as Adam Jolles has shown in relation to France.[29] Their criticism was primarily levelled against established curators and art dealers and the art market as such. This is why, from the outset, the Surrealists in France curated their own exhibitions (as did the members of Art et Liberté). In addition, their exhibitions frequently took place in different locations, such as bookshops or very new galleries.[30]

24 Al-Telmissany, Kamel. "Nahwa fann hurr." *Al-Tatawwur* (January 1940), 40. English translation in LaCoss, *Egyptian Surrealism and 'Degenerate Art' in 1939*, 106.

25 Rosemont, Franklin. *André Breton. What is Surrealism? Selected Writings*. New York et al.: Pathfinder 1978, reprinted 2012, 394.

26 The title apparently goes back to Jean Cocteau's essay collection, *Le rappel à l'ordre*, of 1926.

27 Bardaouil, *Surrealism in Egypt*, 131.

28 Kane, Patrick M. *The Politics of Art in Modern Egypt: Aesthetics, Ideology and Nation-Building*. London and New York: I. B. Tauris 2013, 56.

29 Jolles, Adam. *The Curatorial Avant-Garde: Surrealism and Exhibition Practice in France, 1925-1941*. Pennsylvania: Pennsylvania State University Press 2013, 10.

30 Drost, Julia. "Il sogno della ricchezza: Surrealismo e mercato dell'arte nella Parigi tra le due guerre." In "Il sistema dell'arte nella Parigi dei Surrealisti: mercanti, galleristi, collezionisti." Edited by Elisabetta Pallottino and Antonio Pinelli. *Ricerche di storia dell'arte*, no. 121. Rome: Carocci editore 2017, 6.

However, the Egyptian art market and gallery scene were not comparable to those in France, and the criticism of the Surrealists and the left in Egypt was mainly directed against academic art and conservative art institutions, such as the above-mentioned Société des amis de l'art of Muhammad Mahmud Khalil. Against this background, the members of Art et Liberté saw themselves in the role of subversive elements: "The subversive elements are the termites of society: they do not destroy it, at least not them alone, they erode it."[31] Their intention was to confuse, disturb, unsettle, so as to bring down the system.[32]

Here it becomes clear that Art et Liberté, similar to Breton in France, tried to work subversively within the existing structures and to find new ways of interpreting rather than destroying the existing order. The Surrealists did not introduce any new formats but, as before, organised exhibitions, mounted them in galleries or alternative venues, produced invitation cards and exhibition catalogues and held openings.[33] They used elements of the established art system, which was closely linked to the political powers in place, and tried to subvert it. However, in contrast to conventional forms of production and exhibition, the Surrealists detached themselves from dependency on juries, salons, prizes – that is, from any mechanism of sanction and promotion that put power in the hands of established institutions. This dissident attitude resulted in alternative concepts, in accordance with which artists and writers curated and organised their own exhibitions. The anti-capitalist attitude of the Surrealists also showed itself in the types of art they exhibited and which were rather unsuitable for purchase by private individuals.[34] These included mannequins, installations with diverse and

31 "Les éléments 'subversifs' sont les termites de la société: ils ne la détruisent pas, en tout cas pas eux seuls, ils la rongent. Par la parole ou par le geste, la subversion tend à démentir une morale, à troubler un rite, à dérégler l'organisation sociale. Elle est un attentat à la communauté du lieu commun." Bonnefoy, Yves and Farhi, Berto (eds.). *Georges Henein. Œuvres*. Paris: Denoël 2006, 954.

32 This concept of art continues to this day: "Art should not please. On the contrary. Art has to show where it hurts in our societies, in our world. We urgently need the courage back to pick up this role of disturbers again." Leysen, Frie, festival director and curator. Richard Watts. "Disturbing, not pleasing, should be art's role," accessed 31 January 2018, http://performing.artshub.com.au/news-article/news/performing-arts/disturbing-not-pleasing-should-be-arts-role-246981 .

33 Part of this were, for example, midnight openings. The exhibition openings of Art et Liberté, in contrast, took place at the usual times; for example the first exhibition at the Nile Club started at 6 pm. *Al-Tatawwur*, no. 2 (February 1940).

34 The anti-capitalist attitude was nevertheless more theoretical than practical, since the Surrealists had a strong interest in selling their work, as Julia Drost has shown. This demonstrates a certain contradiction between their anti-capitalist convictions and material realities, between the rejection of the market and its functioning on the one hand,

partly perishable materials (for example, the use of fern in the "Exposition internationale du Surréalisme" of 1938 in Paris), sketches, etc.

Art et Liberté also resisted linguistic convention by bringing the Arabic language back into an art context that had been largely dominated by the French language: the exhibition catalogues are bilingual (Arabic-French) and *al-Tatawwur* is exclusively in Arabic. With the inclusion of Arabic, the group not only broke with convention but also gave expression to its Trotskyist sentiments, which aimed at a closeness to workers, peasants, and all those who were oppressed and exploited. *Al-Tatawwur* regularly addressed social issues and problems and its rallying slogans sought to engage readers directly.[35]

Another aspect of the movement's autonomy, and also of the blurring of borders between the arts, was the frequent collaboration between writers and visual artists, for example in catalogues or publications where illustration and text interacted with each other. The principle of confusing, disturbing, and unsettling was carried beyond the exhibitions to catalogues that were a deliberate extension of the exhibition space.

Unsettling, Disturbing, Confusing – The Viewer as Discoverer

The exhibition practices of the Surrealists differed significantly from those of the museum or the salon. They made possible a new encounter with and an experience of art that was reminiscent of what the Dadaists had introduced in Europe. This included an emancipation from standard habits of exhibiting and viewing. Surrealist exhibitions were designed as expansive installations that transformed the usual frontal encounter of the viewer with the object into a spatial experience that appealed to all the senses – including sometimes the sense of smell. The idea was of a total work of art that, in contrast to the usual assemblages of objects exhibited one alongside the other,[36] created a relationship between them. The visitor discovered not only objects but, with them, the space. Thus, they not only changed the manner in which we

and their aspirations towards an alternative system on the other. See Drost "Il sogno della ricchezza: Surrealismo e mercato dell'arte nella Parigi tra le due guerre," 8-13.

35 See for example: "The woman who serves the man and the man who serves the leader, belong to the same class: the class of slaves." (*al-Mar'a alati takhdumu al-rajul, wa-l-rajul aladhi yakhdumu al-ra'yis, kalahuma min tabaqat wahida: tabaqat al-'abid.*). *Al-Tatawwur*, no. 2 (February 1940), 21.
or: "A government in which there is no justice had better not exist." (*al-Dawla alati la 'adala fiha khayr laha al-la takun*). *Al-Tatawwur*, no. 4 (April 1940), 14.

36 I am talking here deliberately about objects and not works, because a not insignificant part of Surrealist exhibitions consisted of objects of the most diverse provenance and character (e.g. shop-window mannequins).

approach a picture on the wall of a museum, but also questioned our attitude to life in general. The exhibitions of the group Art et Liberté also aimed to do this.[37] As Sam Bardaouil has pointed out, there were several parallels between the exhibitions of Art et Liberté and those in Paris and London. The use of shop-window mannequins was one example, as were live performances during which the exhibition space was turned into a stage.[38]

The exhibition cards and catalogues represented a blurring of the borders of the exhibitions and an extension of their impact beyond the exhibition space into the reality and private sphere of the individual viewer. They were material extensions of the exhibitions, and by creating spaces of potential signification they aimed at a strong atmospheric effect. In the exhibitions themselves, this effect was achieved by placing the individual objects in relation to each other, forming a theatrical space. The objects gestured towards something that was not materially tangible, but was present nevertheless and that created a particular atmosphere or mood. For Breton, it was the "atmosphere" that distinguished a Surrealist exhibition from a regular one.[39] Niklas Luhmann defined "atmosphere" as follows: "With regard to the individual objects occupying the space, the atmosphere is precisely that which they are not, namely the other side of their form; hence also that which would disappear if they were to disappear."[40] Consequently, atmosphere is subjective and connected to the sensory perception and sensibility of the individual. However, the panorama of possibilities of association also strongly depends on the individual's particular cultural, economic and social standpoint and mindset and is therefore variable. Above all, it demands an openness on part of the viewer, who has to be willing to engage with something new.

Art et Liberté's aim was to use a radically new aesthetic, which deliberately foregrounded the ugly and the banal, to provoke and thus introduce a new way of thinking. Viewers (of the exhibitions as well as readers of the catalogues and invitation cards) were pushed out of their passive role into one of active discovery by having to make a considerable effort to explore meaning.

[37] All information regarding the exhibitions is confined to verbal descriptions.

[38] The exhibition of 1941 included a dance performance similar to that of the Surrealist Paris exhibition in 1938, in which dancer Hélène Vanel appeared. Bardaouil, Sam. "Dark Dark Loud and Hysteric: The London and Paris Surrealist Exhibitions of the 1930s and the Exhibition Practices of the Art and Liberty Group in Cairo." *Dada/Surrealism* 19, 2013, 9, accessed 26 February 2018, http://ir.uiowa.edu/cgi/viewcontent.cgi?article=1273&context=dadasur.

[39] Regarding the atmosphere, see Görgen-Lammers, Annabelle. *Exposition internationale du Surréalisme, Paris 1938*. Munich: Schreiber 2008, 21.

[40] Luhmann, Niklas. *Die Kunst der Gesellschaft*. Frankfurt am Main: Suhrkamp 1997, 181: "Bezogen auf die Einzeldinge, die die Raumstellen besetzen, ist Atmosphäre jeweils das, was sie nicht sind, nämlich die andere Seite ihrer Form; also auch das, was mitverschwinden würde, wenn sie verschwänden."

The fundamental principles of the Surrealist approach such as alienation, combination, collage, and juxtaposition of apparently unconnected objects or meanings were applied both in the objects exhibited and in the catalogues and invitation cards. The exhibitions and these associated materials may be divided into three core areas that were characteristic of the Surrealists' approach: 1) disorder/anarchy, 2) puzzling mysteriousness, 3) desacralisation/humour.

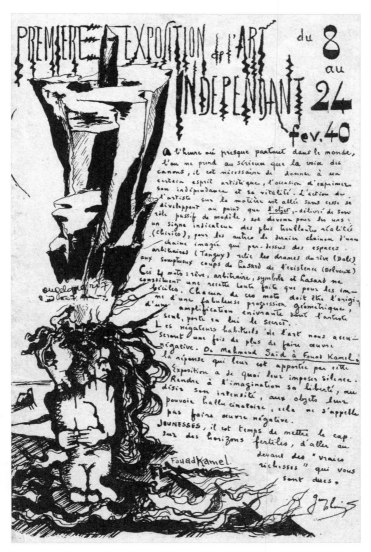

Figure 4: Back cover of the catalogue of the first Exhibition of Independent Art, 1940. Bardaouil and Fellrath, *Art et Liberté*, 60. Courtesy Sam Bardaouil.

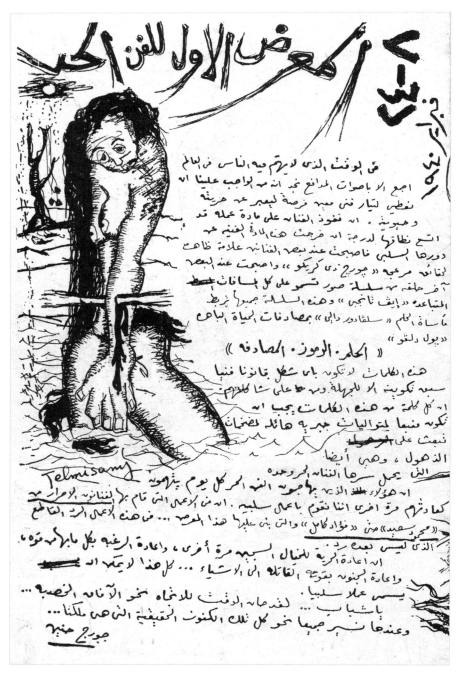

Figure 5: Front cover of the catalogue of the first Exhibition of Independent Art, 1940.
Bardaouil and Fellrath, *Art et Liberté*, 60. Courtesy Sam Bardaouil.

1. Disorder and anarchy

The catalogue of the first exhibition of Art et Liberté had an Arabic section and a French section that differed from each other in visual presentation (Figures 4 and 5). The text by Georges Henein in Arabic and French (here in the English translation of Sam Bardaouil) took up most of the page:

> At a time when almost everywhere in the world, the only voices being taken seriously are those of cannons, it is vital that a certain artistic spirit be allowed to express its independence and vitality. The action of the artist upon matter had been continuously developing, to the point that the object, delivered from its passive role as a model, has become for some a sign of the most troubling realities (Chirico), and for others the final link in a chain of images which, for arbitrary spaces (Tanguy) unites the drama of dreams (Dali) with the existence's sumptuous games of chance (Delvaux). These four words: dream, arbitrary, symbol and chance make up a recipe only for fools. Each of these words must represent the origin of a fabulous geometric progression, an intoxicating amplification, a secret that the artist alone carries within himself.
>
> Art's habitual naysayers will accuse us yet again of creating a negative oeuvre. From Mahmoud Saïd to Fouad Kamel! The reply that they will receive from this Exhibition will silence them. Giving imagination its true liberty, desire its intensity, and objects their hallucinatory power: that is not creating a negative oeuvre.
>
> YOUNG PEOPLE, it is time to set off for fertile horizons, to head towards the "true riches" that are your due.[41]

Against the background of the destructive forces of World War II, Henein conjures up the transformational powers of dreams, the arbitrary, symbols, and chance. According to Henein, it is a secret that artists alone carry within them. He appeals to the young generation to become active and move forward to the true riches, such as freedom, imagination and desire. In the Arabic part, the text is illustrated in the left-hand margin with a drawing by Kamel al-Telmissany. It shows a naked, maltreated, and dismembered female body in a dried-up landscape. The illustration in the French version is by Fuad Kamel and Angelo de Riz (both members of Art et Liberté) and shows in the lower left-hand corner a kneeling woman with long hair embracing a being with a human body and the head of a horse. Her hair becomes part of

41 Bardaouil, *Surrealism in Egypt*, 246.

the landscape, from which smoke seems to rise. Above it towers a boulder, drawn by Angelo de Riz, through which a pole drills lengthwise, threatening to shatter both. The contrast between cold matter and the two fragile beings crouching on the ground could not be greater. A script reminiscent of horror films completes the suggestion of the last days of civilisation. Both catalogue pages are written by hand, lending them a personal character, as if it was a manuscript rather than a printed product. In the Arabic version, there are a few corrections and crossed-out words, suggesting a manuscript at correction stage. This aesthetic of the unfinished, raw, and sketch-like is part of the concept and corresponds to the idea of a 'movement', i.e. of something not yet established. The pamphlet style of the catalogue pages suggests a sense of urgency and mobility and a contrast to stability and power. The visual and textual elements, as well as the artists and writers, are put into a spatial relationship with one another, thus enabling a multidimensional viewpoint as opposed to a linear one.

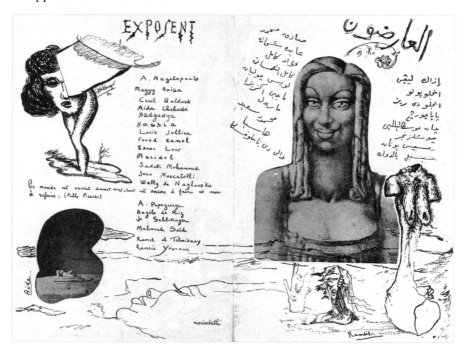

Figure 6: From the catalogue of the first Exhibition of Independent Art, 1940, which was also reproduced in *Don Quichotte*, no. 10, 8 February 1940. Bardaouil and Fellrath, *Art et Liberté*, 17. Courtesy Sam Bardaouil.

The names of the participants in this first exhibition of Art et Liberté (Figure 6) are printed both in Arabic and French. The two versions use

the same typeface but different illustrations. The Arabic version flouts every calligraphic convention and the writing appears almost childlike. The layout of visual and textual elements on the page seems random in both versions, without apparent creative planning. The names are arranged alphabetically in both, according to first name in Arabic and last name in French, thus resulting in a different order. A floral ornament after the title "The exhibitors" (*al-'aridun*) in the Arabic version contrasts sharply with the writing that contradicts every ideal of beauty.

The main part of the page is taken up by a painting entitled *La Femme aux boucles d'or*[42] (1933; "Woman with Golden Curls") by Mahmud Said (1897-1964), whom the Surrealists included in their exhibition because of his innovative approach and authenticity; Said was not a Surrealist and did not describe himself as such. To the left and right of the painting are the names of the artists. In the Arabic version, there are 18 names, in the French version, 19. The name of the painter Hadgadya, alias Miriam Nissenholtz (1895-1985), is missing in the Arabic version.[43] In the lower third on the right-hand side is an illustration by Ramses Yunan in the style of *À la surface du sable*[44] (1939; "On the Surface of the Sand"). In its monumentality and appearance of an exaggerated image of sensuality, Said's *Woman with Golden Curls* juts almost pyramidally out of the sand of this desert or death landscape with its maltreated and dismembered female bodies.[45] To the left and right of the image are the names of the artists. In the original painting, the female figure is situated in a different context: over her left and right shoulders we can see a port city with an oriental character.[46]

42 Original: Oil on canvas, 81,3 x 60cm, reproduced in Bardaouil and Fellrath, *Art et Liberté*, 109.

43 She was the daughter of Russian immigrants and the first woman to study at the Bezalel Art School in Tel Aviv. She lived in Cairo at the beginning of the 1940s and later emigrated to the USA.

44 Original: Pencil on paper, 27 x 22.5 cm, reproduced in Bardaouil and Fellrath, *Art et Liberté*, 175.

45 Ahmad Rasim writes in his article on Mahmud Said in *La Femme Nouvelle* (December 1949): "At first glance one feels that the creature painted is not a woman but a satanic being borrowing a human mask, expressing a confused thought, an enigmatic idea embodied by necessity in this material world. It is such images which reside in the subconscious and meet our dreams." In Karnouk, Liliane. *Modern Egyptian Art 1910-2003*, Cairo and New York: The American University in Cairo Press 2005, 23.

46 One source claims that the left half of the picture represents the West, the right the East: "For the artist, his sitter's mixture of African, Eastern and European features represented the essence of Egypt. Over her left shoulder, we see Venice (the West) and over her right, a minaret (the East)."
Accessed 21 January 2018, https://frieze.com/article/art-et-liberte-rupture-war-and-Surrealism-egypt-1938-1948.

This collage of image and text (including the image titles, which are not explicitly mentioned but are present in the background) creates a complex texture of violence, destruction, prostitution, poverty, and hopelessness that permits multiple interpretative possibilities depending on the imaginative powers of the viewer.

In the French version, the page layout is entirely different: On the right-hand side is a list of names of the participants, written in a very uneven hand, on the left a drawing by Jo Schlesinger of a deconstructed female figure, consisting of a huge head resting on two legs. One half of her face is almost completely covered by a kind of axe (here again, we find the contrast between the vulnerable human body and hard matter). The figure stands in a barren landscape, mirroring in some ways the withered tree in the background. Beneath her is a photograph by artist Aida Chehhata[47] that shows a reclining female sculpture resting like a sphinx on a plinth. To its right, a tiny pyramid can be seen. At the bottom right is a drawing by Jean Moscatelli showing a female head with closed, or half-closed, eyes forming part of a landscape. Inserted between the two horizontal parts of the picture is a quotation from Pablo Picasso: "Le monde est ouvert devant nous, tout est encore à faire et non pas à refaire." (The world is open to us, everything remains to be done rather than redone.) In a certain way, this slogan mirrors the spirit of departure in Henein's introductory text in the exhibition catalogue, which says:

> Giving imagination its true liberty, desire its intensity, and objects their hallucinatory power: that is not creating a negative oeuvre. YOUNG PEOPLE, it is time to set off for fertile horizons, to head towards the 'true riches' that are your due.[48]

Simultaneously, this quotation forms the visual horizon of the composition of this image against which the names of the artists rise up as if part of the future. This reconnection to an internationally recognised, but at least sporadically Surrealist artist and thus to an artistic authority represents – as is so often the case with quotations – a kind of legitimation and valorisation of one's own work. The artists' names are part of a dream landscape in which the female element holds a central place. The incongruities between the two versions that are both textual and visual make each of them unique. Therefore, it is not a case of the most faithful translation from one language into another but of a new composition of meanings.

47 The French version reads Aida Chehadé, but this is a different surname. It may be the result of an inaccurate transcription.

48 Georges Henein, First Exhibition of Independent Art, 8-24 February 1940 (al-Ma'rad al-awwal li-l-fann al-hurr), in Bardaouil, Surrealism in Egypt, 246.

The disorder staged by Art et Liberté appears at first glance to be a state of anarchy that subverts every viewing habit and does not indicate any principle of order. In fact, it is a reordering according to new criteria. The usual composition of catalogues and invitation cards is undermined and only apparently left to chance, for everything was carefully planned down to the smallest detail and considered for its impact. The desired effect is the opposite: the composition of the page does not seem carefully planned, but resembles a sketch on which the names of the artists were scribbled. Compared to the standard catalogue, this is an anti-catalogue that lists the artists casually and without any order (other than the alphabetical order). Readers do not know what the nationalities or the disciplines of these artists are. Although they are presented as individuals, they are framed as part of a group and merge with its identity and mission.

2. Puzzling mysteriousness

Both astrology and cosmology were important elements of Surrealism. They offered an additional level of perception in an endeavour to discover the world in all its diversity. The world is subconsciously absorbed in all its mysteriousness and can in no way be comprehended by rational analysis alone. Because the Surrealists were primarily concerned with seeing the world through different eyes so as to discover its hidden dimensions, they were open to astrology and the occult. Therefore, the eye as a symbol for a new way of seeing is central to Surrealism. The orientation especially of French Surrealists to so-called "primitive" art from Oceania, Africa, the Mayas, and the Inuit[49] was a further aspect of their search for the undiscovered and its hidden powers. Behind the masks, figurines, and everyday objects were hidden new forms, mystic symbols, and mysterious rituals that were of interest to the Surrealists, opening up new dimensions in their search for the "marvellous." The marvellous is a central term in Surrealism as it refers to "the eruption of contradiction within the real" (Louis Aragon, 1926).[50] The artist's task was to discover the marvellous and make it visible to others. The Surrealists rejected any kind of linear narration and provoked reactions with their circular or labyrinthine structures. Just like the catalogue pages, the invitation cards were not accessible at first sight but needed first to be decoded. The aesthetic experience of an exhibition visit was to spread beyond the exhibition space and keep viewers/readers in

49 Leclercq, Sophie. *La rançon du surréalisme. Les surréalistes face aux mythes de la France coloniale (1919-1962)*. Dijon: Les Presses du réel 2010.

50 "Le merveilleux, c'est la contradiction qui apparaît dans le réel." Aragon, Louis. *Paris Peasant*. London: Pan Books 1980, 217; first publication in French: *Le paysan de Paris*. Paris: Éditions Gallimard 1926.

their role as discoverers. The emancipation from the existing order to which the members of the group aspired went hand in hand with an emancipation of the recipient, who was expected to act as a socially responsible and intellectually capable individual.

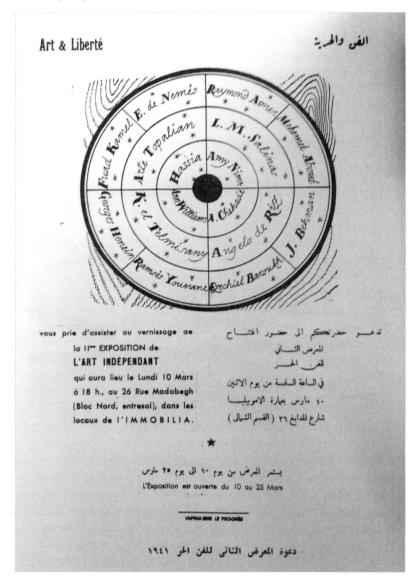

Figure 7: Invitation card for the second Exhibition of Independent Art, 1941. Samir Gharib, *al-Sirialiyya fi misr,* al-Hay'a al-misriyya al-'amma li-l-kitab, 1986. Inserted photo pages between pages 88 and 89.

The invitation card of the second exhibition of Art et Liberté (10 to 26 March 1941, Figure 7) shows a circle divided into three inner rings. This form, without beginning or end, symbolises both perfect unity and an infinite loop of possible repetitions. Crosshairs divide the circle and its inner rings into four quarters. The outer ring is again divided in half in each quarter. A group of four is formed respectively if read from the centre outwards: 1) Aida Chéhade, Angelo de Riz, Ezechiel Baroukh, J. Behman; 2) Amy Nimr, L. M. Salinas, Raymond Abner, Mehemet About; 3) Hassia, Arte Topalian, Fuad Kamel, Eric de Nemes; and 4) Ann Williams, Kamel al-Telmisany, Georges Henein, Ramses Yunan. At first sight, the circular shape seems to cancel any hierarchy in favour of a spatial connection. But the placing of the four women artists (Aida Chéhade, Amy Nimr, Hassia, Ann Williams) at the centre of the constellation indicates a gender hierarchy, as their male colleagues are located on the middle and outer rings.

A black circle at the centre evokes associations with a target, and this impression is confirmed by a background that recalls wood grain. However, in its entirety, it also evokes associations with an astrological chart. Such an interpretation is supported by the spherical arrangement of the individual names as if against a starry sky (see also the small stars in the respective name fields that remind one of the heavenly firmament). The Surrealists' affinity with magic and the occult is well known, as is their rejection of organised religion.[51] Moreover, the depiction reminds one of a labyrinth that symbolically represents the path of life and the right orientation.

The ambiguity of this invitation card matches the Surrealist approach that leaves viewers with much room for interpretation and never releases them into a state of absolute clarity. It is all part of a total work of art, intended to engage viewers beyond their exhibition visit or catalogue reading, thus affecting their everyday life, for:

> Surrealism, a unitary project of total revolution, is above all a method of knowledge, and a way of life; it is lived far more than it is written, or written about, or drawn. Surrealism is the most exhilarating adventure of the mind, an unparalleled means of

51 Lepetit, Patrick: "Surrealism played magic against religion, and consequently occultism against religion." Kober, Marc. "The Magic Powers of Ancient Egypt: Georges Henein, André Breton and Horus Schenouda." *Dada/Surrealism* 19 (2013), accessed 25 January 2018, https://ir.uiowa.edu/cgi/viewcontent.cgi?article=1272&context=dadasur; "But the Surrealists – as atheists, revolutionists, dialecticians, historical materialists, poets – have not been the dupes of any 'other-wordly' delusion." Rosemont, *André Breton*, 28.

pursuing the fervent quest for freedom and true life beyond the veil of ideological appearance.[52]

The accompanying exhibition was held in the half-finished Immobilia building at Madabegh Street 26, near the office of Art et Liberté. In two descriptions of the exhibition that take up the image of the labyrinth, we read:

> The layout was designed as a dimly lit labyrinth with hand-shaped cutouts and upside down posters hanging along the way in an attempt to confuse rather than guide[53] ... After a million turns in a labyrinth, where inverted posters serve as Ariadne's thread, we are finally there at the entrance of the second exhibition of independent art. First impression: we would really like to know how to get out.[54]

The puzzling mysteriousness of the invitation cards and their many possible meanings went hand in hand with the labyrinthine structure of the exhibition and the sense of being lost and abandoned in meaninglessness.

3. Humour and desacralisation

A third important aspect of the visual imagery of Surrealism was humour, which is also a form of desacralisation. It is found both in the exhibitions and in the cards and catalogue pages discussed here.

The catalogue of the second exhibition in 1941 at the Immobilia building includes short portraits of the participating artists with their names as well as a few sentences in Arabic, French or English about themselves or their "working methods" (Figures 8 and 9). Some artists are pictured only from behind,[55] others in profile or frontally. The profession of the artist and his/her presentation in conventional catalogues is mocked and thereby subverted. The highly individual pieces of information are markedly different from one another in content, style, and language.

[52] Rosemont, *André Breton*, 31.

[53] Bardaouil, *Surrealism in Egypt*, 182.

[54] Bastia, Jean. *Journal d'Égypte*, 16 March 1941, in Bardaouil. *Surrealism in Egypt*, 182.

[55] Interestingly enough, the following are three of the founding members of the group according to the material available to me: Henein, al-Telmissany and Yunan.

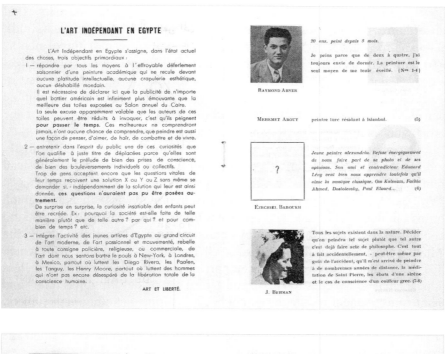

Figures 8 and 9: From the catalogue of the second Exhibition of Independent Art, 1941. The Henein-Farhi Archives, Paris. Courtesy Sam Bardaouil.

It reads like a persiflage of a conventional catalogue and carries ad absurdum its seriousness and authority. Raymond Abner (20 years old), for example, states that he has been painting for the past three months and only because "… between two o'clock and four o'clock I always feel sleepy. Painting is the only way I can stay awake."[56] He is already part of an exhibition even though his (real or invented) efforts have been negligible and not even primarily concerned with art production. The notion of the artist who spends years perfecting his technique is thus ridiculed.

The photographic portraits of the participating artists are also highly individual. Ezechiel Baroukh's portrait, for example, is absent and instead replaced in the catalogue by a framed question mark. The statement says: "Young Alexandrian painter. Flatly refuses to provide us with a photograph or his opinions. His friend and opponent Edouard Lévy is nonetheless kind enough to inform us that he enjoys classical music, Om Kalsoum, Fathia Ahmen, Dostoyevsky, Paul Éluard … ." The staged arrogance with which this artist supposedly refuses to be part of the catalogue and nonetheless appears in it with a question mark and a third person description is funny and again aims at undermining the authority of the printed exhibition document.

Georges Henein, who is presented as a 26-year old polemicist, not as a poet, and is portrayed from behind smoking a pipe, calls upon the intellectuals, writers and artists that

> the hour of great revenge approaches. The spirit of furious eruption will soon be at the steering wheel of History. The best torments are still to be invented. And this time there is no question of lacking imagination. Comrades, be cruel.

The exhibition catalogue, or rather anti-catalogue, and the pamphlet here merge into one document. Art and politics appear as intrinsically tied to each other and the imagination serves the aim of revolution.

The invitation card to the third exhibition in 1942 at the Hotel Continental plays humorously, almost in a childlike way, with the dissolution of any order (Figure 10). If in the previous cards and catalogue pages an alphabetical or gender order was still discernible, it seems here to have devolved into complete anarchy. The names of the participating artists are graffiti-like and in different fonts, as if each artist had left his/her individual trace on the walls or pavements. The list of participants[57] turns out to be a search

56 The English translations of the following statements are all by Sam Bardaouil, see Bardaouil, *Surrealism in Egypt*, 247-249.

57 Also in the exhibition were some artists from Lebanon (Geneviève Moron, Henri-Pierre Fortier, Georges Cyr, Omar Onsi, Antoine Tabet). They belonged to a loose grouping

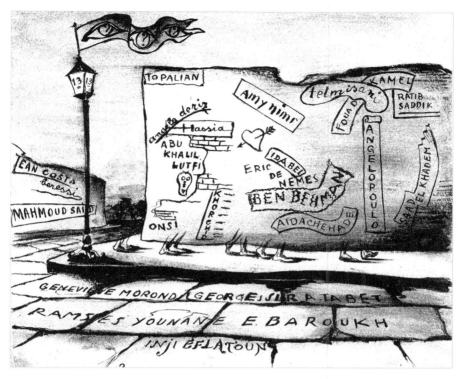

Figure 10: Invitation card for the third Exhibition of Independent Art, 1942. Bardaouil and
 Fellrath, *Art et Liberté*, 59. Courtesy Sam Bardaouil.

during which one keeps discovering new details. Viewers are obliged
to let their gaze wander in every direction, turning their head now and
then so as to take in everything. The walls are marked by decay; in many
places the plaster is crumbling, exposing the brickwork beneath it. Next
to the names various symbols that create a link with André Breton can
be recognised:[58] a skull indicating that the old must die before something
new can emerge; a heart as an allusion to Breton's *Amour fou*; the ghostly
feet as an allusion to his *Pas perdus*;[59] the street lamp with the Bretonian

around architect Antoine Tabet. This group existed from the beginning to the middle of
the 1930s and regularly met in Beirut. Source: Conversation with Jad Tabet, 4 March
2015. For information on Lebanese participation in the exhibition of Art et Liberté in
Cairo, see Bardaouil, *Surrealism in Egypt*, 186.

58 I am grateful to Julia Drost for this reference.

59 *Les pas perdus* is a collection of 24 texts by André Breton written between 1917 and
1923 and published by Gallimard in 1924.

cypher 13;[60] the flag with the eyes meaning that only the inner eye leads to true understanding. However, the pupil has a question mark that hints at uncertainty regarding the future. It is a ghostly scene, without any signs of human life. The street lamp, a symbol for André Breton and for Surrealism, is the only source of light. At the same time, this setting gives an insight into the Surrealist practice of the *flâneur*, as Lori Waxman points out: "The Surrealists were walkers… They walked to encounter the unknown and the mysterious, the dreamlike and the uncanny …."[61] *Flâneurs* preferred to stroll through the city by night, the mysterious thus gaining a different dimension, while also expressing their aversion to daily working life.[62]

The invitation card becomes a *mise-en-scène* in which Surrealism appears to be the only possible alternative for the future. The old lies far away in darkness and is only barely recognisable in the background, although it still is present. Through this perspective, the artists of Art et Liberté position themselves in the foreground. They have signed their names on the walls of a crumbling society, walls that stand here representing society's ideational and institutional constructs. Like many other avant-garde movements, Surrealism was inherently self-reflexive, i.e. it characteristically adopted a perspective placing its own role in relation to past, present and future. Bourdieu maintained that the specific past was nowhere more present than among the representatives of the avant-garde, "who are defined by it even in their … intention to leave the past behind."[63] Through this invitation card the claim of Art et Liberté, which in large part coincided with the claims of André Breton, becomes clear: Surrealism captures the city and society and signs itself into that which already exists. The walls are not pulled down, but remain standing and are newly manned.

Conclusion

Hal Foster refers to the avant-garde as "a hole in the symbolic order of [their time],"[64] thus referring to the unsettling movement in avant-garde

60 In Tarot symbols, the cyphers 17 and 13 stand for A and B, the initials of André Breton. "Merveilleux et surréalisme." *Mélusine*, no. 20. *Cahiers du Centre de Recherche sur le Surréalisme*. Lausanne: Éditions l'Âge d'Homme 2000: 307.

61 Waxman, Lori. *Keep Walking Intently. The Ambulatory Art of the Surrealists, the Situationist International, and Fluxus*. Berlin: Sternberg Press 2017, 13-14.

62 Breton writes in Nadja: "I prefer, once again, walking by night to believing myself a man who walks by daylight. There is no use being alive if one must work." Waxman, *Keep Walking Intently*, 49.

63 "… die bis in ihre … Absicht hinein, die Vergangenheit hinter sich zu lassen, von dieser bestimmt werden." Bourdieu, *Die Regeln der Kunst*, 384.

64 Hal Foster in Bürger, Peter. *Nach der Avantgarde*. Weilerswist: Velbrück Wissenschaft 2014, 39.

practice that aimed at unnerving viewers and readers, pulling the rug from under them. The subversive strategy of the Surrealists, as of avant-garde movements in general, consisted primarily in challenging the existing order and the dominant discourse regarding aesthetics and politics. They aspired to a "new ordering of the discourse in the arts" ("…Neuordnung des Diskurses in der Kunst …") and the questioning of "that entire ensemble of practices in the arts that serve as a support for those in power" ("Es geht darum, jenes ganze Ensemble von Praktiken in der Kunst, die der Macht als Stütze dienen, in Frage zu stellen.").[65] In a similar vein, Georges Henein in a letter to Henri Calet about Art et Liberté's first exhibition, described it as "a brilliant artistic earthquake" from which "the bourgeois of the region still haven't recovered."[66]

The subversive strategies of Art et Liberté can be deduced from their exhibitions as well as from the associated invitation cards and catalogues. Entering the exhibition was intended to be like crossing a threshold where individuals left their accustomed order and emerged transformed. This liminal experience aimed at an enhancement of sensory experiences and the cognitive repertory, broadening the conventional logic that represents only a fraction of all possibilities.[67] With their invitation

65 Weibel, Peter. "Die Diskurse von Kunst und Macht." In *Foucault und die Künste*. Edited by Peter Gente. Frankfurt am Main: Suhrkamp 2004, 145.

66 "Vous ai-je dit que l'exposition de l'Art Indépendant a été une brillante secousse artistico-sismique? Les bourgeois de la région n'en sont pas encore revenus. Ils n'ont d'ailleurs pas la moindre raison d'en revenir. Par contre, des couples ont réussi à faire l'amour dans les salles de l'exposition et le Musée d'art moderne s'est vu dans l'obligation d'acquérir pour la première fois, des œuvres surréalistes." In Lançon, Daniel. 'Le Caire (1934-1941): le défi des avant-gardes européennes pour les écrivains égyptiens et pour Georges Henein en particulier.' Kunz, Edith and Hunkeler, Thomas. *Les Métropoles des avant-gardes*. Geneva: Peter Lang 2009, 163-174, 2010. http://hal.univ-grenoble-alpes.fr/hal-00872951/document, 9.

67 What Marie Cavadia, a Surrealist poet in her own right who held a regular salon in her house, wrote regarding the second exhibition "Exposition de l'Art Indépendant" 1941 equally applies to the catalogues and invitation cards: "Before entering into the 'Independents' you better put your honest little logic in the cloakroom, saturated with this everyday imagery … life creates many others! … On your way out you are going to find your honest little logic again, and I am not certain that after this beautiful adventure into the unreal, which you just traversed, you are not thinking about getting rid of it (*the little logic*) forever." Marie Cavadia, "La 2ème exposition de l'art indépendant." *Images*, 18 March 1941, accessed 1 February 2016, http://www.ramsesyounan.com/la-deuxieme-exposition-par-maria-cavadia/. "Avant d'entrer chez les 'Indépendants' vous feriez bien de déposer au vestiaire votre honnête petite logique quotidienne, repue de cette imagerie quotidienne que la vie – elle en fait bien d'autres! … A la porte vous retrouverez votre honnête petite logique quotidienne et je ne suis pas certaine, qu'après cette belle aventure que vous venez de traverser dans l'irréel, vous ne songiez point à l'abandonner pour toujours."

cards and exhibition catalogues, Art et Liberté sought not only to draw attention to the exhibitions themselves, but also to present the uninitiated with puzzling images that left them with open questions. The established structures of conventional cards were challenged, followed by exhibitions that were equally unconventionally structured. The reordering of the Surrealists consisted not least in expanding by a spatial dimension the two-dimensionality of conventional exhibitions and catalogues, thus breaking through the limitations of pictorial representation whose outer boundary was contained by the frame. The salon and the art system were rejected as part of the prevailing bourgeois order, even though the bourgeoisie was also the target audience, as well as the economic and cultural identity of numerous members of Art et Liberté.

CHAPTER 7
ALTERNATIVE SALONS: CULTIVATING ART AND ARCHITECTURE IN THE DOMESTIC SPACES OF POST-WORLD WAR II BAGHDAD[1]

AMIN ALSADEN

Since my first hours in [late 1940s] Baghdad, one of the most beautiful things I observed was the bond of friendship between young poets and writers and artists, who were resolute in advancing the revolution in techniques of writing and in styles of painting and sculpture ... It was not difficult for me to see that the current of innovation in Iraq acquired much of its impulse and strength from this solidarity among writers and artists, which was not known to be as prominent among writers and artists in other Arab countries at that time.

Jabra Ibrahim Jabra[2]

[1] I am grateful for a series of conversations over the past few years with several attendees of the domestic gatherings described in this chapter – artists, architects, their friends, families, and contemporaries – who have alerted me to the vivacity of these assemblies as well as to their foundational significance for the later development of both art and architecture in mid-twentieth-century Baghdad. I am also thankful for the feedback I received from the editors and anonymous reviewers whose fresh eyes helped me to refine the narrative presented here. Needless to say, none of these individuals is responsible for the ideas, interpretations, or assessments expressed here, which are entirely my own (individual contributions are acknowledged in citations). At the risk of inadvertently forgetting some names, I would like to thank those who have been helpful with long interviews or quick conversations, providing information and leads, sharing photographs, artworks, and other documents relevant to the focus of this chapter, and most importantly, by being generous and supportive. These individuals include: Aliya al-Qaraghulli, Balkis Sharara, Bresia Houssein Fawzi, Burhan Yousef, Ellen Jawdat, Hamdi al-Touqmachi, Hanan al-Rawi, Hayat Jamil Hafidh, Hussain Alrikabi, Ishtar Jamil Hamoudi, Ismail Nasir Shahinian, Kahtan al-Madfai, Khalid Kishtainy, Laman al-Bakri, Lamees Nejim, Lamia Abbas Imara, Lorna Selim, Mahmud Uthman, Mehdi Alhassani, Miriam Knight, Mohamad Sabri, Mohamed Makiya, Mubejel Baban, Nasir Chadirji, Nuri Mustafa Bahjat, Omar al-Damluji, Omar al-Haidari, Rifat Chadirji, Sahira Makiya, Samira Baban, Saniha Amin Zeki, Sohaila Abd Al-Wahab Darwish, Suha al-Bakri, Valentinos Charalambous, Wadia Najim, Widad al-Orfali, and Yasmin Sabri. All Arabic translations are by the author, unless otherwise indicated.

[2] Jabra, Jabra Ibrahim. *Princesses' Street: Baghdad Memories*. Translated by Issa J. Boullata. Fayetteville: University of Arkansas Press 2005, 122-123.

In February 1956, the first exhibition at the al-Mansur Club was launched, marking a decisive shift in the manner in which art was exhibited, evaluated, and disseminated in modern Baghdad.[3] "It is a source of pleasure and pride," the organisers boasted, "for the al-Mansur Club to be the first social institution" to acknowledge the coming of age of art locally, and for their show to distinguish itself by "representing all artistic trajectories despite their differences," thus bringing together all Baghdadi artists, encompassing the prevalent individual as well as group agendas.[4] The ambition, from the very beginning, was to hold a recurring annual exhibition, in addition to creating a permanent gallery where Club members could view and purchase works year-round. Local and international corporations, including the Royal Dutch Airlines (KLM) and the Iraq Petroleum Company (IPC), supported the exhibition and funded its prizes, which were selected by an appointed jury. King Faisal II was announced as the official patron, and also exhibited one of his paintings in the first show.[5] Furthermore, the catalogue of this first exhibition featured some of the earliest attempts to compile comprehensive historical accounts of the development of art locally.[6]

3 Officially called the "Baghdad Exhibition," it came to be known later simply as the al-Mansur Club Exhibition. *Ma'rad Baghdad lil-rasm wa al-naht 1956 fi nadi al-mansur* (Baghdad Exhibition for Painting and Sculpture 1956 at the al-Mansur Club). Baghdad: Sharikat al-tijarah wa al-tiba'ah al-mahdudah 1956.
 The al-Mansur was a new neighbourhood in Baghdad that was planned and populated around the turn of the 1950s. Ali Haidar al-Rikabi was the head of the al-Mansur Land Company that oversaw this development. The city's racetrack moved to this area, and the al-Mansur Club was soon opened early in the decade. Jabra Ibrahim Jabra was persuaded by al-Rikabi to buy a plot and build his house there (as did several other artists and architects; Jabra, however, did not finish building and moving into his house until 1962). He recalls that he was one of the first members of the Club. See Jabra, *Princesses' Street*, 49-50.

4 This was mentioned to suggest that the show did not favour one art group over another, and also welcomed independent artists. Such a statement would not have been necessary before the formation of the various art groups in the early 1950s, each of which convened separate exhibitions for its members. al-Sa'id, Sabah, 'Abd al-Amir Rahmat Allah, 'Ali Haidar al-Rikabi, et al. "Hadha al-ma'rad." *Ma'rad Baghdad lil-rasm wa al-naht 1956 fi nadi al-mansur* (Baghdad Exhibition for Painting and Sculpture 1956 at al-Mansur Club). Baghdad: Sharikat al-tijarah wa al-tiba'ah al-mahdudah 1956, 2-5; quotation 3.

5 The king had learned to paint prior to ascending the throne in 1953. He did not regularly participate in local exhibitions, so this was a special occasion.

6 Jabra, Jabra Ibrahim. "Al-fann al-hadith fi al-'iraq," and Naeme, Alan. "Modern Iraqi Art." *Ma'rad Baghdad lil-rasm wa al-naht 1956 fi nadi al-mansur* (Baghdad Exhibition for Painting and Sculpture 1956 at al-Mansur Club). Baghdad: Sharikat al-tijarah wa al-tiba'ah al-mahdudah 1956, 6-13, and 4-8.

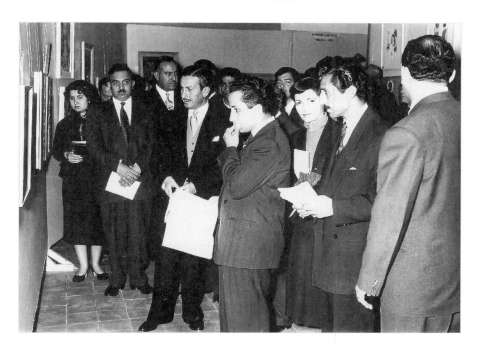

Figures 1a and 1b: King Faisal II and Prime Minister Noury El Said are seen at different openings of the al-Mansur Club exhibitions (there were three of these exhibitions, in 1956, 1957, and 1958), guided by Ali Haidar al-Rikabi, and surrounded by artists, dignitaries, and other guests. Images courtesy of Hussain Alrikabi.

Due to these ambitions and the resources invested, and more importantly because Baghdad was by then ready for these more formal affairs, the al-Mansur Club exhibitions were a huge success. However, they also created a backlash and heated debates, and led to calls for better quality art and a more meaningful relationship with the public. The reaction was based on the perception that this was an exclusive club, and that by exhibiting there, artists were not only preventing the general public from accessing their works (which many seemed to have believed were inaccessible for other reasons, including aesthetic ones), but also, that they were being co-opted by the financial and political elite, not to mention associating with the regime.[7] Nonetheless, by its third iteration in 1958, this exhibition had become so important that a group of excluded artists, mostly students, staged a protest by organising a counter-exhibition entitled "Ma'rad al-marfudat" (Exhibition of Rejects), an obvious nod to the French Salon des Refusés.[8]

[7] Khalid al-Qassab recalls that simply accepting the invitation to participate in the first exhibition at the al-Mansur Club brought sharp criticisms of social climbing and cosying up to the monarchy, given the royal family's patronage of the Club. This was a time when the atmosphere in Baghdad was tense, reflecting the wide public discontent with government policies. Khalid 'Abd al-'Aziz al-Qassab, *Dhikrayat fanniyah* (Artistic Memories). London: Dar al-Hikmah 2007, 106.
The exhibition's organisers apparently anticipated the backlash, and addressed it in their introduction to the catalogue. They proposed that even though it might be surprising for artists to hold an art show at the prestigious al-Mansur Club, the decision made sense because the artists reflected society in their works and the Club reflected it in its membership (adding that some of these members represented intellectual elites who believed in the centrality of intellectual activity in society). al-Sa'id et al., "Hadha al-ma'rad," 2-5.
By the second exhibition of 1957, a clear sense of hierarchy can be detected in that the organisers' works were displayed in the main hall, while those of their students and by amateurs were shown in a secondary space, a decision that was denounced by some local critics. Expectations for the second edition of the exhibition were especially high, as captured in a review that appeared in *al-Funun* magazine. While the piece was all praise for the more established artists like Faik Hassan and Jewad Selim, its scathing critique of the work of other artists conveyed the writer's desire for a higher overall quality for all exhibited works. Kakafian, Ardashis. "Hawl ma'rad nadi al-mansur" (On the al-Mansur Club Exhibition). *Al-Funun*, no. 1, Year 2 (20 March 1957): 28, 33.
The exhibition at the al-Mansur Club, another critic added, was evidence of a problem with art in Baghdad: many artists continued to produce work in a Western vein, introduced into a country that had nothing to do with the West. The space of the al-Mansur Club exacerbated the situation – it was as distant and inaccessible to the public as were the handful of wealthy visitors who saw it (who themselves, the article accused, were insipid and impure characters, contaminated by the West). Khalis, Salah. "Nahu fann 'iraqi asil" (Toward an Authentic Iraqi Art). *Al-Funun*, no. 23, Year 2 (18 December 1957): 4-5.

[8] This exhibition opened in April that year, constituting a rebellion by young artists against the jury members who did not deem their works to be worthy of inclusion in the al-Mansur Club exhibition that year (reportedly, the jury had rejected 400 out of the

The first exhibition at the al-Mansur Club was emblematic of the increasing institutionalisation of art and architectural cultures in post-World War II Baghdad. In January 1956, that is, only a month before the al-Mansur Club exhibition, the government recognised the Iraqi Artists Society, and its president, architect Mohamed Makiya, and other members collaborated with the organisers to ensure the exhibition's success. The Iraqi Artists Society was founded in recognition of the need for a formal and collective common ground (aside from the various art groups), to showcase artworks regardless of group affiliation (or even the work of the few artists who remained independent), and to have a structured professional association that looked after the interests of the growing body of artists, representing them locally as well as abroad.[9]

In 1957, the Iraqi Artists Society organised its first comprehensive exhibition, another big success. Although it was an initiative by the artists themselves, it also received official support and patronage, and was inaugurated by King Faisal II and Prince Abd al-Ilah on 10 May that year.[10]

500 works submitted). The two main figures behind *Ma'rad al-marfudat* were Noori al-Rawi and Kadhum Haidar, who were simultaneously attempting to establish a new art group following their graduation. Participants included Ismail Fattah, Saad al-Tai, Tariq Madhloom, Suzanne al-Shaikhly, Ghazi al-Saudi, Nimat Mahmud Hikmat, and Widad al-Orfali. *Ma'rad al-marfudat* was opened at the hall of the Union of Iraqi Women (previously known as the al-Muthana Club). It was modelled on the renowned eponymous French exhibitions of the nineteenth century. Al Sa'id, Shakir Hasan. "Al-mabhath al-rabi': al-fann al-tashkili." In *Hadarat al-'iraq* (The Civilization of Iraq), vol. 13. Edited by Nukhbah min al-bahithin al-'iraqiyin. Baghdad: Dar al-hurriyah lil-tiba'ah 1985, 379-426; 411; Al Sa'id, Shakir Hasan. *Al-Fann al-tashkili al-'iraqi al-mu'asir* (Contemporary Iraqi Plastic Art). Tunis: Al-munazzamah al-'arabiyah lil-tarbiyah wa al-thaqafah wa al-'ulum 1992, 33; Al Sa'id, Shakir Hasan. *Fusul min tarikh al-harakah al-tashkiliyah fi al-'iraq, al-juz' al-thani* (Chapters in the History of the Plastic Movement in Iraq, the Second Volume). Baghdad: Al-jumhuriyah al-'iraqiyah, wizarat al-thaqafah wa al-i'lam, da'irat al-shu'un al-thaqafiyah wa al-nashr 1988, 34-35.

9 Before the Iraqi Art Festival (*Mahrajan al-fann al-iraqi*) – a comprehensive programme of exhibitions, lectures, and other events organised by the Iraqi Artists Society in 1956 – meetings were held with representatives of the various art groups in Baghdad, who agreed that the Iraqi Artists Society was to be recognised as the comprehensive official entity that represented all Iraqi artists, while the groups were to be considered unofficial art and intellectual movements. al-Mafraji, Ahmad Fayyadh. *Jam'iyat al-taskhliliyin al-'iraqiyin: 1956-1978* (Iraqi Artists Society: 1956-1978). Baghdad: Jam'iyat al-taskhliliyin al-'iraqiyin 1979, 12.

10 According to Mahmoud Sabri, secretary of the Iraqi Artists Society at the time, the exhibition exhausted the organisation's entire budget. There was a series of other solo exhibitions organised since the society's establishment as well. Sabri. "Ma'a al-fannan al-'iraqi Mahmoud Sabri" (With Iraqi Artist Mahmoud Sabri). *Al-Funun*, Year 2, No 10 (10 July 1957): 8-9, 16-17.
 Khalid al-Qassab recounts that the first Iraqi Artists Society exhibition was held at the Royal Olympic Club, a large modern building designed by architect Ahmad Mukhtar.

The annual exhibitions of the Iraqi Artists Society and the al-Mansur Club were the comprehensive showcases of local production; there was, however, also a series of smaller ones, from solo exhibitions to those organised by art groups or by other institutions. At this stage in the development of art in modern Baghdad, the major exhibitions – with their structured system of selection, evaluation, display, publicity, patronage, and accompanying commercial activity – bore the all-too-familiar signs of European art salons.[11] Prior to these exhibitions, however, it is implausible to speak of a typical art salon tradition in this context.

If the significance of the conventional art salon lies in the emergence of an institutional system responsible for evaluating production, nurturing debates and criticism, and disseminating art among a wider public, an alternative informal culture existed in pre-1956 Baghdad, which accomplished some of these as well as other goals, laying the foundations for further institutionalisation. The epigraph by Palestinian-Iraqi artist and writer Jabra Ibrahim Jabra alludes to this unique culture, which he encountered upon moving to Baghdad in the late 1940s. Indeed, the reason that Baghdad produced several collectives and vigorous movements in both art and architecture – into which Jabra was immediately integrated upon his arrival – was the kind of intense and intimate relationships that had developed between artists, architects, and other intellectuals during and after World War II. They came together within a constellation of spaces – primarily domestic – that fostered candid exchanges, circulated the latest ideas, appraised and disseminated production, and formulated aesthetic

For the show, architect Adil Salih Zaki designed a large structure of metal scaffolding – which surpassed in height the exhibition building behind it – clad in bright colourful fabrics, thus creating an installation that became an effective advertisement for the exhibition. On 10 May 1957, King Faisal II and Prince Abd al-Ilah inaugurated the exhibition. It was comprehensive in that it included all the arts (painting, sculpture, ceramics, architecture, furniture, and photography), and was distinguished by the quality of works on display. It included 200 paintings, 20 sculptures, and 30 architectural works by the likes of Rifat Chadirji, Midhat and Said Ali Madhloom, Abdullah Ihsan Kamil, Kahtan al-Madfai, and Kahtan Awni. al-Qassab, *Dhikrayat fanniyah*, 117-120.

[11] Shakir Hasan Al Said has made an explicit link between conventional art salons and the exhibitions at the al-Mansur Club. For Al Said, these exhibitions represented the nexus of the efforts of Baghdadi artists, a maturation of early 1950s initiatives, and the development of an artistically inclined audience that wished to convey its support and appreciation for art. He added that the exhibitions also represented the yearning of local artists for the type of "global exhibitions ... resembling the salon" that guaranteed for the artists not just the dissemination of their artistic ideas, but also sales. Al Sa'id, Shakir Hasan. *Fusul min tarikh al-harakah al-tashkiliyah fi al-'iraq, al-juz' al-awwal* (Chapters in the History of the Plastic Movement in Iraq, the First Volume). Baghdad: Al-jumhuriyah al-'iraqiyah, wizarat al-thaqafah wa al-i'lam, da'irat al-shu'un al-thaqafiyah wa al-nashr 1983, 27.

taste among the participants as well as in their growing audience. These spaces were the birthplace of not only the "artistic sphere" in Baghdad, but also where the semblance of an art salon proper was born (perhaps this term bridges the definition of the conventional art salon with that of the social salon described by Jürgen Habermas, who designated various spaces in Europe, including the French social salons, as a critical stage in the emergence of the public sphere. What characterised these spaces was their relative inclusivity, primarily of the class to which the host belonged, and how discussions revolved around topics of common concern).[12]

For instance, it was at one of these casual gatherings at the house of artist Khalid al-Jadir that the first meeting of the Iraqi Artists Society took place: nothing short of its founding moment.[13] Likewise, the first exhibition at the al-Mansur Club came into being thanks to family friendships between club members and architect Mohamed Makiya, the first president of the Iraqi Artists Society and a member of the exhibition jury.[14] However, despite the significance of these networks and domestic

12 Habermas, Jürgen. *The Structural Transformation of the Public Sphere: An Inquiry into a Category of Bourgeois Society.* Translated by Thomas Burger. Cambridge, MA: MIT Press 1991.

13 The first meeting took place at the house of al-Jadir (who remained independent and was not affiliated with any of the art groups) on 7 November 1955, to discuss the founding principles of this association. The attendees were: Khalid al-Jadir, Naziha Salim, Mohamed Makiya, Zaid Salih, Khalid al-Qassab, Kahtan al-Madfai, Rifat Chadirji, Yusif Abd al-Qadir, Noori al-Rawi, Kadhum Haidar, Akram Shukri, Ismail al-Shaikhly, Faraj Abbu, Mahmoud Sabri and his wife, and Nuri Mustafa Bahjat (this list was compiled by Noori al-Rawi). Al-Mafraji, *Jam'iyat al-taskhliliyin al-'iraqiyin*, 11; Khalid al-Qassab recounts that the first meeting at al-Jadir's house was also attended by Jewad Selim and Aliya al-Qaragulli. That first meeting was followed by two others, at Jewad Selim's and then Khalid al-Qassab's houses, agreeing on the founding principles. The official application made to the Ministry of Interior was submitted by elected representatives who included: Mohamed Makiya, Aliya al-Qaragulli, Naziha Salim, Kahtan al-Madfai, Akram Shukri, and Khalid al-Qassab, and official approval was received in January 1956. Khalid al-Qassab offered his house and studio in Karradat Maryam as the headquarters for the association, and it was used as such for two years (this was the old family home, adjacent to the modern house designed by Jafar Allawi where the Pioneers Group's first exhibition was held; it was also the place where artists had elaborate thematic annual parties for which they made special ephemeral art pieces and costumes, among other things). Al-Qassab, *Dhikrayat Fanniyah*, 92, 110-113.

14 Makiya was a member of the al-Mansur Club and a good friend of its president, Ali Haidar al-Rikabi (whose children were also friends of Makiya's), and its secretary, the poet Buland al-Haidari. These friendships were strengthened further through the family friends and British colleagues of Makiya's wife, the writers Alan Naeme, Desmond Stewart, and John Haylock (known to be closer to Iraqis than other British expatriates, and their vocal criticism of Britain's influence in Iraq). Makiya, Mohamed. *Khawatir al-sinin: sirat mi'mari wa yawmiyat mahallah baghdadiyah* (Thoughts of the Years: An

spaces in the development of art in modern Baghdad, they have hitherto been overlooked. Their role remains precariously preserved in ephemeral anecdotes by the surviving protagonists, or as a few lines in the memoirs of those, like Jabra, who witnessed these gatherings. These assemblies have been left out of major historical accounts of art and architecture in modern Baghdad, most likely because some writers viewed them more as a private social or recreational part of their lives, choosing to focus instead on the more public and professional dimensions. Other prolific writers like artist Shakir Hasan Al Said did not seem to have attended these gatherings, and interacted with fellow artists and architects on a more individual and professional basis. Additionally, more recent historians might not have been privy to this domestic culture, or have had access to surviving protagonists.

But the focus in this chapter is neither on personal relationships nor on the notion of domesticity. Rather, it is about how the regular domestic gatherings of post-World War II Baghdad created an alternative salon tradition, which left an indelible mark on the city's art and architectural cultures for years to come. Moreover, the discussion is primarily concerned with how these domestic gatherings were pivotal in creating what Jacques Rancière calls a "community of sense," that is, their role in formulating the common understandings and frameworks that were crucial for the arts to acquire meaning and political efficacy.[15] Therefore, it is important to clarify that the role of these domestic gatherings in creating a sense of community is primarily about two intertwined processes: one, the development and drawing the boundaries of artistic practices in order to establish what art

Architect's Biography and the Chronicles of a Baghdadi Neighbourhood). Beirut: Dar al-Saqi 2005, 204.

Lorna Selim suggests a different narrative, in which Makiya might have played a part. She recalls that Ali Haidar al-Rikabi, the head of the exclusive al-Mansur Club, invited artists to have an exhibition there, but they initially refused because it was perceived as a "bourgeois" place. He then offered memberships to Jewad Selim, Faik Hassan, and Faraj Abbu, and they accepted. They subsequently held their exhibition there in 1956, especially because all expenses were covered by the Club. Kajahji, In'am. *Lorna: sanawatuha ma'a Jewad Selim* (Lorna: Her Years with Jewad Selim). Beirut: Dar al-Jadid 1998, 102,

15 The chapter is largely informed by Rancière's ideas on the politics of art. He elaborates: "I understand [the 'community of sense'] as a frame of visibility and intelligibility that puts things or practices together under the same meaning, which shapes thereby a certain sense of community. A community of sense is a certain cutting out of space and time that binds together practices, forms of visibility, and patterns of intelligibility." Rancière, Jacques. "Contemporary Art and the Politics of Aesthetics." In *Communities of Sense: Rethinking Aesthetics and Politics*. Edited by Beth Hinderliter et al. Durham: Duke University Press 2009, 31-50; quotation 31.

meant in this context; and two, developing larger common understandings of the visible that made the work of these artists intelligible and effective within their society.

Figures 2a and 2b: Guests, such as Hafidh Druby, Laman al-Bakri, and Ismail al-Shaikhly at a typical Thursday gathering at Faik Hassan's house, c1953, where they engaged in discussion and listened to music while the artist painted in the same space. Images courtesy of Balkis Sharara and Rifat Chadirji.

Affirming Autonomy

The term "alternative salons" can be misleading, because it assumes the primacy of the salon model; it implies that Baghdadi artists and architects were deliberately pondering a response, concocting a calculated scheme of convening the archetypal European art salon differently. But that was far from the reality. The term "alternative" here does not denote another model consciously operating in comparison with an art salon. If anything, these domestic gatherings were not supported by, and were not extensions of, any official body or institution (that is, these gatherings must be contrasted with the manner in which the European academies instrumentalised the art salons, which later, even with the counter-salons, became the art establishment; or how the European social salons emulated and disseminated court culture).[16] These gatherings were convened at a time when formal art salons or highly structured modern academies and institutions did not yet exist in Baghdad.[17] Instead, they emerged spontaneously and almost unconsciously, in response to this specific context. Therefore, both of the familiar models of European salons – the art and social salons – are inadequate in accounting for the unique tradition that the domestic gatherings constituted in mid-twentieth century Baghdad. These were incubators of a progressive modern culture, spearheaded by protagonists who belonged to a body of intellectuals who were largely in opposition to the government and to its interferences in public life, and who valued their independence.[18]

[16] Therefore, even the reference to Habermas is made with the caveat that his work has problematically conflated the social salons with the rise of an oppositional political public sphere that could challenge and influence the state, whereas salons were in fact usually run by an aristocracy whose ties, interests, and stakes in the state perhaps prevented the discourses of this class from producing effective mechanisms of reform (but they did, however, succeed in expanding the conversation about politics beyond the upper echelons).

[17] Even the Institute of Fine Arts was initially set up as a sort of vocational school, and serious artists were expected to pursue further education and specialisation abroad.

[18] Many of these protagonists in fact worked for the government during the daytime and produced their independent work, whether art or architecture, in the evenings, which may seem like a contradiction. One is reminded, however, of Foucault's words, acknowledging that this is not an irreconcilable paradox: "We need to escape the dilemma of being either for or against. One can, after all, be face to face, and upright." He added that: "Working with a government doesn't imply either a subjugation or a blanket acceptance. One can work and be intransigent at the same time. I would even say that the two things go together." Foucault, Michel. "So is it Important to Think?" In *Power*. Edited by James D. Faubion, translated by Robert Hurley et al. New York: New Press 2000, 454-458; quotation 455-456.

In its uniqueness and departure from familiar models, the new tradition described here as an alternative salon thus involved an implicit stance of defiance. But these novel gatherings were not entirely premeditated or invented from scratch, as they had local precursors. In addition to more formal assemblies hosted by politicians or heads of prominent families, there were regular gatherings, or *diwans*, frequented by poets, writers, journalists, and their friends – gatherings that followed a tradition as old as Baghdad itself.[19] These gatherings usually took place at the residences of wealthier hosts or at coffeehouses. The latter custom morphed into meetings at modern cafés, the most famous of which were the Brazilian and Swiss as well as the al-Waq Waq Cafés.[20] Some of the very first modern art and literary magazines produced by young artists, such as the hand-written *al-Siba* begun by Nizar Salim in the late 1930s or *Ashtarut* by Jamil Hamoudi in the early 1940s, or his influential *al-Fikr al-Hadith* launched in the middle of the decade, were products of family and school friendships that blossomed in these spaces. There was also a magazine released by the Jama'at al-waqt al-da'i' (Lost

19 That is, as old as Abbasid Baghdad. In compiling a historical account of Baghdad's literary assemblies of the twentieth century, Hussain Hatim al-Karkhi suggests that the thirteenth-century book *Kitab al-Aghani* by Abu al-Faraj al-Isfahani was a record of the debates and production that took place in early Arab literary assemblies, thus implying that modern Baghdadis were only continuing their ancestors' customs. Al-Karkhi, Hussain Hatim. *Majalis al-adab fi Baghdad* (Literary Assemblies in Baghdad). Beirut: Al-mu'assasah al-'arabiyah lil-dirasat wa al-nashr 2003, 13.

20 Jabra Ibrahim Jabra describes the Swiss and Brazilian Cafés in the 1940s: "We were also within a stone's throw of the Swiss Café, which offered café au lait and cassata ice cream and was frequented by ladies of all ages, contrary to the custom of cafés in those days. Off to one side in the café was an electric gramophone with recordings of Bach, Brahms, and Tchaikovsky for those who liked to listen to them … Next to the Swiss Café was the famous Brazilian Café, which was more traditional than the Swiss Café and could hold many visitors, most of whom were intellectuals and journalists from the educated class of the city. This café was run by a high-born Syrian man, who liked to mix with his clientele and knew them by name and offered them the best Turkish coffee in town, which was made of Brazilian coffee beans, after which the café was named." Jabra, *Princesses' Street*, 63.
Even though these new cafés provided a non-traditional atmosphere where Baghdad's intellectuals would meet, societal norms continued to exert their weight. Balkis Sharara recalls that when she visited the Brazilian Café in 1953, to meet her future husband, architect Rifat Chadirji, for the second time – their first meeting having been at the house of their mutual friend Samira Baban – she felt that their action challenged the customs of society. That was because coffee houses were perceived to be for men only (however, the very fact that Sharara attended anyway, and that it was permissible and perhaps even desirable to challenge these customs, is telling in terms both of the attitudes of these young women and men and the permissiveness of society itself). Sharara, Balqis. *Hakadha marrat al-ayyam* (This is How Days Passed). Beirut: Dar al-mada lil-i'lam wa al-thaqafah wa al-funun 2015, 114-115.

Time Group) headed by Nizar Salim. This group, as member Adnan Rauf suggests, was very much the product of the new café culture in Baghdad (to the extent that the Jama'at al-waqt al-da'i' opened its own café in 1948, the al-Waq Waq).[21]

Aside from the cafés, very few public spaces existed in the city where progressive intellectuals could meet. The halls of the Institute of Fine Arts were a notable exception, where the few modern artists, writers, and poets met to discuss the latest in their fields, and even politics.[22] Other spaces included bookstores, particularly the famous Mackenzie.[23] These places

[21] These relationships developed, and some of these future artists and intellectuals, still no more than teenagers or young graduates at the time, started meeting in the coffee houses associated more with the youth and modernisers, such as the Swiss and Brazilian Cafés. For a brief account of the activities of these Baghdadi youth during the late 1930s and 1940s, with a focus on the role of Nizar Salim, see Ra'uf, 'Adnan. "Nizar Salim: Rafiq al-Siba" (Nizar Salim: Youth Companion). *Al-Aqlam*, no. 4-5 (April-May 1983), 125-127.

[22] According to Khalid Kishtainy, the Institute of Fine Arts became an oasis for intellectual activity during the 1940s. It attracted for example artists Faik Hassan and Faruq Abd al-Aziz, or poets Buland al-Haidari and Badr Shakir al-Sayyab. No other such place existed in Baghdad, where men and women gathered in public, and had discussions about art, music, and politics. Khalid Kishtainy in conversation with the author, London, UK, 8 October 2016.
 Mahmoud Uthman writes about these spaces: "The 1940s followed by the 1950s was a heroic period in Iraq, if one may call it so, during which a revolution in poetry, art, and literature was begun. This revolution did not begin like all revolutions, covertly in basements, however. It began in cafes, bookstores, and on the pages of newspapers and literary magazines." Uthman elaborates that "[in addition to new publications] the Swiss Café at Al-Rashid Street remained the refuge and primary place of gathering for intellectuals, and then the adjacent Brazilian Café, in addition to the halls of the Institute of Fine Arts." Uthman, Mahmoud A. *Masabih wa zulumat: istithkarat* (Lanterns and Darkness: Reminiscences), 3rd edition. Beirut: Al-mu'assasah al-'arabiyah lil-dirasat wa al-nashr 2012, 49-50.

[23] As a high school student, Mahmoud Uthman recalls a ritual when he and his friends would visit the Mackenzie bookstore, browse and buy some books and magazines (the bookstore owner, Karim Murad, was always accompanied by a group of academics and politicians). Then, they would head to the Swiss Café on al-Rashid Street, where they would spend their time reading and discussing the latest articles and books. Uthman, *Masabih wa zulumat*, 45-46, 50, 101.
 Jabra Ibrahim Jabra writes: "On one of the first days after taking up residence at the college [in Baghdad in the late 1940s], I was at the Mackenzie Bookstore talking to its owner Karim [Murad], a very kind Iraqi who had inherited the bookstore from its original English owners because he had worked with them in managing it since it had been established before the Second World War and had become knowledgeable about new foreign books." This bookstore, adds Jabra, "was the meeting place of many Iraqi and foreign intellectuals. They all had a personal relationship with him, and he carefully tried to meet all their book needs." Jabra clarifies that Murad preserved the name Mackenzie because it was already so famous, to the extent that he was nicknamed "Karim Mackenzie" locally. Jabra, *Princesses' Street*, 34.

were critical, particularly in the 1940s, in bringing together some of the young artists, architects, poets, writers, and other intellectuals, providing public forums where they could meet, discuss their ideas and concerns, and plan collective projects.

The efficacy of these existing public spaces in shaping an independent culture was gradually compromised as the government intensified its crackdown on free speech. The domestic gatherings that brought artists and architects together, however, did not necessarily have to do with escaping the wrath of the state. These gatherings had more instinctive and humble beginnings. While the young artists and architects hailed from households that hosted or attended regular assemblies, or *diwans*, to listen to debates, recitations, stories, and the latest news – an indigenous tradition for which Baghdad and other urban centres in the country were known – they would soon hold their own gatherings, which were more pertinent for their group, professional preoccupations, and as outlets for their modern ideas.[24] Some of the earliest gatherings, like those at Baher Faik's house, followed previous traditions and served as a link between the two generations.[25] But in many other respects, the new gatherings of the younger generation were unprecedented.

Most importantly, these new domestic gatherings, along with the conversations, initiatives, and projects to which they gave rise, revolved

24 Ellen Jawdat emphasises the significance of these gatherings for the art and architectural cultures in Baghdad—mostly because no alternative outlets or substantial cultural infrastructure existed at the time. When she arrived in Iraq in 1947, she recalls that there were hardly any theatrical shows, concerts, galleries, or museums. Therefore, for the educated class, friendships were extremely important (as they filled that void and provided much needed intellectual stimulus). Jawdat recalls that their circle included local and Western friends, with whom they enjoyed dinners, picnics in the countryside, and trips to archaeological ruins. Artists, architects, and writers, were among this group, and their company enlivened her days in the city. Jewad Selim, a childhood friend of her husband Nizar Ali Jawdat, entertained these gatherings by playing the guitar. Ellen Jawdat, e-mail to author, 14 November 2015.

25 Shakir Hasan Al Said makes the explicit link, and suggests that the new gatherings that brought artists together in the 1940s essentially inherited the local tradition of *diwans*. Al Said uses an apt example of the gatherings that took place at the house of Baher Faik, a diplomat, patron, and friend of the artists (the example is particularly compelling because Faik, born in 1903, was considerably older than most of the formally trained artists). These gatherings at Faik's house were also important because he was a connoisseur of the traditional music genre called *maqam*, which he had urged artists such as Jewad Selim and Faik Hassan to appreciate. He was an early local patron of these artists, and ended up with an impressive collection. Al Sa'id, *Fusul min tarikh al-harakah al-tashkiliyah fi al-'Iraq, al-juz' al-awwal*, 118. It is worth mentioning here that Shakir Hasan Al Said was not known to be one of the artists who frequented these gatherings himself, and hence their absence from his seminal accounts of art in modern Iraq.

around the disciplines of art and architecture: they predominantly brought together a younger generation of artists, architects, and their friends and supporters.[26] These figures shared similar backgrounds: the majority came from middle- to upper-middle-class Baghdadi families, and many of them were friends since before they went to college. Most of them were educated in the West, and several married foreigners who returned with them to Baghdad. These individuals, in other words, bridged both worlds and were products of more than one ideological orientation. Therefore, one of the main reasons for gathering separately had to do with the excitement felt by these artists and architects about new – and in their context, unorthodox – ideas, and because their convictions and "bohemian" behaviour might not have been sanctioned by society.[27] In spite of conservative norms, the domestic gatherings allowed men and women to come together to interact socially and exchange ideas.[28] Cost was another factor: these were non-commercial and non-institutional spaces where the attendees could meet at liberty, without

26 This chapter addresses the role of these domestic gatherings in bridging the gap between art and architecture as two distinct and separate disciplines. This was crucial in the post-World War II period because these disciplines grew apart to the extent that there was a whole campaign to bring artists and architects back together (Le Corbusier famously advocated for the synthesis of the arts, while figures like Sigfried Giedion, José Luis Sert, and Fernand Léger called for a new monumentality to catalyse crossovers between art and architecture). Giedion, an early champion of the monumentality discourse, noted the separation between art and architecture, stating: "In these days of specialisation it is exceptional to find a painter who has a real grasp of architectural problems or an architect with a talent for painting." However, he advocated that "a means of co-operation between the two should be found in the future." Giedion, Sigfried. "The Dangers and Advantages of Luxury." *Focus* 1/3 (Spring 1939): 34-39; quotation 37.

27 Balkis Sharara, wife of architect Rifat Chadirji, recalls that she encountered the artists' gatherings for the first time on the day she got engaged. Chadirji took her to the house of Mahmoud Sabri where several of his friends had gathered, including Jewad and Lorna Selim, Faik Hassan, Ismail and Suzanne al-Shaikhly, Qutaibah al-Shaikh Nuri, Samira Baban, Khalid al-Qassab, Zaid Salih, Khalid al-Rahhal, Qahtan Awni, Yusif Abd al-Qadir, Laman al-Bakri, Mohammed Abd al-Wahab, and Dhu al-Nun Ayub. She recalls how she found the atmosphere odd, given societal norms at the time. She observed a table full of drinks and appetisers; there was dancing; the gathering was boisterous, and loud music mixed with conversations and laughter. Sharara, *Hakadha marrat al-ayyam*, 126-128.

28 Laman al-Bakri recalls that women were active on their own in these gatherings, including unmarried women like herself, Mubejel Baban, and Naziha Salim. It was also perfectly acceptable for wives to attend in their own right and not only in the company of their husbands. Laman al-Bakri in conversation with the author, London, UK, 10 August 2014.
 Ellen Jawdat, however, recalls that even though the mixed gatherings organised by Iraqis—as opposed to those by British expatriates in Baghdad, which she also attended—were informal and went late into the evenings, there was still a certain conservativeness about the interaction of the genders. Ellen Jawdat, forthcoming memoir draft, copy provided to author, Washington DC, USA, 4 December 2015.

incurring prohibitive expenses.[29] Moreover, one of the primary differences between these gatherings – as opposed to previous traditions or newer places of assembly like cafés or bookstores – had to do with the intimacy, informality, and safety the domestic spaces provided. Debates raged, and discussions were passionate and intense, but they were ultimately among a relatively small and trusted company, a crucial factor at this time in Baghdad.

The need for these domestic gatherings – and their effectiveness – stemmed from the convergence of specific circumstances. The British reoccupation of Iraq following the 1941 coup d'état led by Rashid Ali al-Gailani, which momentarily overthrew the pro-British monarchy, further agitated a population already disgruntled about continued foreign influence. Likewise, although never fought on Iraqi soil, World War II had a pernicious impact on the country after the government pledged allegiance to Britain and committed to contributing to the war effort, leading to inflation and scarcity of resources. Serious opposition was crushed, and voices demanding full independence were suppressed. Following the war, there were several, often bloody, confrontations, most notably the 1948 uprisings called *al-Wathbah* or the 1952 Intifadah. These protests were fuelled by a sense of camaraderie against a government perceived to be working against Iraq's interests, and which neglected the grievances of the people. In such a tense atmosphere, and given the authorities' aversion to public gatherings of restless and disaffected youth, domestic spaces became safe enclaves for young artists and architects (as well as for other groups, most notably poets). However, even though there was a level of trust and control over attendance, these private spaces also welcomed newcomers.[30] Indeed, they absorbed new like-minded attendees, benefited from their fresh insights and contributions, and in turn influenced them by the kind of discussions that had already developed.[31]

[29] Several of these artists, such as Faik Hassan who was known for his open house, could not provide hospitality to numerous guests on a regular basis.

[30] For example, when architect Rifat Chadirji returned to Baghdad in 1952 from his education in London, he started attending the regular gatherings that were already happening at Faik Hassan's house. Chadirji heard about these from friends, and he recalls that once people came together, intense discussions ensued. Rifat Chadirji in conversation with the author, London, UK, 6 August 2014.
In the case of architect Mehdi Alhassani, who returned to Baghdad a couple of years later, his friend, architect Kahtan al-Madfai who was a member of the Pioneers Group, mentioned the Thursday gatherings, and Alhassani started attending them too. By then, this group also continued its tradition of going out on picnics to paint outdoors on Fridays, but by the time Alhassani joined (when Faik Hassan was building a new house), they were meeting on Thursdays at different houses (not necessarily only at Hassan's). Mehdi Alhassani in conversation with the author, Cambridge MA, USA, 13 May 2014.

[31] Ellen Jawdat suggests that there was actually an eagerness for newcomers. She recalls that they always welcomed new arrivals to Baghdad, because it reminded them of the

Aside from politics, and in spite of such a tense atmosphere, Iraq experienced an extraordinary economic boom during and after World War II. Government-led development began as the war was coming to an end, as a result of the increased American influence in the region, as well as the rising popularity of the idea that development was necessary to achieve peace and prosperity globally – an idea that became more relevant in the non-West, given the backward conditions suffered by large swathes of these geographies due to the ravages of colonialism. Iraq formalised its commitment to the new paradigm in 1950 when it established the famous Development Board, responsible for planning and spending the country's immense oil wealth on various modernisation schemes. The government expenditure trickled down, and the whole country – especially Baghdad – erupted in construction activity. New infrastructural projects, from roads and bridges to ambitious modern services projects, were implemented along with a frenzy of construction activity in the private sector, all of which anticipated and provided an early model for similar aggressive modernisation in the Gulf. The old city of Baghdad, with its familiarity, tightly knit community, and shaded alleys, was being gradually abandoned and replaced with stark modern buildings, open plazas and far-flung amenities that privileged vehicular travel. Within the context of such vast and rapid transformations, domestic spaces provided a retreat – but not necessarily an escape – into the familiar (socially, that is, not spatially, as many of these spaces were now modern houses). In other words, houses, even the brand new ones into which many middle- and upper-class Baghdadis were moving during the 1950s, were places of respite, where artists and architects could process and absorb the unfolding situation and ponder appropriate responses.

These rapid transformations were likewise paralleled by the accelerated growth of the relatively young art and architecture scenes in Baghdad, which had come to maturity at an astounding speed. Considering that the local Institute of Fine Arts was established only in 1939 (with the very first Baghdadi artist receiving his education abroad earlier in the same decade), when these gatherings began in the early 1940s, art in Baghdad – in its academic, global guise – was in its infancy, with just a handful of formally trained artists.[32] In the case of architects, the Department of Architecture

world that existed beyond the city, and because these new individuals brought fresh ideas and enriched their own thinking. Ellen Jawdat, forthcoming memoir draft.

32 Artistic and visual traditions certainly existed in Baghdad, and as some of the historical accounts (especially nationalistic ones) suggest, they can be traced back as far as the Abbasid period and even earlier. However, the emphasis here is on formal training in art forms and techniques, which did not necessarily have a long tradition here. The term "global" is used not to undermine the Western tradition within which these artists were trained, but to point to the fact that by the mid-twentieth century that tradition had

at the University of Baghdad was established much later, in 1959, so that there was a lag of two decades, at least in terms of available professionals.[33] The number of exhibitions increased over time, and the first semi-formal collective, the Friends of Art Society, was founded in 1941 to bring together the few artists and architects as well as amateurs and art enthusiasts.[34] But again, the beginnings were humble, and the number of available artists and architects was rather small, which is why domestic gatherings were so foundational in those early years. On the one hand, the gatherings started precisely because there was such a small group of artists and architects, which encouraged them to find each other and come together.[35] And on the other, the modest size of this group was such that its disciplinary activities, whether in art or architecture, could be more efficiently sustained through informal venues and interactions that revolved around friendships, rather than the more formal, and perhaps impersonal, frameworks.[36]

Although one of the main reasons for regular domestic gatherings appears to have been the lack or incompleteness of an infrastructure capable of hosting

become global, and was perceived as such by artists in Baghdad (as can be gleaned, for example, in the 1951 manifesto of the Baghdad Group for Modern Art).

[33] Likewise, the number of artists sent to receive their training abroad was significantly more than architects, mostly because these artists had plentiful job opportunities teaching at the various colleges and schools, or working for the government, while architects were mainly employed initially (before opening independent offices and dedicating themselves to practice) in government offices like the Public Works Department.

[34] An article published in 1942 conveyed the development happening within art locally, and the role played by the Friends of Art Society. For the first time, the piece contended, art was being viewed with a sense of appreciation by the public, thanks to the efforts of the Friends of Art Society, made evident by the unprecedented success of art exhibitions. Mohammed Jan, Mudhaffar. "Al-fann: min mustalzamat al-nahda" (Art: A Prerequisite for Renaissance). *Al-Saba* 7/6 (25 September 1942): no page numbers, private collection, Baghdad.

[35] Ellen Jawdat suggests that the small size of the group was one of the main reasons for these gatherings. There were very few people interested in the arts – that is, art and architecture – in Baghdad at the time, so those who were naturally gravitated towards each other. Ellen Jawdat in conversation with the author, Washington DC, USA, 14 December 2015.

[36] An anecdote told by Jabra points to the size of this community even as late as the end of the 1940s: "In May of 1949, a play in English was performed in King Faysal II's Hall (now the People's Hall). On such occasions you would see around you most of the intellectuals of Baghdad … because the city had not yet grown very much in size or population. One felt that one knew everyone who deserved to be known in the city and that, in return, one was known to them all." (The irony of this observation, however, is that on the same occasion, Jabra was finally able to recognise the writer Agatha Christie, who was living in Baghdad at the time with her husband, archaeologist Max Mallowan, even though he met her several times; the recognition astounded Jabra, not only because he knew and had read her work for years, but because it took him so long to realise that Mrs Mallowan was none other than Christie). Jabra, *Princesses' Street*, 39.

and sustaining artistic activity at this point, there were in fact several places where artists and architects met and held their exhibitions, including the halls of the Institute of Fine Arts, the Costumes Museum, and the Olympic Athletic Club, as well as various colleges where exhibitions were organised occasionally. If anything, the domestic gatherings complemented the more formal and growing infrastructure, and were crucial in bringing about and defining the nature of the emerging institutions. However, a point was made of withdrawing into domestic spaces because they served a specific purpose. It can be argued that artists and architects resorted to these spaces because it was crucial for them first to consolidate and affirm their autonomy, at a time when art and architectural cultures were nascent and vulnerable embryonic experiments. This is not to suggest that these protagonists were isolated from society, but that they needed to identify and establish the boundaries of their disciplines before going public.[37] In other words, and in spite of their strict disciplinary focus, informality, conviviality, privacy, and blurred boundaries – or perhaps because of all these things – the domestic gatherings constituted their own institution, described here loosely as an alternative salon.[38]

Cultivating Forums

These gatherings emerged casually out of friendships, some of which went back to the artists' and architects' childhoods. Many of them became friends because they were neighbours, schoolmates, or relatives. These gatherings, however, originated neither at houses (even though there were local precedents in the *diwans*), nor in the city at cafés, bookstores, or cultural institutions. Instead, they were born in the rural landscapes surrounding Baghdad. Out of a tradition said to have been initiated by Jewad Selim and Isa Hanna in the early 1930s, a number of friends and students of the artist Faik Hassan started accompanying him regularly to paint outdoors.[39]

37 These artists and architects were not isolating themselves from society, nor were they delusionally re-enacting the typical modernist claim that aesthetics can have an independent existence or that an aesthetic regime can be entirely separate from life and politics. Rancière suggests that "separateness [of art] promises the opposite: a life that will not know art as a separate practice and field of experience. The politics of aesthetics rests on this originary paradox." Rancière, "Contemporary Art," 38.

38 The efficacy of this appellation, even though not entirely accurate, is discussed again at the end of the chapter.

39 Shakir Hasan Al Said states that the tradition for which Faik Hassan became famous, of going to the outskirts of Baghdad to paint landscapes, started immediately after Hassan returned from Paris in 1938, when he began accompany Isa Hanna, another Iraqi artist. But the tradition goes back to the early 1930s, when Isa Hanna and Jewad Selim used to

Figure 3: Artist Jewad Selim, with friends, during one of the regular painting trips in the early 1950s, here to the north of Iraq. Image courtesy of Hanan al-Rawi.

go on similar trips, and visited Abd al-Qadir al-Rassam regularly to receive instruction in oil painting (al-Rassam in turn was probably the first known artist to paint land-scapes of the Iraqi countryside). Al Sa'id, *Fusul min tarikh al-harakah al-tashkiliyah fi al-'Iraq, al-juz' al-awwal*, 91 and 95.

With the return of more artists from their education abroad, and the training of new generations at the local Institute of Fine Arts, these trips became more frequent. They were not only opportunities to paint and to discuss the latest art trends or debates around the world, but were also informal improvised training sessions, and an opportunity for the participants to assess and critique one another's works.[40] These artists usually spent an entire day walking, painting, swimming, and debating, usually on the outskirts of the city, especially in the orchards of al-Jadriyah district (which later became the site of the University of Baghdad); but there were also trips to mountainous landscapes in the north and to other parts of the country. These outdoor trips were highly regimented: each participant had to bring their painting supplies, reading material, and food; the group also carried a gramophone and records to listen to music while painting. The Société Primitive (al-jama'ah al-bida'iyah, or SP) emerged out of these trips during the 1940s.[41]

Known for his refined work, and as head of the Painting Department at the local Institute of Fine Arts, Hassan assumed a mentoring role among his friends and admirers who joined the outings. Soon enough, he added a studio to his house in Baghdad, and the group started meeting regularly there. A veritable tradition was soon established: meeting at Hassan's place at least once a week on Thursdays, and going on painting trips on Fridays.[42] The

40 Khalid al-Qassab recounts that the frequent trips to the outdoors started when Faik Hassan and Isa Hanna used to go to the al-Karradah orchards in Baghdad, moving from one spot to another and painting along the way. These trips soon included a larger group of artists. They would gather every Friday morning, and usually head to the orchards at the al-Jadriyah peninsula in Baghdad (where the University of Baghdad campus was later constructed). They brought their day's supplies, as well as a gramophone and records, and listened to classical music. These trips started in 1943, according to al-Qassab, and lasted for 15 years. Khalid al-Qassab claims that the participants created a record of at least 60 different trips. Al-Qassab, *Dhikrayat fanniyah*, 34-40.

41 There are various accounts for when exactly the SP was founded. Shakir Hasan Al Said suggests that it was as early as 1941 (thus suggesting that its formation paralleled that of the Friends of Art Society). Al Sa'id, *Al-fann al-tashkili al-'iraqi al-mu'asir*, 28.
 In another book, Al Said affirmed his claim that the SP was formed in the early 1940s, either 1940 or 1941. Al Sa'id, *Fusul min tarikh al-harakah al-tashkiliyah fi al-'Iraq, al-juz' al-awwal*, 130. In yet another piece, however, Al Said claims that the SP was established in 1943, from a group of Hassan's friends and students who used to paint outdoors or gather at Hassan's place, following the success of his Painting Department at the Institute of Fine Arts. Al Sa'id, "Al-mabhath al-rabi'," 397.
 Khalid al-Qassab narrates that the group was formed (and started going to paint outdoors) in 1943, but the name Société Primitive was coined only in 1947, by Hassan. Al-Qassab, *Dhikrayat fanniyah*, 40-41.

42 Rifat Chadirji suggests that these gatherings were not only regular, but that when he returned to Baghdad in 1952, they used to happen almost daily, rotating between the houses of the SP members, with Faik Hassan's house as the unofficial centre. Chadirji, Rifat. *Al-ukhaidir wa al-qasr al-balluri: nushu' al-nazariyah al-jadaliyah fi al-'imarah*

group met weekly, without invitations or announcements, to socialise while Hassan painted in his studio.[43] One of the main factors that made Hassan's house an important place for regular gatherings – other than the simple yet essential fact that he could actually provide a space – was because a tight group of friends had already formed around him.[44] But Hassan's place was far from the conventional local *diwans* or European social salons, because, with limited means, he could hardly entertain his guests with the usual hospitality. Participants brought their own food and drinks, while he simply provided a welcoming and safe space to meet. Hassan's studio became legendary: it was an artist's studio and exhibition space, a living room, a school of sorts, library, music chamber, and forum, all at once.[45] Guests gathered to watch him paint and demonstrate certain techniques and concepts, while they browsed through art books and magazines, listened to classical music and traditional Iraqi *maqam*, and discussed the latest art theories, movements, and the ongoing concerns of artists and architects locally.[46]

(al-Ukhaidir and the Crystal Palace: The Formation of the Dialectic Theory in Architecture). London: Riadh Al-Rayyis 1991, 44.

[43] Hassan did not necessarily invite anyone, nor did he serve anything. He just sat painting in his studio, and friends arrived with their drinks and food. This was how Rifat Chadirji remembers a typical gathering at Hassan's house, which he captured in some of his photographs that showed Hassan working on a painting while his guests gathered at a table at the other end of the room, conversing. Rifat Chadirji in conversation with the author, London, 6 August 2014.

[44] The fact that Hassan could provide the space was crucial. He was still single in the 1940s, and was raised by his mother (the absence of a father figure gave him a lot more freedom than his peers). Therefore, opening his studio to his friends, without the control or censorship of anyone in the family – something that many of his peers did not enjoy – was important, especially at a time when Iraqi society was still largely conservative, and frowned upon the mixed gatherings that at times involved drinking and debating until the early hours of the morning, and perhaps even disapproving of the kind of topics discussed.
Laman al-Bakri emphasises that Faik Hassan's gatherings worked well because he was the only artist capable of holding them: he had the right space, he had no family at the time (until he married his French wife), and could take in all the diverse characters who attended, whereas others might have shied away. Laman al-Bakri in conversation with the author, London, UK, 10 August 2014.

[45] Laman al-Bakri echoes this idea in her recollections of the weekly gatherings at Faik Hassan's house in the 1950s. Hassan had a dedicated room in his family house, and this room became his reception space, library, and studio (but he lived upstairs with his family, who were conservative, and guests never saw them). Hassan was also known, in spite of his modest income, to spend everything he had on buying the best art magazines and books, and on music records. Laman al-Bakri in conversation with the author, London, UK, 10 August 2014.

[46] Ismail Nasir Shahinian, a student of Faik Hassan and early member of the SP group, recalls that they gathered at Hassan's house every Thursday, not only to listen to classical music and Iraqi *maqam*, discuss the latest art news, and look at books and magazines

Ritualising these new assemblies, occurring initially in Hassan's house, was a significant step in the development of the domestic gatherings.[47]

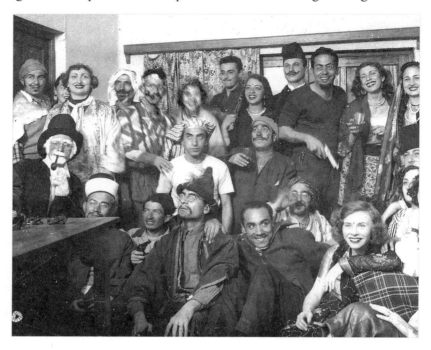

Figure 4: Costume party at Jewad Selim's house, c1951, attended by the likes of artists Lorna Selim, Mahmoud Sabri, Qutaibah al-Skaikh Nuri, Nizar Salim, Isa Hanna, Ismail Nasir Shahinian, and their friends, including Laman al-Bakri, Hussein Taha al-Nejim, Samira Baban, among others. Image courtesy of family of Hussein Taha al-Nejim.

in Hassan's library, but to also hear Hassan explaining art and discussing famous artists and old masters. Ismail Nasir Shahinian in phone conversation with the author, 2 October 2016.

47 The fact that these gatherings became ritualised and bound to specific spatial boundaries was crucial in the process of creating the community of sense that Rancière described. Whereas humanity has known products like painting or sculpture for a long time, Rancière states that 'art' is a rather recent invention, a mere two centuries old. And art as such has only been known through "a certain partitioning of space … made of some spatial setting, such as the theater, the monument, or the museum." Rancière, "Contemporary Art," 31. While Baghdad did not yet have specialised museums or galleries, the isolation and partitioning of the group into a specific setting, away from cafés or bookstores, was essential for defining art as a discipline, especially in a context where artists repeatedly complained about lack of audience appreciation and issues of reception. For Rancière, art does not simply involve creating works in conventional genres like painting or sculpture; rather, he proposes that it is when these works are perceived within common spatial and institutional frames that create a sense of definition and disciplinary boundary, upon which the sense of community – which endows these works with a common meaning – is largely contingent.

There were also the occasional costume parties at various houses, most notably that of Jewad Selim and Khalid al-Qassab, each revolving around a particular theme.[48] These were festive gatherings meant to celebrate specific occasions, often around New Year's Eve, so there might not have been much of the usual sustained intellectual exchanges. The attendees played music, danced, and simply enjoyed a pleasant evening. However, these parties were important for three main reasons. First, because their main purpose was socialising, they involved meeting outside the regular frameworks of specific art groups (formed in the early 1950s, becoming increasingly divisive over the years). At these parties, figures like Jewad Selim and Faik Hassan came together, along with the members affiliated with their groups, as well as other art enthusiasts and friends.[49] Second, artists such as Selim, Hassan, Ismail al-Shaikhly, Zaid Salih, and Khalid al-Rahhal produced temporary artworks that decorated the houses where they gathered – often large murals in mixed media, or makeshift installations in perishable materials; the artists would compete among themselves in their quest to produce remarkable pieces.[50] And third, the preparations involved elaborate costumes that the attendees produced themselves, which in their own right were yet other types of ephemeral artworks. Some dressed up like movie stars, while the majority attempted to represent diverse cultural and historical figures, depending on the theme (a phenomenon that deserves another paper all by itself, especially in terms of the attendees' evident interest in and affinities with the rest of the world).

With the friendships that had developed, and with a strong tradition already established, similar gatherings started happening at other houses too. For example, Ellen and Nizar Ali Jawdat, upon arriving in Baghdad in 1947, entertained guests at their place and attended gatherings at their friends' houses as well. The Jawdats' gatherings, which were sometimes held at their Chardagh (an informal riverside pavilion) during summer evenings,

[48] Some of these themes became political, such as that of 1961, which was about the Congo, in recognition of the contemporaneous crises in central Africa. Al-Qassab, *Dhikrayat fanniyah*, 93.

[49] Laman al-Bakri points out that Jewad Selim and Faik Hassan remained good friends even after each established their own group. Laman al-Bakri in conversation with the author, London, 10 August 2014.
 However, Lorna Selim suggests that there was a rift between her late husband and Hassan, even though the two remained friendly. She recalls that Jewad no longer felt welcomed within the SP after he had established his own group, so they stopped their visits to the regular gatherings at Hassan's house. Lorna Selim in conversation with the author, Wales, UK, 28 September 2015.

[50] Khalid al-Qassab alludes to such competition in his description of these costume parties, which he called carnivals. Al-Qassab, *Dhikrayat fanniyah*, 90-93.

were attended by artists, architects, and writers, who listened to Jewad Selim playing the guitar, and engaged in endless discussions about art and architecture and their public perception, Arabic poetry, and politics.[51] Jabra, who arrived in Baghdad the following year, recalls that his humble room at the Baghdad Hotel "was the meeting place of many of the most well-known of Iraq's writers, artists, and professors whose ages ranged from twenty-two to thirty-two," adding that "it daily witnessed animated discussions about what was being written and painted in Baghdad and in all the other Arab capitals."[52] And after Rifat Chadirji returned to Baghdad and got married in 1954, these gatherings started taking place regularly at his house as well.[53] But a tradition had been established such that even though these gatherings were taking place at various houses, they often convened on Thursdays. And by being liberated from their association with a single place, the gatherings became nomadic, and primarily about coming together in domestic spaces – that is, the houses of the attendees constituted an extended network – conversing, and planning group projects.

Discussions took centre stage at these gatherings, and were in fact the central reason for artists and architects coming together.[54] During the early gatherings, particularly the weekly painting trips, the discussions revolved around how artists could capture nature, on the effects of light in a painting, and the use of colour.[55] In other words, the early debates were concerned with the craft and techniques of painting, especially after the artists had developed an interest in modern schools of painting, particularly Impressionism and Post-Impressionism – an enthusiasm said to have been ignited by their interaction with Polish and British painters who passed through Iraq during

[51] In summer, Jawdat recalls, the gatherings went late into the night, until the roof of their house was cool enough to sleep on (a local habit during summer, before the introduction of air-conditioning). Ellen Jawdat, e-mail to author, 14 November 2015.

[52] Jabra, *Princesses' Street*, 62.

[53] Balkis Sharara recalls that they had rather limited means at the time, but they managed to host guests by borrowing furniture and other necessities from Chadirji's nearby family house. Sharara, *Hakadha marrat al-ayyam*, 154-156.

[54] Laman al-Bakri emphasises that the main purpose of these gatherings was to engage in the discussions that took place, since attendees did not go expecting hospitality. Laman al-Bakri in conversation with the author, London, UK, 10 August 2014.

[55] Samira Baban recalls that these were the main discussions during the early outings, which she started attending from around the mid-1940s, with her siblings and future husband, Qutaibah al-Shaikh Nuri. Faik Hassan used to explain Impressionism and its associated artists, their work and lifestyles, such as Paul Cézanne, Paul Gauguin, and Vincent van Gogh. At that point Jewad Selim was not going out with them, probably because he was pursuing his education abroad, and Hassan was a kind of mentor to everyone in the group. Samira Baban in conversation with the author, Amman, Jordan, 19 February 2017.

the early 1940s.[56] However, discussions at these gatherings evolved with time, and by the first half of the 1950s they became primarily concerned with the role of art, the responsibilities of the artist, and the kind of work that must be produced in this context. The return of Mahmoud Sabri from his education abroad, joining these discussions around the turn of the 1950s, had a decisive impact. Sabri and his friends, known for their Marxist leanings (some of them were members of the Iraqi Communist Party), called for an art that served and reflected society's urgent needs and grievances, such as poverty, inequality, and political oppression.[57] On the other hand, Jewad Selim and his associates, known to be progressives, advocated for the autonomy of art, believing that artists must devote themselves to developing their craft, and to aesthetically reflecting the specificity of local culture in order to produce innovative art of a global calibre and resonance.[58] Faik Hassan and his followers, choosing to remain apolitical, stood somewhere in between; although they did not necessarily articulate or push for a clear agenda, they

56 While some of the British artists remained in Baghdad until the end of World War II, the Polish artists were there for a much shorter period. These soldiers were members of the Polish Army that had entered Iraq and become part of the British 10th Army, organised into a formation that came to be known as the Polish II Corps. They were also known as the Anders Army, after their leader General Władysław Anders. Various sources indicate that the troops were in Iraq between 1941 and 1943. General Anders himself recounts that he was transferred to Iraq in September 1942 and found Polish troops already positioned there. Anders, Władysław. *An Army in Exile: The Story of the Second Polish Corps*. London: Macmillan 1949; Davies, Norman. *Trail of Hope: The Anders Army, An Odyssey Across Three Continents*. Oxford: Osprey Publishing 2015; Kochanski, Halik. *The Eagle Unbowed: Poland and the Poles in the Second World War*. Cambridge, MA: Harvard University Press 2012. Khalid al-Qassab recalls that the brigade consisted of several artists, including Matushak, Yarima, Jabofski, the Haro brothers, and Noboloski (all names are mentioned in Arabic in the original source, and this is the closest transcription); they established close friendships with Iraqis, particularly Faik Hassan, who was close to Matushak, Jewad Selim, who admired Jabofski, and Ata Sabri. The Haro brothers are said to have painted murals for a coffee house on al-Rasheed Street as well as in the Swiss Café. Al-Qassab, *Dhikrayat fanniyah*, 33.

57 Laman al-Bakri recalls that there was a whole period when the topic of discussion at these gatherings was focused (especially when Communists became more active, most notably Mahmoud Sabri, Rafid Baban, and Qutaibah al-Shaikh Nuri) on the question of whether art must be produced for art's sake, or to reflect the needs of society. Laman al-Bakri in conversation with the author, London, UK, 10 August 2014.

58 Rifat Chadirji recalls the distinct positions of both Mahmud Sabri and Jewad Selim. While Sabri advocated that art must be political, because all artists were political whether or not they realised that, Selim believed that if art were politicised, content would overpower technique (technique here implies form and aesthetic qualities and how an artwork is made, which Chadirji implies was of paramount importance for Selim). By the time Chadirji joined the regular gatherings, around 1952, he recalls that Selim was beginning to attend less frequently, because he had become alienated by the increasingly heated politicised discussions. Chadirji, *Al-ukhaidir wa al-qasr al-balluri*, 44-45.

conveyed an understanding of art that was about direct observation and recording of nature – that is, the joys of capturing landscapes and scenes of everyday life. Increasingly, this became about highlighting the specificity of local culture, especially because Selim and the Baghdad Group for Modern Art continued to push for this as an integral part of their agenda.[59]

The discussions were often heated, to the point that loud quarrels would break out when the more sensitive topics were brought up, but everyone remained good friends, and the discussions would resume and evolve the following week.[60] In terms of political orientations, although the attendees had different views, artists and architects were generally known to represent the left in Iraq.[61] The "left" is a vague term here, but one often used to designate local intellectuals during this period, implying a progressive ethos that was more about being closer to the people and their rights and aspirations, and opposition to autocratic, divisive, and oppressive regimes, than it was about any interest or allegiance to particular political ideologies or forms of governance (with the exception of a few individuals).[62] But even though the majority of artists and architects were not politically involved, a number of attendees were fairly active.[63] It was the voices and arguments of

[59] The positions of these three notable figures did not necessarily correlate strictly with the art groups of the 1950s or their members. Sabri, for example, participated in some of the exhibitions of the Baghdad Group for Modern Art, but he was more consistently an SP member; the SP, however, led by Hassan, did not necessarily endorse or adopt Sabri's views.

[60] Samira Baban in conversation with the author, Amman, Jordan, 19 February 2017.

[61] Makiya, *Khawatir al-sinin*, 209.

[62] Khalid al-Qassab confirms this by recalling that while most artists made a point of remaining neutral and distant from any specific political bloc, they shared the public's desire for increased freedoms and democracy. He recounts, for example, how British politician Aneurin (Nye) Bevan was on his way back from India when he stopped in Baghdad and wished to meet local artists as a way of gauging cultural progress in Iraq. The meeting was organised by the British Embassy soon after the establishment of the Iraqi Artists Society in 1956, and took place at Jewad Selim's house. Al-Qassab recalls that the artists subsequently found out that Bevan had warned Prime Minister Noury El Said, pointing out that the artists were unhappy with the general situation in Iraq. Al-Qassab, *Dhikrayat fanniyah*, 113. Samira Baban characterises everyone in these gatherings as a progressive. Even though her husband was a leftist (and was later imprisoned because of his links to the Iraqi Communist Party), the group never discussed politics in their gatherings – discussions were always about art. Samira Baban in conversation with the author, Amman, Jordan, 19 February 2017.

[63] For example, Mubejel Baban (along with her sister Samira) came to be introduced to the artists and their gatherings through her brothers, Rafid and Hamid, and used to attend their house meetings as well as the painting picnics. Mubejel was involved in political activity from the age of 15 (she had an affiliation with the Iraqi Communist Party), and became a strong advocate of women's and civil rights in Iraq. She was imprisoned in 1960, and her family suffered deeply following the 1963 coup. But she describes

these more active participants, especially Sabri, that created the contentious debates and forced several members into adopting highly defined and strong opinions.[64] While such discussions might have created fissures that did not exist previously, they were generally constructive in terms of urging an articulation of individual and group positions, as well as a further refinement in the works produced by the attendees – reflecting their convictions and responses to the ongoing conversations. Indeed, the vigorous intellectual and aesthetic agendas that emerged in mid-twentieth-century Baghdad were some of the defining features of the city's art and architectural cultures, and largely the outcomes of these domestic gatherings and the parallel formation of art groups.

The discussions that unfolded during these gatherings, along with the collective concerns and ambitions they represented, were not tied to a specific individual, group, or place. Instead, they were sustained by a constellation of domestic spaces and a specific network of attendees. Identifying this network helps in painting a more vivid picture of these gatherings.[65] Although a few

herself and her family merely as "leftists" and liberals (that is, they simply embraced and propagated certain ideas but were not, like some others, in opposition or were mobilising crowds against the government). Mubejel Baban in conversation with the author, London, UK, 6 October 2016.

64 Samira Baban recalls that Mahmoud Sabri was the most vocal in the group, and his return to Baghdad and his presence often created heated discussions. When the attendees gave him a chance to speak, Faik Hassan would end up telling Sabri to be quiet in order for everyone to focus on painting. Samira Baban in conversation with the author, Amman, Jordan, 19 February 2017.

Rifat Chadirji recalls that when he returned to Baghdad in 1952 and joined the artists' gatherings, it was he, Mahmoud Sabri, and Yusif Abd al-Qadir who started calling for art to serve society (Chadirji was known for his Marxist affinities, but he emphasises that he was never active politically or organisationally). There was a huge debate about the subject, and Jewad Selim gradually withdrew from these discussions. Rifat Chadirji in conversation with the author, London, UK, 5 August 2014.

65 According to the surviving participants, who attended these gatherings during the 1940s and early to mid-1950s, and the available visual evidence of various gatherings, these attendees included: Abd al-Amir Ahmad, Abdullah al-Omari, Abdullah Ihsan Kamil, Aliya al-Qaragulli, Ata Sabri, Baher Faik, Balkis Sharara, Bresia Houssein Fawzi, Buland al-Haidari, Burhan Yousef, Butrus Hanna, Dhu al-Nun Ayyub, Fuad Alsaden, Isa Hanna, Ellen Jawdat, Faik Hassan, Faruq Abd al-Aziz, Hafidh Druby, Hasan Charchafchi, Helen Hanna, Hussein Taha al-Nejim, Ismail al-Shaikhly, Ismail Nasir Shahinian, Jabra Ibrahim Jabra, Jafar Allawi, Jean al-Omari, Jewad Selim, Joan Madhloom, Kahtan Awni, Kahtan al-Madfai, Khalid al-Jadir, Khalid al-Qassab, Khalid al-Rahhal, Laman al-Bakri, Latifah Qaftan, Lorna Selim, Mahmud al-Awqati, Mahmoud Sabri, Margie al-Qadhi, May Qaftan, Mehdi Alhassani, Midhat Ali Madhloom, Mohammed Abd al-Wahab, Mubejel Baban, Nadhim Ramzi, Nail Simhairi, Naziha Salim, Nizar al-Qadhi, Nizar Jawdat, Nizar Salim, Nuri Mustafa Bahjat, Qutaibah al-Shaikh Nuri, Rafid Baban, Rifat Chadirji, Sabih Shukri, Said Ali Madhloom, Salem al-Damluji, Salma al-Shaikh Nuri, Sami al-Shaikh Qasim, Samira

poets and writers attended, these were primarily gatherings of artists and architects (and their ratios reflected the reality that there were a lot more artists than architects at this point), as well as of amateurs, art enthusiasts, and their friends, siblings, and spouses (many of the non-artist attendees became important art patrons and supporters).[66] Additionally, the gatherings brought together men and women who were primarily young professionals (older artists and architects, for example, did not necessarily attend, or at least not on a regular basis).[67] What a comprehensive list of the names of those in this network would not reveal, however, is that there were closer friendships among certain individuals, and that smaller groups with specific aesthetic or intellectual affinities were formed. However, representatives of these groups often came together in the house gatherings or parties regardless of their affiliations – and the discussions reflected the collective interests and concerns of the extended network. Furthermore, a list of names and a basic description of these domestic gatherings also does not reveal that these meetings yielded more than just conversations.

Baban, Suzanne al-Shaikhly, Valentinos Charalambous, Vartan Manoogian, Wadia Najim, Yusif Abd al-Qadir, Zaid Salih, and Zakiya Salih.

This list is not exhaustive, and there were earlier as well as later gatherings for which it does not necessarily account. Furthermore, none of these individuals was present at all gatherings, but all of these names collectively represent those who are known to have attended several meetings, where discussions revolved primarily around art or architecture.

66 Contrary to the suggestion made by Jabra in the quoted epigraph, these domestic gatherings did not always bring poets, writers, and artists together in one place. There might have been intellectual solidarity and individual friendships, but the two camps – poets and writers, and artists and architects – convened in separate assemblies (Jabra's suggestion, although not necessarily alluding to space, is understandable in that he was reflecting on his own experience; he was a unique figure in that his activity encompassed poetry, writing, and painting, thus bridging between these groups). Rifat Chadirji, Mehdi Alhassani, and Laman al-Bakri emphasise that poets and writers had their own circles. Rifat Chadirji in conversation with the author, London, UK, 6 August 2014; Mehdi Alhassani in conversation with the author, Cambridge MA, USA, 11 March 2014; and Laman al-Bakri in conversation with the author, London, UK, 10 August 2014.

Poet Lamia Abbas Imara, who was a regular at contemporaneous gatherings of poets and who knew Jewad Selim well, confirms that she did not participate in any of the artists' gatherings. Lamia Abbas Imara in phone conversation with the author, 17 October 2016.

67 There was also a good number of musicians (like Vartan Manoogian and Fuad Alsaden). Perhaps the biggest professional group was physicians. A number of them painted, like Khalid al-Qassab, Qutaibah al-Shaikh Nuri, and Nuri Mustafa Bahjat. Out of the other higher education institutions at the time, before the establishment of the University of Baghdad in 1957, the College of Medicine was known for its theatrical shows, parties, and art exhibitions of works created by its students.

Figures 5a and 5b: Opening of Jewad Selim's first solo exhibition at the house of Nizar and Ellen Jawdat, 1950. Images Courtesy of Lorna Selim.

Indeed, the friendships that were strengthened during these meetings, as well as the exchanges that ended up articulating new positions, trajectories, and ambitions, started to produce more palpable outcomes. The 1950s

ushered in a new era, when two momentous exhibitions – both of which were organised at houses – brought about a new phase in the development of art in this context. One was Jewad Selim's first solo exhibition in 1950, held at the house of his friends Ellen and Nizar Ali Jawdat. Lorna and Jewad Selim were regular guests at the Jawdats' home, and the latter's decision was not necessarily motivated by anything other than the fact that they had the space, and because friends already gathered there frequently.[68] However, as spontaneous as the Jawdats' impulse probably was, and as ostensibly inconsequential as an exhibition at a house might appear, the exhibition was seminal for several reasons. Because of Selim's subsequent unparalleled influence, this was the first step towards encouraging him to play more of a leading role locally (he launched his own collective, the Baghdad Group for Modern Art, the following year). The show at the Jawdats was also one of the first instances where architects took the initiative in supporting their artist friends, at a time when the latter were struggling to sell their works, and when a serious, engaged, and appreciative audience was still emerging in Baghdad. Furthermore, the exhibition left a strong impression precisely because it brought Selim's work to a slightly different and wider audience. Given the position and reputation of Nizar's father – Ali Jawdat al-Ayubi, who served as prime minister of Iraq several times – the Jawdats socialised not only with fellow artists and architects, but also with a group of affluent politicians and diplomats. In other words, this was a precursor to the type of exposure that the al-Mansur Club exhibitions would later afford artists. Significantly, and after seeing the success of Selim's show, the SP was encouraged to hold its first ever exhibition.[69]

68 Ellen Jawdat recalls that they organised Selim's exhibition in their house to repay him for his generosity (he had gifted them his sculpture *The Master Builder*), and because there was no other suitable venue for an exhibition of that kind at the time. The Jawdats lived at a modern house at the Iraqi Railways quarter in western Baghdad, with a relatively empty living room and easy parking for guests. Ellen Jawdat, email to author, 14 November 2015. The invitation cards for Selim's exhibition indicate that the opening was on 16 May 1950. Jewad Selim, printed and hand-coloured invitation cards, private collection, Washington DC, USA.

69 Khalid al-Qassab recalls that the idea of holding the first exhibition of the Pioneers Group (then still the SP) came up in the fall of 1950, during a mutual critique session that followed one of their regular outdoors Friday painting picnics. Al-Qassab remembers that Jewad Selim's exhibition, which was quite a success, was fresh in their minds as it had taken place recently. The members of the SP found in Selim's exhibition at the Jawdats' the answer to where their own show would be held, namely, a house. The idea of mounting a public exhibition in a house was a new one in Baghdad, al-Qassab goes on, and Selim's had proved that it was indeed possible and encouraged them to have the group's exhibition at one of their houses. Al-Qassab took the initiative, and managed to convince his father to allow him to use their new family house. Al-Qassab, *Dhikrayat fanniyah*, 74-76.

The SP's exhibition was held at the brand new, modern house designed by architect Jafar Allawi for the family of Khalid al-Qassab.[70] Because the second SP show in 1952 was held at a proper exhibition hall at the Costumes Museum, displaying works at a house was emblematic. Not only was this about emulating the model that the Jawdats began with Selim, but it was also crucial for the group's exhibitions to be inaugurated from the comfort and familiarity of one of their members' houses at this vulnerable and transitional point in their history, to allay the initial trepidations about the validity of such a step.[71] This was an ideal demonstration of how domestic spaces were incubators of new ideas and initiatives before they had matured and become more institutionalised. And while the experiment was a success in that it encouraged the SP to carry on and organise many public annual exhibitions later, it was a failure in other ways. The SP lost Jewad Selim when he decided to start his own collective, after dissatisfaction with his experience in that first SP exhibition (Selim wanted a more rigorous conceptual basis for art).[72] But the failure had a silver lining, because the Baghdad Group for Modern Art, formed in 1951, was followed by a transformation within the SP in 1952, when the group decided to adopt the Arabic name Jama'at al-ruwwad (Pioneers Group) and to play a more active public role.[73] Along with these two groups, led by Selim and Hassan

[70] The first SP exhibition opened on 22 December 1950 and went on for three days. The show displayed not only artworks, but also paraphernalia of the group's outdoor trips, thus turning it into a sort of public announcement of the existence of this collective and its activities – in other words, it became the group's official founding date. There were 150 artworks on display. Participants included Faik Hassan, Jewad Selim, Khalid al-Qassab, Mahmoud Sabri, Zaid Salih, Yusif Abd al-Qadir, Ismail Nasir, Faruq Abd al-Aziz, and Qutaibah al-Shaikh Nuri. This was the first annual show; the group ended up organising 24 in total. Al-Qassab, *Dhikrayat fanniyah*, 76-78.

[71] Faik Hassan, the group's leader, was reportedly not entirely convinced initially about the idea of holding a public exhibition, but other members like Khalid al-Qassab and Mahmoud Sabri pushed for it. Al-Qassab, *Dhikrayat fanniyah*, 74.

[72] Jabra Ibrahim Jabra suggests that Selim founded his own group because he was dissatisfied with the lack of shared conceptual basis or affinity among the works displayed at the SP's first exhibition of 1950, in which he participated. He therefore decided to leave the group and to establish his own. Jabra, *Princesses' Street*, 124.

[73] Most historical accounts make the claim that the al-Ruwwad (Pioneers) Group was the first art group in Baghdad, purportedly established in 1951. However, these accounts either rely on anecdotes, or on a conflation between the SP and the al-Ruwwad, into which the SP evolved. Invitation cards to the group's exhibitions reveal three significant facts. First, the name SP continued to be used alongside the Arabic al-Ruwwad (that is, the collective chose to present itself locally as al-Ruwwad while also preserving their earlier identity, using the SP as their logo as well as their English name). The invitation card to the first exhibition, which opened on 22 December 1950 at the house of Khalid al-Qassab, made absolutely no mention of the words al-Ruwwad or Pioneers, and no attempt was made to translate the "S.P." that designated the group's name. The participants in the first exhibition were ten: Faik Hassan, Jewad Selim, Isa Hanna, Yusif Abd

respectively, Hafidh Druby followed suit in 1953 and established the Iraqi Impressionists Group (Jamaʿat al-intibaʿiyin al-ʿiraqiyin).

These groups created the kind of healthy competition and artistic production that were to transform art in Baghdad in the following years; they were the linchpin that tied the informal domestic gatherings to the more institutional forms of evaluating, displaying, and disseminating art established following 1956. It would not be an exaggeration to claim that these art groups, as well as the more professional associations, were in fact engendered within domestic spaces too. For example, even though the SP emerged spontaneously in the early 1940s from the group of friends that gravitated towards Hassan during the painting picnics on Fridays, the regular meetings at the residences of Hassan, al-Qassab, or Sabri were pivotal in forming the collective.[74] In other words, it can be argued that the SP was in fact nothing but these informal assemblies.[75] The frequent gatherings shaped the SP, and they likewise became ingrained as an integral component of the collective's rituals. Moreover, these domestic gatherings laid the foundations for other collectives and initiatives. In his act of rebellion – which effectively founded the first group with a clear intellectual and aesthetic agenda – Selim brought a number of friends who were largely those with whom he interacted regularly at such domestic gatherings.

Although Baghdad is well known for these art groups of the 1950s – to which belonged the majority of artists and architects – the role of the more informal domestic gatherings in the formation of these groups has

al-Qadir, Khalid al-Qassab, Mahmoud Sabri, Faruq Abd al-Aziz, Nuri Mustafa Bahjat, Qutaibah al-Shaikh Nuri, and Ismail Nasir.

Second, the name al-Ruwwad was used only in the second exhibition, which opened on 8 February 1952 at the Costumes Museum (that is, following the founding of the Baghdad Group for Modern Art). The participants became 12, with the additional participation of Lorna Selim and Rafid Baban. Therefore, and this is the third significant fact, Jewad Selim participated in both the first and second exhibitions, even after he had established his own group. He did not, however, participate in the third exhibition, which opened on 20 March 1953, and dropped to only six participants: Hassan, Hanna, Nasir, Sabri, Ismail al-Shaikhly, and Zaid Salih. Invitation cards to the SP exhibitions, private collection, London.

74 Al Saʿid, *Fusul min tarikh al-harakah al-tashkiliyah fi al-ʿIraq, al-juzʾ al-awwal*, 120.

75 Because of the early central role played by Faik Hassan's house in the culture of regular gatherings, some attendees consider these gatherings to be inextricably linked with the SP. For example, Kahtan al-Madfai contends that even though artists and architects came together at his place, or at the house of Laman al-Bakri or Khalid al-Qassab for example, these regular Thursday meetings involved members of what he described as an extended SP network. Kahtan al-Madfai in conversation with the author, Athens, Greece, 25 January 2015.

remained unacknowledged.[76] Even the Friends of Art Society, a semi-formal association that brought artists and architects, as well as amateurs and art enthusiasts, together in the 1940s was born at the house of artist Akram Shukri; the famous photographs that depict its early members were taken at the house of Mohammed Selim, Jewad Selim's father, which implies that its meetings continued to take place in domestic spaces, and were bound together by friendships between artists, architects, and other attendees.[77] Likewise, the Iraqi Artists Society, into which the Friends of Art Society arguably metamorphosed in the 1950s, was born at the house of Khalid al-Jadir. Furthermore, given that this was the artists' initiative (that is, aside from being officially licensed, it was not supported financially or logistically by the government), the Iraqi Artists Society used the house of Khalid al-Qassab as its headquarters in the first two years.[78] These meetings, and the use of domestic spaces for more professional purposes, were not seen as an aberration – they were merely the extension of a tradition of domestic gatherings that had already been established as the norm for several years.

Lasting Legacy

But it was precisely then, in the second half of the 1950s, when Baghdad's art and architectural cultures were being institutionalised in professional associations and academies, that the beginning of the end of the regular domestic gatherings became evident. On the one hand, many of the young attendees had by then established families and careers that drew them away from these meetings.[79] And on the other, the groups that had been formed earlier in the decade, along with their intellectual agendas, had deepened the rifts that had begun with their founding. The annual exhibitions and the further refinement of artistic production by the members of these groups

[76] Lorna Selim believes that even though these gatherings were meant for recreation and the exchange of ideas, they gave birth to the more formal groupings and exhibitions later. Kajahji, *Lorna*, 50.

[77] Following the initial meeting in February 1941, Akram Shukri, Isa Hanna, and Karim Majid submitted an official letter to the Ministry of Interior in order to get approval for the new society. Shukri was voted its president, while Isa Hanna was treasurer, and Nahida al-Haidari secretary (in a remarkable early participation of a woman at a time when the art scene was largely dominated by men; al-Haidari, however, does not appear in the early photographs). Al-Qassab, *Dhikrayat fanniyah*, 54.

[78] This was the old family home, adjacent to the modern house designed by Jafar Allawi where the SP's first exhibition was organised. Al-Qassab, *Dhikrayat fanniyah*, 113.

[79] Ismail Nasir Shahinian suggests that the regular gatherings of the 1940s and 1950s evolved into meetings of families when artists got married, and these occasional social meetings continued for many years. Ismail Nasir Shahinian in phone conversation with the author, 2 October 2016.

made it clear that there were ideological differences and aesthetic preferences that went beyond the earlier convergences primarily around friendships or the affirmation of disciplinary autonomy. Furthermore, two years after the formation of the Iraqi Artists Society, the 1958 coup d'état brought about an important shift. The change in the political system did not have an immediate impact on the arts (especially on the work of established artists), but the new responsibilities that artists and architects assumed, occupying more critical positions in the government or leading larger projects, meant that they were no longer available to convene at leisure as they used to do. Moreover, a gathering, even in domestic spaces, under a paranoid and constantly challenged military regime was no longer a plausible option.

The decisive blow, however, came with the next coup of 1963. In the early hours of the power transition, the new regime detained numerous intellectuals and set the tone for an era of terror. Any trepidation people might have had about the repercussions of expressing opinions or congregating freely under military rule had turned into a nightmarish reality. Therefore, the gatherings of artists and architects stopped, not only because no one dared to host them anymore, but also because most people would not want to be caught in an assembly where potentially controversial opinions might be expressed.[80] Yet, even though these gatherings came to an end, they had served their purpose of cultivating art and architectural cultures locally.[81]

In addition to the constructive discussions that took place, the formation of collectives, the articulation of individual and group agendas, and the organisation of exhibitions and public events, there were three major outcomes to the exchanges at the domestic gatherings.

The first had to do with the cross-pollination between ostensibly competing artistic collectives, namely the SP and the Baghdad Group for Modern Art. There was an undeniable chasm that only widened following Selim's decision to

80 Mehdi Alhassani recalls that the gatherings stopped following the coups (in 1958, but especially after 1963). No one went to such gatherings any more because trust was shattered and the potential consequences were severe. More importantly, no one would dare to organise any. When architect Midhat Ali Madhloom built a new house and wanted to bring his friends together, he had to inform the police in advance. Mehdi Alhassani in conversation with the author, Cambridge MA, 13 May 2014. Samira Baban, who had to go into hiding for months following the 1963 coup, remembers that they could not discuss anything serious even at home, for fear that school teachers would interrogate their children. Samira Baban in conversation with the author, Amman, Jordan, 19 February 2017.

81 After 1956, when the Iraqi Artists Society was founded, Balkis Sharara recalls that the regular gatherings had become more sporadic for various reasons. This was partly to do with the kind of spouses these young artists and architects married, who were younger and not interested in art. It also had to do with the deepening differences and increased polarisation. But Sharara contends that these gatherings had planted the seeds of renewal in art and architecture and paved the way for the following generations. Sharara, *Hakadha marrat al-ayyam*, 160-162.

establish an independent group, especially when his collective was distinguished not only by a strong intellectual agenda, but also by evident aesthetic affinities among its members, which resulted from adopting this agenda.[82] The group's message, delivered in its 1951 manifesto, was compelling: combining modern methods with the specificity of local culture in order to produce unique work that would at the same time be a contribution of Baghdadi artists to global art. While the SP was initially content with continuing their earlier tradition of capturing nature, particularly the landscapes visited by group members on their weekly painting trips, their production soon began to shift. By the middle of the decade, even Hassan was committed to locally inflected modern experiments that seemed to be an ideal fulfilment of Selim's manifesto.[83] The only way these ideas could have been transferred from one collective to the other was through the regular gatherings and parties where members of the various groups came together and debated their ideas. Because of their informal nature supported by friendships, the gatherings became vessels from which ideas spilled over from one group to another.

The second remarkable outcome of the domestic gatherings was the transfer of key ideas from artists to architects during the 1950s and 1960s. From the very beginning, architects participated in founding the various art collectives and contributed to their initiatives; the early photographs of the Friends of Art Society show at least three architects: Jafar Allawi and the brothers Midhat and Said Ali Madhloom. As more architects returned from their formal training abroad, they joined the regular domestic gatherings, as well as the art groups formed in the 1950s (for example, Kahtan Awni and Nizar Ali Jawdat contributed to establishing the Baghdad Group for Modern Art, while Kahtan al-Madfai, Rifat Chadirji, and Mehdi Alhassani were associated with the SP). Their friendships with artists, strengthened through close interactions at the regular gatherings, were soon manifested in numerous projects on which artists and architects collaborated, including exhibitions,

82 Faik Hassan did not seem to endorse Selim's project. Khalid al-Qassab recounts that Selim joined the SP upon his return from London and participated in the group's first two exhibitions. When he proceeded to establish his own group, he believed he could still be a member of both. But Hassan rejected this and asked him to make a decision about which group he wished to belong to. Al-Qassab, *Dhikrayat fanniyah*, 80.

Lorna Selim believes that Hassan was not behind the standoff. She recalls that after Jewad started the Baghdad Group for Modern Art, Ismail al-Shaikhly returned from Paris and became a member of Hassan's group. It was apparently al-Shaikhly – not Hassan – who said something to the effect that Selim had created his own group, so should not remain in the SP. Lorna Selim in conversation with the author, Wales, UK, 28 September 2015.

83 "Bayan Jama'at Baghdad lil-fann al-hadith" (Declaration of the Baghdad Group for Modern Art), reprinted in Shakir Hasan Al Sa'id, *Al-bayanat al-fanniyah fi al-'Iraq* (Art Declarations in Iraq). Baghdad: Wizaret al-i'lam, mudiriyet al-funun al-'ammah 1973, 25 and 27.

pavilions, and buildings, among others; perhaps the most iconic of these was the collaboration between Rifat Chadirji and Jewad Selim on the July 14 Monument, popularly known as the Liberty Monument, in Tahrir Square. Likewise, the relationship manifested itself through patronage, because architects became avid collectors and supporters of the work produced by fellow artists. Midhat and Said Ali Madhloom, the Jawdats, Chadirji, and Makiya were important early patrons in this context. Furthermore, architects opened the first commercial art galleries in Baghdad – the EA Gallery by Rifat Chadirji, and al-Wasiti Art Gallery by Said Ali Madhloom and Henri Svoboda. This intimate relationship indicates that these two camps were essentially part of a shared art-architectural culture, and that the intellectual agendas and explorations pursued by artists were absorbed by fellow architects as well.[84]

There is perhaps nothing that elucidates this shared culture more clearly than the overall shift towards the expression of local specificity that came to characterise modern art and architecture in Baghdad. In art, this gradually took shape during the 1950s, while a shift in architecture became evident by the middle of the following decade. These shifts were not necessarily independent, however, as certain aspects of the aesthetic repertoire developed by artists were shared by the architects. This constitutes the third major outcome of the exchanges that took place at the domestic gatherings. There were other strong influences with which architects had to contend – including the prevalent contemporaneous discourses within global architectural culture, such as historicism, monumentality, and regionalism, which invariably called for acknowledging local or regional character in architecture. Nevertheless, their interaction with fellow artists had a strong impact. It was during the domestic gatherings and heated discussions that these issues became salient and ingrained in the minds of both artists and architects.[85] The protagonists had

[84] Architect Kahtan Awni made the unequivocal link between artistic and architectural experiments, suggesting that the very first attempts to express local specificity were marked by the formation of the Baghdad Group for Modern Art, when a group of artists, architects, and intellectuals came together towards that objective. The works of Jewad Selim and his students, Awni added, were the early manifestations of these ambitions. Awni, Qahtan. "Al-shakhsiyah al-mutamayizah lil-'imarah al-'iraqiyah: athar al-turath wa al-mujtama' wa al-khalq al-fanni fi takwiniha" (The Distinct Character of Iraqi Architecture: The Impact of Heritage, Society, and Artistic Creation in Its Formation). Unpublished article, 10 April 1971, reproduced in Khalid al-Rawi, "'Imarat qahtan 'awni: dirasah tahliliyah wa tawthiqiyah" (The Architecture of Qahtan Awni: An Analytical and Documentary Study). Master's thesis, University of Baghdad 1990, Chapter 2, Section 3.

[85] For example, Mehdi Alhassani vividly recalls that soon after the new Department of Architecture was established in 1959, and at one of the regular house gatherings, Rifat Chadirji suggested that they should discuss the question of which material was the most quintessentially Iraqi (after artists and architects held a similar discussion about which was the most Iraqi colour). During that discussion, when architects decided that bricks were the most unique local material, Chadirji suggested that this was the type of subject

to argue and take positions, and to consider producing work that was relevant to their local audience. At the same time they wished to remain connected to the global art and architectural cultures to which they belonged, while mining the distinctive aspects of local culture – particularly their rich history from Mesopotamia through to the Abbasid period and the unique folkloric and vernacular heritage. Several artists, such as Selim, fragmented and abstracted a wide array of local referents, including elements of local architectural heritage, deploying them within their new compositions, thus presenting fellow architects with a ready palette that the latter in turn incorporated into their projects during the next decade.[86] The experiments in which both artists and architects engaged were a fulfilment of aspirations that were first articulated among friends, often during the regular domestic gatherings.

As demonstrated by these three outcomes (each of which deserves a thorough examination that is well beyond the focus and limits of this chapter), the domestic gatherings of post-World War II Baghdad had an enduring impact on the city's art and architectural cultures. These assemblies allowed the protagonists not only to convene and debate, but also offered learning opportunities, and friendly yet highly efficacious forums for refining the evaluation and criticism of artistic and architectural production. Patronage and support for artists, from fellow architects and other friends and enthusiasts, evolved in these spaces as well. Furthermore, the gatherings gradually opened up to a larger public when exhibitions were organised at the houses of the participants, and when unprecedented forms of collectivity emerged, and were manifested in the various art groups and professional associations. From their early beginnings, and even though they were held in private spaces, these domestic gatherings had permeable boundaries that allowed for newcomers – boundaries that became increasingly open, and were eventually dissolved, as the meetings started playing a more prominent role in mediating between participants and the public. That is, these gatherings gradually integrated artistic and architectural production into society, and established common frameworks necessary for giving meaning to new aesthetics in this context. Most importantly, it was in these domestic spaces that ideas were exchanged and more sophisticated intellectual agendas were formed and evaluated. They can be called alternative salons precisely because they served, in an informal manner, the purposes of more conventional salons at a time when the latter did not yet exist.

that must be taught in the new architecture school. Mehdi Alhassani in conversation with the author, Cambridge MA, 13 May 2014.

86 This was especially evident in Selim's group of works from the second half of the 1950s, called "Baghdadiyat," in which he aesthetically celebrated the culture and unique character of the city. These works often contained fragments of vernacular architecture, such as domes, arches, round windows, balustrades, ornate column capitals, and so on.

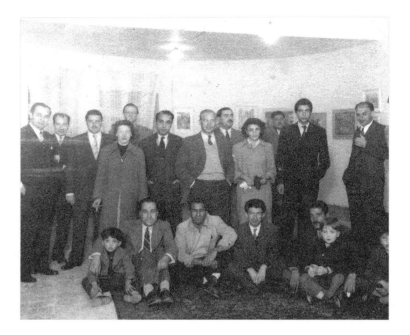

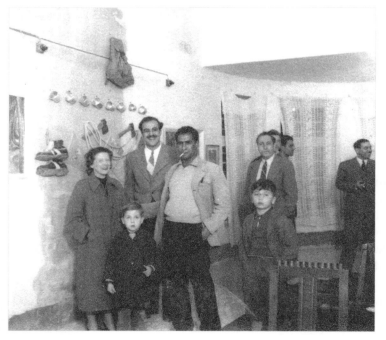

Figures 6a-6d: Opening of the SP (Société Primitive) first exhibition at Khalid al-Qassab's
House, 1950. In addition to the artworks of the participants, paraphernalia of the group's

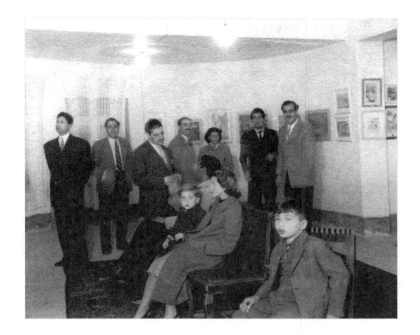

outdoor trips were also displayed during this exhibition. Images courtesy of Hanan al-Rawi.

Describing the gatherings as alternative salons, however, remains inaccurate because of the idiosyncratic tradition that came to define these assemblies. Employing the analogy to conventional art salons does, however, provide a reference point against which the uniqueness of these Baghdadi domestic gatherings can be appreciated. Because of their singular nature, the gatherings must be regarded as an institution in their own right. This was an independent institution that had a specific lifespan, roughly from the early 1940s until the late 1950s; it was founded and sustained by a specific group of participants and contributors; yet it had an osmotic and ever-expanding perimeter that allowed in new participants, and it mediated between the private and public spheres whenever the need arose; it was an institution that occupied not just one place but a network of spaces (the houses of various artists and architects, and at times even the outdoors); it took on many guises (meetings, picnics, parties, exhibitions); it absorbed dissent, negotiated differences, and allowed for an evolution of ideas as well as the articulation of individual and group positions. Rather than viewing its ephemerality and end as a total demise, these domestic gatherings must instead be seen as a transitional institution that gave life to various tangible outcomes, as well as creating a more professionalised culture akin to that of conventional art salons.[87]

And even though these domestic gatherings were pivotal in the growth of art and architecture in a number of ways, several key dimensions might not be immediately evident. These spaces constituted safe shelters where the protagonists could weather adverse political circumstances that would have been too disruptive had these exchanges taken place in public spaces or official institutions. Therefore, and at some level, these gatherings and the associated art and architectural cultures were critical in transcending the political ruptures and instability that plagued Iraq during this period.[88] Furthermore, the gatherings also succeeded in transcending the diverse

[87] Needless to say, politics had a more detrimental impact in the long run. Beyond the dark moment of 1963, the 1968 coup d'état signalled a new era: hardly any artist or architect could produce freely or contemplate independence from the state (perhaps architects were less afflicted than artists in terms of aesthetics, as they did not face the same representational expectations; architects did, however, suffer because of changing professional norms under the Ba'th, and because commissions were given not for the merits of a design or the experience of an architect, but more for tribe or sectarian associations; architects like Mohamed Makiya left the country, while Rifat Chadirji started focusing more on projects in the Gulf). The tight grip of the regime, as well as the subsequent wars into which Iraq was plunged, made celebrations of national themes the utmost priority and the most rewarding, not to mention the safest, genre of artistic production. There was always dissent, but it was largely muted, enigmatic, and highly coded.

[88] Again, that was the case until the regime became so oppressive and tyrannical that a tradition of this nature could no longer be sustained.

ideological orientations and political activities of the attendees, creating opportunities for constructive debate and the refinement of ideas, individual and group positions, and various artistic approaches. In addition, these gatherings transcended any purported divisions in Baghdadi society in terms of religion (they brought together Muslims and Christians), sects (Shias and Sunnis), ethnicities (Kurds and Arabs), classes (affluent and humble backgrounds), and gender (women and men). In other words, apart from serving the country's art and architectural cultures, these gatherings were unique and cogent prototypes of how a small group of progressive individuals could exercise its agency in overcoming the obstacles and limitations of their circumstances, negotiating between their disciplines and their society, and between their local culture and the world, all the while cherishing their experience and producing brilliant works despite the odds.

At a fundamental level, and even though these gatherings remained the privilege of a few, the tradition they created had far-reaching consequences. Not only did they nurture a camaraderie that helped their participants to persevere and establish the foundations of vigorous art and architectural cultures in Baghdad, but this tradition would later yield more institutional forms of debate, display, and dissemination. Therefore, these gatherings conveyed a tacit defiance. Their regular, spirited, and welcoming assemblies existed in spite of strict and conservative societal norms, against the backdrop of political oppression, and within an alienating context of vast and rapid transformations. Likewise, they took place outside the prevalent norms of formalised and professionalised art and architectural cultures that their members had witnessed during their training in the West. The art and architecture that was produced challenged imported practices, appropriating and transforming modernism, and yet was situated within a global culture that they wished to imagine and to participate in defining. Therefore, this was laconic resistance that worked against various forms of pressure, dominance, and exclusion.[89] By appearing to disengage from politics in its conventional form of demonstrations, activism, or explicit public statements, Baghdadi

[89] The classic analysis of cultures of resistance conducted by James C. Scott is germane here. He points out how "ideological resistance is disguised, muted, and veiled for safety's sake" and that "the realities of power for subordinate groups," that is, of being constantly under threat by dominant powers, "mean that much of their political action requires interpretation precisely because it is intended to be cryptic and opaque." Scott discusses how homes have historically been sites of dissent and contestation, as opposed to open assemblies where the hegemony of a dominant power rules. Of particular relevance are his chapters on the use of space and methods of disguise: "Making Social Space for a Dissident Subculture" and "Voice under Domination: The Arts of Political Disguise." In Scott, James C. *Domination and the Arts of Resistance: Hidden Transcripts*. New Haven, CT: Yale University Press 1990, 108-135 and 136-182; quotations 137.

artists cultivated their own alternative politics.[90] Their pocket of resistance demonstrated the vitality of being open to the world, inclusive of diversity, and relentlessly progressive. Most importantly, their domestic gatherings conveyed the ability to imagine alternative modes of convening, debating, and producing within unlikely circumstances.

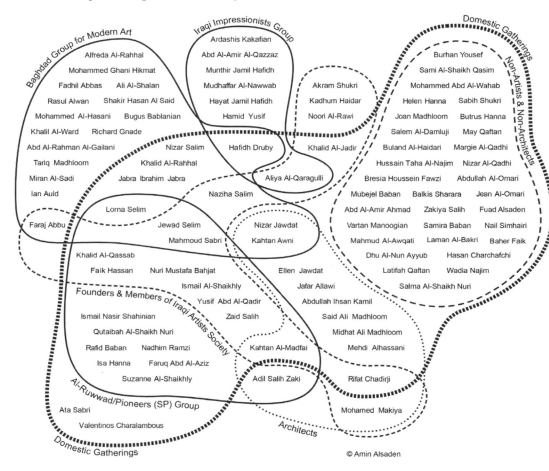

Figure 7: Relationships between attendees of the regular domestic gatherings, in terms of their overlap with the three main art groups and the beginnings of the Iraqi Artists Society, covering approximately a decade, from the late 1940s to the late 1950s (neither a definitive list of all attendees, nor of all artists and architects in Baghdad at the time; the names shown are based on extant documents, such as invitations and photographs, memoirs and published material, and interviews). Courtesy of the author.

90 Rancière believes that the politics of art are "made possible by continuously playing on the boundary and the absence of boundary between art and non-art," and he adds that "political art had already been made possible by that mixing, by a continuous process of border crossings between high and low art, art and non-art, art and the commodity." Rancière, "Contemporary Art," 42 and 43.

PART IV

CIRCULATIONS AND GUIDANCE

CHAPTER 8
PATTERNS FOR GLORY: THE REWARD SYSTEM IN NORTH AFRICAN ART SALONS UNDER FRENCH RULE AROUND 1900*

CAMILLA MURGIA

In May 1895, the *Revue Tunisienne*, an official Tunisian journal, published a review of the newly founded Salon tunisien, the first edition of which had taken place the previous year. The journal gave detailed accounts of the speeches by different political and cultural representatives at the opening of the show on 8 May. Among them, Général Servonnet, president of the Institut de Carthage, proudly claimed that visitors would surely be impressed by the remarkable role played by "les œuvres d'origine locale."[1] Shortly after, in a second speech, he insisted on France as an artistic model, in an apparent contradiction of his earlier comment.[2] Perhaps unintentionally, he expressed the dual character of North African art salons. The Salon tunisien, as well as other salons of North Africa such as the Salon of the Société des artistes algériens, followed the structure of the French official Salon. However, while art exhibitions increased in North Africa from the 1890s onwards, the official Salon started to decline in France. North African salons clearly developed from a French background, but evolved with different scopes and therefore gave rise to different issues. Within this context, the reward system, like that of its model, the Paris Salon, was representative of this transformation.

This chapter investigates the mechanism of reward and aims to understand to what extent it was crucial in the development of North African salons. The number of prizes awarded helped these events to gain a national and international reputation, and contributed to shaping local art as an autonomous cultural entity. My overall objective is to analyse the

* *For Gabry and Ricky, thank you for teaching me that borders do not exist.*

[1] "Deuxième exposition artistique à Tunis," *Revue Tunisienne, organe de l'Institut de Carthage*, no. 7 (July 1895), 282.

[2] "Deuxième exposition artistique à Tunis," 290.

interaction between French and North African salons. First, I will discuss the historical relationship between them. The study of art exhibitions in Algiers and Tunis allows us to understand the importance of the reward system as a catalyst for Algerian and Tunisian art. Second, I will focus on the role of the reward system as a mediator between the French model and the perception of North African national arts that was generated by the exhibitions. The focus on Algeria and Tunisia portrays two different political situations and therefore illustrates the diverse approaches of French colonisation as well as of local responses to it. On the one hand, Algeria was constituted as a French administrative department called Algérie française, consisting of three main divisions – Alger, Constantine and Oran – which was dependent on the French government from 1848 to 1955 just like any other French department.[3] On the other hand, in 1881 Tunisia became a French protectorate, which allowed Tunisians to manage administrative divisions such as finance or education while their country remained under French control with regard to borders, wars, and military actions.[4] French colonisation triggered a rearrangement of foreign residents and, more generally, an influx of foreigners, which rapidly increased, rising to roughly half of the inhabitants of Tunis by 1911.[5]

North African salons provide a wealth of material on the development of the artistic sphere in the region and its relationship to France. They also offer insight into the reasons that led to the rise of artistic patronage. Within this context, the French salon has often been mentioned as a model for many other artistic manifestations. However, the relationship between the French exhibitions and the North African salons betrayed complex mechanisms of construction of national identity through artistic encouragement, rather than a straightforward filiation. Indeed, the two manifestations differed fundamentally from each other, despite their regular interaction. Furthermore, the development of North African salons corresponded to a profound rearrangement of the Paris Salon and of the perception of state art in general. Nevertheless, in order to understand the impact of this readjustment, it is worth briefly discussing the origins of the Paris Salon and the changes it went through.

[3] For a general overview of the Algerian colonial period, see: Peyroulou, Jean-Pierre and Abderrahmane Bouchène, Ouanassa Siari Tengour, Sylvie Thénault (eds.). *Histoire de l'Algérie à la période coloniale, 1830-1962*. Paris: Éditions de la Découverte 2012.

[4] On the political situation of Tunisia see: Martin, Jean-François. *Histoire de la Tunisie contemporaine. De Ferry à Bourguiba*. Paris: L'Harmattan 2003.

[5] Hamida, Abdesslem Ben. "Cosmopolitisme et colonialisme. Le cas de Tunis." *Cahiers de l'Urmis* (online) 4 (December 2002), accessed 21 June 2018, http://journals.openedition.org/urmis/4.

Historical Context: The Rise of the Paris Salon

The original term "salon" referred to an official, state exhibition of contemporary art. Founded in 1667, the Paris Salon was an institutional manifestation.[6] Only members of the Académie Royale were allowed to exhibit their works. The exhibition took place in the Louvre Palace, to emphasise the link between the state, represented by the king, and the Academy. The room devoted to the exhibition was known as the Salon carré, which lent its name to the event itself. The Salon was the last step in a long process of art institutionalisation and theorisation in France that had begun in 1648 with the foundation of the Académie Royale.[7] From its first edition, the Salon exhibition aimed to display the progress of French art both at a national and an international level, projecting the king's image as a patron of the arts. This situation changed with the 1789 Revolution. While the Academy was dismantled in 1793, the Salon continued to run and was reshaped to conform to revolutionary doctrine.[8] Its conception, organisation and scope were profoundly reordered, because all artists were now entitled to exhibit their works.

From the 1790s onwards, the Salon became more autonomous, independent from a didactic perspective but still dependent on state policy. During the Napoleonic period, Dominique Vivant Denon (1747-1825), director of the newly founded Louvre and responsible for running the Salon, used it to promote the French school and to show artistic progress.[9] Vivant Denon ascribed this function, more or less directly, to the establishment of a reward system consisting essentially of first, second, and third class medals, which were often followed by official commissions.[10]

6 On the history of the Salon, see Lemaire, Gérard-Georges. *Histoire du Salon de Peinture*. Paris: Klincksieck, 2004; Monnier, Gérard. *L'art et ses institutions en France. De la Révolution à nos jours*. Paris: Gallimard 1995.

7 On the function of the Academy, see Lichtenstein, Jacqueline and Christian Michel. *Conférences de l'Académie royale de Peinture et de Sculpture: Volume 1, 1648-1672*. Paris: Ecole Nationale Supérieure des Beaux-Arts 2007.

8 Caubisens-Lesfargues, Colette. "Le Salon de peinture pendant la Révolution," *Annales Historiques De La Révolution Française* 33, no. 164 (1961): 193-214; Heim, Jean-François, Claire Béraud and Philippe Heim. *Les Salons de peinture de la Révolution française, 1789-1799*. Paris: C.A.C. Éditions 1989.

9 Dupuy, Marie-Anne (ed.). *Vivant Denon: L'Oeil de Napoléon*, exhibition catalogue. Paris: Éditions de la Réunion des Musées Nationaux 1999; Laveissière, Sylvain (ed.). *Napoléon et le Louvre*. Paris: Éditions du musée du Louvre 2004.

10 On many occasions, and most of the times successfully, Vivant Denon suggested to reward rising and young artists such as Théodore Géricault, convinced of the impact of a Salon medal. The French National Archives demonstrate Vivant Denon's tireless efforts to transform the reward system into an opportunity to finance young artists, and to make the event a crossroads for contemporary art. In the case of Géricault, Vivant

The perception of the Salon evolved throughout the nineteenth century, and continued to be deeply affected by political events in France. The event and its administration, as well as the jury admitting the works and giving out rewards, were often criticised, the jury mostly for the mediocre quality of the artworks displayed.[11] Printed reviews and critics played a pivotal role here, affecting public taste but also generating debates. The year 1880 represented in a certain sense the logical outcome of these debates. Following the request of Minister of Culture Jules Ferry (1832-1893), the artists exhibiting at the Salon created the Société des artistes français. The Society's main aim was to regulate the Salon, which therefore passed from being under state authority to management by a newly founded society. The end of the official Salon as a state manifestation echoed the debates surrounding its role as a supporter of artistic conventions in accordance with the academy system.[12]

By mid-century, the hierarchy of genres was being increasingly questioned and the supremacy of history painting jeopardised. To restore the established artistic order as well as the Salon's reputation, Philippe de Chennevières (1820-1899), director of the Fine Arts division of the French Ministry of Education, managed to create, as early as 1874, a Prix du Salon. This prize was meant to be awarded every year to a young talented artist at the end of the Salon exhibition. It initially consisted of a three-year sojourn in Rome, clearly imitating the more prestigious Prix de Rome, which had been awarded by the dismantled Académie Royale through a competition open to students. In May 1881, a couple of months before the establishment of the Société des artistes français, the prize was rearranged into a one-year travel grant, and Rome was no longer defined as a compulsory destination.[13] Furthermore, the Conseil supérieur des beaux-arts, an administrative

Denon proposed a 500 francs medal for his *Portrait équestre de M.D.* exhibited at the Salon of 1812. He explained his recommendation to Napoleon as follows: "C'est la première fois que cet artiste expose, et il débute par un ouvrage qui donne les plus grandes espérances et promet un très habile peintre de batailles". Paris: Archives Nationales de France (herafter ANF), O2 157, no. 351.

11 Hauptmann, William. "Juries, protests, and counter-exhibitions before 1850," *The Art Bulletin* 67, no. 1 (1985): 95-109. On the Paris Salon in the first half of the nineteenth century, see also Chaudonneret, Marie-Claude. "Le Salon pendant la première moitié du XIXe siècle: musée d'art vivant ou marché de l'art ?," *Archive ouverte en Sciences de l'Homme et de la Société* (2007), accessed 27 September 2012, HAL Id: halshs-00176804; "Les artistes vivants au Louvre (1791-1848): du musée au bazar," in '*Ce Salon à quoi tout se ramène*': *le Salon de peinture et de sculpture, 1791-1890*. Edited by James Kearns and Pierre Vaisse. Bern: Peter Lang 2010, 7-22.

12 Mainardi, Patricia. *The End of the Salon: Art and the State in the Early Third Republic*. Cambridge, UK: Cambridge University Press 1993.

13 Richemond, Stéphane. *Les salons des artistes coloniaux. Suivi d'un dictionnaire des sculpteurs*. Paris: Éditions de l'Amateur 2003, 15.

committee, was put in charge of the award, and the Salon jury was pushed out of the decision-making process. This change clearly betrayed an administrative intention of separating state awards from the Salon, which was progressively relegated to the rank of a contemporary art exhibition. A couple of years later, the break with the Salon became yet more explicit. The award was renamed Prix National and now consisted of a two-year grant, one year of which had to be spent in Italy.

This development exposed a rupture between the academic system and governmental administration, underlining a progressive shift of the Salon's status from a mirror of contemporary art production to a stage of national values. Within this context, the number of cultural manifestations that characterised the art scene in North Africa had to cope with a significant readjustment of what was considered an appropriate model to follow. It is therefore not surprising that North African salons also reflected such a complex functioning, and questioned the role of art shows in general.

Mirroring and Questioning the French Model

From the 1880s, a number of art exhibitions took place in Morocco, Algeria, Tunisia and Egypt that demonstrated a strong link to the mechanisms of display of French art and their associated cultural practices. Given the number of shows and the diversity of contexts, I will focus on Algeria and Tunisia as representative examples of the complex relationships between North Africa and France. The rise of a "national art" in Algeria and Tunisia respectively and the perception of it in North Africa deeply depended on these events, while at the same time standing in contrast to the progressive decline of the Paris Salon, which had been intended as an official manifestation of cultural policy legitimated by state patronage.

A major characteristic of North African salons was their constant reference to the French model, juxtaposed with attempts to create different, autonomous events. This capacity to both mirror and question the Paris Salon was possibly the legitimisation of the connection between these numerous shows. The French salon helped with the launch of a career, following an academic tradition and convention, for instance with regard to historical painting. More importantly, it grew out of a government initiative: even after the rupture of the revolutionary period it remained a state event, an official artistic manifestation. In contrast, North African salons emerged from non-state initiatives and struggled – at least in their early stages – to be recognised as official state events.[14]

[14] This struggle to be recognized as official events by both French and North African governments was partly because the exhibition format was not yet fully established. For

In February 1911, the newspaper *L'Afrique du Nord Illustrée* insisted that the Algerian Salon was radically different from an art exhibition.[15] Contrary to art shows, the Salon proposed a selection of artworks chosen by a jury, and according to the magazine, this was the main distinguishing feature of the event. Furthermore, the Salon had to be considered with regard to its didactic role because it was meant to contribute to building artistic knowledge. Crucial to this goal was not a large number of exhibited items but the award system, as the art critic pointed out:

> What makes the value of a Salon is not the number of canvases exhibited or sold. What puts this event into context, what gives it its educational value and, even for the exhibitors, its enlivening and rewarding role, is to become an artistic process for which thoughtful, pondered, personal and significant work has been prepared....[16]

The presence of a jury facilitated this relationship between artists and the public, and legitimised a recognition to come. It elevated the event from an art exhibition to a prestigious event. The jury in Paris, established for the Paris Salon in the late eighteenth century, never ceased to be criticised and questioned because of the quality of the artworks admitted or the number of prizes awarded.[17] During the Napoleonic period, Vivant Denon showed the administration's impact on the choice of the rewards, as he was directly responsible for submitting to the Emperor a list with the names of artists to be rewarded.[18] These rewards were tangible in the form of first, second, and third class medals, but also as official commissions that clearly impacted artists' careers, especially those of young and emerging artists. With the establishment of the Prix du Salon, medals were replaced by a series of grants that became increasingly popular during the last decades of the nineteenth

instance, the exhibition venue or the number of exhibitors varied from year to year. On this, also see Alain Messaoudi's chapter in this volume.

15 "Le XIIIe Salon Algérien," *L'Afrique du Nord Illustrée*, 15 February 1911, 1 (1-4) Aix-en-Provence, Centre de Documentation Historique sur l'Algérie (CDHA), 44 ARC 308.

16 "Le nombre de toiles exposées, le nombre de toiles vendues ne font pas la valeur d'un Salon. Ce qui le situe dans le temps, ce qui lui donne sa force éducatrice, ce qui lui confère même pour les exposants son rôle d'animateur et de récompense, c'est de devenir une solennité artistique pour laquelle on a préparé l'œuvre réfléchie et médités, personnelle, significative ...," "Le XIIIe Salon Algérien," 1.

17 Chaudonneret, "Le Salon pendant la première moitié du XIXe siècle."

18 Some of these lists have survived and have been published in Vivant Denon's correspondance: Dupuy, Anne-Marie, Isabelle le Masne de Chermont and Elaine Williamson (eds.). *Vivant Denon, directeur des musées sous le Consulat et l'Empire. Correspondance (1802-1815)*. Paris. Éditions de la Réunion des Musées Nationaux 1999, 2 vols.

century, while the jury disappeared.[19] North African salons echoed these debates about the jury's establishment and competences, especially regarding their fairness. In the case of the Salon tunisien, a Comité du Salon was appointed on the occasion of the first edition of 1894. It consisted of four members, three of whom were Général Servonnet, the painter Bridet, and the high school teacher Vayssié.[20] In 1901, the committee had to cope with an increasing number of exhibitors, now 408, while the previous edition (that of 1900), included 308 artists. The Algiers Salon of the same year exhibited works by only 186 artists.[21] Buisson, deputy president of the Tunis Salon Committee for 1901 and master of the Collège Alaoui, insisted on the commitment of jury members and drew attention to the challenges of their task:

> I will say only one thing about this Jury, which does not claim to be infallible, because I think that this is indisputable: its members have shown a praiseworthy devotion to our society and have spared neither their time nor their sorrows. They have followed only their own conscience, beliefs and artistic faith to take a decision.[22]

Prizes as Medals: The Salon Tunisien and a Pedagogical Aesthetic

The prizes awarded on the occasion of the 1901 Salon tunisien revealed the growing role of the event in the artistic sphere. They were distributed across the Salon's four divisions: 1) painting; 2) sculpture and medal engraving; 3) prints and drawings; and 4) architecture, decorative arts, photography and pottery. Awards consisted of medals and distinctions (magna or summa cum laude). The latter referred to a didactic vocabulary and echoed the origin of the Salon tunisien itself, initiated by the Institut de Carthage. The event was intricately linked to a pedagogical function as the first awards

19 For an overview of the system of grants, see Richemond, *Les salons des artistes coloniaux*.

20 "Une exposition de Beaux-Arts à Tunis." *Revue Tunisienne*, no. 2 (April 1894): 307-309, 307.

21 "Institut de Carthage. Ouverture du sixième Salon tunisien." *Revue Tunisienne*, no. 31 (July 1901): 368-374, 369.

22 "De ce Jury, qui ne se prétend pas infaillible, je ne dirai qu'une chose, parce que je la crois incontestable, c'est que les membres qui l'ont composé ont fait preuve d'un méritoire dévouement à notre société et n'ont épargné ni leur temps ni leurs peines, qu'enfin ils n'ont écouté, pour se décider que leurs convictions, que leur conscience, que leur fois artistique." "Institut de Carthage. Ouverture du sixième Salon tunisien," *Revue Tunisienne*, 371.

demonstrated. On the occasion of the first exhibition of 1894, 25 artists received a distinction. Medals were first introduced, alongside distinctions, in the following edition of 1895. From 1901 onwards, awards seemed to be regularly divided into first, second, and third class medals and other distinctions (see Table 1).[23]

The reference to the reward system of the French salon was explicit in the case of Tunisian exhibitions, especially given that the event was conceived as an artistic manifestation of the newly founded Institut de Carthage, which played a crucial role in the Tunisian cultural sphere, as pointed out by Patrick Abéasis.[24] This promotion included a series of exchanges between Tunisia and France, well-illustrated by the diversity of the Salon's exhibitors, who had been predominantly European in its first edition.[25] Founded in 1893, the Institut de Carthage was part of the cultural programme developed during the French protectorate in Tunisia after 1881.[26] Political changes occurred in a period of transformation, which witnessed a considerable influx of artists from Europe – and particularly France – to Tunisia. Within this new cultural configuration, the Salon tunisien provided a platform for promoting the arts at a local level, but also enabled an easy circulation of contemporary art more generally. The proposed acquisitions that F. Picard, president of the Institut de Carthage, compiled on the occasion of the 1901 Salon highlighted the international character of the event.[27] For instance, the French artist Antoinette Chavagnat (d. 1906), who exhibited a watercolour entitled *Oeillets*, was included in the acquisitions list. The number of prizes that he won and that Picard mentioned in the list pointed to the Salon tunisien's international range. A first Grand Prix at the Rouen exhibition of 1897 was followed by a gold medal at Bologna and a distinction at the Salon tunisien of the same

23 For the regulations of the 1901 Salon, see: Paris: ANF, F21 4745, folder 1: "Tunis. Salon de l'Institut de Carthage". The reward system is described in Article 10.

24 Abéasis, Patrick. "Le Salon Tunisien (1894-1984). Espace d'interaction entre les générations de peintres tunisiens et français." In *Les relations tuniso-françaises au miroir des élites*. Edited by Noureddine Dougui. Manouba: Publications de la Faculté des Lettres, 1997, 229-254.

25 Abéasis, "Le Salon Tunisien (1894-1984)," 230.

26 Abéasis, "Le Salon Tunisien (1894-1984)," 231. Alain Messaoudi offered a detailed study of the impact of the French protectorate on Tunisian art and museums, which showed the complexity of the relationship between the two countries: "Un musée impossible? Exposer l'art moderne à Tunis (1885-2015)," HAL archives ouvertes, 2016, hal-01284670. On the diversity of projects led by the French government in Tunisia, see: Kmar, Kchir-Bendana. "Les missions scientifiques françaises en Tunisie dans a deuxième moitié du XIXᵉ siècle." *Les Cahiers de Tunisie*, nos. 157-158, (1991), 197-207.

27 F. Picard, "Liste des achats proposés pour le Salon de 1901 au moyen de mille francs." Paris: ANF, F21 4745, folder 1: "Tunis. Salon de l'Institut de Carthage."

year. Chavagnat went on to win a third class medal at the Salon in 1898, and a first class medal in 1901 (see Table 1).

Because of its political status as a protectorate, Tunisia was expected to have its own budget for education and fine arts purposes. However, the Institut de Carthage regularly appealed to the French administration for artistic and/or financial support for the Salon. Much attention was paid, for instance, to the acquisitions of artworks for which the French government regularly granted a subsidy of 1,000 francs.[28] According to the Institut's administration, the acquisition grants were aimed at constituting a collection of works of art that was expected to serve as a base for a future fine art museum.[29] The subsidy queries also mentioned the creation of a tombola, intended to support the artists, for which they were awarded – for the Salons of 1903 and 1904 – one vase from the Sèvres manufactury and a set of ten different prints after old masters such as Rembrandt, Hans Holbein, or Antoine Watteau.[30] The lottery was officially to support the artists but was clearly meant to raise the Salon's visibility, to create a further link with France, and to contribute to the show's economic viability. The money gained by the sale of lottery tickets allowed the acquisition of some artworks exhibited at the Salon. For instance, on the occasion of the 1912 Salon, the Institut de Carthage was able to acquire artworks by Jean Antoine Armand Vergeaud (1876-1949), Antonin Bréfort Porché (1869-1923), Louis Randavel (1869-1948), Georges Le Mare (1866-1942), and Pierre Demoutier (1866-1942).[31]

French artists, especially young representatives of the French avant-garde, did not hesitate to exhibit their works at the Salon tunisien. The

[28] See: Ministerial decree, issued for the 1901 edition of the Salon on July 19 1901. The demand for the subvention was apparently issued – and granted – for every edition of the Salon as showed in the 1925 query, addressed to Monsieur Schoeffler, secretary of the Ministry of Fine Arts and dated 14 February 1925. Paris: ANF F21 4745, folder 1: "Tunis. Salon de l'Institut de Carthage".

[29] The president of the Committee of the Institut de Carthage insisted on the preservation objective of the subvention, stating that it was thought to be "pour l'achat d'œuvres que notre association est chargée de conserver en vue de la création ultérieure d'un musée des Beaux-Arts". Letter to the French Ministry of Interior, Tunis, 19 March 1901. Paris: ANF F21 4745, folder 1: "Tunis. Salon de l'Institut de Carthage"

[30] The vase from the Sèvres manufactury as well as the lists of prints for the editions of 1903 and 1904 of the tombola are mentioned in the correspondence about the subventions. See for instance: Ministerial decree, April 15 1903, stating the terms and conditions of the Salon; Notification of the subvention from the French Ministry of Fine Arts to the Résident Général of Tunisia, 10 May 1904. Paris: ANF F21 4745, folder 2: "Salon des Beaux-Arts, 1903, 1904".

[31] "Salon Tunisien. Tombola; tirage du 7 mais 1912." *Revue Tunisienne*, no. 94 (July 1912): 443-444.

Salon emerged within this context as a liberal, broad-minded manifestation mirroring the more prestigious Parisian exhibitions, but offering a less biased and dogmatic reception of artworks. For instance, avant-garde painters Marie Laurencin (1883-1956) and Albert Gleizes (1881-1953), who exhibited at the Salon tunisien of 1913, had provoked a number of debates a year earlier when exhibiting in Paris.[32]

To enhance both the official character of the Salon tunisien and its international visibility, governors general and ministers were regularly invited to openings and visits. The reward system confirmed their pivotal role for success. In the opening address to the 1897 edition, Paul Gauckler (1866-1911), director of the Antiquities and Fine Arts division of the Regency and president of the Salon's committee, insisted on discovering and staging young artists' works.[33] The reward system was essential to this as it could launch a career, as the Paris Salon did from the post-revolutionary years onwards. Gauckler demanded a commitment to the young generation of artists and aptly summarised the exhibition's objective: "Our exhibitors are not people who have arrived, but people who are arriving …."[34] To enhance the impact of rewards on the Salon, particular attention was drawn to the number of prizes, which was reduced from this edition onwards, apparently at the request of Tunisian exhibitors.[35]

The revision of the prize system provided the Salon committee with the opportunity to diversify the awards, deviating, as a result, from the French model. Prizes were handed out by political authorities in order to call attention to the scale of the event, and to the prestigious and official nature of the award. They also explicitly evoked the reward system of the Paris Salon. For instance, a Prix du Salon, consisting of a medal, was meant to celebrate the most talented artist, without regard for his or her nationality. In 1897, this prize was awarded to Norwegian painter Fritz Thaulow (1847-1906), who was living in Paris but travelled to North Africa like many of his fellow contemporaries.[36]

32 Abéasis, "Le Salon Tunisien (1894-1984)," 232.

33 On Gauckler, see Bacha, Myriam. "Paul Gauckler, le père Delattre et l'archevêché de Carthage: collaboration scientifique et affrontements institutionnels." In *Autour du fonds Poinssot*. Edited by Monique Dondin-Payre, Houcine Jaïdi, Sophie Saint-Amans and Meriem Sebaï (2017), accessed 2 January 2018, http://journals.openedition.org/inha/7158.

34 "Nos exposants ne sont pas des gens arrivés, mais des gens qui arrivent (…)." "Discours de M. Gauckler," *Revue Tunisienne*, no. 15 (July 1897), 358. (356-359).

35 "Discours de M. Gauckler," *Revue Tunisienne*, 358.

36 "La distribution des récompenses au Salon tunisien," *Revue Tunisienne*, no. 15 (July 1897): 354-356, 355.

Alongside medals and distinctions, the year 1897 saw the establishment of the Brodard prize and the Prize of the Société des peintres orientalistes français (SPOF). The first referred to the Paris painter Ferdinand Brodard, and was given to the artist who exhibited the most complete and uniform set of artworks.[37] The second prize was created by the Société des peintres orientalistes français, which played a crucial role in the development of North African art and exhibitions. According to Gauckler, the prize consisted of a Medal of Vermeil and was devoted exclusively to artists born or resident in North Africa who had presented a landscape or genre painting at the Salon.[38] Tunisian painter Alcide Bariteau (1862-1943) won the first medal of the SPOF in 1897, and devoted his career to the depiction of landscapes and "natives" of Tunisia and Algeria. The involvement of the SPOF in the Salon tunisien was particularly representative of the almost paradoxical struggle to build a national art that was perceived as autonomous, while at the same time was supported by the French authorities. Tunisian shows give evidence of this seemingly paradoxical effort. The SPOF not only established a Prix des Orientalistes but also proposed, on the occasion of the Salon tunisien, an exhibition of about one hundred artworks produced exclusively by its members.[39] This show echoed the Paris exhibitions of the SPOF, which initially took place at the Galerie Durand-Ruel, one of the most important commercial galleries of Paris during this time.[40]

With the intention of stressing the importance of the artistic achievements for the Tunisian nation, the Salon committee also allowed, starting from 1897, the awarding of the medals of "commander," "officer," and "first class knight" of the Nichan-Iftikhar Order, which the Bey of Tunis had established in 1835 to pay tribute to those who had played a particularly significant role in the country's artistic progress. Some of the artists who won a prize at the Salon, such as Thaulow, also received the decorations of the Nichan-Iftikhar Order.[41]

The diversity of awards given during the Salon tunisien were evidence of a dual intention. First, the Institut de Carthage aimed at providing young artists with a platform for artistic exchange and for promoting their

37 "La distribution des récompenses au Salon tunisien," *Revue Tunisienne*, 359.

38 "La distribution des récompenses au Salon tunisien," *Revue Tunisienne*, 359.

39 "L'exposition de la Société des Peintres Orientalistes Français à Tunis," *Revue Tunisienne*, no. 15 (May 1897): 186-189, 186.

40 Richemond, *Les salons des artistes coloniaux*, 29. On the SPOF, see Richemond, Stéphane and Pierre Sanchez. *La société des peintres orientalistes français (1889-1943)*. Paris: Éditions l'Échelle de Jacob 2008.

41 "La distribution des récompenses au Salon tunisien." *Revue Tunisienne*, 356.

own (national) art. Second, the Salon functioned as a bridge between the North African artistic context and France. This relationship was more complex than it appeared, because it embodied the perception of a model that was not merely imitated or followed but was questioned, challenged, and developed further, marking a need for differentiation.[42] The Prix des Orientalistes, established in 1897, lay at the heart of this connection between Tunisian and French salons. The fact that the SPOF conceived the award was the result of an ongoing debate and exchange between the two systems. Founded in 1893, the SPOF was much indebted to Léonce Bénédite (1859-1925), keeper of the Musée du Luxembourg and among the most important supporters and admirers of the Orientalist movement in France.[43] Art lovers such as Arthur Chassériau (1850-1934) and artists such as Etienne Dinet (1861-1929), who were members of the SPOF committee, quickly championed the society's support of the study of Oriental and Middle Eastern art.[44] The prize established at the committee's request at the Salon tunisien was a concrete and immediate way to promote art and directly support artists. The argument employed by Alexandre Fichet (1881-1967), president of the artistic division of the Institut de Carthage and responsible for the Salon tunisien, to ask the French government for financial support for the Salon of 1919, was representative of the intention of creating an autonomous and referential event. Fichet insisted on the need for funding, claiming that before World War I the Salon relied entirely on "local resources," which were, however, not sufficient.[45]

The Reward System in Algeria

This link between North Africa and France is also illustrated by the creation, in 1897, of the Société des artistes algériens, which rapidly became the Société des artistes algériens et orientalistes (SAAO). The SAAO was directly linked to the SPOF, and included, among others, sculptor Charles Cordier (1827-1905) and painters Maxime Noiré (1861-1927), Ferdinand Antoni (1872-1940), Etienne Dinet, and Georges Rochegrosse (1859-

[42] The complexity of this relationship depended on the changes in the political situation and evidently on French colonisation, which somehow contributed to the establishment of a cultural permeability between France and North Africa. On this question, see Benjamin, Roger. *Orientalist Aesthetics. Art, Colonialism, and French North Africa, 1880-1930.* Berkeley, CA: University of California Press 2003, 11-32.

[43] In her chapter in this volume, Nancy Demerdash-Fatemi calls attention to the crucial role that Bénédite played in the creation of an Orientalist taste.

[44] Richemond, *Les salons des artistes coloniaux,* 28.

[45] Letter from Alexandre Fichet to the Deputy Secretary for Fine Arts, 24 November 1919. Paris: ANF, F21 4745, folder 3.

1938), most of whom were regular exhibitors at the Salon tunisien. The SAAO reinforced the need for an artistic platform for North African art, functioning as a bridge, once again, between the Algerian government, the North African artists themselves, and the French model. It also promoted the sale of exhibited artworks, showing the impact of the Salon on artists' careers and on the art market. According to art critic Raoul d'Artenac, the exhibitions of the SAAO indicated the need for artworks and the development of the art market, at the same time as granting a basic and crucial income to artists.[46]

From 1905 onwards, the SAAO organised a Salon based on the French model, regularly displaying works by French artists such as Auguste Rodin (1840-1917), who exhibited in 1912, granting an additional visibility to the event. The SAAO also established a reward system, mainly consisting of grants alongside medals. Both the Algerian government and the SPOF were active partners in this process. In 1905, grants by the governor general of Algeria and the city of Algiers were established, to be awarded at the annual Salon.[47] Like the Salon tunisien, the Algiers exhibition was intended to display the state of the arts in a nation which, according to contemporaries, had experienced an economic boom. The close relationship and connection between North Africa and France was expressed through the award, in 1907, of the SPOF's Medal of Vermeil. This prestigious award was given to artists living in Algeria or Tunisia and exhibiting at the Salon. In the same year, the Society's president, Léonce Bénédite, established the Prize of the Villa Abd-el-Tif, consisting of a two-year fellowship conceived as an artist-in-residence grant for artists to sojourn in Algiers, thereby creating another link between France and Algeria.[48]

The Algerian Salon rapidly proved itself as the ground for the rise of a new generation of young artists noted for their mobility. In June 1914, the poet Pierre Cusin proudly reported the success of young Algerian artists who were recognised internationally, such as Henri Dabadie (1867-1949), who exhibited at the Musée du Luxembourg in Paris, exclusively devoted to contemporary art, or Armand Assus (1892-1977), who was admitted to the Salon des artistes français in Paris.[49] Cusin underlined the autonomy of

[46] D'Artenac, Raoul. "Le Salon des Orientalistes." *La Dépêche algérienne*, 1913 (?) (CDHA, 44 ARC 318).

[47] Richemond, *Les salons des artistes coloniaux*, 58-59.

[48] On the Villa Abd-el-Tif prize, see Cazenave, Elisabeth. *La Villa Abd-el-Tif: un demi-siècle de vie artistique en Algérie, 1907-1962*. Alger: Association Abd-el-Tif 1998.

[49] Cusin, Pierre. "Un succès algérien au Salon des artistes français." *Mauritania* (June 1914): 3 (3-4) (CDHA, 44 ARC 323).

the Algerian school, calling attention both to its recognition in France and
to its artistic differentiation from the French model.[50] In terms of Salon
organisation this model was evidently predominant, as demonstrated for
instance by the creation of the Villa Abd-el-Tif, which was conceived as an
Algerian pendant to the French Villa Médicis in Rome.[51] The struggle for
artistic autonomy increasingly developed, and possibly corresponded to a
strong intention to build an indigenous artistic generation for the Algerian
community that would be closer to North African artistic development
than to the French context.

Despite claims for autonomy, the link between the Algerian Salon and
the French model persisted and evolved further, leading sometimes to a
conflict between competitive artistic societies, while struggling to establish a
predominant role in promoting contemporary art. For instance, Bénédite had
to cope with the success of the rival Société coloniale des artistes français
(SCAF), founded in 1908 by the painter Louis-Jules Dumoulin (1860-
1924), which was much involved in the awards given on the occasion of the
1922 Colonial Exhibition of Marseille. The exhibition catalogue proves the
link between these societies by publishing the names of the members of the
SPOF together with an historical note on its foundation and regulations.[52] To
compete with the SPOF's prizes, the SCAF awarded a series of travel grants
on the occasion of this exhibition. The conflicting relationship between
Bénédite and Dumoulin was well known, and demonstrated the overall
climate of rivalry that characterised artistic development in North Africa
during the first decades of the twentieth century.[53] This competitiveness
was also manifested in the number of travel grants and funding established
during these years.[54]

[50] "L'essentiel est qu'il y ait maintenant une école algérienne, tant en peinture qu'en
sculpture, école affranchie des dogmes rétrécis et du pompiérisme officiel, et que cette
école soit précisément en art à la tête de la réaction nécessaire qui se dessine contre le
conventionnel, le léché, émasculé des traditions de l'Ecole." Cusin, "Un succès algérien
au Salon des artistes français," 3.

[51] Cazenave. *La Villa Abd-el-Tif.*

[52] *Catalogue de l'Exposition Nationale Coloniale de Marseille. Section officielle des
Beaux-Arts.* Marseille: Detaille 1922, 24-27. On the SCAF, see Richemond Stéphane
and Pierre Sanchez. *La Société coloniale des artistes français puis Société des beaux-
arts de la France d'outre-mer: répertoire des exposants et liste de leurs œuvres.* Paris:
L'échelle de Jacob 2010.

[53] The conflict between the two men relied on the fact that SPOF members were not
allowed to intervene into SCAF's activities. Richemond, *Les salons des artistes
coloniaux,* 35.

[54] Richemond, *Les salons des artistes coloniaux.*

Shaping the Perception of a "National" Art

The reward system greatly helped Tunisia and Algeria to build a notion of "national" art, but also, and perhaps more importantly, the perception of what was considered national. This process of construction was particularly visible in the number of initiatives developed almost in parallel to the Salon and through – or thanks to – the reward system. The process enabled the questioning of the French model, even with regard to the most important protagonists of the relationship between North Africa and France. In 1921, for instance, Bénédite was excluded from the jury of the Grand Prix artistique de l'Algérie, composed of Etienne Dinet, some art lovers, and the professor of history of art of the University of Algiers. The jury clearly explained its decision: "We judged that he was in no way qualified to give his opinion on a painting or a statue."[55] Bénédite was replaced by a far less representative figure, Martial Douël (1874-1952), a civil servant at the Ministry of Finance.

In the case of the Algerian Salon, this questioning was shown through the perception of the Salon itself and its differentiation from the French model. D'Artenac insisted, for instance, on the importance of the Salon which, according to him, "was not a mundane ritual, coming back regularly every year,"[56] alluding to the critical importance that the French Salon acquired in the nineteenth century. The art critic pointed out that a Salon

> must be an act, of a useful ceremony, long prepared, where the artist shows the result of his work and research and where the public comes to form his taste, learn to be moved, to feel and exalt his faculties to ennoble his existence.[57]

Within this context, prizes developed alongside a number of artistic societies and associations, whose structure and regulations showed the intention of valorising the rising artistic scene in North Africa. For instance, the Société algérienne des amis des arts (SAAA) asked Paul Léon (1874-1962), head of the Fine Arts division in France, to become its honorary president in

55 "Le Grand Prix artistique de l'Algérie." *L'Afrique Latine* (1921), 333 (CDHA, 44 ARC 30).

56 "Un 'Salon' n'est pas un rite mondain, revenant régulièrement tous les ans" D'Artenac, Raoul. "Le Salon Algérien." *La Dépêche Algérienne*, 2 February 1911 (CDHA, 44 ARC 318).

57 "Le 'Salon' doit être un acte d'utile solennité, longuement préparé, où l'artiste montre le résultat de son travail et de ses recherches et où le public vient former son goût, apprendre à s'émouvoir, à sentir et à exalter ses facultés pour ennoblir son existence." D'Artenac, Raoul. "Le Salon Algérien." *La Dépêche Algérienne*, 2 February 1911 (CDHA, 44 ARC 318).

1924.[58] The SAAA's request clearly stated the intention of ascribing to Algiers the status of an artistic centre, and of strongly involving France in this process because of its "national impact." As a result, the reference to France became a way of maintaining continuity with the country but also of creating, through this reference, an artistic identity that was meant to be characteristic of Algeria alone.[59] Contemporary voices stated that the founding of the SAAA was a way to support separate artistic development in Algeria, even though it followed the model of French societies in Paris and Lyon, among others.[60]

It seems clear that rewards can be a tool to measure the scale of an artistic identity in progress. This might explain why the reward system was so complex and detailed in Algerian and Tunisian salons. It also might explain why artistic societies did not hesitate to ask the French government to provide rewards to distribute to artists. This was still the case, for instance, of the Union artistique de l'Afrique du Nord (UAAN), founded in 1925 and which organised a salon every year. The exhibition catalogues show the scale of growth of the reward system. Although no prizes were awarded during the first exhibition in 1925, by 1935 the Salon catalogue listed a full six categories of prizes, including two Grand Prix for painting, one prize for sculpture, one for young artists, one for foreign artists and two consisting of travel grants.[61] In October 1930, the president of the UAAN, Dollin du Fresnel, wrote to Paul Léon to ask for financial support to award some medals to the most talented young artists exhibiting at the show.[62] Paul Léon's involvement indicated the strong connection between the Algerian exhibition and the French model, but also the intention to grant prestige and stability within the contemporary artistic panorama. The reference to France is particularly evident in the number of reports made on Algerian art academies, established mainly in the 1870s and 1880s and dependent on

[58] Letter from the président of the Société Algérienne des Amis des Arts to Paul Léon, director of the Fine Arts division, Alger, 4 February 1924. Paris: ANF, F21 4898, folder 2.

[59] "Notre but tient en peu de mots: nous désirons faire d'Alger, capitale économique, une capitale artistique. En organisant des expositions et des conférences où les représentants de la métropole et même de l'étranger auront la plus grande place, nous essaierons de développer dans l'Algérie le goût des belles choses." Paris: ANF, F21 4898, folder 2.

[60] "La Société Algérienne des amis des arts." L'Echo d'Alger, 27 February 1924 (CDHA, 44 ARC 322).

[61] Catalogue du premier Salon officiel de l'Union artistique de l'Afrique du Nord. Algiers: Imprimerie Pfeiffer et Assante, 1925. Paris: ANF, F21 4734, folder 2a: Algérie, Alger. "Exposition Villa Abd-el-Tif"; Catalogue du Dixième Salon des l'Union Artistique de l'Afrique du Nord (Alger, 1935) 1 (CDHA, 44 ARC 16). For an overview of the prizes awarded during the former edition of this Salon, see 8-9.

[62] Letter from Dollin du Fresnel to Paul Léon, Alger, 31 October 1928. Paris: ANF, F21 4898, folder 2/2.

the French administration. These institutions preceded the rise of Algerian salons and indicated the need for an artistic institutionalisation.

The attempts to follow a didactic structure based on the French model, and to provide a background to the rise of an artistic generation, characterised the first decades of Algerian artistic institutionalisation. The issue of the new generation was rather critical, as it concerned not only artistic production, but also its identity and recognition. Within this context, a number of requests for funding were made in order to sponsor the creation and development of an educational structure. The link to the reward system, considering emulation as a key resource, is striking. On the occasion of the 1882 inspection of the institutions of Algiers, for instance, Paul Lefort (1829-1904,) general inspector of the Fine Arts division, provided an annotated table of the different schools eligible to receive financial subsidies alongside medals.[63] Rewards partially followed the salon system, as they included some travel grants (bourses de voyage). But they also showed a strong concern with artists' education and careers by including study grants (bourses d'études), savings accounts (livrets de caisse d'épargne) and prizes consisting of books on art subjects (livres pour prix). Lefort was well aware of the importance of the French model and the impact of rewards. In April 1880, he wrote a report to the Interior Ministry on the state of Algerian art schools in the three departments of Alger, Oran and Constantine.[64] The report clearly stated the need for funding, but also for competitions allowing the development of artistic practice and apprenticeship through rewards.[65] Lefort insisted on the benefit of rewards, such as medals and art books, as an important contribution to the development of the younger generation of artists. The report therefore includes proposed rewards.

This elaborate reward system showed the reference to French models but also, interestingly, the development of an artistic perception, which needed to be independent from a given model. Tunisian and Algerian exhibitions functioned, in this context, as vehicles for this perception and more generally for the awareness that a new generation of artists was emerging in

63 Lefort, Paul. "Funding proposals," 5 May 1882. Paris: ANF, F21 8083, folder "Ecoles municipales de dessin. Algérie."

64 Lefort, Paul. Letter to E. Turquet, 29 April 1880. Paris: ANF, F21 8083, folder "Ecoles municipales de dessin. Algérie."

65 "Souvent, aussi, j'ai eu à noter dans les écoles de Dessin les plus fréquentés le manque d'émulation de la part des élèves. Des concours, donnant droit à des récompens- es distribuées sous formes de médailles ou de dons de livres d'art, modifieraient cet état des choses et deviendraient pour les élèves de puissants stimulants : ces moyens d'encouragement il appartiendrait, dans ma pensée, à l'administration des Beaux-Arts d'en doter les Écoles, aux moins les plus fréquentées." Lefort, Paul. Letter to E. Turquet, 29 April 1880. Paris: ANF, F21 8083, folder "Écoles municipales de dessin. Algérie."

these countries. The debates on the role of the salon that the local journals reported, for instance, highlighted this concern for a "national" art, which had to be considered on the same level as those of other European countries. Because the French model deeply influenced the structure of North African exhibitions, it was evident that these salons were in between a pre-existing model – the French – and the establishment of a new autonomous system. The reward system was representative of this struggle for independence, as it was not only constantly rearranged but also brought to the fore crucial issues of artistic policy, such as state patronage and artistic education.

Table 1. Prizes awarded at the Salon tunisien, 1894-1901 transcribed from the *Revue Tunisienne* (RT).

Year	Award	RT
1894	1° Avec mention *Hors Concours*	No. 2, 339
	Mlle Hélène Achillopoulo (aquarelle), M. Albert (photogravure), Le service des antiquités et arts de la régence, D'Anselme de Puisaye (dessin à la plume), Marcel Blairat (peinture et aquarelle), P. Bridet (dessin à la plume), Louis Chalon (peinture), Le collège Alaoui (travaux arabes), M. Faure (peinture et aquarelle), Mlle Géneviève Grégoire (aquarelle), Petrus Maillet (architecture), Pipelart (dessin à la plume), Paul Proust (dessin à la plume), Mme Viola (peinture)	
	2° Avec mention *Très bien*	
	MM. Camus (peinture), Delatre (aquarelle), Goemane (aquarelle), Ant. Hirschig (peinture), Truelle (peinture)	
	3° Avec mention *bien*	
	Mlle Augias (imitation de tapisserie), Fermé (peinture sur verre), Nina Raffo (miniature sur parchemin), MM. Barrocchi frères / Ahmed Djamal / Piperno père et fils (étoffes orientales), Albert Samama (photographie d'amateur)	

1895 Médaille spéciale d'honneur No. 4, 293-294
Le Service beylical des Antiquités et des Arts

Médaille d'honneur
Mme Viola

Premières médailles
MM. Any, E. Cambiaggio, Rovel, M. Proust et
Sinibaldi

Deuxièmes médailles
Gaston Adam, Mme Aubert

Mlle Augias, Mme Burnett, MM. Brodard, Boze,
Frangini, Fabio (gravure), Mme Gamet (sculpture),
MM. Haret (sculpture sur bois), Lamotte,
Lauwerens, Mme Pétrus Maillet, Mme Meunier,
MM. Nardac, Léonard et Gobillot (photographie),
Searle (photographie)

Mentions honorables
M. Ancona, Mme Augias (barbotines), Mlles Bidaut,
Buis, Couyotopoulo (tapisserie), MM. Catalanotti,
Camus, Mlle Emma Darmon, M. Dapoigny, Mme
Dulac, M. Dumont, Mlle Alice Fegitz, MM.
Martin, Offand, Mlles Machiavelli, Patry, MM.
Provenzal, Parisi, Raimbault, Mlle Raffo, MM.
Sadoun, Samama (photographie), Vella (terre cuite),
Cavaillon, Mlle R. Cambiaggio

Récompenses spéciales pour l'installation de
tapisseries et teinture
MM. Barbouchi, Ahmed Djemal et Piperno

1896 Prix du Salon, Médaille d'honneur No. 11, 477-478
M. de Zorn

Rappel Mme Louise Viola

1ère médaille
M. Ambroise, Mlle Emilie Desjeux, MM. Duvent,
Linde Hermann, Tollet, Tony, Commandant Dollot,
Mlle Emilie Dybowski, MM. Martin Félix, Betrand,
Mme Gérard Goin, MM. Mouillard, Paul Lafond,
Poseler Louis

Rappel de 1ère médaille
MM Avy, Rovel, Maurice Proust, Marcel Blairat

2ème médaille
Mlle Marguerite Avosa, MM. Beaune Adolphe,
Boivin Emile, Grasset, Junès David, Mme Pillet,
Mlle Schazman, Mme Le Cyredeau, Mme Coquelet-
Mereau, MM. Boutique, de Retz, Mlle Henriette
Sichel, Mme Dorel Elisabeth

Rappel de 2e médaille
MM. Adam Gaston, Brodard Fernand, Boze Honoré

Mentions honorables
M. Achard Louis, Mme Bernamont, Boucherot,
MM. Caillot, le capitaine Camus, Carlier, Chanet,
Coquelet-Mereau, de Couesnongle, Mlle Emma
Darmon, MM. Maurice Faure, Fulconis, Mme
Galtier, Gauthier, Augias, MM. Guetta, Guillemin,
Emmanuel Grammont, de Joybert, Le Sage,
Lombard Edmond, le capitaine Lachouque,
Masserano, Ory Gustave, Mme Prébet, MM.
Horace Richebé, Schazmann, Mme Solanet, Mlle
Wachmann.

1897 Médaille d'honneur: <u>Prix du Salon</u> No. 15, 355-356
M. Fritz Thaulow (Norvège)

<u>Prix des Orientalistes Français</u>
M. Bariteau, de Bône

<u>Prix Brodart</u>
M. Beaune, de Tunis

<u>Peinture</u>
Médaille 1ère classe: MM. Pujol, Lazerges,
d'Otémar, Paupion, Paquin
Algérie et Tunisie: MM. Noiré, Boivin
Rappels: MM. Mouillard, Tony Tollet, Rovel, Linde
(Tunis)

Médaille 2è classe: Depré, Gounin, Belles, Melbye,
Bonencontre, Humblot
Algérie et Tunisie: MM. Salles, Bertrand, Sintès,
Noailly, Bariteau, Delaplanche, Mousso
Rappels: MM. Brodard, Junès David, de Retz, Mme
Boucher-Le Dyre (Tunis)

Médaille de 3ème classe
M Gentz, Mme Caire, MM. Baye, Liot, Son, Sallé,
Bernet, Renaudot
Tunisie et Algérie: Mlle Raynaud, MM. Reinaud,
Reymann, de Couesnongle, Mlle Nourse, MM.
Protais-Girard, Boesvilwald

Mentions honorables
Mlles Lesage, Chavagnat, Mmes Giron, Giesler,
Rouaix-Duneau, MM. Goepp, Waldmeyer, Corneiller
Tunisie et Algérie: MM. Galland, Deshayes, Querry,
Mlle Wachmann

Dessins

Médaille de 1ère classe: MM. Romberg, Fabrès

Médaille de 2ème classe: M. Dufour, Mlle Deniset (Alger)

Médaille de 3ème classe: Mlle H. Maréchal

Mention honorable: Mlle Brichard

Gravure

Rappels de médaille de 1ère classe: MM. Paul Lafond, Posseler

Aquarelles

Médaille de 1ère classe: M. Proust, Mlle Dybowska

Sculpture

Médaille de 1ère classe: MM. Froment-Maurice, Belloc

Rappels de médailles de 1ère classe: MM. Félix Martin, Bertrand

Médaille de 2ème classe: M. Laurent-Leclaire (Paris)

Mention honorable: M. Frette (Oran)

Céramique

Médaille de 3ème classe: M. Collin (grès flambés)

1898 <u>Médailles d'argent</u> No. 19, 395

Peinture: MM. Ernst, Goepp, Guérin, Liot, de la Nézière, Mellbye, Polack, Trémolières, Taupin,

Aquarelle: Mme Paule Boeswillwald, M. Spaddy

Sculpture: Mme la comtesse Albazzi, M. Henry Nocq

<u>Médaille de bronze</u>

Peinture: Mme Charderon, Mlle Poncin, Mme Plantier-Vassal, MM. Bauré, Adler, Cartier-Karl, Renard Mary, Mme Solanet, MM. Rémy Saint-Loup, Renanrd Mary, Perrault Henry, Steinhel, Vaysse,

Aquarelle: Mlle Antoinette Chavagnat

Sculpture: Eustache Sylla

Mentions honorables: Me F. d'Alvar, MM. Baratte, Borel, Canet, Ed. Célérier, J. Des Essarts, Mme Faux-Froidure, MM. Galmiche, Girardot, Gruet, Guinier, F. Lambert, Landry, Mlles Marie Lévêque, Léonie Louppe, M. Lux, Mlle Offner, MM. Pelosi, Prost, Mme Signard, M. Tillier

1899 ——————————————— No mention

1900 ——————————————— No mention

1901 <u>Section I: Peinture</u> No 31, 373-374

Première médaille: MM. Antoni Ferdinand, Delaplanche Georges-Aimé, Madeline Paul, Noailly Francisque, Pinchart Emile, Smith Wilhelm

Deuxième médaille: MM. de La Barre-Duparcq Léon-Charles, Rigotard Alexandre, Rousseau Henry, Silvestre Antonin

Troisième médaille: MM. Berton Paul-Emile, Besset Cyrille, Bréfort Antonin, Chataud Marc-Alfred, Desurmont Georges, Garnier Georges-Paul-Auguste, Mme la comtesse de Nobili Marie-Louise

Mention honorable: MM. André-Chaumière Charles-Eugène, Blondel Elie, Mlle Bougourd Cécile-Augustine, MM. Castrogiovanni André, Delahogue Alexis-Auguste, Delahogue Eugpne-Jules, Huber Léon, Pillot André, Schiottz-Jenser N.F., Mlle Vassel (Jehanne) Lucie-Marguerite, M. Venot Roger

<u>Section II: Sculpture, Gravures en médailles</u>: Néant

<u>Section III: Pastel, aquarelle, gravure, dessin</u>

Première médaille: Mlle Chavagnat Antoinette, Mme Faux-Froidure Eugpnie, M. Mellbye Gudbrand

Deuxième médaille: M. Cartier Karl, Mlle Iwill Renée

Troisième médaille: M. Bailly Louis-Eugpne, Me Bartholomé Marie, MM. Duchemin François-Alexandre-Adolphe, Muller Fritz, Parize François

Mention honorable: M. Bougourd Auguste

<u>Section IV: Architecture, Art décoratif, Céramique, Photographie, etc</u>

Première Médaille: MM. Lelièvre Eugène et Octave, Mme Troll Marie

Deuxième médaille: MMmes Morache-Breuilh J.,
Wolfrom Jeanne

Troisième médaille: Mlles Foucart Alice, du Fresnel
Clotilde, M. Lacour Victor, le Photo-Cercle de
Tunis, MM. Soler François, Samama-Chikli Albert,
Mlle Wachman Henriette.

Mention honorable: M. Chercuitte Georges, Mme
la comtesse Lucien de Kerambriec, MM. Peters
Auguste, Vautrin Georges

CHAPTER 9
FROM EGYPT TO EUROPE AND BACK: EGYPTIAN STATE PATRONAGE AND CIRCULATION OF ART ABROAD SINCE 1989

CATHERINE CORNET

Largely depicted today as inefficient and corrupt by many independent cultural actors, the state sector in Egypt has played an important role in the formation of public taste and the presentation of Egyptian identity abroad. In terms of international circulation, it has been crucial for the international exposure of artists since the beginning of the twentieth century.[1] This chapter reveals the important role played by the state network in circulating Egyptian artists abroad, and deciphers the main features of government orientations in public taste, while scrutinizing Egyptian "soft power" from 1989 onwards. In the 2000s, the term "soft power" – meaning the power of attraction, as opposed to the power of coercion, or hard power – entered the Egyptian public discourse.[2] The expression, "loss of Egypt's soft power," was quoted "by intellectuals and commentators following every crisis when Egypt was at a disadvantage, in negotiations and peacemaking, such as the Iraq War, Nile Basin talks, and the Palestinian-Israeli conflict."[3] The press started to speak about the country's soft power (*Quwwa al-na'ima*) and the issues that should be addressed to regain cultural influence. Egyptian soft power in this context is studied by observing the way in which Egypt has presented its cultural production internationally. The focus is on the years following the creation of the Salon al-Shabab (Youth Salon) in 1989, examining the two main state institutions dedicated to the circulation of Egyptian art in Europe:

[1] Venice Biennale. "Gli Artisti Egiziani alla XXI Esposizione Biennale Internazionale d'Arte." Venice: Biennale di Venezia 1938.

[2] For a discussion of soft power, see Nye, Joseph. *Soft Power: The Means to Success in World Politics*. New York: Public Affairs 2004.

[3] Ali, Amro. "Brothers in the Hood: Egypt soft power in the Arab World." *Open Democracy* (2012), accessed 5 February 2018, https://www.opendemocracy.net/amro-ali/brothers-in-hood-egypt%E2%80%99s-soft-powers-and-arab-world.

the Academy of Egypt in Rome and the Egyptian Pavilion in the Venice Biennale.

Building on the seminal work of Jessica Winegar, who separated the aesthetic stances of Egyptian artists in the Mubarak era between those who emphasised "indigenous sources of authenticity (*asala*)" and those who privileged "international sources of authenticity (*mu'asira*)," the following discussion examines the links between national salons such as the Salon al-Shabab, and international forums.[4] The participation of Egyptian artists in two Italian arenas is analysed, their itineraries studied and an attempt made to understand the implications for an artist's reception and identity. How can the study of the Academy, the Biennale and the Youth Salon system of artistic circulation enlighten us on state orientations in the cultural sphere? What kind of artists have been privileged since 1989? How have selected artists been presented? How does the state appraise the works of the artist in its field of action? These are the research questions that are addressed here, to better define the Egyptian state narrative and the soft power exerted beyond its borders.

The Salon al-Shabab

In 1989, the Egyptian Ministry of Culture created the Salon al-Shabab, or Youth Salon. Initially named the Experimental Salon of Young Artists, its title was soon changed to Youth Salon. In the 1980s the presence of the public sector in the fine arts was reorganised around big fairs, all of which were directed towards shaping an international image. The state sponsored the International Biennale of Alexandria, the International Biennale of Cairo, the Egyptian International Print Triennial and the International Symposium of Sculpture in Aswan. At the national level it introduced smaller endeavours, such as the National Exhibition of Art, the Autumn Salon for Mini-Prints, the Exhibition of Arabic Calligraphy, the Nile Salon of photography,[5] and since 1989 the Youth Salon.

The idea underlying this new arena was to "revitalise" the visual arts and the governmental tools that had been criticised for their inefficiency and bureaucracy: artists under 35 could now present their work, highlighting

4 Winegar, Jessica. *Creative Reckonings: The Politics of Art and Culture in Contemporary Egypt*. Stanford, CA: Stanford University Press, 2006.

5 Federico, Elena di and Neisse, Judith. "La place de l'artiste dans la société." In *Etude sur le profil des professionnels artistiques et culturels en Méditerranée non européenne*. Roberto Cimetta Fund 2007, 2, accessed 2 February 2018, http://portal.unesco.org/culture/en/files/37164/12108534403Egypte.pdf/Egypte.pdf.

the "youthfulness" of the Salon.[6] The jury, constituted of members of the Supreme Council for Culture and of the National Centre of Fine Arts, selected a committee of distinguished professors, art critics, and government arts leaders.[7] This committee would judge more than one thousand artworks received. Out of these, around two hundred pieces would be selected to be exhibited for one or two months at the Salon. In turn, around forty pieces would receive awards ranging from 500 Egyptian pounds (around 86 dollars) to 5,000 Egyptian pounds (around 860 dollars). The Youth Salon was open to new artistic genres as well as painting or sculpture, and after 2009 considered entries from video, installation, or photography that had not featured in previous art salons. Soon after its creation, the Youth Salon became one of the most discussed artistic arenas in Egypt. Every year, in autumn, it provided an occasion for discussing "Egyptian art," modernity, contemporary art and artistic trends. Compared to other venues, the Youth Salon was clearly perceived as the place where Egyptian artists would become professionals in the eyes of the general public, as acknowledged by the art scene and the press. In a review, journalist and editor Lina Attalah insisted that

> for the past 20 years, the Youth Salon in Egypt has been an avenue for emerging visual artists to exhibit their work in one of Cairo's colossal exhibition halls. Setting foot in the salon registers for many young artists as a point of departure on the trajectory of professionalising their practice.[8]

Yet, the most important function of the Youth Salon was to allow the emergence of a "national art" that could be displayed internationally. The nexus with the global contemporary art scene was clear; "at points in time, the salon was home to concepts of developing 'national art' with one of the government's art institutions supporting artists in their quest to move the nation's art forward and to position it in the international art arena."[9] In the 2000s, it became even clearer with a change in the generation of curators involved with the Youth Salon. International contemporary artist Hassan Khan took the lead in 2009, and added another mission to the Salon by proposing the inclusion of new mediums not traditionally accepted in the other large Egyptian artistic fairs, such as installations or videos.

6 Mikdadi, Salwa. "Egyptian Modern Art." In *Heilbrunn Timeline of Art History*. New York: Metropolitan Museum of Art 2004, accessed 2 February 2018, http://www.met-museum.org/toah/hd/egma/hd_egma.htm.

7 Nagi, Azzedine. *Encyclopedia of Fine Arts in Egypt [Mu'assasat al-funun al-tashkili-yya fi misr – 'asr al-hadith]*. Cairo: Nahdat Misr Publishing House 2007, 47.

8 Attalah, Lina. "Youth Salon." *Contemporary Practices* 5 (2010): 78-81, 78.

9 Attalah, "Youth Salon," 78.

At the 26th edition of the Youth Salon in 2015, the opening address of Minister of Culture Helmy al-Namnam exemplified what this Salon meant for the Egyptian authorities. He positioned art nationally as an important tool to fight foreign cultural influences and religious extremism. During his speech, he claimed that the Salon came "at the peak of the cultural challenges of globalisation, and the spread of radical thoughts that attempt to threaten our Egyptian identity and culture."[10] Art should serve as the antidote for the two wrongs of Egyptian society; on the one hand, the extreme Westernisation imposed by globalisation, and on the other, the fanaticism brought about by radical Islamism. In this fight for Egyptian identity and culture, the best equation appeared to be "Youth" plus "Art" which equalled the "real Egypt": "Youth plays an important role in confronting these challenges while spreading hope towards real human development."[11]

During the same Salon, al-Namnam also confirmed the importance of the relationship between local and global audiences. The Youth Salon was thought of as a hyphen between these two levels: it "is one of the important cultural initiatives in Egypt, and through it researchers can understand the youth's hopes and goals, as well as this age group's relationship with the local and international community."[12] This approach to internationalisation is typically what was criticised by the Asala Collective studied by Winegar. In an interview held in 2009, Izz al-Din Nagib, the founder of the collective and a member of the first Youth Salon committee, stated that especially after 2009 "the most important thing was to go beyond national art and search for modernity and postmodernity in the West, and any kind of innovation, and concentration on installation at the expense of other kinds of art."[13] The stance of the Asala Collective could be compared to a group of *refusés* in their positioning vis-à-vis the Salon. Seen by their detractors as "camel painters", they, in turn, perceived the endeavour of making Egyptian artists international as the main fault of the Salon.[14] De facto, the internationalisation of Egyptian artists was the key feature of the Salon, as we shall illustrate. Starting from the Salon al-Shabab, artists transitioned through the Academy of Egypt in Rome to eventually reach the highest recognition – the Venice Biennale.

10 "Egypt's 26th Youth Salon inaugurated," *Al Ahram*, October 2015, accessed 5 February 2018, http://english.ahram.org.eg/NewsContent/5/25/152675/Arts--Culture/Visual-Art/Egypt%E2%80%99s-th-Youth-Salon-inaugurated.aspx.
11 "Egypt's 26th Youth Salon inaugurated."
12 "Egypt's 26th Youth Salon inaugurated."
13 Winegar, *Creative Reckonings*, 163.
14 Winegar, *Creative Reckonings*, 167.

The Academy of Egypt in Egyptian State Cultural Policy

The Academy of Egypt in Rome is a unique institution, as well as the most important Egyptian cultural centre in the world. As such, it has had a clear relevance and agency in the Egyptian cultural landscape. As a showcase of Egyptian art and state narrative in Europe, it is a good object of study of the official discourse on the arts abroad. It is here that the state sector narrative is formulated and organised for Egyptian elites and foreigners alike, and, more importantly for our study, where the most appreciated artists of the Salon al-Shabab are invited to spend a year. The directors of the institution, from Muhammad Nagy to Faruk Husny, have been among Egypt's most important visual artists and painters.

The idea of the Academy dates back to 1924, when Egyptian artist Ragheb Ayad, who was studying in Italy at the time, sent a letter to Egypt's Ambassador in Italy asking him to create an Egyptian Academy in Rome, to "open a window on Europe and represent the country's creativity."[15] A palace close to the Coliseum was chosen under the responsibility of artist Sahab Rafaat Almaz, who had come to Italy to study on a scholarship from King Fuad I. The first real director, artist Muhammad Nagy – also first Egyptian director of the Fine Arts School in Cairo and former director of the Museum of Modern Art – was nominated by royal decree in 1947. His successors were amongst the most important figures of Egypt's visual arts' scene of the time, from painter sculptor Abdel Kader Rizk to artist and future Minister of Culture Faruk Husny.

In 1958, the Egyptian Ambassador in Italy, Tharwat Okasha, who later also became minister of culture, backed the project. A decade later, in 1966, the Academy, whose offices in Via Omero were located in the middle of the Villa Borghese garden, was officially inaugurated. The statue of the so-called "Prince of Poets" Ahmed Shawky, designed by famous sculptor Gamal al-Segeini, dominates the square next to the Academy. In 1975 the Ministry of Culture created the State Award for Creativity (*Ja'izat al-dawla li-l-ibda' al-fanni*), "to support research in the field of arts." Since then, young artists under 40 have been selected in the fields of architecture, contemporary music, cinema, theatre and literature. The beneficiaries spend the first three months in Perugia to learn Italian and then 12 or 18 months at the Academy, where three to five scholarships are awarded every year. The Academy also organises the selection of artists for the Venice Biennale: The Biennale is not only among the most

[15] [no author]. "History of the Academy of Egypt" [La Storia dell'Accademia d'Egitto]. *Accademia d'Egitto Website,* accessed 12 January 2017, http://www.accademiaegitto.org/la-storia-dellaccademia/.

important events on the international artistic scene, it is also, traditionally, a showcase event for Egyptian cultural policy. The country participated for the first time in 1938 and has maintained its own national pavilion since 1952. To access the Academy of Egypt, the participation to the Salon al-Shabab in Cairo appears mandatory, as becomes clear when studying the profiles and itinerary of its laureates. The Salon's laureates who also received the Creativity Award were led towards an "art for mutual understanding," taking root in the "immortal artistic forms" of Ancient Egypt. The carver Hany al-Ashkar was a recipient of the Creativity Award in 2002. Before winning this prize, al-Ashkar participated in the Youth Salon in 1999 and 2000 as well as in the Autumn Salon for mini-prints in Cairo every year from 1997 to 2000.[16] To him, this period in Rome was the moment "when the world embraced me."[17] He is aware that he was clearly given a chance by the state: he was 20 years old, did not have much experience, and travelling abroad represented a real opportunity, since in Italy "every village hosts an exhibition."

The Egyptian Pavilion at the Venice Biennale

Finally, access to the Egyptian Pavilion at the Venice Biennale was clearly a consecration for young artists coming from the Salon al-Shabab. Along with Iraq, Egypt has been the only Arab country represented in Venice between 1895 and 1984. First participating in 1938, between 1946 and 1972 Egypt was present at every Venice Biennale and established its pavilion in 1952, five years after the creation of the Academy of Egypt (at the time called the Royal Academy). Being nominated as curator or artist for the Egyptian Pavilion and being displayed in one of the most important artistic international arenas in the world clearly represented a crucial career path for state-supported Egyptian artists.

In the first Egyptian Biennale booklet of 1938, the emphasis was put on the renaissance (ital. *risveglio*, arabic *nahda*) in visual arts, and in particular on figurative art since the beginning of the twentieth century.[18] In this framework, sculptors and painters such as Mahmud Mukhtar, Rizk, Farage, Gaber, Said or Nagy were selected to represent Egypt. For this generation, being educated in Europe was clearly presented as an

16 [no author], *Hany al-Ashkar Biography*, Zamalek Gallery Website, accessed 12 January 2017, http://www.zamalekartgallery.com/en_ex_artist.php?artistID=44&exhibition ID=1023&availiable=.

17 Hany al-Ashkar, personal communication, Rome-Cairo (Via Skype), 13 March 2015.

18 Venice Biennale. "Gli Artisti Egiziani alla XXI Biennale Internazionale d'Arte." Venice: Biennale di Venezia 1938.

advancement.[19] The importance of the renaissance, *nahda*, would remain a persistent feature in the history of the Egyptian Pavilion at the Biennale. Muhammad Nagy – the first director of the Academy of Egypt – insisted in his 1948 Venice presentation on the *creazioni grandiose*, the great creations of Egyptian artists since antiquity.[20]

The link between the two "Italian" institutions is intricate. For instance, the heads of the Royal Academy of Egypt have occasionally served as curators of the Biennale, as it was the case with Abdel Kader Rizk in 1950.[21] Later in the century, both institutions were still intertwined: from 1989 to 1995, George Fikry participated in the Youth Salon every year. He won the first prize at the Biennale in Cairo (1994) and was selected for his first Venice Biennale (the 52nd Biennale). He explains that "Venice was a break even in my artistic career, it changed my vision of my work and the direction I wanted to take."[22] George Fikry mounted a solo exhibition at the Academy in 2001 and is now a well–known and internationally well-quoted artist. Since his studies in the Maronite school of Cairo where his drawing teacher led him on the path of arts, he benefited from state sponsorship. He explains that "nothing could have happened without art critic Ahmed Salem who organised through the Cultural Foundation my first exhibition in the government halls."[23] The trajectories of artists sponsored by the state seem to follow this triangulation: Youth Salons, selection at the Academy, and then the Venice Biennale Pavilion.

Yet, for the Egyptian government, the most successful story that exemplified and confirmed the rightness of state policies was Egypt's first award for its pavilion at the Venice Biennale in 1995. The Golden Lion was awarded to three laureates of the Salon al-Shabab, Akram al-Magdoub, Hamdi Attia and Mehdat Shafik, for their artwork at the Egyptian Pavilion titled *Un ambiente per l'ascesi* (A Room for Ascension). This first and only Golden Lion won by Egypt was extensively discussed in the Egyptian governmental sphere and state-sponsored press.[24] This ultimate consecration confirmed that the Youth Salon was indeed the first step for entering the international scene and in particular the Venice Biennale.

[19] Cornet, Catherine. "The Egyptian Pavilion at the Venice Biennial." In *Venice Biennale and the Arab World*, Ca Foscari edition, Cambridge Scholars Publishing [forthcoming].

[20] Venice Biennale. "Gli Artisti Egiziani alla XXIV Biennale." Venice: Biennale di Venezia 1948.

[21] Venice Biennale. "Gli Artisti Egiziani alla XXV Esposizione Biennale d'Arte." Venice: Biennale di Venezia 1950.

[22] George Fikry, Personal communication, Rome-Cairo (Via Skype), 12 March 2015.

[23] Fikry, Personal communication.

[24] Abdel Rahman, Maha. "Abu Saada: Egypt was awarded the Golden Lion prize in 1995" [Masr Hamdet Gaiza 'Asad Zahbi am 1995]. *Veto Gate* (2015), accessed 5 February 2018, http://www.vetogate.com/1882623.

The trajectory starting with the Salon al-Shabab, and then international-ised through the Academy of Egypt and the Egyptian Pavilion in Venice, was governed by the Ministry of Culture both domestically and abroad. In that context, the influence of Minister of Culture Faruk Husny, who held the post for 24 years (1987-2011), was significant. The directors of the Academy of Egypt have since its beginnings come from Egypt's higher state institutions. Most of them have been artists and faithful civil servants, and all have been very close to the levers of power: Muhammad Nagy was formerly director of the Modern Art Museum in Cairo, Salah Kamel was an art professor and cultural attaché in Italy. Saleh Abdoun was the former head of the Cairo Opera House and became director of the Academy in 1979. Mustafa Abdel-Moeti, former director of the National Centre for the Arts, took up the post in 1987. Magdi Kanawi, an art professor from Alexandria, followed in 1995. In 2000, the painter Faruk Wahba took over. Samir Gharib, former director of the Egyptian National Library, the Dar al-Kutub, followed in 2002. Since the creation of the Salon al-Shabab in 1989, the profiles of the directors of the Academy of Egypt and those responsible for the Venice Biennale have remained unchanged. They are part of the state sector.

Art Salons and Tathqif: "Getting the people cultured"

A strong commonality of these artists/civil servants coming from the state sector is their ideological commitment to the Nasserist inheritance. As Raymond Williams argues, "the historical constitution of the field of visual arts through colonialism, and its cementing through the institutions of nationalist socialism, necessarily linked visual art practice to national ideology …"[25] They belonged to a state culture that believed governments should have a strong grip on all spheres of life that they considered were strategic and important "to educate the masses." Similar to the Ministry of Culture created in 1958 on the French model, the whole network around the Salon was influenced historically by the socialist concept of centralised production and dissemination of culture, often with a clear and explicit message.[26] The cultural orientations were clearly in the hands of the presidential palace. Minister of Culture Faruk Husny, who was appointed in 1987 and stayed in charge until the 2011 revolution, was very close to First Lady Suzanne Mubarak, who was herself strongly interested in culture and education (especially literacy campaigns). Thanks to this relationship, he was

25 Williams, Raymond. "Marxism and Literature." *Marxist Introductions Series*, London/ New York: Oxford University Press, 1977.

26 Pahwa, Sonali and Jessica Winegar. "Culture, State and Revolution." *Middle East Report* 42 (2012).

considered untouchable. During his 24 years of service, he often exploited this status in confrontations with the religious establishment, Islamist activists, and in facing down the scandals and attacks on him. Although President Sadat had downgraded the role of the Ministry of Culture, the Mubarak regime reinstated its power. Husny was a key person in the new interpretation of the state mission and the *tathqif*, the "culturisation" of the masses through their enlightenment.[27]

The Creativity Award of the Academy of Egypt in Rome was consciously not awarded to artists who belonged to the Cairo elite. In 2002, for instance, it was awarded to the artist Ashraf Abbas, who was born in Luxor and studied at the Faculty of Fine Arts of Minia University before accessing the Salon, and to Rasha Aly Mahmoud, a ceramist from Alexandria who was introduced to the arts through the Culture Palaces.[28] Internationalisation also meant that the three institutions were the places where complicated identity negotiations were taking place. Nubian artist Fathi Hassan, now an international figure, recalls how much he suffered from racism in Cairo. Yet, what he would have never achieved in Egypt because of his Nubian identity was possible in Italy, at the Academy, thanks to Faruk Husny: "Faruk started presenting me as an Italian artist, for them I am not Egyptian, I will always stay a Nubian."[29] The internationalisation of the state artist figure helped him to create a new identity, and to become free from persistent national blockages.

After 2001, the *tathqif* narrative of "getting the people cultured" encountered the powerful international narrative of development policies. It was immediately translated into Egyptian terms: art became a "development tool" during this decade. The *tathqif* or cultural development should concern in particular the poorest stratas of society and the most peripheral regions of Egypt. "One cannot only develop a country through economy, culture is key for a country's development. We need to cultivate people, to cultivate their ideas and spirit," explained Samir Gharib, director of the Academy from 2002 to 2004.[30] The same word *thaqafa* (culture) is used in the larger sense of education of the masses. Gharib comes from Asyut in Upper Egypt; he remembers this reality, and considers one of his major achievements as the "building of libraries in poor areas, for low-level and ill-educated people in Egypt." Similarly, he believes the Academy was an important means "to develop the cultural experiences of young artists." The government's

[27] Pahwa and Winegar, "Culture, State and Revolution."

[28] For an introduction to the Culture Palaces, see Winegar, Jessica. "Culture is the solution: The civilizing mission of Egypt's culture palaces." *Review of Middle East Studies* 43, 2 (2009): 189-197.

[29] Fathi Hassan, personal communication, Rome-Fano, Italy (via Skype), 15 March 2015.

[30] Samir Gharib, personal communication, Rome-Luxor (via Skype), 1 April 2015.

mission should be that of general instruction and training even within an
elitist institution. Artist George Fikry shared this idea of the role of the
Egyptian state, stating that it should improve the less artistically developed
sectors of society or the peripheral regions: "It is a pity that the Culture
Palaces have lost their influence on the Egyptian territory. They do not reach
the villages and peripheral regions anymore and do not exercise the role that
the state should play, the artistic development of remote regions of Egypt."[31]
In 2015, minister Helmy al-Namnam still linked the artistic itinerary to
development: "Youth play an important role in confronting these challenges
while spreading hope towards real human development."[32] The pedagogical
role of art is thus a theme common to many different cultural spheres during
this period, yet the state narrative clearly considers it the priority and the
meaning of a true cultural policy.[33]

State-sponsored "Enlightenment" versus Political Islam

At the end of the Mubarak era, the state-sponsored cultural sphere experienced
the typical consequences of the *Infitah* doctrine[34] in the economy: a small
group of people who held power called for a liberalisation of the economy.
The liberal ideology won culturally, with the connivance of the secular
left, which was clearly co-opted during this time.[35] The *wasat al-fann*, the
artistic crowd, had shrunk to a small court around Faruk Husny, "*Fannan
wa wazir al-thaqafa*" the "artist and Minister of Culture, Faruk Husny" as
the press called him to please him. In the Academy's exhibition statement
by Egyptian Ambassador and artist Mustapha Khedre in 2003, then director
Faruk Wahba wrote that it was "impossible to distinguish the artist from the
ambassador and the ambassador from the artist, we can note that art is above
even his working life, and influences all his activities."[36] No contradiction

31 Fikry, Personal communication.
32 "Egypt's 26th Youth Salon Inaugurated," *Al-Ahram*.
33 For the pedagogical role of art in the decade 2001-2013 see Cornet, Catherine (2016),
 In Search of an Arab Renaissance, Accessible: https://www.theses.fr/197352480. Also
 see Rancière, Jacques. *Aisthesis: scènes du régime esthétique de l'art.* Paris: Galilée,
 2011, 12.
34 The *Infitah* ("Openness") doctrine was developed by Egyptian President Anwar Sadat
 in the 1970s. The programme of economic liberalisation was to put an end to the so-
 cialist era and the development of the state sector in Egypt implemented by President
 Nasser.
35 Abaza, Mona. "The Trafficking with Tanwir (Enlightenment)." *Comparative Studies of
 South Asia, Africa and the Middle East*, Vol. 30:1 (2010), 4.
36 Khedre, Mustafa. *Khedre Mustapaha Exhibition Booklet*. Rome: Academy of Egypt
 2003.

was felt in being both an artist and an ambassador in the elitist environment
of the visual arts abroad. According to Fathi Hassan, the Academy was
considered by many as the "Accademia alberghiera egiziana a Roma" (The
Egyptian Hotel Academy in Rome), an "18-room hotel in Rome's city
centre" where "all Egyptian golden boys and *fils à papa* come and rest in the
beautiful setting of Villa Borghese."[37] For the painter Nazli Madkur, who
exhibited at the Academy in 2001,[38] the artists selected and showcased by
the Salons and the Academy "do not really reflect what happens in Egypt."[39]
Artists were selected through the usual governmental mechanisms that were
deeply rooted in nepotism; "the criteria are very often everything but artistic
criteria. Sometimes, they decide to give a chance to people who do not have
the chance to go abroad, often they assign them to the people working at the
Cairo universities, professors and students,"[40] that is, to civil servants of the
Ministry of Culture. Madkur's own career started with exhibitions in private
galleries, such as Akhenaton (in 1984 and 1986) or Safar Khan Gallery (in
1999 and 2012) and in foreign cultural centres like the American one (in
1982). This explains her freedom of tone vis-à-vis the state sector.

Following the ideological storm ignited by 9/11, Nasserist ideology lost
its appeal. Egyptian society pushed to adhere to the Egyptian state position:
art was considered as a marker of secularism, nationalism and *tanwir*
(Enlightenment).[41] In this context, the figure of Faruk Husny was once more
a key to understanding the centrality of the ministry in the state-sponsored
cultural world, since he personally embodied the "enlightened" Egyptian
regime.[42] In his biography of the Academy website, Husny is described as
the one who "promoted freedom of expression defending it from obscurantist
forces and reactionary trends."[43] He allegedly firmly believed that art was
the ultimate enlightened medium to fight darkness and ignorance and
thwart terrorism. In the name of "Enlightenment" and secularism, Husny
took on board the leftists who were quite influential on the artistic scene
due to their presence at the Fine Arts universities. The strategy described
by Baker for the 1990s continued to be applied during the first decade of
the twenty-first century. The Egyptian government perpetrated theatrical

37 Hassan, personal communication.
38 See Nazli Madkur's website, accessed, 12 May 2013, http://www.nazlimadkour.com/
 statment.php#sthash.NlkcCQMq.dpuf (no longer accessible).
39 Nazli Madkur, personal communication, Rome-Cairo (via Skype), 1 April 2015.
40 Madkur, personal communication.
41 Abaza, "The Trafficking with Tanwir," 4.
42 Abaza, "The Trafficking with Tanwir," 8.
43 [no author] The Directors of the Academy of Egypt [I direttori dell'Accademia d'Egitto].
 Accademia d'Egitto Website, accessed 12 January 2017, http://www.accademiaegitto.
 org/farouk-hosny/.

and well-mediatised assaults on violent groups, "ostensibly to protect the arts, as a cover to strike at all forms of political, social, or even charitable activity under independent Islamic auspices, including that of the Islamic mainstream" to win the support of the left.[44]

The Mubarak opposition, like the Muslim Brothers, identified its enemies on the cultural scene as, precisely, the "leftist elite." Young Muslim Brother film director Abdelaziz Dwidar explained in an *al-Masry al-Youm* article: "The secular left has high-jacked the cultural scene and does not accept other types of narratives ... The liberal elite and the leftists from the old regime had the control of the whole field and would not accept any other kind of art."[45] Nasserism and modernism are linked ideologically in the state cultural sphere and used as the backbone of the regime's crackdown on the Muslim Brothers. Ideally, the salons and the cultural centres abroad should represent a safe haven where the regime can develop a counter-narrative against the Islamists, but the issues at stake in the cultural sphere seem less difficult to deal with than the economy or tackling burning political discussions on constitutional rights.

Affirming Authenticity

Contrary to the criticism set forth by the Asala Collective – or perhaps to reply to these critics – the internationalisation of the artists of the Salon al-Shabab was largely based on affirming Egyptian authenticity (*asala*). Faruk Wahba, director of the Academy from 2000 to 2002 and exhibitor at the Venice Pavilion in 1990, participated at the Salon al-Shabab from the second to the seventh edition (1990-1995). In his artistic biography, he explained this tension between internationalisation and the search for authenticity and Egyptian identity. His first works privileged figurative representations – from portraits of Egyptians to nudes. However, through a scholarship to Germany he discovered the rules of the game of the international "white" art scene, and what he perceived as deep racism. For the first time in Germany, he discovered with bitterness that he would never be an "international" artist. It was a complete shock:

> After these successful rounds in Germany and some European cities, at last he realized that he belonged to different roots, even

44 Baker, Raymond, William. *Islam Without Fear. Egypt and the New Islamists*. Harvard: Harvard University Press 2006, 70.

45 [no author]. Azzedine Dwidar, Filmmaker of 'The Report' [Azzedine Dwidar, *Mughrig al-taqrir*]. *Al-Masry al-Youm*, 4 March 2013, accessed 5 February 2018, http://www. almasryalyoum.com/news/details/300164.

the colour of his complexion was different. The romantic notion of an international artist buzzing around the mind of every artist who exploits Europe, soon dissipated in the air. Finally he became convinced of the bitter fact that once there are any indications of a real and genuine talent – in a foreigner – to manifest themselves, they would be, at the same time, insistent calls to drive him out, even tear him up by the roots ..![46]

For artists from the state sector, returning to the roots often meant feeding into the "Egyptomania" discourse. The reference to Ancient Egypt has remained a powerful idea where national narrative is concerned.[47] For Wahba, the discovery of Ancient Egypt also derived from his German experience: his mentor Joseph Beuys, a professor at the Academy of Düsseldorf, put him on the mummies track after nights of discussion about the Ancient Egyptian civilisation that fascinated Beuys. Ancient Egypt was then considered a "revelation":

> It is worth knowing that Egyptian civilization was not a matter of concern in the artist's [i.e. Wahba] earlier experimentation. But a casual visit to the Egyptian museum in Cairo was a decisive turn for his interest. For him, the Mummy of Ramsis the second – greatest king of Ancient Egypt, was a dazzling discovery.[48]

Faruk Husny is presented in his biography for the Academy of Egypt as the one who "completed a historical restoration of the Sphinx; this is why the international press like the dailies *Le Monde* or *Corriere della Sera* have dubbed him the 'Minister of the Sphinx'."[49] The exploitation of Ancient Egypt and its contemporary translation led to success for Wahba and Husny, as for many others. It could also be considered as a *conditio sine qua non* for being selected at the Venice Biennale in the 1990s, as in the 2000s.

At the Venice Biennale in 2013, the work by another participant of the Salon al-Shabab, and recipient of the 2005 Creativity Award at the Academy of Rome in mural painting, Muhammad al-Benawy, could be deemed "authentically Egyptian" by the same standards. He displayed in the pavilion a mosaic that used Nile clay as a reference to Ancient Egypt. Benawy builds abstract topographies, like aerial views of mud landscapes,

[46] Wahba, *Faruk Wahba Website*, accessed 14 January 2015, http://faroukwahba.com (no longer accessible).

[47] Radwan, Nadia. "Des égyptiens égyptomanes." *Qantara* 87 (2013). 30-34.

[48] Wahba, *Faruk Wahba Website*.

[49] [no author] The Directors of the Academy of Egypt [I direttori dell'Accademia d'Egitto]. *Accademia d'Egitto Website,* accessed 12 January 2017, http://www.accademiaegitto. org/farouk-hosny/.

and "the resulting 'map' takes the viewer on a journey into Egypt's past and present," according to the article commenting on his Biennale work.[50] The artist explains:

> Being one of the basic elements of Creation, the Mud (clay) is the secret of life and its eternity ... from Mud, not only Mankind is created, but everything else as well ... When I am forming units of Mosaic Mud, I feel warmth and as if I am a part and parcel of this great Universe; these units are the Great Egyptian Heritage.[51]

Ancient Egypt as a source of inspiration of "modern enlightened art" is still among the main tools of the nation's construction.[52] The state's artistic discourse of the period reflected a larger tension between national and Islamic identity in Egypt. Another major common cultural trait of post-colonial societies, as Maria Kingsley noted for the creation of an "Indian identity," is that these societies go through the same process of trying to be, at the same time, "part of the modern global economy and remaining a unique, national, self-defining community."[53] This search for authenticity and the role of art as a confirmation of one's authentic self is common to many post-colonial societies.[54] Egyptology was triggered in Egypt to inscribe the origin of the state in a pre-Islamic history and genealogy. Pre-Islamic history is exploited to affirm a national rather than religious identity, especially while politically the state is harshly fighting the cultural influence of Political Islam. In the case of the international exposure of the artists displayed at the Salon al-Shabab, authenticity was sought by challenging the European hierarchy of arts, whereby visual arts and music were considered high genres. This applied to the framework of the youth award and the Biennale-privileged videos and installations, but also of more traditional artistic genres that would traditionally be categorised as crafts, such as ceramics, graphics and carving.[55] Considered minor in the Western hierarchy of arts, they were interpreted and modernised in the context of the state network. Ahmed Askalany, for instance, who received a grant in

50 Maggio, Luca. "Mosaico oggi, interview with Mohamed Banawy." *Mosaico Art Now* (2012), accessed 2 February 2018, http://www.mosaicartnow.com/2012/10/mosaico-oggi-interview-with-mohamed-banawy/ 2.

51 Maggio, "Mosaico oggi," 2.

52 Anderson, Benedict. *Imagined Communities: Reflections on the Origin and Spread of Nationalism*. London: Verso 1991.

53 Kingsley, Maria. "Art and Identity: the Creation of an 'Imagined Community' in India." *Global Tides*, Vol. 1, Art. 2, accessed 2 February 2018, http://digitalcommons.pepperdine.edu/globaltides/vol1/iss1/2, 2.

54 Kingsley, "Art and Identity," 4.

55 For a discussion of the categories of arts and crafts, see Chapters 2 and 5 of this volume.

2004 at the Academy of Egypt, used palm trees to shape his Upper Egypt figures. In his work, he connects traditional forms and materials to confront the complexities of contemporary art, weaving palm leaves using an ancient Egyptian craft technique typically associated with basic objects such as baskets. Similarly, al-Ashkar's art of carving is considered, according to al-Ashkar himself, to have less value than painting by the contemporary art scene: "I believe this prejudice comes from the material we use to incise our works. It is only paper and people believe it is less precious than a canvas."[56] His work was nevertheless supported by the state sector, and al-Ashkar eventually became curator of the Venice Biennale after having participated at the Salon al-Shabab.

As stated above, new media were sponsored particularly after 2009 at the Youth Salon. The most recent works of George Fikry testify to this attention to folklore, re-mediated by very contemporary tools. In his art video *The Icons of Narration*, Fikry deploys "folkloric symbols" from pre-Islamic Egyptian history. He uses signs of Ancient Egyptians who employed oxides on the walls, as well as the techniques of Coptic art from the sixth to the eighth centuries, "before the ideological twist of Islamic art came with its geometrical forms."[57] In the context of the enlargement of the cultural sphere from an Islamic perspective, the struggle for Egyptian identity by a Coptic artist went through the use of folkloric, "primitive" and "genuine" identity markers from older historical periods, mainly dating back to pre-Islamic art. Painter Nazli Madkur perceives a danger in this strong attachment to the past in the younger generation. Their interest in folklore seems to her to be a real obsession, whereas, on the contrary, you "should relate to humanity and not a specific folklore, not just glorify the past. Folklore is a kind of nostalgia. You can go through it, borrow from it, but it is a trap, since it is very sweet and beautiful. Yet, life is more difficult than that."[58] Folklore and traditional arts, however, have an important specificity that perfectly fits the period: they are less obviously political than other visual arts.

Private Galleries: A Challenge to the Youth Salon and the State Sector

Starting in the 2000s, an important phenomenon entered the visual arts scene in Egypt – the opening of influential private galleries. This

56 al-Ashkar, personal communication.
57 Fikry, Personal communication.
58 Madkur, personal communication.

significantly undermined the agency of the Ministry of Culture in the visual arts and changed the rules of the game for Salon artists: "Before, the state owned the galleries. You had to make applications to be shown in the Akhenaton Gallery, the palaces of art, the Gezirah Gallery."[59] Artists benefited from numerous advantages, such as free venues, the free printing of booklets, and the management of invitations for the event. The chance of being exhibited without backing was very slight. "You had to be a real challenger to get a chance," says Madkur. With the opening of private galleries such as Townhouse, Musharabieh and Safar Khan (up to 25 private galleries were established in Cairo during this time), new funding became available. Many artists sponsored by the state decided to leave the public sector. Ahmed Askalany's artistic itinerary reflects this new network. He comes from Qena in Upper Egypt. He participated in several of the Youth Salons mainly in the years 1996, 1998, 1999 and 2000, and was awarded a grant in 2001-2002 at the Academy of Egypt. Although Askalany clearly developed as an artist through the state-sponsored field, thanks to his awards at the Youth Salons and a grant from the General Organisation for Cultural Palaces in Cairo in 1999, his admission to the Academy followed his exhibition in the independent Musharabieh Gallery (2001), managed by an Italian curator.[60] He then had an "independent" career that included exhibitions in private galleries, such as "Rats room and other tails" (Musharabieh Gallery, 2001), and the solo exhibition "Delusion" at the Townhouse Gallery in 2004. George Fikry also shifted from the state-sponsored environment during this period (Cairo Biennale in 1994 and 2006, exhibition in the fine arts sector in 2007, several Youth Salons, and in the 2009 Youth Salon as a Commissioner) to join independent organisations like the Townhouse Gallery with projects such as "Inside, outside on the Walls of Townhouse" (2008).

Another important perceived flaw of the state sector was its bureaucracy and nepotism. If artists realised the opportunity provided by the state, what stopped them most from embracing it was the perception that its bureaucracy was overwhelming. Hany al-Ashkar, the son of a military man who had an artistic streak but no possibility of pursuing a real artistic career, successfully followed the state-backed path: he was awarded a grant from the Academy in 2002 to become curator of the Egyptian Pavilion at the Venice Biennale in 2015. On the day of our interview, he had been waiting to meet with the Minister of Culture for days. To him the problem with

59 Madkur, personal communication.
60 "Ahmed Askalany. Curriculum vitae." *Mashrabia Contemporary Art Gallery*, accessed 2 February 2018, http://www.mashrabiagallery.com/uploads/2/6/9/8/26980055/ahmed_askalani_c.v..pdf.

power was not censorship but bureaucracy, yet another very strong form of power: "Egypt will die of bureaucracy. If it is true that we need to suffer to create, we suffer way too much with this."[61] Though he recognised that there was a renaissance in the arts sector during Mubarak's final administration, he acknowledged that it came from Internet- and social media-savvy young artists who had created an opening for freedom of expression during this period. Similarly, Samir Gharib, who was close to Faruk Husny and therefore fully immersed in the system, still criticized the bureaucracy of that time very openly, stating that it prevented any dynamic action: "We created the fund for culture to bypass the usual bureaucracy of the ministry and to be able to allocate grants more directly."[62] As in the films of the famous Egyptian comedian Adel Imam, criticising the bureaucracy was acceptable in the governmental and state-sponsored sectors, as if bureaucracy did not really depend on actual power.[63]

Conclusion

In his 2013 study of *Art and Politics in Modern Egypt*, Patrick Kane comments that the arts are "likely to remain a proving ground" for political and ideological expression in Egypt.[64] The exploitation of arts in the Nasserist period was strong; this was much less so in the last decade of Mubarak's rule, when the state no longer had the same control over the cultural narrative. Yet, in the visual arts sector, Egypt's soft power abroad was still largely dependent on the state network that selected young artists at the Salon al-Shabab and had them tour internationally through grants and participation at the Academy of Egypt and the Venice Biennale. The narrative arising from the encounter of state institutions and artists calls for an authentic and modern Egyptian identity that needs to shrink from foreign influences, perceived as the Westernisation imposed by globalisation on one side, and the ideologies linked to radical Islam and coming from the Gulf on the other. From the Salon al-Shabab to the Venice Biennale, Egyptian artists are still requested to exploit a pre-Islamic Ancient Egypt and to favour "authentic" Egyptian cultural expressions to ensure Egypt's soft power abroad. The national narrative is whitewashed and simplified for

61 al-Ashkar, personal communication. For the links between bureaucracy and power, see Mommsen, Wolfgang J. *The Political and Social Theory of Max Weber: Collected Essays*. Chicago: University of Chicago Press 1992. 46.

62 Gharib, Personal communication.

63 Mommsen, *The Political and Social Theory of Max Weber*, 46.

64 Kane, Patrick. *The Politics of Art in Modern Egypt: Aesthetics, Ideology and Nation Building*. London: I.B Tauris 2013, 178.

an international audience, and in this endeavour the use of Ancient Egypt is the smallest common denominator. Yet, the agency of Egyptian artists is clear in their re-imaginings in new genres and new media and shows that there is a lively art scene, despite the difficult political, economic and social conditions under which they operate.

CHAPTER 10
GUIDING THE ARTIST AND THE PUBLIC?
THE SALON D'AUTOMNE AT BEIRUT'S SURSOCK
MUSEUM

NADIA VON MALTZAHN

Beirut's Sursock Museum, a centre for modern and contemporary art in
Lebanon's capital, reopened its doors to the public in October 2015 after
an extensive renovation and extension. Founded in 1961, the museum soon
became known for its annual Salon d'Automne (Autumn Salon), a group
exhibition of contemporary art in and from Lebanon. The Salon was launched
at a high period for contemporary art in Lebanon – when new galleries were
opening in Beirut and the city was establishing itself as a regional cultural
hub – and quickly became a symbol of the museum. The first president of
the museum's committee, Lady Yvonne Sursock Cochrane, announced the
third Salon with the words that "the time had come to stop encouraging and
proceed to establish criteria that can guide both the real artists and the public
in general."[1] The guidance of public taste and of the artists themselves was
one of the Salon's declared missions. In the following, the role of the Salon
d'Automne in art patronage will be examined by looking at the selection
process, the artists and the public. The focus will be mainly on the first three
decades of the Salon's existence. The aim is also to understand the role of
the Sursock Museum as an institution in shaping the artistic landscape in
Lebanon.

The Beginning

The Sursock Museum was set up as an endowment under the supervision
of Beirut's municipality. In his will, Nicolas Ibrahim Sursock (ca.1875-

[1] Preface, exhibition catalogue *Salon d'Automne 1963*, Beirut: Sursock Museum 1963;
 "*Inauguration, ce soir, du III^{ème} Salon d'Automne au Musée Sursock*: Lady Cochrane:
 "une sévérité nécessaire," *L'Orient*, 28 November 1963.

1952), from a wealthy landowning family, bequeathed his mansion (built in 1912) and art collection to the city of Beirut, to be held in a *waqf* (trust fund) under the guardianship of Beirut's municipality upon his death. The house was to be turned into a "public museum for ancient and modern art from Lebanon, other Arab countries or elsewhere," as well as an exhibition hall where works by Lebanese artists were to be exhibited.[2] After his death in December 1952 the villa was – by presidential decree – initially used as a guesthouse for visiting heads of state, but eventually the will had to be honoured and a committee was appointed to transform the mansion into a museum. The committee's first public activity was an exhibition in the spirit of André Malreaux's "Musée Imaginaire" at Beirut's UNESCO Palace in February 1957, which displayed reproductions offered mainly by UNESCO and the New Graphic Society of New York.[3] In 1961, the Sursock Museum finally opened its doors and showed its first group exhibition from 18-28 November. Entitled "Exhibition of paintings and sculptures by Lebanese artists" (Arabic) or "Exhibition of works of Lebanese painters and sculptors" (French), it was essentially the first Salon d'Automne of the new museum, picking up the tradition established by the Lebanese Ministry of National Education and Fine Arts in 1954.[4] Whereas the exhibition catalogue of the 1961 group exhibition at the Sursock Museum and the majority of reviews did not yet speak of a "salon," the cover of the second exhibition catalogue of 1962 – available only in French – was headlined with "Salon d'Automne."[5] Before we begin a fuller discussion of the Sursock Museum's salon, let us briefly look at the origin of what came to be known as Salon d'Automne.

The original Salon d'automne was established in Paris in 1903 as a progressive alternative to the traditional annual salon organised by the French Academy of Fine Arts (École des beaux-arts). Unlike the existing

2 Melki, Loutfalla. "Nicolas Sursock: l'homme et son muse." In *Musée Nicolas Sursock, Le Livre*. Beirut: Chemaly & Chemaly 2000, 19-23.

3 Exhibition catalogue. *Liban. Aujourd'hui s'ouvre le premier musée imaginaire au monde. Quatorze Février MCMLVII*. Beirut: Sursock Museum, 1957. See also Malreaux, André. *Le Musée Imaginaire*. Paris, 1947. The UNESCO Palace was built in 1948 (designed by Farid Trad) to host UNESCO's third international congress, and became one of the main spaces for large exhibitions and other cultural events. See www.palaisunesco.gov.lb.

4 For the Ministry's first Salons d'Automne, see its exhibition catalogue 1956, in which the salons of 1954 and 1955 are also mentioned.

5 Of a range of reviews of the first exhibition, only the *Revue du Liban* of 25 November 1961 speaks of a Salon d'Automne.

juryless alternative Salon des indépendants (established in 1884), the Salon d'automne strove to keep up high aesthetic standards by appointing a jury each year that included not only artists, but also other cultural personalities of the time.[6] The Society of the Salon d'automne that organised the salon wanted to open up the jury and give a place to young artists, thus making it the salon for the independents who had succeeded in the art world, and responding to "the necessity of a commercial representation, but with the desire to mark its will for openness and modernity."[7]

In independent Lebanon, the earliest record of a group exhibition of Lebanese artists dates from 1947, when the Ministry of National Education and Fine Arts organised an exhibition of Lebanese artists in the National Museum under the patronage of President Bechara al-Khoury in April of that year.[8] From the early 1950s, the term "salon" was used in French and the term *ma'rad* (exhibition) in Arabic, the catalogues usually being bilingual in Arabic and French. In 1954, the Ministry of National Education and Fine Arts launched a Salon d'Automne, which was held annually for at least three years, and later also a Salon du Printemps. At some point they discontinued holding the two in parallel and kept the Salon du Printemps, which was later referred to simply as "Salon."[9] The ministry

6 Altshuler, Bruce. *From Salon to Biennial – Exhibitions that made Art History, Volume I: 1863-1959*. London: Phaidon, 2008, 61. The jury was changed each year and members were selected from the founding members, current members and honorary members, the latter being personalities from outside the circle of professional artists and their conflicts. Monnier, Gérard. *L'art et ses institutions en France*. Paris: Gallimard 1995, 273.

7 Monnier, *L'art et ses institutions en France*, 273.

8 Lebanon gained independence in 1943. Before independence, there had been a number of art salons. In 1938, the Société des Amis des Arts organised a group exhibition of painting and sculpture referred to as "Salon" (in French), which was repeated the following year in the basement of the parliament building. Oughourian, Joseph. "Le Salon." *Phenicia* (May 1938), 1-16; al-Assi, Farid. "Le Salon." *Phenicia* (May-June 1939), 37-44. For an account of earlier group exhibitions, such as the 1931 exhibition at the Arts and Crafts school, see Lahoud, Edouard. *Contemporary Art in Lebanon*. Beirut: Dar al-Machreq 1974, XL.

9 Agémian, Sylvia. "Salon d'Automne et Salons du Musée." In *Musée Nicolas Sursock, Le Livre*. Beirut: Chemaly & Chemaly 2000, 134. See also the Ministry of National Education and Fine Arts exhibition catalogues: "Ma'rad al-fananin al-lubnaniyin fi-l mathaf al-watani (Exhibition of Lebanese artists in the National Museum)" 1947; "Salon d'Automne 1955;" "IIIᵉ Salon d'Automne 1956;" "VIIᵉ Salon de Peinture et de Sculpture 1959" (ma'rad al-rabi'a); "Le VIIIᵉ Salon de Peinture et de Sculpture" 1960; "XIIᵉ Salon de Peinture et de Sculpture 1965;" "XIIIᵉ Salon de Peinture et de Sculpture 1966;" "XIVᵉ Salon de Peinture et de Sculpture 1967;" "XVᵉ Salon de Peinture et de Sculpture 1968;" "XVIᵉ Salon de Peinture et de Sculpture 1969;"

appointed a jury that consisted of cultural figures (including architects) as well as of artists, who were mentioned separately from the other jury members. When the Sursock Museum launched its Salon d'Automne in autumn 1961, it continued the tradition established by the ministry. For the first nine editions, the museum's Autumn Salons ran in parallel to the ministry's Spring Salons that were usually held at the UNESCO palace, and some of the jury members overlapped.[10] It is not clear whether the Sursock Museum chose to hold a Salon d'Automne merely in reference to the time of year it took place, or whether it was explicitly continuing the path of the French example with its emphasis on openness and modernity. Since Lebanon had no dominant art academy or official salon to rebel against, it is likely that the name was initially chosen to reflect the time of year and create a counterpart to the ministry's spring salon. What is clear is that the Sursock Museum's Salon d'Automne strove to guide both the artist and the public, and to institutionalise Lebanese contemporary artistic production.

The Jury

The selection process of works by a jury appointed by the museum committee was crucial in this endeavour. Speaking to this, art critic Nazih Khatir opened his review of the fourth Salon d'Automne at the Sursock Museum with the following words:

> A salon without [a] jury is a fair 'for crumbs' [pour croutes]. The 'Salon des Indépendants' in Paris is a clear proof. We do not want such an 'outfit' for our salons. Nor such an end. We are thus happy that for organising its 4th Salon d'Automne, the Committee of the Sursock Museum has this year too called for a jury, and that this jury has opted to be demanding: 'Of a total of 355 works submitted, 98 have been retained.' Only.[11]

"XVIIIe Salon de Peinture et de Sculpture 1971;" "XXIe Salon de Peinture et de Sculpture 1974."

10 To name some examples, Victor Hakim was a jury member for the ministry's eighth Salon du Printemps (1959), and Sursock's third, fourth and fifth Salons d'Automne; Assem Salam was a jury member for the ministry's third Salon d'Automne (1956), and of Sursock's sixth, 17th, 18th, 19th and 22nd Salons d'Automne. Camille Aboussouan, long-term curator of the Sursock Museum, was also a jury member for the ministry's 1956 salon.

11 Khatir, Nazih. "Salon d'Automne 1964: Trois prix … et des problèmes," L'Orient, 20 December 1964.

One might not agree with the jury's choice, but according to Khatir the selection process led to what he called a "true salon" that reflected the core of the Lebanese artistic movement. French art critic and fourth Salon jury member André Bercoff likewise praised the selection process as always a balance between subjective and objective criteria:

> A salon raises awareness; two symmetric trials await the artist and the jury, who with each canvas start again the necessary synthesis between personal taste and the internal laws governing the success of a work... Through discussions, questioning, learning and renouncing, the multiform hydra, with its unknown and manifold destinies, of what is called Lebanese painting appeared again this year.[12]

In the 30 editions that have taken place between 1963 and 2016, there has been a rigorous selection process by a jury appointed by the museum committee.[13] Nearly half of the jury members of the first eight salons (1961-1969) were Europeans or Americans, some of whom were living and working in Beirut at the time (André Bercoff, Arthur Frick, John Ferren, John Carswell),[14] while others were invited for the occasion (including Belgian painter and critic Roger van Gindertael, British painter William Townsend, French art critics Georges Boudaille, Jean-Jacques Lévêque, and André Fermigier, Jean Salles, and Italian art teacher Roberto Pisani) (Figure 1). Since the ninth Salon, the jury members have been mainly Lebanese nationals (Table 1).[15]

12 Bercoff, André. "Les Cent Fleurs," *L'Orient*, 16 December 1964.

13 For the first two salons (in 1961 and 1962), the museum committee itself selected the works.

14 Journalist and critic André Bercoff, of Russian-Spanish heritage, was born in Beirut in 1940 and holds French and Lebanese citizenship. The American artist John Ferren spent a year in Beirut as an artist in residence sponsored by the United States Information Agency under the US State Department (1963-1964). British artist, scholar and teacher John Carswell joined the Department of Fine Art at the American University of Beirut from 1956 to 1976. During this period, the art department was chaired by American artist and educator Arthur Frick. On Ferren, see Rogers, Sarah A. "The Artist as Cultural Diplomat." *American Art* 25:1 (Spring 2011), 112-123.

15 The ninth Salon in 1974 marked the reopening of the Sursock Museum after its first renovation and extension. It is possible that a conscious decision was taken to appoint a mainly Lebanese selection committee to mark the new phase. However, external factors may equally have played a role, since the 10th Salon took place in late 1982/early 1983 in the middle of the civil war.

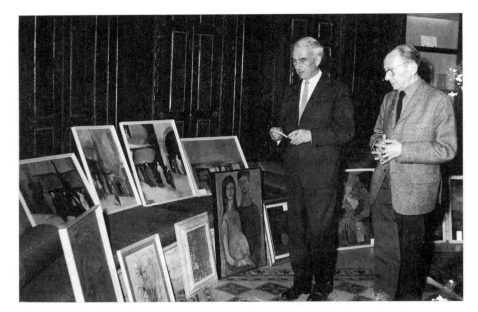

Figure 1: Jury members Roger van Gindertael (right) and William Townsend (left) selecting
works for the fifth Salon d'Automne, 1965. Courtesy of the Nicolas Ibrahim Sursock
Museum.

The presence of foreign art critics in the jury was a subject of discussion,
in particular in relation to the heated debates about abstract versus figurative
art that dominated the early salons. Some attributed the jury's preference
for abstract over figurative art – which reportedly shocked visitors initially
but started a trend that continued in subsequent salons – to the presence
of French art critics Georges Boudaille, Jean-Jaques Lévêque and André
Fermigier.[16] Although the jury members were appointed by the museum
committee, the two sides did not always see eye to eye. The museum
committee was connected to the municipality, and included members of
Lebanon's bourgeoisie who did not necessarily share the same taste as
contemporary art critics.[17] Amin Beyhum, mayor of Beirut and *mutawalli*
(custodian) of the museum, made no secret of the fact that he was attached to
the figurative style of painting in which his generation was formed.[18] In the
preface to the seventh Salon catalogue, Camille Aboussouan, curator of the
museum, recounts his conversation with committee member Abdul Rahman
Labban, who told him the following story:

16 Akar, Mirèse. "Comment départager les torts?," *L'Orient-Le Jour*, 29 November 1974.

17 Akar, "Comment départager les torts?."

18 Exhibition catalogue *VIᵉ Salon d'Automne*. Beirut: Sursock Museum 1966.

> A young American visits a friend preoccupied with modern art. Walking through the garden, she notices a charming little boy with intelligent eyes and tells the owner of the house: How handsome he is and what a vivid look! – Ouf! My son, that's nothing at all, come see his photograph which is much more beautiful![19]

Labban alludes to the point that abstract and pop art in certain Lebanese milieus of the time were raising questions on the evolution of plastic art, where the imagined idea of an object became more important than the object itself. Art critic Joseph Tarrab recounts a similar joke about Paul Guiragossian's participation in the sixth Salon (Figure 2): "Ah, they don't want figurative art, they want abstract art," Guiragossian was saying, so he removed a figure from the painting he was working on and made it "abstract," submitted it and won a prize![20]

This would reduce the artist's agency to conforming to the current trend. According to art historian Gérard Monnier, writing about the nineteenth-century Paris Salon, the social, commercial and professional power wielded by the salon not only had a profound impact on artists' careers, but also redefined the experience of how the public encountered a work of art. Artists often created their work with the known parameters of the Salon in mind.[21] The Sursock Museum's salon might have been less powerful as it did not hold a monopoly over exhibition space in the way that the nineteenth-century Paris Salon did, but it was nevertheless one of two main forums in which art in and from Lebanon was showcased in a group exhibition. While the Guiragossian anecdote is certainly an exaggeration, we can assume that the juries' selections partly influenced subsequent submissions, in particular in the Salon's first decade. The jury was consciously appointed to this end. Italian art teacher Roberto Pisani, for instance, invited to the ninth Salon jury, was specifically asked by the committee to focus on figurative art, since it had noticed that many of the recent submissions were abstract.[22] The shift to abstraction was a sign of the time. Lebanese artists were linked to Europe in terms of networks and artistic formation; many painters exhibiting at the salons were at least partly educated abroad (in particular in Paris and Florence), and were in touch with European artistic trends of the period.

19 Exhibition catalogue *VIIᵉ Salon d'Automne*. Beirut: Sursock Museum 1967.

20 Conversation with Joseph Tarrab, Beirut, 5 October 2016. The anecdote is also re-counted by Agémian, "Salon d'Automne," 157.

21 Monnier, *L'art et ses institutions en France*, 141.

22 Roberto Pisani: "Le Comité du Musée Nicolas Sursock m'a demandé d'apporter cette année une attention particulière à l'art figuratif pour ce Salon d'Automne car il avait constaté que la presque totalité des derniers envois concernait l'art abstrait." Exhibition catalogue *IXᵉ Salon d'Automne*. Beirut, Sursock Museum 1974.

Figure 2: Double spread page (pp.19-20) from the 1966 sixth Salon d'Automne catalogue
showing Paul Guiragossian's prize-winning entry. The work was purchased by the
Sursock Museum in the same year. Courtesy of the Nicolas Ibrahim Sursock Museum.

The debate about abstract versus figurative art preceded the first
decade of the Sursock Museum's Salon d'Automne. Jalal Khoury, in
his review of the first salon in *L'Orient Littéraire*, talks about how "the
figurative is – surprise – in sharp recline compared to the invasion of
modernist conceptions."[23] The day after the first salon's opening, a
reviewer wrote in *Le Jour*, "Why does the abstract prevail, and by far,
over the figurative? This is a question we no longer ask," as art "always
takes on a new language."[24] While several of the French-language
reviews of the first Salon mention the dominance of abstraction over
figuration as a matter of fact, one of the Arabic reviews expresses
outright shock: "It was impossible to know the head of a painting from
its tail!"[25] The newspaper *al-Shams* seemed to share the opinion of the
more conservative Beiruti bourgeoisie.

23 Khoury, Jalal. "Aujourd'hui, jour 1 du Musée Sursock," *L'Orient Littéraire*, 18
 November 1961.
24 "Brillant inauguration du musée Nicolas Sursock," *Le Jour*, 19 November 1961.
25 "Fi-l-zawiya" (In the corner), *al-Shams*, 21 November 1961.

Non-figurative art works gained most of the prizes in the early editions.[26] Prizes for painting and sculpture were first handed out by the fourth Salon's jury (1964/1965). Artists and critics alike criticised the fact that it was not announced in advance that prizes would be given, and demanded that an institution should clearly publicise its process for selecting prizes for the best and most representative art. Since there had been no mention of prizes in advance, some artists who had allegedly participated in the Salon out of "friendship" – not submitting their best work – did not stand a chance in the competition. However, as was noted, this was a good lesson for subsequent salons, in which the competition would be open to all.[27] In the sixth Salon's catalogue, jury member Georges Boudaille lists a number of criteria for the selection process, trying to establish objective guidelines in view of most members' "ignorance" of Lebanese art. This might have been responding to complaints by some artists about the selection process during the fifth Salon. In the context of the latter, artist Stelio Scamanga wrote in *An-Nahar* that it was impossible for a foreign art critic to accommodate the problems a Lebanese artist encountered in his art, and that only the artist himself could judge his painting.[28] He openly expressed his objection to subjecting his work to foreign art critics.

For the ninth Salon in 1974, the museum committee decided not to hand out prizes – apparently because those given by the jury in previous salons did not always conform to their taste – but instead to use the funds to acquire more works. This was communicated in advance through a press release, widely published in the Lebanese press. The Sursock Museum Prize would eventually be suspended between 1974 (ninth Salon) and 1994 (17th Salon), mainly due to the civil war. Between 1991 (15th Salon) and 1998 (22nd Salon) a new prize, the Dorothy Salhab Kazemi Prize, was awarded to young artists in memory of Kazemi who had died in 1990 at the age of 48. This prize was discontinued in 1998, but since 2009 (29th Salon) emerging artists have been rewarded by a new prize offered by the museum's long-time committee and Board of Trustees member Hind Sinno.[29] In 2016 (32nd Salon), the museum launched for the first time an Audience Choice Award. This was in line with the efforts of the new post-renovation museum administration to build up a more dynamic outreach programme and work on engaging the public.

26 Akar, Mirèse. "Au Musée Sursock: Le savoir – peindre libanais," *L'Orient*, 5 December 1965.

27 Khatir, Nazih. "Salon d'Automne 1964: Trois prix… et des problèmes," *L'Orient*, 20 December 1964.

28 Scamanga, Stelio. "Idha aradna al-nahda, fa-la-nakhuq al-mathaf al-da'im" (If we wanted a renaissance, let's have a permanent museum), *An-Nahar*, 12 December 1965.

29 Hind Sinno was also a jury member of the 11th, 18th, 19th, 20th and 22nd Salons d'Automne.

The jury was generally composed of representatives of some of the fine art departments at national and private universities in Lebanon, as well as of art critics – both foreign and increasingly local – and at times, the acting president of the Lebanese Artists Association for Painters and Sculptors (LAAPS). The relationship between LAAPS and the museum was not always without tension, however, in particular in the early period, as will be discussed below. The jury, moreover, often included some of the pre-eminent architects of the country, who were also major public figures in Lebanon's cultural life, such as Pierre al-Khoury and Assem Salam, who acted on twelve and nine juries respectively. On average, the jury rejected around three quarters of the submitted works and 60 per cent of the artists (some artists submitted several works), and thus had a notable say in setting trends.[30] The speed with which trends seemed to change was noted by several critics. Mirèse Akar in 1966, on the occasion of the opening of the sixth Salon, noted that usually in art history the time unit for reference was at least a decade, but in Beirut, it seemed to be one year or even just one season.[31] In the same vein, French critic André Fermigier states in the eighth Salon exhibition catalogue (1969) that the styles that used to last decades now barely lasted two winters.[32]

At the same time, a multitude of exhibitions were taking place in Beirut in the 1960s and early 1970s, and some critics complained in 1974 that they were seeing the same paintings three times – in the ministry's Salon du Printemps at the UNESCO Palace, in the individual exhibitions at the growing network of art galleries, and at Salon d'Automne of the Sursock Museum. Having compared the data for the spring and autumn salons that year, it follows that only five out of 340 paintings were exhibited in both salons. 45 out of 162 artists participated in both salons, however, so it is possible that the style of paintings was familiar.[33] The Salon d'Automne that year was praised mostly for its professional display in the newly extended museum space (Figure 3), rather than for the quality of the art works.[34]

[30] These numbers were derived from a review of 25 salons for which data was available in terms of how many number of works were submitted and selected, the number of artists who submitted works and the number of artists selected.

[31] Akar, Mirèse. "Le paradis officiel de l'art libanais," *L'Orient*, 29 December 1966.

[32] Exhibition catalogue, *VIII^e Salon d'Automne*. Beirut: Sursock Museum 1966.

[33] Exhibition catalogues, *IX^e Salon d'Automne* and *XXI^e Salon de Peinture et de Sculpture 1974*.

[34] Survey of exhibition reviews. The Sursock Museum underwent its first major renovation and extension between 1970 and 1974, when Nicolas Sursock's mansion was made more functional for a museum.

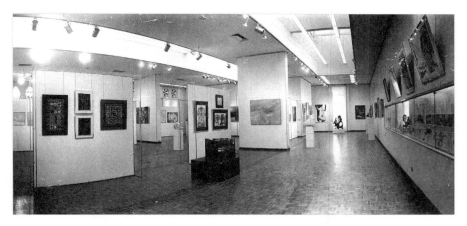

Figure 3: The ninth Salon d'Automne in the newly expanded museum space, 1974. Courtesy of the Nicolas Ibrahim Sursock Museum.

The Artists

Who participated in Sursock Museum's Salon d'Automne, and who did not? Were the artists exhibited representative of contemporary Lebanese artistic production? And what did it mean for artists to participate in the Salon? Due to its rigorous selection process, the Salon was valued as a proof of quality. Even in the 10th Salon in the autumn of 1982, the first held during the civil war in Lebanon (1975-1990) after a period of interruption, selection standards were upheld.[35] The Salon remained an important forum for up-and-coming artists to exhibit their work. According to art critic César Nammour, "there was a lot of enthusiasm to exhibit. The selection process in particular ... brought about the idea that the salon was elite. If you were accepted by Sursock, you'd reached a certain standard."[36] Artist and poet Etel Adnan, one of the leading intellectual figures of the day, equally praised the value of the Sursock Museum's salon, emphasising that it helped many artists to become known.[37]

However, exhibition reviews in the daily newspapers were always mentioning "absent" artists. At times they did not explain the reasons for artists not participating, for instance concerning the absence of Michel al-Mir, Adel Saghir, Munir Najem or Juliana Seraphim in the Salon d'Automne of 1962 (all of whom had participated in the ministry's

35 Tarrab, Joseph. "Une revanche posthume," *L'Orient-Le Jour*, 21 December 1982.
36 d'Arc Taylor, Stephanie. "'The place to see and be seen': Beirut's legendary museum rises from the ashes," *Guardian*, 7 October 2015.
37 Conversation with Etel Adnan, Paris, 10 September 2017.

Salon du Printemps that year),[38] or Aref Rayess, John Hadidian, Amine al-Basha and others in the ninth Salon of 1974. The absence of some of the "regulars" in specific salons might be more easily explained by the overall context – such as the 10th Salon that was held in 1982 in the middle of the war. Some artists boycotted the Salon for personal reasons. For example, established artists such as Halim al-Hage, Youssef Ghasub, Michel Basbus, Nicolas Nammar, Michel al-Mir, Rafiq Sharaf and others refrained from participating in the third Salon in 1963 because they felt that they should have been invited to take part in its preparation. They were offended that no member of the Lebanese Artists Association for Painters and Sculptors, founded in the early 1950s, was included in a jury that "even included foreigners."[39] While the Association welcomed the establishment of the museum and the honouring of Nicolas Sursock's will – which they had advocated – they disagreed with the management of the early salons. After having learned that the exhibition would be organised "without referring to the official reference which is the Lebanese Artists Association" they formed a committee composed of artists Adel Saghir, Amine al-Basha and Nicolas Nammar, to discuss the matter with the museum.[40] Before the first Salon opened in November 1961, they published a letter addressed to the Sursock Museum curator Camille Aboussouan and distributed among artists, demanding the following:

> The people in charge at the Sursock Museum will organise every year a Salon open to living Lebanese artists.
>
> The Association of Painters and Sculptors has the right of inspection of the jury in charge of selection and acquisition.

[38] Stetié, Salah. "Inauguré avant-hier au Musée Sursock: Le Salon d'Automne," *L'Orient*, 26 November 1962.

[39] Dagher, Iskandar. "Ma'rad al-kharif lil-rasm wa al-naht fi mathaf Sursock" (Autumn Salon for painting and sculpture in the Sursock Museum), *Al-Khawatir*, 6 December 1963. For the founding date of the Association, Jalal Khoury wrote in 1961 that it had already existed for eight years. Khoury, Jalal. "Critère unique au musée Sursock: La qualité", *L'Orient*, 28 October 1961. On the association's Facebook page, it states that the Lebanese Artists Association for Painters and Sculptors (LAAPS), founded in 1952, was officially registered in 1957 under the name of "The Painters and Sculptors Society," and was given its current name within the framework of the Lebanese Academy of Fine Arts (1958) as a union and an advocacy group. See LAAPS website, accessed 19 January 2018, www.laaps.org/aboutus.php.

[40] Hanin, Riad. "Mathaf Sursock yanqudh karamat Lubnan al-fanniya: limadha qat'at jam'aiyat al-fananin ma'rad al-mathaf?" (The Sursock Museum saves Lebanon's artistic dignity: Why did the artists' association boycott the museum's exhibition?), *Al-Jarida*, 26 November 1961.

The Ministry of Education has to be represented in all museum committees.

Artists admitted by the jury have right to the same exhibition space.

The museum is obliged to acquire at least one work of every artist exhibited.

75% of the acquisition budget will be invested in the acquisition of local works.

All aesthetic trends should be admitted.[41]

Not all artists represented by the Association agreed with the conditions set forth by the letter, leading to some resigning their membership. However, the resentment towards the museum for not following the Association's guidelines lasted several years. On the occasion of the third Salon in 1963, a review expressed the same view that as long as the exhibition was open to artists, the Association should participate in organising it; the exhibition should reflect the general level that painting and sculpture had reached in Lebanon.[42]

In an article in *An-Nahar* in the context of the fifth Salon d'Automne in 1965, Rafiq Sharaf explained his reasons for being the first artist to have boycotted the Sursock Museum for three years – after having exhibited one painting in 1962. One reason was that the museum encouraged what he called the "abstract rage," with real talents paying the price for this following of a fashion. He alleged that most artists participating were students and amateurs.[43] In a conversation, Amine al-Basha shared a similar criticism in his recollection of the Sursock Museum's Salon d'Automne. He observed that the Salon exhibited artists with very little experience, alongside – or even while rejecting some – works of established artists who had worked hard to reach their professional level.[44] Sharaf writes how the Salon exhibited paintings not belonging to any school or method but following a fashion, and how the museum favoured critics writing about it

41 The letter's demands are reproduced in Khoury, "Critère unique au musée Sursock."

42 "Jawla thaqafiya … la-huna wa la-hunaka: "ma'rad al-kharif" wa jama'iya al-fananin" (A cultural tour … to here and there: The "autumn salon" and the artists' association), *Al-Akhbar*, 8 December 1963.

43 Sharaf, Rafiq. "Rafiq Sharaf: qat'atu m'arad sursuq bi-surur wa rida wa irtiyah" (Rafiq Sharaf: I boycotted Sursock's exhibition with happiness and satisfaction and ease), *An-Nahar*, 12 December 1965.

44 Conversation with Amine al-Basha, Beirut, 30 March 2017.

with a pre-conceived idea of this abstract fashion. He considered this trend as going against the artist's individual personality. According to him, the Sursock Museum and those like it believed that the new art produced in Lebanon was "questionable" (*mashkuk bihi*), and instead should be inspired by Europe in order to be new and great and become a reference. Opposing this view, Sharaf and others argued that they were already creating a new art, drawing on their personalities and experiences. They were happy to boycott the exhibition, and planned to "boycott any construction that aimed to squeeze [them] into its imported concepts and criteria."[45] His boycott did not seem to last, as the ninth Salon (1974) included three works by him (*La plaine de Kayal*, *La plaine de Majdaloun*, *La route vers le Nord*). While he was director of the Faculty of Fine Arts at the Lebanese University, Sharaf even served on the jury of the 12th and 13th Salons d'Automne in the late 1980s.

Sharaf's view of the Salon d'Automne promoting European-style art was shared by others. Dalal Hadidi started her article reviewing the fourth Salon in 1964 with the following statement:

> Where are we in these paintings? Where are our experiences and our traditions and our life? Even the abstract ones are Western, although the East produced the first abstraction, a heritage of hundreds of years. The West transferred from our palaces, from our mosques, from the inscriptions of our carpets, the first seeds for this colour of art. As for us, we have started to transfer this Western distortion to our abstraction, because the confidence of the Lebanese artist in himself and his heritage has been shaken in front of the flashiness of Western civilisation.[46]

The critic wonders whether artists like Said Akl or Adel Saghir did not win prizes because of their use of Arabic calligraphy or because their art was inspired by their Eastern heritage. She maintained that the winning works like Shafiq Abud's were imitations of Western artists.[47] The Salon d'Automne always claimed to reflect the spirit of contemporary Lebanese artistic production, although the question of what constituted Lebanese art was a subject of debate in the context of the Salon. Was the Salon shaping taste according to European artistic preferences of the time, as Sharaf and Hadidi suggest? A good percentage of the jury members came

45 Sharaf, "Rafiq Sharaf".
46 Hadidi, Dalal. "Fatit madrasit Paris 'ashit madrasit New York!" (The Paris school is out, the New York school is alive!), *An-Nahar*, 20 December 1964.
47 Hadidi, "Fatit madrasit Paris."

from outside the country and most of the laureates of the first decade were educated in Paris (including Shafiq Abud, Viola Kassab, Salwa Rawda Shuqair, Aref Rayess, Elie Kanaan, Nadia Saikali), Florence or Rome (including Aref Rayess, Paul Guiragossian, Hussein Madi). Some had first studied in Lebanon, either in studios of some of the established artists like Mustafa Farrukh (such as Wajih Nahle), or at the Lebanese Academy of Fine Arts (ALBA) that was founded in 1943 (including Michel Basbus, Hussein Madi, Nadia Saikali, Georges Guv). Many of the later artists were educated at ALBA, which was modelled on the French Academy of Fine Arts but never became an authoritative institution.[48] Lebanon's art world has always been marked by a high degree of mobility both to and from the country. Strongly connected as it is to regional and international arenas, there has never been a move to establish a "national" art in Lebanon.[49]

The submission of artworks to the Salon d'Automne was open to all Lebanese artists – regardless of place of residence – as well as to foreign artists residing in Lebanon. While in some years reportedly not much new talent was discovered, some of the known artists who were repeatedly taking part in the Salon surprised the public with new styles. The two artists who were considered to have always remained consistent in their style were Khalil Zghaib and Sophie Yeramian, often referred to as "our two naïfs." Both of them were rewarded in the eighth Salon for their bouquets of flowers (1969), with Khalil Zghaib winning one of museum's three first prizes and Sophie Yeramian one of six second prizes. Some artists, notably John Hadidian and Aref Rayess, won prizes in both painting and sculpture, Aref Rayess even winning them in the same year (fifth Salon in 1965). Sculptor Salwa Rawda Shuqair managed to gain prizes in four salons in a row (fifth to eighth Salons) (see Table 1). She is one of the few pre-war Lebanese artists to have gained international recognition, with Tate Modern dedicating a solo show to her in 2013.[50] She is often portrayed as a recent discovery recognised late in life, although her work was obviously appreciated in Lebanon as early as the 1960s (Figure 4).

48 Further research is needed into the role of the artists' education and training in their artistic production, and the rise of the Lebanese Academy of Fine Arts and its link to the Salon d'Automne.

49 On the question of "national" art in Lebanon, see Naef, Silvia. *A la recherche d'une modernité arabe: L'évolution des arts plastiques en Egypte, au Liban et en Irak*. Geneva: Éditions Slatkine 1996, 183-195.

50 Morgan, Jessica (ed.). *Saloua Raouda Choucair*. London: Tate Publishing 2013.

Figure 4: Prize handed out to Salwa Rawda Shuqair at the seventh Salon d'Automne, 1967.
Courtesy of the Nicolas Ibrahim Sursock Museum.

The Sociétaires

Starting with the 13th Salon (1987), artists who had exhibited in at least five previous salons were elected "members" (*sociétaires*) and were invited to present works to the annual exhibition without having to submit them to the jury. The number of members increased yearly, from seven in 1987 (13th Salon) to 28 in 1995 (18th Salon) to 55 in 2000 (23rd Salon) (Table 2). In the traditional Paris Salon and the annual Summer Exhibition in London, the "members" were elected members of the Academy, for whom the salon was created and by whom it was run. In the absence of an authoritative academy in Lebanon, the Sursock Museum took over some of its functions. However, being a member of the Sursock Museum did not bring any role or responsibility with it. The only function of the membership system was to be admitted to the Salon without being subjugated to the jury's taste. It thus did not lead to the artists becoming invested in the museum and carried little meaning for them. The practice of admitting members *hors* jury was thus discontinued after 2000, connected to the fact that for several years the standards of their submissions had been highly criticised, both by the museum curator and art critics.[51] According to art critic Joseph Tarrab, "some

[51] See newspaper articles and exhibition catalogues.

artists just sent *n'importe quoi*, which was not fair to the other artists who had to go through the selection process."[52] Loutfalla Melki, long-time curator of the museum from 1980 onwards, wrote in the preface to the 23rd Salon (2000) that this year the jury had decided to award neither the Sursock Museum Prize, twinned that year with a prize by the Société Générale Bank, nor the Dorothy Salhab Kazemi prize for young artists, due to the insufficient quality of the works submitted. It was one of the salons with the highest rejection ratio, exhibiting only 32 works by 21 artists out of 444 submitted by 176 artists. What is more,

> the jury reaffirms one more time that the majority of works presented by members of the salon don't have the quality required for a Salon d'Automne. Following this, the jury proposes to the Museum Committee to stop the membership system currently in use and put a new model in place for an up-to-date Salon d'Automne, in line with the real situation of visual arts in Lebanon, at the beginning of the twenty-first century.[53]

This was the end of the membership system.

The Public

In an article published in the *Guardian* on the occasion of the reopening of the Sursock Museum in 2015, Lebanese novelist Hanan al-Shaykh was interviewed about her recollection of the Salon d'Automne: "'We were all full of ourselves,' she admits. 'Everyone used to go, the crowds were amazing … only the crème de la crème of society. People went because it was prestigious, not because they were interested in art.'"[54] Reviews of the first exhibitions mention how "the opening was attended by large numbers; the elite of Lebanese society attended to express their joy, and to see the exhibition;"[55] that "Society turned out *en masse* for the Salon d'Automne of Lebanese painters and sculptors;"[56] and how "the ladies wandered around in their clothes and their decoration, as though they were in a reception for a king," reminiscent of an "atmosphere of pride and aristocracy."[57] Many remember the Salons

52 Conversation with Joseph Tarrab, Beirut, 5 October 2016.

53 Loutfalla Melki, Exhibition catalogue *XXIIIe Salon d'Automne 2000*. Beirut: Sursock Museum, 2000.

54 d'Arc Taylor, "The place to see and be seen."

55 Hanin, "Mathaf Sursock yanqudh karamat Lubnan al-fanniya."

56 "Sursock Exhibition," *The Daily Star*, 17 December 1964.

57 Aql, Raymond. "Mahrajan al-rasm wa al-naht fi qasr Nicolas Sursock: Mathaf al-athar al-fanniya al-haditha min al-awqaf al-madaniya alti tushakal turath lubnan al-thaqafi" (Exhibition of painting and sculpture at the Nicolas Sursock palace: the museum of

d'Automne of the 1960s and early 1970s in a nostalgic way, and while there were unquestionably a certain number of socialites attending the exhibitions, it was also the place for art enthusiasts. Art historian Salwa Mikdadi remembers the Salon fondly: "The Sursock's autumn exhibition was the first event I was always looking forward to every year in the 1960s, when I was coming to Beirut as a 17-year old from Jerusalem."[58]

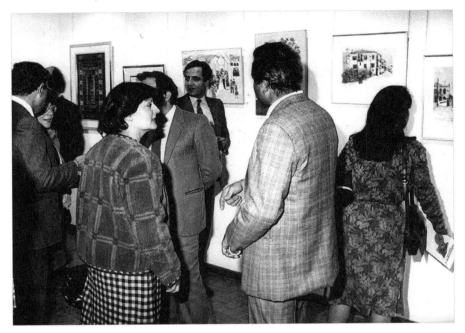

Figure 5: Visitors at the 10th Salon d'Automne, 1982. Courtesy of the Nicolas Ibrahim Sursock Museum.

The public was thus an important component of the Salon. As artist and art teacher John Carswell explained, "for a society to create and nurture an artistic tradition, there are two requisites; first, there must be the artists themselves; and second, there must be a public to support them." Carswell maintained that the relatively conservative public in Lebanon initially did not facilitate artists finding a place in Lebanese society.[59] The public was just getting introduced to contemporary art in the 1960s, with a rising

modern artistic artifacts from the civil endowments that compose Lebanon's cultural heritage), *Al-Aml*, 22 November 1961.

58 Salwa Mikdadi, comment made during "The Museum As… An International Symposium on Museum Futures," held at the Sursock Museum on 2 October 2015.

59 Carswell, John. *Lebanon – The Artist's View*. London: British Lebanese Association 1989.

number of exhibition spaces and shows. The museum committee repeatedly emphasised how the Salon allowed the public to discover new talents. While people had access to contemporary art through individual exhibitions, the annual Salon allowed them to take stock and get a more complete overview of artistic production and trends.[60] Critics also made the point that unlike in the exhibitions taking place in galleries, artists did not have to please the public in their work exhibited at the Salon.[61] Unlike most salons, works exhibited at Sursock Museum's Salon d'Automne were not for sale – although of course the latter helped in getting the works known.

While the high period of the Salon d'Automne was without doubt the pre-war period, it still had its place in the 1990s. Its importance as a comprehensive showcase of current artistic production was stressed both by the exhibition catalogues and reviewers. "This event attracts a lot of people: artists to exhibit and amateurs to watch," wrote a reviewer in 1995. "This Salon d'Automne, in short, constitutes a mix of the different artistic trends and certainly gives an idea about the landscape of visual arts in Lebanon … The event of the country in the field of visual arts is the Salon d'Automne of the Sursock Museum."[62] The museum also tried to attract new audiences after the war, reaching out to schools, for instance, as was recounted in Helen Khal's review of the 1998 Salon:

> Again, as in the past, the Sursock Museum has put together what is undoubtedly the year's best and most comprehensive exhibition of contemporary art in Lebanon. It's a 'must-see' that offers something for everyone. Schools by the dozens have been bringing their students in to see the show – and students in turn have been returning with their parents for a second look.[63]

Conclusion

The Salon d'Automne was one of the main channels through which the Sursock Museum acquired art, which forms an important part of its total collection. It documents Lebanese art from the 1960s until today. Reading

60 Akar, "Comment départager les torts?," "Talents d'aujourd'hui et espoirs de demain," *L'Orient-Le Jour*, 18 December 1986; May Makarem, "Exprimer par les couleurs des émotions nouvelles," *L'Orient-Le Jour*, 16 March 1994.

61 Davidian, Edgar. "73 artistes, témoins de leur temps, au 26ᵉ Salon d'automne," *L'Orient-Le Jour*, 28 December 2005.

62 K.M., "Salon d'Automne : Paysages artistiques," *Magazine*, 15 December 1995.

63 Khal, Helen. "Exhibits come in all shapes and forms at Sursock's Autumn Salon," *The Daily Star*, 30 December 1998.

through the exhibition catalogues and reviews, it becomes clear that the Salon played a role in the development – or at least the documentation – of what could be termed a "canon" of Lebanese art, in particular in the first 20 editions (1961-1996). Walking through the Sursock Museum's second floor, where works from the permanent collection are presented, the Salon's legacy for modern Lebanese art is visible.[64] The jury and museum committee were major players in setting trends – the former explicitly, the latter implicitly by appointing the jury and deciding on acquisitions. The museum as exhibition space was an important vehicle through which to form public taste, both during the temporary Salon exhibitions and through its permanent collection display by which it marks its place in Lebanon's art history. The market component of the Salon – providing a commercial representation – was less developed, as the works on display were not on sale at the museum. There is little doubt, however, that exhibiting at the Salon d'Automne raised the visibility of an artist and his and her works. The Sursock Museum actively contributed to shaping Lebanon's artistic landscapes from the 1960s until the 1990s, the period focused on in this chapter.

The later editions need to be studied also, keeping in mind the development of new media – the 25th salon (2004/2005) included video installations for the first time – which became an important mode of expression in Lebanon's post-war art. The fact that the quality of members' submissions dropped must have affected the Salon's relevance by the late 1990s. At the same time, new forums were opening up for group exhibitions, like Ashkal Alwan's Sanayeh or Corniche projects, as well as new gallery and exhibition spaces.[65] One article asked in 1998:

> Around '40' years after the creation of the Salon d'Automne, is it still valid to exhibit in one space and *sous le même regard* all the generations of Lebanese artists …? Going back to history reminds us that the Salon d'Automne of the Sursock Museum was, before the war, the ultimate place for reflection on visual art and artistic promotion of the country. The Salon d'Automne was the event through which discoveries and surprises were made.

64 This held particularly true for the second floor permanent exhibition display ("Collection Display – A Selection of Works: 1961-2012") between October 2015 and September 2017, following the reopening of the museum and before the collection display was rearranged in mid-September 2017.

65 Ashkal Alwan, or the Lebanese Association for Plastic Arts, is a non-profit organisation based in Beirut that has been active since 1993. In the 1990s, it organized a number of group exhibitions in public spaces, such as the Sanayeh Project in 1994, the Sioufi Garden Project in 1997 and the Corniche Project in 1999. See Ashkal Alwan's website, accessed 19 January 2018, www.ashkalalwan.org.

It was through the Salon d'Automne that numerous talents were launched.[66]

The author goes on to complain that there were now too many group exhibitions. Finishing on a positive note, he mentioned that the Salon d'Automne nevertheless still provided a useful space for young artists. Since its reopening in October 2015, the Sursock Museum is back on the scene. After some hesitation, the museum re-launched its Salon d'Automne in November 2016 – to be held biannually. Its impact in the twenty-first century artistic landscape remains a subject for future inquiry.

Table 1. The Salon d'Automne (SA) at the Sursock Museum. Dates, Prizes, Jury Members.

SA	Date	Prizes	Jury
1	18-28/11/1961	No prize	Museum Committee
2	24/11-10/12/1962	No prize	Museum Committee
3	28/11/1963-5/1/1964	No prize	Wassek Adib, André Bercoff, John Ferren, Victor Hakim, Louis Tabet
4	15/12/1964-15/1/1965	Painting: Shafiq Abud, John Hadidian Sculpture: Viola Kassab (Sursock Museum Prize)	Wassek Adib, André Bercoff, Arthur Frick, Victor Hakim, Pierre al-Khoury
5	7/12/1965-7/1/1966	Painting: Elie Kanaan, Hussein Madi, Aref Rayess (Sursock Museum Prize) Special Mention: Nadia Saikali, Munir Najem, Mohamed Sakr Sculpture: Salwa Rawda Shuqair (Sursock Museum Prize) Aref Rayess (Sculpture Prize) Special Mention: Alfred Basbus, Michel Basbus	Roger van Gindertael, Wassek Adib, Pierre al-Khoury, André Bercoff, Louis Tabet

66 "Le XXII^ème Salon d'Automne au Musée Sursock: De nouveaux talents prometteurs," *La Revue du Liban*, 26 December 1998.

6	28/12/1966-12/2/1967	Painting: 1. John Hadidian, 2. Paul Guiragossian, 3. Joumana Bayazid, 4. Wajih Nahle Italian Cultural Centre Prize: Munir Najem Sculpture: 1. Aref Rayess, 2. Joseph Basbus, 3. Salwa Rawda Shuqair Italian Cultural Centre Prize: Moazzaz Rawda	Georges Boudaille, Pierre al-Khoury, Abdul Rahman Labban, Jean-Jacques Lévêque, Assem Salam
7	12/12/1967-12/01/1968	Painting: 1. Elie Kanaan, 2. Rita David; Munir Najem; Mohamed Sakr, 3. Simone Baltaxe Martayan; Stelio Scamanga Italian Cultural Centre Prize: Nabil Mattar Sculpture: 1. Michel Basbus; Salwa Rawda Shuqair, 2. Moazzaz Rawda, 3. Antoine Berberi; Jamil Molaeb	Victor Hakim, Abdul Rahman Labban, Jean Salles
8	3-26/1/1969	Painting: 1. Levon Moumjian; Nadia Saikali; Khalil Zghaib, 2. Lotti Adaimi; Antoine Asfar; Georges Guv; Stelio Sca-manga; Harout Torossian; Sophie Yeramian Sculpture: 1. John Hadidian, 2. Joseph Basbus; Salwa Rawda Shuqair Italian Cultural Centre Prize: Hussein Madi	John Carswell, André Fermigier, Jean Khalifé
9	27/11/1974-10/1/1975	No prize	Roberto Pisani, Museum Committee

10	20/12/1982-20/1/1983	No prize Homage to Farid Aouad (1924-1982), Hussein Badreddine (1939-1975), Michel Basbus (1921-1981), Jean Khalife (1923-1978), Ibrahim Marzuk (1937-1975), Khalil Zghaib (1911-1975)	Aimée Kettaneh, Pierre al-Khoury, Abdul Rahman Labban, Joseph Rabbat, Rickat Salam, Samir Tabet, Georges Tohmé
11	21/12/1984-21/1/1985	No prize	Sylvia Agémian, Nazih Khater, Pierre al-Khoury, Hind Sinno, Joseph Tarrab
12	16/12/1986-31/1/1987	No prize Homage to Sophie Yeramian (1915-1984)	R.P. Abdo Badaoui, Rafiq Sharaf, Hussein Madi, Joseph Rabbat
13	12/1987-1/1988	No prize Homage to Alfons Philipps (1937-1987)	R.P. Abdo Badaoui, Rafiq Sharaf, Pierre al-Khoury, Hussein Madi, Joseph Rabbat
14	12/1988-1/1989	No prize Homage to Fadi Barrage (1939-1988), Olga Limansky (1903-1988)	Sylvia Agémian, Pierre al-Khoury, Hussein Madi, Joseph Rabbat, Joseph Tarrab
15	20/12/1991-1/1992	Dorothy Salhab Kazemi Prize: Youssef Aoun (painting) Homage to Diran (1903-1991), Munir Najem (1933-1990), Dorothy Salhab Kazemi (1942-1990)	Joseph Abu Rizk, Sylvia Agémian, Hussein Madi, Joseph Rabbat, Samir Sayegh, Joseph Tarrab
16	2/4-2/5/1993	No prize (decision by the jury to hand out neither the Dorothy Salhab Kazemi prize for young artists nor the Sami Rafi prize for young sculptors)	Pierre al-Khoury, Hussein Madi, Joseph Rabbat, Ramzi Saidi, Samir Sayegh, Sylvia Agémian, Jean-Philippe Schweitzer, Joseph Tarrab

17	15/3-15/4/1994	Dorothy Salhab Kazemi Prize: Flavia Codsi (painting) Homage to Saliba Douaihy (1915-1994), Paul Guiragossian (1926-1993), Youssef Hoyek (1883-1962), Rachid Wehbe (1917-1993)	Sylvia Agémian, Joseph Rabbat, Assem Salam, Samir Sayegh, Joseph Tarrab
18	31/1-5/3/1995	Rima Amyuni (Sursock Museum Prize) (painting) Dorothy Salhab Kazemi Prize: Youssef Aoun (painting)	Camille Aboussouan, Pierre el Khoury, Assem Salam, Hind Sinno, Sylvia Agémian, Joseph Tarrab, Samir Sayegh
19	29/11/1995-14/1/1996	Dorothy Salhab Kazemi Prize: Vartan Aror (Sculpture) In Memoriam: George Chanine (1951-1995)	Hind Sinno, Assem Salam, Pierre al-Khoury, Wassek Adib, Sylvia Agémian, Joseph Rabbat, Joseph Tarrab, Samir Sayegh
20	25/10-30/11/1996	Flavia Codsi (Sursock Museum Prize) (painting) Dorothy Salhab Kazemi Prize: Theo Mansour (painting)	Nayla Kettaneh Kunigk, Hind Sinno, Sylvia Agémian, Wassek Adib, Pierre al-Khoury, Joseph Rabbat, Samir Sayegh, Joseph Tarrab
21	28/11/1997-10/1/1998	Joseph Abi Yaghi (Sursock Museum Prize) Dorothy Salhab Kazemi Prize: Rana Raouda (painting) Special Mention: Anita Toutikian In Memoriam: Michel Akl (1923-1997)	Wassek Adib, Syvia Agémian, Nayla Kettaneh Kunigk, Nazih Khater, Samir Sayegh, Joseph Tarrab
22	11/12/1998-31/1/1999	No Sursock Museum Prize Dorothy Salhab Kazemi Prize: Anita Toutikian (Installation) Special mention: Jacko Restikian, Nabil Helou, Halim Mehdi Hadi, Theo Mansour	Nayla Kettaneh Kunigk, Janine Maamari, Hind Sinno, Syvia Agémian, Assem Salam, Nazih Khater, Joseph Tarrab, Samir Sayegh

23	12/12/2000-14/1/2001	No prize (due to insufficient quality according to the jury)	Nayla Kettaneh Kunigk, Janine Maamari, Nazih Khater, Samir Sayegh, Nabil Tabbara, Joseph Tarrab
24	3/12/2003-17/1/2004	Halim Mehdi Hadi (Sursock Museum Prize) Dima Hajjar (Jury Prize) Special Mention: Bassam Geitani	John Carswell, Syvia Agémian, Jacques Assouad, Nazih Khater, Pierre al-Khoury, Ramzi Saidi, Assem Salam, Hind Sinno, Joseph Tarrab
25	2/12/2004-15/1/2005	Fulvio Codsi (Sursock Museum Prize) Antoine Mansour (Sursock Museum Prize)	Syvia Agémian, Hind Sinno, Jacques Assouad, Nazih Khater, Nicolas Nammar, Ramzi Saidi, Samir Sayegh, Joseph Tarrab
26	28/12/2005-28/1/2006	No prize	Adel Koudaih, Sadek Tabbara, Alfred Tarazi, Joseph Tarrab
27	22/12/2006-31/1/2007	Samar Mogharbel (Sursock Museum Prize)	Pascale Feghali, Adel Koudaih, Walid Sadek, Samir Sayegh, Sadek Tabara, Alfred Tarazi, Joseph Tarrab
28	3-31/3/2008	Charles Khoury (Sursock Museum Prize) Gilbert Hage (Jury Prize) Special Mention: Abdel Rahman Katanani	John Carswell, Adel Koudaih, Samir Sayegh, Sadek Tabbara, Samir Tabet, Alfred Tarazi, Joseph Tarrab
29	12/1-12/3/2009	May Catherina Abboud (Sursock Museum Prize); Samir Muller (Sursock Museum Prize); Abdel Rahman Katanani (Emerging Artist Prize); Laure Ghoraieb & Mazen Kerbage (Jury Prize) Special Mention: Zeina Assi; Oussama Baalbaki; Ziad Tarabah; Jasenka Tucan-Vaillant	Assem Salam, Gregory Buchakjian, Adel Koudaih, Samir Sayegh, Joseph Tarrab

30	2/12/2010-4/1/2011	Raouf Rifai (Sursock Museum Prize)	Assem Salam, Maha Sultan, Adel Koudaih, Samir Sayegh, Joseph Tarrab
		Youssef Nehme (Emerging Artist Prize)	
		Mario Saba (Jury Prize)	
		Special Mention: May Haddad; Karim Joreige; Annie Kurkdjian; Hassan Zahreddine	
31	28/1/2011-17/2/2012	Raffi Tokatlian (Sursock Museum Prize); Raya Mazigi (Emerging Artist Prize); Joe Kesrouani & Muhamad Saad (Jury Prize)	Assem Salam, Maha Sultan, Adel Koudaih, Samir Sayegh, Joseph Tarrab
		Special Mention: May Abboud; Leila Jabre-Jureidini	
32	25/11/2016-27/2/2017	Abed Al Kadiri (Sursock Museum Prize); Dala Nasser (Emerging Artist Prize); Nevine Bouez (Audience Choice Award)	Reem Fadda, Walid Sadek, Rasha Salti, Hind Al Soufi, Kaelen Wilson-Goldie
		Special Mention: Engram Collective; Raymond Gemayel	
33	25/10/2018-14/1/2019	TBD	Tarek Abou al-Fetouh, Nizar Daher, Rania Stephan, Christine Tohme, Jalal Toufic

Table 2. Members (*sociétaires*) of the Sursock Museum's Salon
d'Automne (SA) between 1987 and 1999.

SA	Members (*Sociétaires*)
13	Samir Abi Rached, Alfred Basbus, Joseph Basbus, Lotti Adaimi, Odile Mazloum, Nadia Saikali, Sophie Yeramian
14	Samir Abi Rached, Lotti Adaimi, Joseph Basbus, Mouna Bassili Sehnaoui, Paul Guiragossian, Halim Jurdak, Hussein Madi, Odile Mazloum, Wajih Nahle, Nadia Saikali, Torossian
15	Samir Abi Rached, Lotti Adaimi, Antoine Asfar, Amine al-Basha, Joseph Basbus, Mouna Bassili Sehnaoui, Maya Eid, Zaven Hadichian, Hassan Jouni, Halim Jurdak, Helen Khal, Hussein Madi, Odile Mazloum, Wajih Nahle, Salwa Rawda Shuqair, Mohammad Al Rawas, Sami Rifai, Harout Torossian, Rachid Wehbe
16	Samir Abi Rached, Yvette Achkar, Lotti Adaimi, Michel Akl, Amine al-Basha, Mouna Bassili Sehnaoui, Maya Eid, Zaven Hadichian, Hrair, Hassan Jouni, Halim Jurdak, Hussein Madi, Joseph Matar, Odile Mazloum, Wajih Nahle, Salwa Rawda Shuqair, Mohammad al-Rawas, Aref Rayess, Sami Rifai, Juliana Seraphim, Cici Sursock, Moussa Tiba, Harout Torossian, Rachid Wehbe
17	Shafiq Abud, Desiree Abu Jaber, Samir Abi Rached, Yvette Achkar, Lotti Adaimi, Michel Akl, Amine al-Basha, Alfred Basbus, Joseph Basbus, Mouna Bassili Sehnaoui, Maya Eid, Hrair, Aram Jughian, Halim Jurdak, Mohammad Kaissi, Elie Kanaan, Hussein Madi, Joseph Mattar, Odile Mazloum, Wajih Nahle, Salwa Rawda Shuqair, Mohammad al-Rawas, Aref Rayess, Sami Rifai, Moussa Tiba, Harout Torossian
18	Shafiq Abud, Samir Abi Rached, Lotti Adaimi, Krikor Agopian, Loulou Bassiri, Amine al-Basha, Mouna Bassili Sehnaoui, Antoine Berberi, Maya Eid, Joseph Faloughi, Zaven Hadichian, Hrair, Hassan Jouni, Aram Jughian, Halim Jurdak, Mohammad Kaissi, Elie Kanaan, Joseph Mattar, Odile Mazloum, Wajih Nahle, Mohammad al-Rawas, Aref Rayess, Sami Rifai, Samir Tabet, Moussa Tiba, Harout Torossian, Nada Yammine, Fadl Ziade

19 Shafiq Abud, Desiree Abu Jaber, Samir Abi Rached, Yvette Achkar,
 Lotti Adaimi, Krikor Agopian, Michel Akl, Rima Amyuni, Loulou
 Baassiri, Amine al-Basha, Antoine Berberi, Maya Eid, Joseph Faloughi,
 Chucrallah Fattouh, Zaven Hadichian, Hassan Jouni, Aram Jughian,
 Halim Jurdak, Mohammad Kaissi, Elie Kanaan, Helen Khal, Hussein
 Madi, Adnan El Masri, Joseph Mattar, Odile Mazloum, Jamil Molaeb,
 Samir Muller, Wajih Nahle, Greta Naufal, Norikian, Samia Osseiran
 Jumblatt, Salwa Rawda Shuqair, Aref Rayess, Sami Rifai, Nadia Saikali,
 Samir Tabet, Harout Torossian, Fadl Ziade

20 Desiree Abu Jaber, Samir Abi Rached, Lotti Adaimi, Michel Akl, Loulou
 Baassiri, Amine al-Basha, Haibat Balaa Bawab, Mouna Bassili Sehnaoui,
 Antoine Berberi, Houry Chekerdjian, Fulvio Codsi, Rita David, Maya
 Eid, Joseph Faloughi, Chucrallah Fattouh, Zaven Hadichian, Fouad
 Jaouhar, Joseph Harb, Hassan Jouni, Aram Jughian, Halim Jurdak, Elie
 Kanaan, Helen Khal, Boulos Khawam, Charles Khoury, Hussein Madi,
 Adnan El Masri, Joseph Mattar, Odile Mazloum, Samar Mogharbel,
 Jamil Molaeb, Samir Muller, Wajih Nahle, Greta Naufal, Norikian, Samia
 Osseiran Jumblatt, Mohammad El Rawas, Aref Rayess, Sami Rifai,
 Gisele Rohayem, Marwan Saleh, Samir Tabet, Moussa Tiba, Harout
 Torossian, Nada Yammine, Fadl Ziade

21 members, names not listed in the exhibition catalogue 57

22 Shafiq Abud, Samir Abi Rached, Lotti Adaimi, Krikor Agopian, Rima
 Amyuni, Youssef Aoun, Loulou Baassiri, Haibat Balaa Bawab, Youssef
 Basbus, Mouna Bassili Sehnaoui, Antoine Berberi, Charles Chahwan,
 Houry Chekerdjian, Flavia Codsi, Fulvio Codsi, Amal Dagher, Maya
 Eid, Joseph Faloughi, Chucrallah Fattouh, Mansour Habre, Hrair, Rose
 Husseiny, Fouad Jaouhar, Sami Jarkas, Hassan Jouni, Aram Jughian,
 Halim Jurdak, Mohammad Kaissi, Elie Kanaan, Helen Khal, Helou Ange
 Khalil, Boulos Khawam, Charles Khoury, Naziha Knio, David Kurani,
 Bassam Kyrillos, Hussein Madi, Adnan El Masri, Joseph Mattar, Odile
 Mazloum, Jamil Molaeb, Samir Muller, Jean-Marc Nahas, Wajih Nahle,
 Samia Osseiran Jumblatt, Salwa Rawda Shuqair, Mohammad al-Rawas,
 Aref Rayess, Sami Rifai, Gisele Rohayem, Mario Saba, Ghada Saghieh,
 Marwan Saleh, Missak Terzian, Harout Torossian, Lucy Tutunjian, Fadl
 Ziade

POSTSCRIPT
IN CONVERSATION WITH
BRITISH ARTIST EILEEN COOPER, RA

COORDINATOR OF THE ROYAL ACADEMY'S
249th SUMMER EXHIBITION, 2017

This has been adapted from the transcript of a conversation between Eileen Cooper and Nadia von Maltzahn at the Sursock Museum on 28 October 2017 in the framework of the conference "Contextualising the Art Salon in the Arab Region".

Nadia von Maltzahn: It is my great pleasure to introduce you to Eileen Cooper (OBE) from the Royal Academy, a contemporary painter and printmaker. Eileen studied at Goldsmiths College from 1971 to 1974, in the cohort of students selected by Jon Thompson. She went on to study Painting at the Royal College of Art under Peter de Francia, graduating in 1977, and soon began to exhibit her work. At the same time, Eileen has always taught part-time in numerous institutions including St Martins, the Royal College of Art and the Royal Academy Schools. Eileen became a Royal Academician in 2000, and from 2010 to 2017 served as Keeper of the Royal Academy. She was the first woman to be elected to this role since the Academy began in 1768. The Keeper is responsible for supporting and guiding the students of the Royal Academy.

We invited Eileen to this conversation in her role as coordinator of the 249th Summer Exhibition at the Royal Academy in 2017. The Summer Exhibition prides itself on being the largest open submission exhibition in the world, hanging over 1,200 works by both emerging and established contemporary artists. It has run continuously since the academy opened in 1769. It is the only institution that has held an annual open-call exhibition which is the equivalent of the art salon, every year for the last 250 years. That is why we were very interested to hear Eileen's reflections on the Summer Exhibition. Eileen, can you give us an idea about the last exhibition?

Eileen Cooper: Thank you for welcoming me. I have to start by saying I am a bit of a fraud, because I am not presenting a paper. I am not an academic. I am most definitely in the other camp of somebody who thinks through making. That's my mantra. I have been a Royal Academician since 2000,

and this is the first time I have coordinated the Summer Show. I thought I'd start with a quote from our ancient laws. It is written in the laws of the Royal Academy that

> there shall be an annual exhibition of paintings, sculptures, engravings and designs, being the Summer Exhibition, in which all artists of distinguished merit shall be permitted to exhibit their works. An entry is open to anyone who pays the price.

We have to cap the send-in at 12,000 works, because physically it is harder (for the selection committee) to look at any more than that. Since about five years ago we have been doing the first stage digitally. So we look at 12,000 works in a week. A team of academicians are the jury. When we were talking earlier about juries, that struck so many points for me – the grumbling of the jury, the partisans sometimes, and of course all the jurors are either architects or artists, so they're kind of including and judging and selecting from sometimes their peers, sometimes – oh well, often – younger artists and then also the category that is more difficult, I think – amateur artists. I realise that more and more amateur artists are actually people who were art-school trained, who just don't happen to make a living as an artist. And I think their work is very worthy. One of the challenges is to keep the quality as high as possible. So that's the background of the Summer Show.

My mission was to set the theme for this year. My theme grew, and it was very hard to message, it wasn't like a one-liner which is always a good catch for the public. My mission was to make it cross-generational, which it always is actually, cross-cultural, international – but not just the kind of big international stars that we often get at the Academy – but to spread the word internationally that the Academy is a great venue, and a great commercial venue, and first and foremost that artists need to sell their work. This year we were incredibly successful, raising over five million pounds in sales, and 70 per cent of that goes to artists. I don't know how successful I was at getting my message out internationally. As part of my preparatory work – I started in October 2016, the show was summer 2017 – we had as part of the Frieze Art Fair in London a rather wonderful African art fair, so I was able to go to that and meet people and talk to galleries and say you must get people to submit. Because the first part is digital, anybody from anywhere in the world could submit. I wanted inclusion and diversity, breadth of practice. We know that we have got excellent paintings and sculpture, excellent architectural drawings, prints and photography coming in, but I thought that we needed to be reflective of what's happening in contemporary art, which we are a little bit. Through my guidance, we put two rooms towards film, and we had one big film installation, and a smaller room by Isaac Julian, and another

smaller room of two artists showing quite substantial, more narrative films, two women artists as it happens. I also wanted to introduce performance, which we managed to do successfully. We staged the performances every Friday evening, and that kind of worked. People knew that they were on, so we had lots and lots of visitors. As I say, I don't know how really successful I can claim to be. I don't think we had a lot of success in showing artists from this region (the Arab region). But I suspect that artists from this region who were based more internationally actually sent in from London or Paris, and we probably did include a number.

Nadia: Thank you for this introduction, Eileen. I want to pick up on a couple of things, first of all the selection process itself. You said you are mainly artists and architects selecting the work. What does it mean for you as an artist, and what does it mean for you to be a group of artists selecting the work of other artists? As a comparison with what happens here in Beirut, for example, is that the jury is usually composed of art critics or …

Eileen (interrupting): I personally wouldn't let art critics anywhere near it!

Nadia: … sometimes artists, but this is always a debate. So I am wondering whether it is a debate and how you feel about being an artist selecting the work of other artists?

Eileen: Well, having been a life-time teacher, I have always selected work from people who applied to come first to the Royal College and then to the Royal Academy Schools. It's part of the job. I don't think we can pretend to get it right the whole time, we miss things, especially in the digital selection in terms of new media or drawing. It can be very subtle, and you don't always understand the scale of something, the texture, so we will be missing a lot. Especially if we are looking at 12,000 works. However, what we hope we get is a broad enough selection of work that we bring in. The next stage is when about 4,000 selected works come to the Royal Academy. We do another round of selection and we start to hang immediately. And I hope that there is – and there always is – works of quality. You might not like them, but they deserve to be there. And I think that is a really interesting show, slightly controversial perhaps, provocative, welcoming, all of those things. I don't know if I have answered your question.

Oh, the jury. The jury is quite an argumentative group, especially as the days are long and they get hungry and fed up. Especially if they are not seeing anything they love. And these are artists between the ages of probably 40 and 75. And I think we are all quite partisan, but I hope I am less partisan. I have been a teacher so I want to be as broad as possible. I was sometimes disturbed that people seemed to select work that was quite like

theirs, and if you keep pointing this out then you would get slapped down. But in the hang, that is another possible area to select the work you really want. I was able to put together quite a diverse panel of selectors, because some people couldn't do it which means that you can ask other people, but it's normally by rotation. We were unusual in that we were five women and two or three men.

Nadia: That's good. Thank you for that. Just to stay a bit on the theme of selection, here at the Sursock Museum Salon you had at one period, between the 1980s and the early 2000s, a system of membership, where all the artists who had been through five salon juries of the Salon d'Automne, the autumn salon here in Beirut, were allowed to submit to the Salon without going through the jury. This started in 1987 with seven artists and was then stopped in 2000 when the membership increased to 55 *sociétaire*s or members. But they stopped this practice because there was a lot of debate that the members were not sending in any work that was of interest; they didn't take it seriously because they didn't have to go through the jury system. And I know the situation is quite different in the Royal Academy, but can you say a little about the balance, also about the Royal Academicians who don't have to go through the selection?

Eileen: Yes, it's similar in the way that the Royal Academicians don't go through selection. But the reality is that they've been selected from, I suppose, the visible and hopefully exceptional artists of around Great Britain and a little bit wider in the world. But you're supposed to have your practice, and although you don't need to be British, your practice is supposed to be based in the UK. So they've already been selected, and it's a very, I suppose, complicated process. You can't fix it for anybody to get elected because the people voting are individual mavericks, as most artists are. So you might get a little cabal of people who try to propel somebody forward to be elected, but it's not going to happen unless you get a substantial number of the votes. But yes, they don't go through the jury, although we do give feedback sometimes if they send in too many things that are too large to hang, because of course we can hang very large works but if somebody sent in six large works … so we now have a square footage, a square metrage.

Nadia: You mentioned briefly in a conversation yesterday that Academicians only have to go through the jury if they want to submit in another category, so … the works are sent in through seven categories, I think.

Eileen: About that. It's particularly the architects. The architects are all in practice, so they will send in drawings that are made in the office and as part of their practice, and they may send models or digital works. Often a

lot of them want to send in paintings, because that's what they do as well in their spare time. That can be quite controversial among the painters because the space is tight – even though we have these fabulous ten galleries of the Royal Academy. You know, once you're hanging 1,200 works, space is an issue. So I think that, by discussion, gently a message goes out ... Yes, we'll hang it but you won't get a fabulous spot if we don't like it...

Nadia: And you just mentioned, when you talked about the criteria for being an Academician, that the artist's practice should be based in Britain. So one question that we have been discussing at the conference is the relationship between art – or between the salon – and the idea of the nation, and also that the salon was a forum that conveyed specific values and attitudes and aspirations. I was listening to a radio programme about the Summer Exhibition, where your artistic director Tim Marlow mentioned that, if you want to take the temperature of what's happening in British art and amateur areas, then this is really an interesting place to come to. And here for Lebanon, it was always only artists who were either based in Lebanon – of any nationality – or from Lebanon who could submit to the Salon, so it was related to the country somehow.

Eileen: I mean, the truth of it is, although the artists, the Academicians, are established in the UK, the world is now so international that they may be working in Trinidad or South America; certainly the architects are absolutely all over the world. But I think that's a good quote, it's a great way to take the temperature of contemporary art. I also believe it gives a great alternative space to the gallery system and the kind of Tate aesthetic and what used to be very much, in the 1980s, a Charles Saatchi-dominated art world, and that's not so much the case now. And during that time I think lots of artists saw the Summer Show as being a really viable space to show new work and hopefully to sell their work.

Nadia: Do you have an idea how many submissions you get from outside Britain? Is it something that you advertise for?

Eileen: We do advertise: my modest journey to the Contemporary African Art Fair, for example, and to say to as many people as I could, "You should send in!" We were very privileged to have quite a lot of African artists this year. Not just based in the different countries throughout Africa, but based around the world. We had artists from South America, Korea, China ... It would take a new piece of research – if you got anybody wanting to do it – to come and work with us to find out exactly how successful we are. I don't know if they'll be able to continue that next year. I would love to believe that they will build on what I've very publicly said we should be doing.

Because next year is our 250th anniversary, so it might be that the Summer Show is all about the Royal Academy. Which I think would be a bit of a shame, I think that without the welcome and the breadth of our artists, we are a pretty sad place, really.

Nadia: That's what it's all about in the end.

Eileen: Just one thing, though. As more and more artists – professional artists – see it as a great space to show, it gets harder and harder for the amateur, or naive artist. At one stage, probably in the 1970s, the Academy was quite discredited and lots of contemporary artists just would not consider joining or showing there, so it was filled up with Academicians of a fairly low grade … amateur artists…

Nadia: And how did the shift occur?

Eileen: The Academicians had to become more active and say, "this is really worthwhile" to their contemporaries. I think in the 1970s or 1980s, a lot of people who had been educated at the Royal College began to accept being elected. So it was down to canvassing a little bit on people's behalf to say: "We should have Peter Blake" or "we should have John Hoyland," and then people agree. John Hoyland gets elected and he accepts rather than turning it down and he then plays a part, and then particularly those, I would say, the pop artists and that generation of British artists who were influenced by American abstraction joined, and then it began to get a lot more force, really, more creative force.

The Academy has no state funding, so we've always been very entrepreneurial. We've always had to make our own income. And when the Academy was set up, it was to show the work of the Academicians and to fund the activities of the Academy, and central to that was the setting up of a free school. An art school. It used to be undergraduate and post-graduate, now it's all post-graduate. And we have a free course which I believe is very high-level, very intensive – that's what I was involved in. And it's free to anybody!

Nadia: And how do you see the link to the school? Because in many places the schools, actually the art academy, traditionally was very much linked to the salon, to the exhibition practice. Do you see your students submitting to the Summer Exhibition and being part of it or … where is the link between the educational aspect and the Exhibition?

Eileen: The truth of it is … probably 10 years ago – certainly 20 years ago – students wouldn't submit. They weren't interested in showing at the Summer Show.

Nadia: Why?

Eileen: Because it was dreary. They didn't want to show there. Also then, it's always an issue of money for students. Even though they're not paying fees at the Royal Academy, they've still got to live in London. I think it's 30 pounds per entry now, so if people were going to submit two works – that's 60 pounds. It's still a big decision for students. But we can't have free entry, because the Summer Show raises money, for example, to run the schools. So, more recently, if someone like me, who's had a big teaching career, is very visibly saying, Send in! There would be a higher proportion of, not necessarily younger, but, say, emerging artists who will send in. And I will make a point of trying to include as many of them as possible.

Nadia: From what you say, the Academy also has to be very active in a way, or proactive, in showing the relevance of the Exhibition within the wider exhibition space, because the context has changed so much, and you have so many other forums in which to exhibit...

Eileen: Yes, but as it seemed to be very commercially successful ... obviously, more and more artists want to get there...

Nadia: I have a quote on this, it's from one of the reviews from this year's Exhibition, where it says:

> On the morning after the Royal Academy's celebrity-studded party for the opening of the Summer Exhibition, a rash of red dots appeared all over its walls. A pretty impressive 254 of them. Whatever the critics say – and they always have a go at the Summer Show – the public love it.

So it talks about the whole relation to the market and selling the art works. I mean, you were mentioning it, it's one of the main aims of the Summer Exhibition.

Eileen: Absolutely. And you meet so many people who come just once a year to buy a piece of art. I think Britain lagged behind, certainly behind Europe and the States, in buying contemporary art. When I was an emerging artist, it was very rare that you'd sell anything. But now there really is a hungry market and quite predatory, I think, for emerging artists.

Nadia: Where do you see the future of the Summer Exhibition?

Eileen: Well, I think, our strength is our independence. Our strength is also our members, people like me who will get involved and to tell you what it takes really. I knew that I would have this great big period of time which would be taken away from me and I knew that this was going to be a job

worth doing. I needed to put my own practice on the back boiler. Everything was brought forward for me, and then my head was clear. I was able to go around, and also messaging it to the public and the buyers and the critics and other artists, you know, the Academicians ... it's part of the pact. You have to do it, and if you coordinate it like me, then you're pretty central to all of that. And a lot of people won't do it. So, somebody like (Royal Academician) Anish Kapoor, he's never done it. He's much too busy. Anthony Gormley I don't think has done it, so a lot of our big stars ... Maybe they'll do it some time? I think we have Grayson Perry next year. I don't know if you know who that is. He's, uh, huge, *huge* at the moment. So he's coordinating it.

Nadia: I'd like to see if there are any questions from the audience.

Amin Alsaden: Thank you very much for the conversation. I'm extremely curious, and it's still completely unclear, about the criteria: How is the selection made at the end? You alluded to the fact or the observation that people are picking works that seem similar to their own.

Eileen: They get a lot of flak for that, they do, yeah.

Amin: No, but – is that the criteria …?

Eileen: No, no, absolutely not!

Amin: … and they pick whatever they want, or how do you guys agree and what's the criteria, what defines today good quality art?

Eileen: So, we don't have to agree. If somebody wants a work in – you know, it's flashing past on a big screen. And if one or two people want that work, it comes into the next stage. And then it's in the gallery in the second stage of the selection process … I suppose, the criteria are what interests you. What's unfamiliar, for me. I'm speaking about things that are unfamiliar, have great quality and strength, they interest me; I'm very interested in multimedia … so it's a personal … it's absolutely personal…

Amin: Do you guys have discussions about this?

Eileen: Oh, endlessly! These are quite difficult cross-generational discussions. Because a lot of the people, my more senior Academicians, will completely disagree with my criteria. Completely. That's why the Summer Show is always different. Sometimes it's better than others. It's a, it's a *beast*. It's a beast. One of the things that I always take into account is, a lot of the work that is submitted every year through the open submissions – forget the Academicians – is very familiar. I might not know the artists but I recognise the work. Sometimes I'm just bored with it. So I won't vote for it. If somebody else does, that's fine, but it doesn't mean it's got a

place on the wall. So when we're finally hanging, the criteria are even more unpredictable. Because sometimes you're looking for something to occupy a spot. Something that you like and … for instance, I was working with Yinka Shonibare in his room and he said, I'm doing some portraits. Go find me some portraits. So we had a whole group of small works and we managed to find about a dozen portraits and then he selected from that. He had got a theme within his room – he had many themes within his room. One of the themes he had was, he wanted to show artists using very different materials. So, you know what doilies are? They're like crochet or … obviously, works with texts, for example, digital works, he had a little film … So, individual artists who are hanging rooms, individual Academicians who are on the panel, have quite a lot of freedom. And yes, we are always discussing, we are always arguing. Some works go up that I think *why* are they hanging up? It's completely crazy, it could only be run by artists. Curators should not set foot there!

One final thing: During the two weeks of the hang, we also produce – I mean, it's a completely crazy, intense time – we produce a list of works. Because people go around, they don't know what they're looking at until they have this published list of works and a catalogue with a whole group of essays. It's intense. There is lots of discussion and massive disagreement. My committee was very friendly and very supportive – apart from one person. Sometimes they fall out, they hate each other and never communicate again.

Nadia: I think it's one thing you always have – the committee or the jury sort of fighting with each other to some extent, and also the critics. You can read critiques from the nineteenth century, and from the twentieth century, and from the twenty-first century, and some sentences are always the same…

Eileen: I don't think the critics really know how to look at it anymore. One final comment and then I'll go. We had a much loved and much hated British critic, Brian Sewell, who used to call the Royal Academy the old whore of Piccadilly, because we always had to earn our living…

Nadia: Thank you very much, that's a perfect quote to end on!

SELECTED BIBLIOGRAPHY

Newspapers and Magazines

L'Afrique du Nord Illustrée: journal hebdomadaire d'actualités nord africaines: Algérie, Tunisie, Maroc (Algeria)

Al-Ahram (Egypt)

Al-Akhbar (Lebanon)

Alger Étudiant (Algeria)

Al-Aml (Lebanon)

Annales de Géographie (France)

Annales Historiques de la Révolution française (France)

Al-Aqlam (Iraq)

L'Aurore (France)

Autorité (Egypt)

Bosphore égyptienne (Egypt)

La Bourse égyptienne (Egypt)

Chronique (Egypt)

The Daily Star (Lebanon)

Débats (Egypt)

La Dépêche tunisienne (Tunisia)

La Dépêche algérienne (Algeria)

L'Écho d'Alger (Algeria)

L'Égypte Nouvelle (Egypt)

Egyptian Gazette (Egypt)

L'Égyptienne (Egypt)

Femme (Tunisia)

Al-Funun (Iraq)

Images (Egypt)

Al-Jarida (Lebanon)

Le Jour (Lebanon)

Journal du Caire (Egypt)

Journal égyptien (Egypt)

Al Khawatir (Lebanon)

Magazine (Lebanon)

Al-Masry al-youm (Egypt)

Mujtam'a wa 'umran (Tunisia)

Al-Musawwar (Egypt)

An-Nahar (Lebanon)

Nouvelle Revue d'Égypte (Egypt)

L'Orient (Lebanon)

L'Orient Le Jour (Lebanon)

L'Orient littéraire (Lebanon)

Petit Égypte (Egypt)

Le Petit Matin (Tunisia)

Phare d'Alexandrie (Egypt)

La Presse (Tunisia)

Le Progrès (Egypt)

Les Pyramides (Egypt)

La Réforme (Egypt)

La Revue du Caire (Egypt)

Revue tunisienne (Tunisia)

Al-Saba (Iraq)

Scarabée (Egypt)

La Semaine égyptienne (Egypt)

Le Sémaphore algérien (Algeria)

Sphinx (Egypt)

Al-Tatawwur (Egypt)

Tunis-Socialiste (Tunisia)

Secondary Sources

Abaza, Mona. "The Trafficking with Tanwir (Enlightenment)." *Comparative Studies of South Asia, Africa and the Middle East* 30/1 (2010): 32-46.

Abéasis, Patrick. "Le Salon Tunisien (1894-1984). Espace d'interaction entre les générations de peintres tunisiens et français." In *Les relations tuniso-françaises au miroir des élites*. Edited by Noureddine Dougui. Manouba: Publications de la Faculté des Lettres 1997, 229-254.

—. "Alexandre Fichet à Tunis: une vie, une œuvre (1881-1967)." In *Les Communautés Méditerranéennes de Tunisie*. Edited by Abdelhamid Larguèche. Tunis: Faculté des Lettres, des Arts et des Humanités de Manouba, Centre de Publication Universitaire 2006.

Al-Asram, Khalid [Khaled Lasram]. "As-Salun at-tunisi fi 'ahd al-himayah (Le salon tunisien du temps du Protectorat)." *Da'irat al-ma'arif al-tunisiyya* (Encyclopédie de la Tunisie). Tunis/Carthage: Al-mu'assasa al-waṭaniyya bayt al-ḥikmat (Fondation nationale Beit al-Hikma) (2ᵉ cahier) 1991, 108-112.

Álvarez Dopico, Clara Ilham. "Tradition et rénovation dans la céramique tunisienne d'époche coloniale: Le cas d'Elie Blondel, le Bernard Palissy africain (1897-1910)." In *Villes maghrébines en situation coloniales*. Edited by Charlotte Jelidi. Paris: Éditions Karthala – IRMC 2014, 223-249.

Alexandrian, Sarane. *Georges Henein*, Paris: Seghers 1981.

Alexandropolos, Jaque; Canabel, Patrick Cabanel. *La Tunisie mosaïque. Diasporas, cosmopolitisme, archéologies de l'identité*. Toulouse: Presses universitaires du Mirail 2000.

Altshuler, Bruce. *From Salon to Biennial – Exhibitions that Made Art History, vol. I: 1863-1959*. London: Phaidon 2008.

Attalah, Lina. "Youth Salon." *Contemporary Practices* 5 (2010): 78-81.

Awni, Qahtan."Al-Shakhsiyah al-mutamayizah lil-'imarah al-'iraqiyah: athar al-turath wa-l-mujtama' wa-l-khalq al-fanni fi takwiniha" (The Distinct Character of Iraqi Architecture: The Impact of Heritage, Society, and Artistic Creation in Its Formation). Unpublished article. 10 April 1971, reproduced in: *'Imarat Qahtan 'Awni: dirasah tahliliyah wa tawthiqiyah* (The Architecture of Qahtan Awni: An Analytical and Documentary Study). Master's thesis by Khalid Al-Rawi. University of Baghdad 1990.

Azar, Aimé. *Peintres arméniens d'Egypte*. Cairo: Imprimerie française 1953.

Bacha, Myriam. "Paul Gauckler, le père Delattre et l'archevêché de Carthage: collaboration scientifique et affrontements institutionnels." In *Autour du fonds Poinssot*. Edited by Monique Dondin-Payre, Houcine Jaïdi, Sophie Saint-Amans and Meriem Sebaï. Paris: INHA 2017: n. pag. Web.

Bardaouil, Sam. "Dirty Dark Loud and Hysteric: The London and Paris Surrealist Exhibitions of the 1930s and the Exhibition Practices of the Art and Liberty Group in Cairo." *Dada/Surrealism* 19 (2013): n. pag. Web.

—. *Surrealism in Egypt: Modernism and the Art and Liberty Group*. London: I. B. Tauris 2017.

Bardaouil, Sam and Till Fellrath (eds.). *Art et Liberté: Rupture, Guerre, et Sur-réalisme en Égypte (1938-1948)*. Paris: Skira/Centre Georges Pompidou 2016.

Bealieau, Jill and Mary Roberts. *Orientalism's Interlocutors: Painting, Architecture and Photography*. Durham, NC; London: Duke University Press 2002.

Ben Romdhane, Narriman. *Naissance de la peinture de chevalet en Tunisie au XX^e siècle, mémoire de recherche approfondie*. Paris: École du Louvre 1985.

—. "La peinture de chevalet en Tunisie de 1894 à 1950." In *Lumières tunisiennes, catalogue de l'exposition présentée au Pavillon des arts à Paris*. Paris musées/ Association française d'action artistique/Ministère tunisien de la culture 1995, 11-35.

Ben Romdhane, Narriman; Louati Ali; Bida, Habib. *Anthologie de la peinture en Tunisie 1894-1970*. Tunis: Simpact 1998.

Bénézit, Emmanuel. *Dictionnaire des peintres, sculpteurs, dessinateurs et graveurs, nouvelle édition*. Paris: Librairie Gründ 1976.

Benjamin, Roger. *Orientalist Aesthetics: Art, Colonialism, and French North Africa, 1880-1930*. Berkeley, CA: University of California Press 2003.

—. "L'œuvre de Wassily Kandinsky au musée national d'art moderne." *La Revue des Musées de France. Revue du Louvre* 64/5 (2014): 33-42.

—. (with Cristina Ashjian). *Kandinsky and Klee in Tunisia*. Oakland, CA: University of California Press 2015.

Bernard, Augustin. "Le recensement de 1921 dans l'Afrique du Nord." *Annales de Géographie* 169 (1922): 52-58.

Bonnefoy, Yves and Berto Farhi (eds.). *Georges Henein. Œuvres*. Paris: Denoël 2006.

Breton, André. *L'Amour fou*. Paris: Éditions Gallimard 1937.

Brin, Morik. *Peintres et sculpteurs de l'Egypte contemporaine*. Cairo: Les Amis de la Culture française en Egypte 1935.

Caneri, José; De Laumois, André et al. *Un pionnier de l'art français en Egypte: Roger Bréval*. Cairo: Les Amis de la Culture française en Egypte 1938.

Carswell, John. *Lebanon – The Artist's View: 200 Years of Lebanese Art*. London: British Lebanese Association 1989.

Caubisens-Lesfargues, Colette. "Le Salon de peinture pendant la Révolution." *Annales Historiques De La Révolution Française* 33/164 (1961): 193-214.

Cazenave, Élisabeth. *La Villa Abd-el-Tif: un demi-siècle de vie artistique en Algérie, 1907-1962*. Alger: Association Abd El Tif 1998.

—. *Les artistes de l'Algérie: dictionnaire des peintres, sculpteurs, graveurs, 1830-1962*. Algiers: Éditions de l'Onde, Association Abd-el-Tif 2010.

Chadirji, Rifat. *Al-Ukhaidhir wa-l-qasr al-balluri: nushu' al-nadhariyah al-jadaliyah fi al-'imarah* (Al-Ukhaidir and the Crystal Palace: The Formation of the Dialectic Theory in Architecture). London: Riad al-Rayyis 1991.

Chaudonneret, Marie-Claude. "Le Salon pendant la première moitié du XIX^e siècle: musée d'art vivant ou marché de l'art?." In *Archive ouverte en Sciences de l'Homme et de la Société* (2007), accessed 27 September 2012, https://halshs.archives-ouvertes.fr/halshs-00176804.

—. "Les artistes vivants au Louvre (1791-1848): du musée au bazar." In *'Ce Salon à quoi tout se ramène': le Salon de peinture et de sculpture, 1791-1890.* Edited by James Kearns and Pierre Vaisse. Bern: Peter Lang 2010, 7-22.

Chemla, Jacques; Gaffard, Monique; and Lucette Valensi. *Un siècle de céramique d'art en Tunisie.* Tunis/Paris: Éditions Démeter, Éditions de l'Éclat 2015.

Coombes, Annie E. *Reinventing Africa: Museums, Material Culture and Popular Imagination in Late Victorian and Edwardian England.* New Haven: Yale University Press 1997.

Correa Calleja, Elka. *Nationalisme et Modernisme à travers l'œuvre de Mahmud Mukhtar (1891-1934).* PhD thesis, Aix-Marseille University 2014.

—. "Modernism in Arab Sculpture. The Works of Mahmud Mukhtar." *Asiatische Studien/Etudes Asiatiques* 70/4 (2016): 1115-1139.

Corriou, Morgan. "Tunis et les 'temps modernes': les débuts du cinématographe dans la Régence (1896-1908)." In *Publics et spectacle cinématographique en situation coloniale*, 95-133. Tunis: IRMC/CERES 2012.

Crow, Thomas. *Painters and Public Life in Eighteenth Century Paris.* New Haven, CT/London: Yale University Press 1985.

Drost, Julia. "Il sogno della ricchezza: Surrealismo e mercato dell'arte nella Parigi tra le due guerre." In *Il sistema dell'arte nella Parigi dei surrealisti: mercanti, galleristi, collezionisti (Ricerche di storia dell'arte 121).* Edited by Elisabetta Pallottino and Antonio Pinelli. Rome: Carocci editore 2017: 5-14.

Dumas, Dominique. *Salons et expositions à Lyon (1786-1918). Catalogue des exposants et liste de leurs œuvres.* Dijon: L'échelle de Jacob 2007.

Dupuy, Anne-Marie, de Chermont, Isabelle le Masne and Elaine Williamson (eds.). *Vivant Denon, directeur des musées sous le Consulat et l'Empire. Correspondance (1802-1815).* Paris: Éditions de la Réunion des Musées Nationaux 1999.

Esanu, Octavian. *Art, Awakening and Modernity in the Middle East: The Arab Nude.* London: Routledge 2017.

Gerschultz, Jessica. "The Interwoven Ideologies of Art and Artisanal Education in Postcolonial Tunis." *Critical Interventions: Journal of African Art History and Visual Culture* 8/1 (2014): 31-51.

—. *Decorative Arts of the Tunisian École: Fabrications of Modernism, Gender, and Power.* Refiguring Modernism. University Park, PA: Pennsylvania State University Press, forthcoming 2019.

Gharib, Samir. *Surrealism in Egypt and Plastic Arts (Prism Art Series 3).* Foreign Cultural Information Department 1986.

Görgen-Lammers, Annabelle. *Exposition internationale du Surréalisme, Paris 1938.* Munich: Schreiber 2008.

Hauptmann, William. "Juries, protests, and counter-exhibitions before 1850." *The Art Bulletin* 67/1 (1985): 95-109.

Heim, Jean-François, Béraud, Claire and Philippe Heim. *Les Salons de peinture de la Révolution française, 1789-1799.* Paris: C.A.C. Éditions 1989.

Houssais, Laurent; Lagrange, Marion. "Le 'sol ingrat de la province'." In *Marché(s) de l'art en province 1870-1914.* Edited by Laurent Houssais et Marion Lagrange. Bordeaux: Presses universitaires de Bordeaux; Les cahiers du centre François-Georges Pariset 2010, 9-15.

Irbouh, Hamid. *Art in the Service of Colonialism: French Art Education in Morocco 1912-1956.* London: Tauris Academic Studies 2005.

Jabra, Jabra Ibrahim. "al-Fann al-hadith fi al-'Iraq." In *Ma'rad Baghdad lil-rasm wa al-naht 1956 fi nadi al-mansur* (Baghdad Exhibition for Painting and Sculpture 1956 at al-Mansur Club). Baghdad: Sharikat al-tijarah wa al-tiba'ah al-mahdudah 1956, 6-13.

—. *Princesses' Street: Baghdad Memories.* Translated by Issa J. Boullata. Fayetteville, NC: University of Arkansas Press 2005.

Jolles, Adam. *The Curatorial Avant-Garde. Surrealism and Exhibition Practice in France, 1925-1941.* Pennsylvania: Pennsylvania State University Press 2013.

Kane, Patrick. *The Politics of Art in Modern Egypt: Aesthetics, Ideology and Nation-Building.* London: I. B. Tauris 2013.

Kasfir, Sidney Littlefield. "African Art and Authenticity: A Text with a Shadow." *African Arts* 25/2 (1992): 40-53; 96-97.

Kchir-Bendana Kmar. "Les missions scientifiques françaises en Tunisie dans la deuxième moitié du XIXe siècle." *Les Cahiers de Tunisie* 157-158 (1991): 197-207.

Kechari, Bechir. "The Architects of the 'Perchoir' and the Modernism of Postwar Reconstruction in Tunisia." *Journal of Architectural Education* 59/3 (2006): 80-81.

Al-Karkhi, Hussain Hatim. *Majalis al-adab fi Baghdad* (Literary Assemblies in Baghdad). Beirut: Al-mu'assasah al-'arabiyah lil-dirasat wa al-nashr 2003.

LaCoss, Don. "Egyptian Surrealism and 'Degenerate Art' in 1939." *The Arab Studies Journal 18/1*: *Visual Arts and Art Practices in the Middle East* (Spring 2010): 78-117.

Lahoud, Edouard. *Contemporary Art in Lebanon*. Beirut: Dar El-Machreq 1974.

Lançon, Daniel. "Le Caire (1934-1941): le défi des avant-gardes européennes pour les écrivains égyptiens et pour Georges Henein en particulier." In *Les Métropoles des avant-gardes*. Edited by Thomas Hunkeler and Edith A. Kunz. Geneva: Peter Lang 2010, 163-174.

Laveissière, Sylvain (ed.). *Napoléon et le Louvre*. Paris: Éditions du musée du Louvre 2004.

Le Corbusier. *L'Art décoratif d'aujourd'hui*. Paris: Éditions Arthaud 1980.

Lemaire, Gérard-Georges. *Histoire du Salon de Peinture*. Paris: Klincksieck 2004.

Lichtenstein, Jacqueline and Christian Michel. *Conférences de l'Académie royale de Peinture et de Sculpture: Volume 1, 1648-1672*. Paris: École Nationale Supérieure des Beaux-Arts 2007.

Lilti, Antoine. *Le monde des salons. Sociabilité et mondanité à Paris au XVIII^{ème} siècle*. Paris: Fayard 2005.

Loos, Adolf. *Ornament and Crime: Selected Essays*. Translated by Michael Mitchell. Riverside, CA: Ariadne Press 1998.

Louati, Ali. *L'aventure de l'art moderne en Tunisie*. Tunis: Simpact 1997.

Luthi, Jean-Jacques. *La littérature d'expression française en Égypte (1789-1998)*. Paris: L'Harmattan 2000.

Al-Mafraji, Ahmad Fayyadh. *Jam'iyat al-taskhliliyin al-'iraqiyin: 1956-1978* (Iraqi Artists Society: 1956-1978). Baghdad: Jam'iyat al-taskhliliyin al-'iraqiyin 1979.

Mainardi, Patricia. *The End of the Salon: Art and the State in the Early Third Republic*. Cambridge: Cambridge University Press 1993.

Meier, Prita. "Authenticity and Its Modernist Discontents: The Colonial Encounter and African and Middle Eastern Art History." *The Arab Studies Journal* 18/1 (2010): 12-45.

Messaoudi, Alain. "Un musée impossible. Exposer l'art moderne à Tunis (1885-2015)." In *L'orientalisme après la Querelle. Dans les pas de François Pouillon*. Edited by Guy Barthèlemy, Dominique Casajus, Sylvette Larzul, Mercedes Volait. Paris: Karthala 2016, 66-67.

Mikdadi, Salwa. "Egyptian Modern Art." In *Heilbrunn Timeline of Art History*. New York: The Metropolitan Museum of Art 2004, http://www.metmuseum. org/toah/hd/egma/hd_egma.htm.

Monnier, Gérard. *L'art et ses institutions en France. De la Révolution à nos jours.* Paris: Gallimard 1995.

Musée Nicolas Sursock: Le Livre. Beirut: Chemaly & Chemaly 2000.

Naef, Silvia. *Á la recherche d'une modernité arabe.* Geneva: Éditions Slatkine 1996.

—. "Peindre pour être moderne? Remarques sur l'adoption de l'art occidental dans l'Orient arabe." In *La multiplication des images en pays d'Islam.* Edited by Bernard Heyberger and Silvia Naef. Beirut: Orient-Institut Beirut 2003, 140-153.

Naeme, Alan. "Modern Iraqi Art." In *Ma'rad Baghdad lil-rasm wa al-naht 1956 fi nadi al-mansur* (Baghdad Exhibition for Painting and Sculpture 1956 at al-Mansur Club). Baghdad: Sharikat al-tijarah wa al-tiba'ah al-mahdudah 1956, 4-8.

Nagi, Azzedine. *Encyclopedia of Fine Arts in Egypt (Muassasa al-funun al-tashkiliya fi masr – 'asr al hadith).* Cairo: Nahdat Misr Publishing House 2007.

Nakhli, Alia. "La vie artistique en Tunisie sous le protectorat français de 1894-1914." Mémoire de D.E.A., Université Marc Bloch de Strasbourg 2005.

El Nouty, Hassan. *Les peintres français en Egypte au XIXᵉ siècle.* PhD thesis, Université de Paris 1953.

Orif, Mustapha. "De l'art indigène' à l'art algérien." *Actes de la recherche en science sociales* 75 (1988): 35-49.

Pahwa, Sonali and Jessica Winegar. "Culture, State and Revolution." In *Middle East Report* 42. Washington: Merip 2012: n. pag. Web.

Palioura, Maria-Mirka. "Theodore Ralli's diary on his travel to Athos (1885)". In *Knowledge is Light: Travellers in the Near East.* Edited by Katherine Salahi. Oxford and Oakville: Astene and Oxbow Books 2011, 78-87.

Preston Blier, Suzanne. "Enduring Myths of African Art." In *Africa, the Art of a Continent.* New York: Guggenheim Museum 1996, 26-32.

de Puisaye, Jules Anselme. *Choses d'art. Le VIᵉ salon tunisien à l'hôtel des sociétés françaises.* Tunis: Imprimerie rapide 1901.

Al-Qassab, Khalid 'Abd Al-'Aziz. *Dhikrayat fanniyah* (Artistic Memories). London: Dar Al-Hikmah 2007.

Radwan: Nadia. "Les arts et l'artisanat." In *Hassan Fathy dans son temps.* Edited by Leïla El-Wakil. Gollion/Paris: Infolio 2013, 104–123.

Radwan, Nadia. "Des Egyptiens égyptomanes." *Qantara* 87 (2013): 30-34.

—. *Les modernes d'Egypte: une renaissance transnationale des Beaux-Arts et des Arts appliqués.* Bern: Peter Lang 2017.

Ralli, Théo. *Au Mont Athos, Feuillets détachés de l'Album d'un peintre par Théo Ralli*. Cairo: Imprimerie centrale 1899.

Ramadan, Dina. "The Aesthetics of the Modern: Art, Education, and Taste in Egypt 1903-1952." PhD thesis, Columbia University 2013.

Richemond, Stéphane. *Les salons des artistes coloniaux. Suivi d'un dictionnaire des sculpteurs*. Paris: Éditions de l'Amateur 2003.

Richemond, Stéphane and Pierre Sanchez. *La société des peintres orientalistes français (1889-1943)*. Paris: Ed. l'Échelle de Jacob 2008.

Rolin, Béatrice. *Armand Vergeaud (1876-1949)*. Angoulême: Musée des Beaux-Arts 1997.

Roxburgh, David J. "Au Bonheur des Amateurs: Collecting and Exhibiting Islamic Art, ca. 1880-1910." *Ars Orientalis* 30 (2000): 9-38.

Al Sa'id, Shakir Hasan. *al-Bayanat al-fanniyah fi al-'Iraq* (Art Declarations in Iraq). Baghdad: Wizaret al-i'lam, mudiriyet al-funun al-'ammah 1973.

—. *Fusul min tarikh al-harakah al-tashkiliyah fi al-'Iraq, al-juz' al-awil* (Chapters in the History of the Plastic Movement in Iraq, vol. 1). Baghdad: Al-jumhuriyah al-'iraqiyah, wizarat al-thaqafah wa al-i'lam, da'irat al-shu'un al-thaqafiyah wa al-nashr 1983.

—. "Al-Mabhath al-rabi': al-fann al-tashkili." In *Hadarat al-'Iraq* (The Civilization of Iraq), vol. 13. Edited by Nukhbah min al-bahithin al-'iraqiyin. Baghdad: Dar al-hurriyah lil-tiba'ah 1985, 379-426.

—. *Fusul min tarikh al-harakah al-tashkiliyah fi al-'Iraq, al-juz' al-thani* (Chapters in the History of the Plastic Movement in Iraq, vol. 2). Baghdad: al-Jumhuriyah al-'iraqiyah, wizarat al-thaqafah wa al-i'lam, da'irat al-shu'un al-thaqafiyah wa al-nashr 1988.

—. *Al-Fann al-tashkili al-'iraqi al-mu'asir* (Contemporary Iraqi Plastic Art). Tunis: Al-Munazzamah al-'arabiyah lil-tarbiyah wa al-thaqafah wa al-'ulum 1992.

Salim, Ahmad Fuad. *Shahid 'iyyan 'ala harakat al-fann al-masri al-mu'asir* (Witness of the contemporary Egyptian art movement). Cairo: al-Hay'a al-masriyya al-'amma li al-kitab 2008.

Scheid, Kirsten. "The agency of art and the study of Arab modernity." *MIT-Electronic Journal of Middle East Studies (MIT-IJMES)* 7 (2007): 6-23.

Sharara, Balqis. *Hakadha marrat al-ayyam* (This is How Days Passed). Beirut: Dar al-mada lil-i'lam wa al-thaqafah wa al-funun 2015.

Sharawi, Huda. *Harem Years: The Memoirs of an Egyptian Feminist*. Translated from Arabic by Margot Badran. Cairo: The American University in Cairo Press 1998.

Stahl, Ann Brower. "Colonial Entanglements and the Practices of Taste: An Alternative to Logocentric Approaches." *American Anthropologist* 104/3 (2002): 827-845.

Thévenin, Paule (ed.). *Bureau de recherches surréalistes, Cahier de permanence, Octobre 1924-avril 1925*. Paris: Gallimard 1988.

Tignor, Robert L. *Egypt. A Short History*. Princeton/Oxford: Princeton University Press 2010.

Uthman, Mahmoud A. *Masabih wa zulumat: istithkarat* (Lanterns and Darkness: Reminiscences). 3rd ed. Beirut: Al-Mu'assasah al-'arabiyah lil-dirasat wa al-nashr 2012.

Vaisse, Pierre. *La Troisième République et les peintres*. Paris: Flammarion 1995.

—. "Réflexions sur la fin du Salon officiel." "Ce Salon à quoi tout se ramène". In *Le salon de peinture et de sculpture, 1791-1890*. Edited by James Kearns and Pierre Vaisse. Oxford: Peter Lang 2010, 117-138.

Volait, Mercedes. *Fous du Caire, excentriques, architectes et amateurs d'art en Égypte (1867-1914)*. Apt: L'Archange minotaure, coll. L'âme du monde 2009.

—. "Fragments d'une histoire artistique." *Qantara* 87 (2013): 24-27.

—. "27 Madabegh Street. Prelude to an art movement." *Rawi Egypt's Heritage Review* 8 (Fall 2016): n. pag. Web.

—. "The birth of Khedivial Cairo." *Rawi Egypt's Heritage Review* (September 2017): n. pag. Web.

Winegar, Jessica. *Creative Reckonings: The Politics of Art and Culture in Contemporary Egypt*. Stanford, CA: Stanford University Press 2006.

—. "Culture is the Solution: The civilizing mission of Egypt's Culture Palaces." *Review of Middle East Studies* 43/2 (2009): 189-197.

INDEX